Paris
Center of Artistic Enlightenment

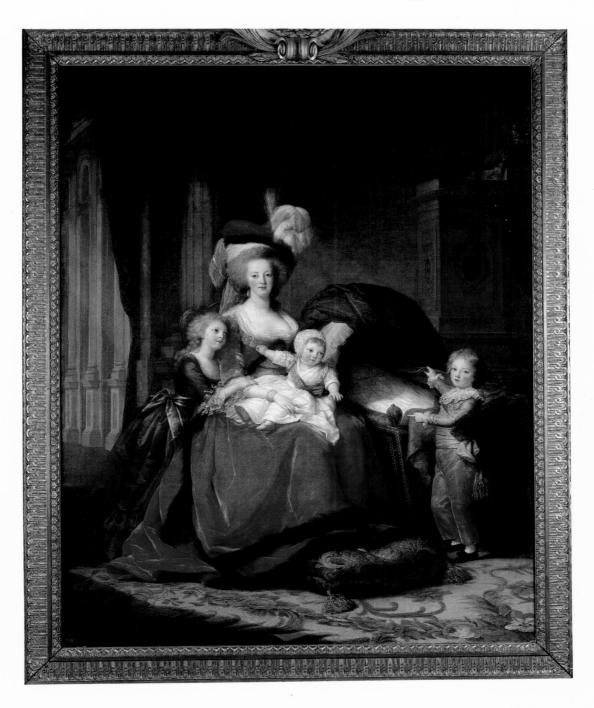

Papers in Art History from The Pennsylvania State University
Volume IV

Paris
Center of Artistic Enlightenment

Paris
Center of Artistic Enlightenment

Edited by

George Mauner
Jeanne Chenault Porter
Elizabeth Bradford Smith
Susan Scott Munshower

Papers in Art History
from
The Pennsylvania State University

Volume IV

This volume is dedicated to the memory of
Harold E. Dickson and Francis E. Hyslop.

Contents

A Silver Anniversary

It is, indeed, a fortuitous concurrence of events for the issuance of Volume IV of the *Papers* to occur during the celebration of the College of Arts and Architecture's twenty-fifth anniversary. Established in 1963, this is a young college, and when one considers the history of the University one might point to another time in the recent past, to the administration of President Milton Eisenhower (1950–56), when the Pennsylvania State College became a University and the several schools were renamed colleges. Until 1963, however, arts programs continued to be dispersed, with landscape architecture in the College of Agriculture; architecture and art history in the College of Engineering; art, music, and theatre in the College of Liberal Arts; and art and music education in the College of Education.

The establishment of the College of Arts and Architecture in 1963 was an important step in the full development of the University as a modern public research university. This establishment was based on a fundamental premise that still guides the University in its further development—that every great research university is built on a foundation of strength in the liberal arts, the sciences, and the arts.

The presence of art history within the context of this College establishes another important premise—that education and training in the practice of the arts must be linked with strong, in-depth studies in the history and literature of the arts. While art history departments often find their homes in colleges of liberal arts and science—and there is a certain logic to this for art history is recognized as a discipline among the humanities—there is an even stronger argument, in my opinion, for linking art history with the arts.

As a performing musician, I know the impoverishment of performance that can occur without the informing and reforming perspective of historical musicology. The analogy for the painter or sculptor is clear, I believe. Similarly, to continue the analogy to music, I know all too well the unfortunate rarefication of musicology that can occur in those monastic retreats where scholarship and performance are divorced.

The College is proud to be able to support the publication of the *Papers in Art History from The Pennsylvania State University.* We believe that in so doing we are assisting the department in making an important contribution to the literature of the field by sharing the Department of Art History Lecture Series with the rest of the academic community. We appreciate the support of the Institute for the Arts and Humanistic Studies at Penn State and the beneficence of Jack and Mary Lou Krumrine, and, most especially, the dedicated efforts of Professor Hellmut Hager and Susan Munshower.

Twenty five years from now when this College celebrates its fiftieth anniversary, I believe that one of the achievements cited will be the establishment of this publication series. I believe it may be said that this was a milepost in our art history department's national and international reputation for excellence.

James C. Moeser
Dean

Preface

It is a pleasure to introduce Volume IV of the *Papers in Art History from The Pennsylvania State University, Paris, Center of Artistic Enlightenment,* in this, the twenty-fifth anniversary year of the College of Arts and Architecture. We believe that this collection of essays is worthy of the occasion.

As in the past, the participating scholars presented papers in the course of the Department of Art History's lecture series. As a rule, the published papers correspond to the lectures. Nevertheless, the speakers are given the opportunity to substitute another paper, one that for any reason they believe to be more suitable for publication in a scholarly journal. In this volume, only one such substitution has been made, a tribute to the high level of the lectures which are open not only to art historians but to the community at large. Each of these papers, then, constitutes a valuable contribution to scholarship but remains accessible to the interested, general reader.

We are most fortunate to have as the opening essay Dr. Sauerländer's presentation of Paris' new consciousness of its own aesthetic and cultural worth in the 13th century. Not only is this a valuable study of the aesthetic awareness of the medieval period, but it establishes the idiomatic fusion of strength and elegance that we associate with French style ever after. The other essays, arranged in chronological order, demonstrate its continuity through the era of the Bourbons, and its appeal for the young Picasso and his artist friends who were drawn to Paris from Barcelona.

The volume does not pretend to completeness. Unfortunately, the Renaissance, when these qualities were most in evidence, will be found to be unrepresented in the collection. Regrettable as this omission is, the volume was never intended to serve as a general textbook, and each essay, while appropriate to the general theme, is to be regarded as an autonomous study, representative of the interests and methods of its author. It is a good indication, in this age of methodological debate, of how important it is to remain undogmatic, if useful and interesting results is our concern.

We wish to express our gratitude to William E. Russey of Juniata College for his indispensable technical assistance; to Joseph Baillio of Wildenstein and Company, New York, who kindly facilitated the publication of three of the color plates; to Stanley Weintraub, Director, and William Allison, Associate Director, of the Institute for the Arts and Humanistic Studies for their continuing support, both moral and financial, of the series; and to James Moeser, Dean of the College of Arts and Architecture, for his enthusiastic and generous involvement in the growth and maturity of the lecture series and the *Papers.*

I would like to thank my co-editors, Jeanne Chenault Porter and Elizabeth Bradford Smith, and our contributors, whose co-operation made work on this issue such a pleasant experience for all concerned.

Special thanks are due Hellmut Hager, Head of the Department of Art History, who initiated the lecture series, and who has sustained our enthusiasm volume after volume, and to Susan Munshower, who has been indefatigable in her efforts to maintain the scholarly and aesthetic standards of the *Papers.*

George Mauner

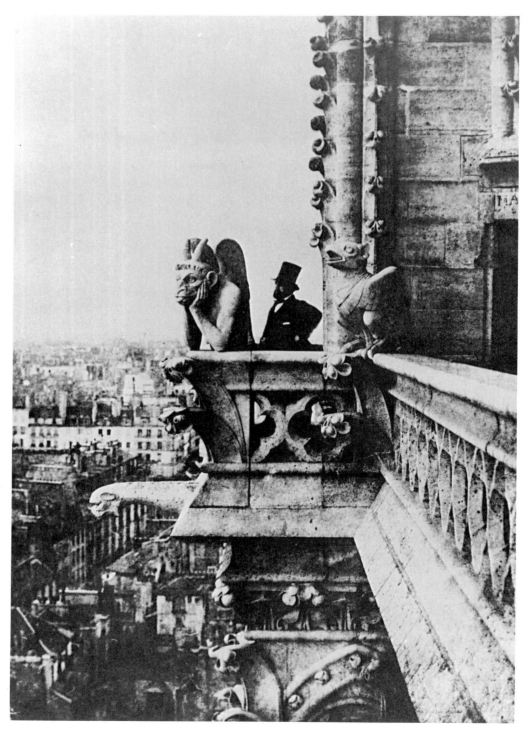

Fig. 1–1 Charles Nègre, *Le Secq on Notre-Dame*, ca. 1853. Photo: The Metropolitan Museum of Art, New York.

Medieval Paris, Center of European Taste. Fame and Realities

<div style="text-align: right">1</div>

"Ecce Paris, Ecce Homo"! In the famous chapter of *Les Misérables,* which appears under this impassioned headline, Victor Hugo bursts out:

> Paris est un total. Paris est la plafond du genre humain. Toute cette prodigieuse ville est un raccourci des moeurs mortes et des moeurs vivantes ... Tout ce qui est ailleurs est à Paris. Paris est synonyme du Cosmos. Paris est Athènes, Rome, Sybaris, Jérusalem, Pantin. Toutes les civilisations y sont en abrégé.[1]

Les Misérables was published in 1862. The myth of Paris as the capital of civilization—of taste and fashion, of modern life and modern art—was at its peak. The dark and visionary Paris of Hugo, of Baudelaire, of Sue was just beginning to change into the modern Paris of the Impressionists and of Zola's "Rougon-Macquart." More than ever Paris sparkled as the center of European taste, the Mecca of elegance, luxury, gastronomy, of *savoir vivre* and—last but not least—of the arts. Many important aesthetic innovations would soon happen outside Paris—the birth of modern architecture and design happened in England and Germany, not in Montparnasse or Montmartre. Abstract painting was rather a German, Russian or Dutch than a French achievement. But the myth of Paris as the artistic Metropolis of the Western World survived unshaken far into the twentieth century and even beyond World War II. In 1937—the year of the last World's Fair held in Paris—Paul Valéry introduced an album of lithographs and engravings with such enthusiastic sentences as,

> "Paris, oeuvre et phénomène, théâtre d'événements d'importance universelle, événement lui-même de première grandeur"[2]

The medieval past, however, offered at best a sort of fantastic and dark background for the modern myth of Paris, the city of light. The famous photograph of Charles Nègre shows Henri Le Secq as a strangely alienated visitor clothed in Brummel's modern costume between the towers and the monsters of the cathedral of Notre-Dame (Fig. 1–1)—those monsters, which are themselves not Gothic but a nineteenth-century fantasy of medieval devilment. Charles Meryon's etching "Le Stryge" from 1853 (Fig. 1–2) represents the same devil as does Le Nègre's photograph. Ravens, the "Nevermore" birds of Edgar Allan Poe, circulate in the background around the lonely Tour Saint-Jacques. The inscription reads:

> "Insatiable Vampire, l'éternelle luxure sur la grande Cité convoite sa pature."[3]

The medieval past is evoked in order to suggest a black and sinister image of modern Paris. From the towers of the Gothic cathedral a lecherous devil is looking down on the city yearning for his prey.

Whilst Haussmann, Baltard or Labrouste from 1840/1850 on, created a modern Paris, the remaining buildings of the medieval past, the cathedral of Notre-Dame, the Sainte-Chapelle, the Palais de la Cité, neglected, despised and half destroyed in the days of the Great Revolution, were restored as historical monuments. The Sainte-Chapelle became more gilded and glittering than it had been during the middle ages.[4] The façade of Notre-Dame received a greater number of Gothic statues than it had ever shown before.[5] The architect Sauvageot published a project to complete the façade of Notre-Dame with Chartresian Spires (Fig. 1–3). The furniture and the decoration of Gothic castles and churches fell into the hands of the brocanteurs and the collectors, who used them in order to compose

pseudo-medieval interiors, which seem to come directly out of some romantic novel. The most famous Parisian example was Alexandre Du Sommerard's picturesque installation of the most heteroclite medieval objects in the Hotel de Cluny during the 1830s (Fig. 1–4). But for the modern myth of Paris as the metropolis of the arts the historical monuments of the middle ages remained of minor importance compared to the new boulevards, to Garnier's opera, to the Cirque d'Hiver, the railway stations or Labrouste's astonishing library buildings. Mark Twain, who visited Paris in 1869, called the Notre-Dame cathedral "the brown old gothic pile" and seems to have been much more fascinated by his excursions to the Morgue, the Jardin Mabille and the Cimetière du Père-Lachaise.[6] For the fame of Paris as the great center of taste, which started in the age of enlightenment, and culminated in the "Belle Epoque," the heritage of the city's medieval past was practically irrelevant.

And yet Paris had enjoyed genuine medieval fame! Not so different from Victor Hugo's bombastic praise of the French capital in *Les Misérables*, Eustache Deschamps (1346–1406), a royal functionary and poet wrote:

> Quant j'ay la terre et la mer avironnée
> et visité en chascune partie
> Jherusalem, Egipte et Galilée.
> Alixandre, Damas et la Surie,
> Babiloine, le Caire et Tartarie
> et touz les pors qui y sont,
> les espices et les succres qui s'i font,
> les fins draps d'or et soye du pays,
> valent trop mieulx ce que les François ont:
> Riens ne se puet comparer a Paris.[7]

The fame of Paris, the belief in the superiority of Paris, goes right back to the Middle Ages. Deschamps' "Balade" was composed towards the end of the fourteenth century. Two well-known views of an only slightly later date: one representing the royal palace and the Sainte-Chapelle (Fig. 1–5) and the other showing the Ile de la Cité with the over-towering façade of Notre-Dame (Fig. 1–6) may give us an idea how the heart of Paris may have looked in Deschamps' days. But we must cite another strophe of the same "Balade" which praises Paris as a great center of the arts and crafts:

> Mais elle est bien mieulx que ville fermée
> et de chasteaulx de grant anceserie,
> de gens d'onneur et de marchans peuplée,
> de touz ouvriers d'armes, d'orfavrerie;
> de touz les ars c'est la flour, quoy qu'on die:

> Touz ouvraiges a droit font;
> subtil engin, entendement parfont
> venez avoir aux habitans toudis,
> et loyaulté aux euvres qu'ilz feront:
> Rien ne se puet comparer a Paris.[8]

For Deschamps, the courtier from the days of Charles V and Charles VI, the superiority of Paris resided not only in the excellence of spices and textiles, but also in the skill of goldsmiths and armourers, engineers and other artists and craftsmen. So even the fame of Paris as a center of the arts had its medieval antecedents.

In another "Balade" Deschamps addresses Paris as the "cité de justice," "mere de foy," "estoc de la theologie" and then goes on:

> Et chascuns doit amer ta seignourie:
> Mainte Dame as de grant beauté parée;
> suir te suelt bonne chevalerie;
> tu as moult d'or, d'argent, de pierrerie
> et de joyaulx sur Grant Pont;
> le grant palais qui les mauvais confont,
> dont le seigneur est chief des fleurs de lis.
> Tes noms durra, tuit dient et diront
> riens ne se puet comparer a Paris."[9]

There it is, the fame of Paris as the city of elegance, feminine beauty, luxury, gold and jewels. A page from the "Grandes Chroniques de France," a lavishly illuminated manuscript produced at Paris between 1375 and 1380 for the king Charles V may illustrate what Eustache Deschamps had in mind (Fig. 1–7). It shows a banquet in the Royal Palace, which Charles V gave in honor of the German emperor Charles IV. The walls of the banqueting hall are covered with damask patterned with gilded embroidery—Deschamps' "fins draps d'or" and the table is charged with golden cups and vessels, productions of Deschamps' "ouvriers d'orfavrerie."

But the renown of Paris as a city of the arts and of refined craftsmanship is even older than the dynasty of the Valois. By the first years of the fourteenth century—in the days of Philip the Fair—the renown of Paris as the most productive center of manuscript illumination in Europe was sufficiently established to enable Dante in the "Purgatorio" of the *Divina commedia* to address Odersi as "l'onor di Agobbio e l'onor di quell'arte ch'alluminar chiamata è in Parisi."[10] What made Paris so famous as a center of illumination was above all the production of luxury manuscripts of tiny format: psalters, breviaries, books of hours for princes or pious ladies of the court. These were lavishly illustrated with delicate miniatures by the hands of highly qualified professional artists such as Master Honoré,

Jean Pucelle or Jean de Noir. A page from the so-called Breviary of Philippe the Fair, a manuscript produced for the French court in the last years of the thirteenth century with illuminations by Master Honoré may illustrate what the Italian poet had in mind when he spoke of "quell'arte ch'alluminar chiamata è in Parisi" (Fig. 1–8).

The fame of Paris as the leading center of modern architecture in thirteenth-century Europe was established even earlier and is emphatically attested to by the German chronicler Burchard of Hall. He tells that the prior of Saint Peter at Wimpfen, Richard of Deidesheim, had the church of his monastery rebuilt in 1270. Richard destroyed the old building "prae nimia vetustate ruinosum" ("which was in ruins because of its old age"). "He called in a master mason very experienced in the art of architecture, who had come recently from the town of Paris in France and ordered the basilica to be built in ashlar in the style of French origin." These are the words of the thirteenth-century chronicler translated from his Latin text, which reads as follows: "accitóque peritissimo architectoriae artis Latomo, qui tunc noviter de villa Parisiensi è partibus venerat Franciae, opere Francigeno Basilicam ex sectis lapidibus construi jubet."[11] The outstanding qualification of the master mason for the German chronicler is proved by the fact that he came directly from Paris in France and had the modern know-how of French and—we may add—Parisian architecture. Nowadays we can still admire at least part of the buildings on which the fame of Paris as a great center of ecclesiastical architecture was founded in the thirteenth century. The two transept façades of the cathedral of Notre-Dame with their miraculous rose windows, which were imitated all over Europe from León in Castilia to Upsala in Sweden, are the prime example of Parisian architecture in the days of Saint-Louis. Jean de Jandun, a master of the arts and teacher at the Collège de Navarre, who died in 1328, praised the transept roses of Notre-Dame in his "Tractatus de laudibus Parisius" with the following words: "Demum libenter addiscerem ubi sunt tales duo circuli, sibi invicem secundum rectam lineam opposite situate."[12] Even in architecture, so it is now claimed, nothing can be compared to Paris. "Rien ne se puet comparer a Paris" to repeat the words of Eustache Deschamps. The second monument, which was seminal for the European fame of Parisian architecture was, needless to say, the Sainte-Chapelle in the royal palace. Jean de Jandun said that entering this shrine of stone and colored glass was like coming into one of the most excellent chambers of paradise, "unam de Paradisi potissimis cameris."[13]

In the text of 1937, which I cited above, Paul Valéry wrote of Paris: "Il n'est point d'autre ville où l'unité d'un peuple ait été élaborée et consommée par une suite aussi remarquable et aussi diverse de circonstances ... C'est ici que notre nation, la plus composée de l'Europe, a été fondue."[14] At the origin of the fame of Paris as a Mecca of the arts and as a teacher of European taste stands a political, administrative and even ideological process, which was fundamental for the course of French history: centralization. Certainly, Paris was an old city, and its eminent role is already recorded in Roman times. "Concilium Luteciam Parisiorum transfert" we read in Caesar's "De Bello Gallico."[15] However, until the twelfth century Paris was not the center of France nor was France the center of European civilization. As art historians we may be interested in the eleventh century sculptures and manuscripts from Saint-Germain-des-Prés, but these capitals and miniatures have no greater historical or aesthetic significance than the productions of other centers in the provinces, in the Loire valley or in the South.[16] It was only when in the twelfth century the Capetian kings began to make of Paris the administrative and the ideological center of their kingdom and to venerate Saint-Denis, the legendary first bishop of Paris, as the patron Saint of the monarchy, that the fame of Paris as a city of the arts began to develop. During the reign of Louis VI (1108–1137) the myth of Paris as the ideal center of France began to be formed. Now it was claimed that the Christian rulers of the kingdom had always regarded Paris as their capital and that even Charlemagne had resided there.[17] And only now the fame of Paris as a city full of splendid buildings and fabulous treasures became a need and soon a reality. The old monasteries in and around Paris—Saint-Martin-des-Champs, Saint-Denis, Saint-Germain-des-Prés, Saint-Pierre de Montmartre, Saint Julien le Pauvre—began to be renovated and were among the first monuments which were built "opere Francigeno" in the new Gothic style.[18] The tombs of their royal founders, who mostly had lived half a millenium ago, were renovated and equipped with carved images. The myth of Paris as the time-honored center of the monarchy was visualized. Perhaps the most venerable of all these tombs was that of Clovis I, the French Constantine, who had converted the monarchy to Christendom by his baptism at Reims cathedral in 497. He was buried at Sainte-Geneviève, and when his tomb was renovated during the reign of king Philippe Auguste (1180–1223) the inscription around the gisant is said to have read: "Parisiis sedem regni constituit," ("he established the seat of the kingdom at Paris").[19] It was this retrospective legend of Paris as the permanent center of the Christian monarch of France since the reign of Clovis I, which was the origin of the legend and the reality of medieval Paris as a center of the arts.

Parallel to its rise as the center of the French royal domaine Paris established its position as the leading

place of learning in Europe. Early in the twelfth century, scholarship and teaching in Paris had still been overshadowed by the cathedral schools in the nearby provinces: Orléans, Laon and Chartres.[20] But with William of Champeaux (ca. 1070–1121), Petrus Lombardus, an Italian, who died in 1160 as bishop of Paris, and Petrus Comestor, who lived until 1178, the school of the cathedral at Paris had definitively bypassed its earlier rivals. "Whatever the competition between the early schools of Laon, Chartres, and elsewhere, without doubt Paris had emerged supreme over all others North of the Alps by the end of the twelfth century."[21] The fame of the left bank as the intellectual mill or oven of the West started in the twelfth century with the rise of the brilliant schools at Sainte-Geneviève and Saint-Victor.[22] Students came from all over Europe and early in the thirteenth century they began to form corporations which called themselves "Universitates magistrorum et scolarium."[23] Guillaume le Breton (ca. 1165—after 1226), chapelain and historiographer of king Philippe Auguste, could proudly write in 1212: "There was never a comparable rush of students in Athens or in Egypt or in any other place in the world, where the taste for studies had flourished. This is not only due to the charm of the place, to the presence of all kinds of goods but also to the liberties and the protection which Philippe Auguste and his father have granted to the students."[24] Here we have it again, the myth of Paris which cannot be compared to any other city. But students from all parts of Europe meant not only renown and fame but also clients; clients for objects of luxury eventually, certainly clients for the book market. The needs of the university made Paris, in the thirteenth century, the greatest center of book production in Europe. These new manuscripts were written by professional scribes, illuminated by professional painters and sold by the "librarii," that is to say, booksellers in the modern sense.[25] Mostly they sold Bibles in small format, the text soberly written in tiny letters but frequently with the luxury of illuminated and often even gilded initials (Fig. 1–9). Odofredus, a professor of law in the competing university of Bologna, described the consequences of this new booktrade very colorfully: "The father says to the son: Go to Paris or Bologna and I will send you a hundred pounds the year. And what did the boy do? He went to Paris and his books were made to prattle with gold letters."[26] By the thirteenth century Paris is regarded as a place of luxury with its attractions—and its dangers.

As important as the role of scholarship and of the schools may have been for the rise of Paris to international fame, it was its political role as the ideal center of the monarchy which put medieval Paris in a position to become the leading art-city of France and soon of Europe. It all began in the twelfth century during the reign of Louis VI (1108–1137) and Louis VII (1137–1180). And it all began at Saint-Denis under the extraordinary Abbot Suger (1122–1151), who was not only a daring and highly imaginative "entrepreneur" but also an ingenious creator of glamour and publicity. The royal abbey was an "haut-lieu" of the monarchy. For more than five hundred years the kings were buried there.[27] Their "insignia" were kept in the treasury of the abbey.[28] Whenever the king went to war or on a crusade, the marshal of the army carried the "oriflamme," the banner of Saint-Denis. There is a famous stained glass window in the transept of the cathedral of Chartres which shows a member of the family, Clement du Mez, who receives the legendary banner from the hands of Saint-Denis himself. The king regarded himself as a vassal of Saint-Denis and his army went into battle with the cry "Montjoie Saint-Denis."[29] In renovating the choir and the façade of the Carolingian abbey church, Suger was eager to enhance this unique position of the royal monastery and to surround it with a glamorous visual aura. In his writings he insists, not without vanity, on the fact that he had called in many masters from different nations in order to execute the stained glass windows for the new parts of his church: "Vitrearum etiam novarum praeclaram varietatem ... magistrorum multorum de diversis nationibus manu exquisita depingi fecimus."[30] Around the rising Capetian monarchy centralization is a strategy not only for political but also for artistic action. If Suger wanted to create a monument of more than regional radiance, which gave visual expression to the central role of his abbey for the kingdom of France, he had to free himself from local styles and to bring in artists from different places, "de diversis nationibus." The abbot seems no less vain when he tells us how delighted he was to hear from pilgrims to Jerusalem that the treasures at Constantinople and the precious objects visible in the Hagia Sophia were less important than those exhibited in his new choir.[31] Suger is hesitant to believe it, but nevertheless flattered by the advantageous comparison with the fabulous riches in the capital of the Byzantine basileus. Again one is reminded of Eustache Deschamps' "Riens ne se puet comparer a Paris." The ambition to be superior and incomparable already begins to appear in the twelfth century.

Suger's constructions at Saint-Denis, the new façade and the new choir of the abbey church, were the first "Parisian" buildings which gained worldwide fame in the eyes of posterity. "Suger planned and executed his church, which not only became the archetype of French cathedrals, but whose style—the Gothic—appears to us as the embodiment of medieval civilization," wrote such a leading authority as Otto von Simson in his standard book on the Gothic cathedral.[32] Suger's Saint-

Denis has for a long time been regarded as the cradle or the fountain-head of all Gothic architecture in Europe and this opinion is an essential part of the fame of medieval Paris as a center of European art. Suger himself regarded his achievement less as an innovation than as a renovation of the time-honored traditions of the royal abbey. In his writings he insists that he was "apprime de convenientia et cohaerentia antiqui et novi operis sollicitus" ("in acting this way"—that is to say, in remodelling parts of the Carolingian church— "his first interest was the concordance and coherence of the old and the new parts."[33] He certainly meant not only the physical connection between the Carolingian and the early Gothic parts of the building, but hinted at tradition and continuity in a deeper, religious and political sense. In this context it is very revealing that he was deliberating "Unde marmoreas aut marmoreis aequipollentes haberemus columnas" (He "speculated from where to get marble columns or the equivalent thereof"). He wondered if he might not acquire them "ab urbe (Romae enim in palatio Diocletiani et aliis termis saepe mirabiles conspexeramus)" ("from the eternal city (for in Rome we had often seen wonderful ones in the Palace of Diocletianus and other Baths)."[34] He failed, but even so the freestanding monolith columns of Suger's deambulatory (Fig. 1–10) with their flawless acanthus-capitals stress not innovation, but continuity and renovation of the Carolingian tradition. And when Suger wanted to evoke the memory of the abbey's founder, the Merovingian king Dagobert I (died in 639), he had a statue carved, which looks like an early medieval—not a Romanesque or early Gothic—representation of a ruler (Fig. 1–11). Finally, the astonishing decision to decorate the portals of the new façade with twenty columns showing statues of kings and priests from the Old Testament hails the position of the royal abbey as a symbolic place for the union of monarchy and church, kings and priests in the kingdom of France.[35] It was the first Gothic portal with statue-columns in the history of medieval art, and all the later development of Gothic sculpture in France, Spain, England and the Empire began here. The idea of the solemn entrance of the church, supported by the apostles, the prophets, the patriarchs, the biblical kings or the Christian Saints, who are represented like columns, was developed in the days of Suger at the Royal Abbey at Saint-Denis.

The fame of Paris as a city of the arts begins in the middle ages with the renovation of Saint-Denis in the first years of the reign of Louis VII (1137–1180). The rising Capetian monarchy needed an art, needed buildings, images, symbols, which were of more than local or regional character. They had to express visually the idea of Paris and Saint-Denis as the sacred center of a new France united under the Capetian kings. The fame of Paris had to be made, to be fostered—to be announced—and that is what Suger undertook with the renovation of his church, which was sparkling with stained glass windows, golden vessels, chandeliers, crosses, pavements, bronze doors and mosaics. And he succeeded. Even after 800 years his church is hailed as a landmark in medieval history and as the very first monument, which made Paris the avant-garde place of European taste and art. I do not say that this is necessarily the historical truth. The origins of Gothic art and architecture are of a complex kind and cannot be reduced to the invention of one single place. But the legend worked. "Saint-Denis n'est pas seulement un chef-d'oeuvre. C'est un fait, considérable dans l'histoire de la civilisation médiévale," affirmed Henry Focillon.[36]

If we turn now to the first building of international fame in the capital itself, we find a similar situation. The construction of a new cathedral seems not to have begun before the accession of Bishop Maurice de Sully to the see in 1160.[37] From this initial moment a tympanum of high significance has been conserved (Fig. 1–12). It represents our lady, the patroness of the cathedral of Notre-Dame and eventually of the whole city of Paris, solemnly enthroned under a canopy, which is crowned by a cross. She is flanked by incensing angels and by a bishop, who stands to her right and a king, who kneels to her left. It has been suggested that the king, who holds a scroll, might be Childebert I (511–558), who was believed to have made an important donation to the cathedral. The bishop, who also holds a scroll and is moreover accompanied by a writing clerk, would then be Saint-Germain, who was regarded as the receiver of Childebert's gift.[38] If this identification should prove to be true—the question is open and probably unsolvable—we would find here the same climate of "renovatio" as twenty years before in the suburban abbey at Saint-Denis. Be this as it may, the assemblage of figures on the tympanum reflects in any case the same union of kingship and priesthood as the statue-columns on the portals of Suger's façade, a union which was characteristic for Capetian France.[39] We have no proof that the kings really sponsored the reconstruction of the cathedral in the capital. But special royal favor for the cathedral is well documented. When Louis VII departed in 1147 for the second crusade he insisted that Notre-Dame had long been connected with the crown "ex longo tempore usu corone regni familiarius adjuncta."[40] Philippe Auguste made a similar statement when he went away in 1190 for the third crusade: "pre ceteres Parisiensens ecclesiam familiarius et affectuosius diligens."[41] So there was definitely a royal, Capetian aura around Notre-Dame in Paris, the first Gothic building of grand scale in the capital.

The idea of renovatio, of "convenientia et cohaerentia antiqui et novi operis" —to repeat Suger's words—

has also shaped the plan and the elevation of the twelfth century cathedral in Paris. Notre-Dame belongs to a small family of distinguished medieval buildings with double aisles, which comprises such capital monuments as Saint-Martin at Tours and Saint-Peter at Cluny and derives in the last instance from the most venerable church of the Latin West, Old Saint Peter's in Rome. In Paris, the appearance of this ambitious plan may possibly be explained by the fact that the predecessor of the twelfth century Notre-Dame, the Merovingian cathedral Saint Stephen, had—if one follows the reconstruction of Michel Fleury—already shown double aisles.[42] If Fleury's proposal is correct, Maurice de Sully's new building would be nothing else than a "renovatio" of Childebert's venerable basilica erected five hundred years earlier. This might even be true of one very striking and unusual feature of the interior. As is well-known, the vaulted churches of the Western Middle Ages had replaced the columns of the early Christian basilica by more solid supports, mostly rectangular or composed pillars. Neither such ambitious constructions as Cluny or Speyer nor the pilgrimage churches, or the great Norman abbeys and cathedrals at Caen or Durham were able—or concerned—to retain the classical column. To my knowledge Notre-Dame in Paris was the first vaulted basilica of the Western Middle Ages which reinstituted the column as the support of the arcades (Fig. 1–13).[43] All the arcades of the choir and of the nave at Notre-Dame show the same stout columns with large, classicizing capitals. This is an astonishing demonstration of "renovatio," but it is a demonstration made with taste. There is something very noble in these long series of perfectly equal columns. The interior of Notre-Dame is an architectural composition of beautiful regularity. Aesthetically, this often underrated cathedral is the first characteristically Parisian building in the history of architecture. In the twelfth and thirteenth centuries the fame of Paris as a city of the arts crystallized around Notre-Dame.

Jean Bony, an architectural historian of rare sensitivity, has some telling words to say about the delicate beauty of the interior of Notre-Dame and of related Parisian buildings from the twelfth century. He praises "the smooth, taut, parchment-like quality of the thin wall" and "the beauty of these thin screens of pale stone, the peacefulness of these flat surfaces."[44] Compared with other great early Gothic buildings—the most striking example for a comparison might be the cathedral of Laon—Notre-Dame in Paris is of a rare discretion. The interior is without dramatic effects. The walls are composed of relatively small stones. The mouldings are extremely refined and avoid strong plastic effects. The responds and the columns of the tribunes are slender and of graceful elegance. The decoration is delicate.

The interior of Notre-Dame is not forceful, but it is refined. Whoever has strolled through Paris with eyes open to the specific aesthetics of Parisian architecture as one may discover it in the hotels of François Mansart or Boffrand, or in the airy lightness of Labrouste's "salle de travail" at the Bibliothèque Nationale, will recognize the roots of such delicateness in the twelfth century interior of Notre-Dame. Paris as an art city has begun to become a reality. The unique blend of intelligence and beauty, which has remained the secret of Parisian art for many centuries, appears here for the first time.

> Il est, à coup sûr, peu de plus belles pages d'architecture que cette façade où, successivement et à la fois, les trois portails creusés en ogive, le cordon brodé et dentelé des vingt-huit niches royales, l'immense rosace centrale flanquée de ses deux fenêtres latérales comme le prêtre du diacre et du sous-diacre, la haute et frêle galerie d'arcades à trèfle qui porte une lourde plate-forme sur ses fines colonnettes, enfin les deux noires et massives tours avec leurs auvents d'ardoise, parties harmonieuses d'un tout magnifique, super-posés en cinq étages gigantesques, se développent à l'oeil, en foule et sans trouble ... ralliés puissamment à la tranquille grandeur de l'ensemble."[45]

This was, in 1831, Victor Hugo's description of the façade of Notre-Dame in Paris (Fig. 1–14). It is as full of inspired admiration as one might expect from the great romantic writer who was never sparing with his words. But in praising "la tranquille grandeur de l'ensemble," Hugo makes a sensitive statement on the eminently Parisian character of this architectural composition. If one compares the frontispiece of Notre-Dame to the façade of other French cathedrals—the prime example is naturally Laon—one will admire the graceful dominance of measure and order. The quiet straight lines of the horizontal galleries and the vertical buttresses have displaced the gables and pinnacles, the turrets and broken cornices we see at Laon, at Amiens and at Reims. One feels tempted to speak of medieval neoclassicism. It remains astonishing to what degree this medieval façade has become part of the architectural physiognomy of post-medieval Paris, the city which nearly always refused to take part in the extravagances of the history of European architecture, which stood away from the Baroque, turned down Bernini and erected Perrault's dignified and academic Louvre façade. The classic tradition of Parisian architecture began with the frontispiece of Notre-Dame. In the enlightened eighteenth century Servandoni's curious façade of Saint-Sulpice, an odd pièce of late baroque or early neoclassical architecture is, at five hundred years'

distance, a modern variation of the design of the medieval façade. And in our own era even such a radical modernist as Le Corbusier called this astonishing medieval monument a "pure construction de l'esprit."[46]

When this gigantic façade was piled up early in the thirteenth century, Philippe Auguste, the most formidable of all the Capetian kings, had for the first time in history united great parts of France around Paris as its capital. After the "Dimanche de Bouvines" in 1214 he became the most powerful ruler of Europe, overshadowing even the fame and the splendour of the Hohenstaufen in the Holy Roman Empire.[47] The iconographic program of the façade of Notre-Dame seems to announce this royal triumph. Seventy years before the kings and the priests of the Old Testament had appeared as columns on the portals at Saint-Denis, symbolizing the union of monarchy and church in twelfth-century France. Now a gallery of 28 over-life-size statues of kings and arcades spreads out above the portals from one end of the façade to the other. It remains an open question if they represent the Jewish kings of the Old Testament as the models and the biblical predecessors of the Christian kings of France or those kings themselves.[48] The people in the streets of Paris had this problem solved by the end of the thirteenth century. In the XXIII manières de vilains, a satirical text, which dates from the eighties of the thirteenth century, we read: "Li vilains babouins est cil ka va devant Notre-Dame à Paris et regarde les rois et dit: Ves la Pepin, ves la Charle Magne et on li coupe la borse par derrière."[49] We may translate freely: "a poor jester goes on the parvis before Notre-Dame, gazes at the statues of the kings and says: look there Pepin, look there Charlemagne and someone cuts his purse from behind." Even if one regards the XXIII manières des vilains as not the most serious source, this text proves that at least as early as the days of Philip the Bald (1270–1285) the people of Paris believed that the rulers of the kingdom—Charlemagne, Pepin and others—were represented on the façade of the cathedral in the capital. Again we see that the rise of the Capetian monarchy, the beginning centralization of France and the origins of Paris as a leading city of the arts were part of the same process in history. The kings gallery at Notre-Dame is like the medieval predecessor of the magnificent "places royales" with their equestrian monuments of Henry IV, Louis XIV and Louis XV, which gave Paris its urbanistic splendour in the seventeenth and eighteenth centuries.

The revolution hated the royal effigies sufficiently to have them destroyed in 1793. Jacques Louis David demanded in the convention "ces dignes prédécesseurs de Capet (that is to say, Louis XVI) qui tous, jusqu'à cet instant, avaient échappé à la loi dont vous avez frappée la Royauté, devaient subir dans leurs gothiques effigies le jugement terrible et révolutionnaire de la posterité."[50] Sébastien Mercier has on some pages of his Nouveau Paris described the heads of the destroyed statues as he discovered them after 1793: "Toute la première race était là, bien noircie par le tems ... L'un sur l'autre entassées derrière l'église, ils restent enterrés sous le plus sales immondices."[51] In 1977 these mutilated heads were rediscovered, moving witnesses of the vicissitudes of French history but also of Parisian art when it began to rise to European fame under Philippe Auguste and Louis VIII (1223–1226; Fig. 1–15).

Guillaume le Breton, the earlier mentioned chaplain and historiographer of Philippe Auguste, praised his king as greater than Alexander and Caesar but hailed him above all as "le fils de Charlemagne," "Karolides."[52] The most perfect of the portals of the west façade of Notre-Dame, the portal which shows as the central image the assumption of the Virgin, seems to have reflected this dynastic panegyric (Fig. 1–16). The jamb statues of this portal which were also destroyed during the revolution and later replaced by neogothic copies, represented besides local Parisian saints such as Saint-Denis, the first bishop and apostle of the city, or Sainte-Geneviève, who had defended the capital against the Huns and was venerated as "defensor civitatis," an emperor and a pope. There is a possibility that these last two statues represented Charlemagne and Leo III, the pope who had crowned the first Frankish emperor at Old Saint Peter's.[53] If this identification is accepted, the program on the jambs of the Virgin's portal at Notre-Dame would be of relevant political actuality: Paris, the city which saw Saint-Denis as its first Christian bishop and had been defended against its foes by Sainte-Geneviève, claims that it had also been the residence of Charlemagne, the center of the Carolingian empire. This is exactly the legendary truth which was proclaimed by contemporary epic poetry such as the "Otival": "tint sa cour kalles a Paris, sa meson."[54]

The central image on the tympanum of this portal shows the assumption of the Virgin (Fig. 1–17). The subject is connected with the main feast of the cathedral of Paris, "in assumptione Beatae Mariae Virginis" on the 15th of August. The particular solemnity of this sculpted image may correspond to this liturgical importance. There is a surprising absence of pathos and expression. No excited gesture, no vehement movement disturbs the symmetrical order of the composition and the character of quiet contemplation. The blessing Christ stands exactly in the center. Two angels bow down as in a liturgical ceremony and raise the Holy Virgin from the sarcophagus with venerating gestures; the

apostles are present as the silent assistants of the miraculous event. The death and the assumption of the Virgin has always been one of the great, moving themes of Christian art, from the charming twelfth century portal at Senlis to Hugo van der Goes' affecting picture at Bruges, through Titian's grandiloquent "Assunta" in the "Frari." Not so at the cathedral in Paris in the days of the great scholastic thinkers. Alexander of Hales, who was master of philosophy at the university of Paris when the portal of the Virgin at Notre-Dame was sculpted, had taught "Ordo est pulcher," "Order is beautiful." [55] There is a latent classicism in the symmetrical order of this delicately tempered representation of Mary's assumption. "Gothic" becomes now a Parisian style, a style more refined, more civilized and soon also more fashionable than all earlier medieval styles. On the doorposts of the same portal the month of May is represented by the figure of an elegant young man of seductive beauty holding flowers and a hawk, the favorite pet of the snobbish nobility in those times (Fig. 1-18). We are between 1210 and 1220. From now on Paris begins to set the tone for refined behavior, fashion and for art and architecture.

Let us turn from sculpture back to architecture. During the reign of Napoleon III, when a new Paris was created under the guidance of Baron Haussmann, Viollet-le-Duc (1814–1879) published the ten volumes of his monumental *Dictionnaire raisonné de l'architecture française*, because he wanted to demonstrate that the spirit of modern engineering was nothing else than the heritage of French and especially Parisian medieval architecture. He wrote:

> "Quand l'ingénieur Polonceau (1788–1814)" — the architect of the "Pont du Carrousel" in Paris— "imagina le système de cercles de fer pour résister à des pressions entre le tablier et les arcs d'un pont, il ne faisait, à tout prendre, qu'appliquer un principe qui avait été employé six siècles avant lui. On vanta, et avec raison, le système nouveau ou plutôt renouvelé, mais personne ne songea à tourner les yeux vers la cathédrale de Paris et bien d'autres édifices du XIIIᵉ siècle, dans lesquels on avait si souvent et si heureusement employé les cercles comme moyen de résistance opposé à des pressions.[56]

This progressive medievalism of Viollet-le-Duc is another aspect of the legend of medieval Paris as the leading art center of the European thirteenth century: Modern functionalism, the railway stations and bridges constructed in iron stem not from the tradition of the "Ecole des Beaux-Arts," which Viollet-le-Duc despised, but from the rationalism of Gothic architecture in Paris.

Viollet-le-Duc's prime examples were the transept façades of Notre-Dame, which had been erected during the reign of Saint Louis between 1245 and 1265 by Jean de Chelles on the North side and by Pierre de Montereau on the South side (Fig. 1-19).[57] Barely half a century had passed since the foundations had been laid out for the old, powerful west façade. The progress seems miraculous. Stone cutting has now become so skilful, the use of iron reinforcements so subtly developed, that these façades have gained an incredible lightness. The gables, which crown and surround the single portal are thin and seem nearly weightless. The rose window spreads out like a huge embroidery, but its circular pattern has been laid out with the compass in a strict mathematical order. This is a highly intelligent kind of architecture. The thin bars of stone in the interior of the large circle of the rose window are carefully stabilized by the rectangular frame of the buttresses, the lower gallery and the crowning gable. In the spandrels between the rose window and the frame we discover those small circles—those "oculi" —which reminded Viollet-le-Duc of the new construction system of Polonceau's bridge.

The astonishing success of Parisian architecture at certain moments of architectural history depended always on the normative clearness of the fashionable systems it offered to the civilized world. This is certainly true of Parisian architecture and architectural theory from the seventeenth century until the time of Durand (1760–1834). But in a certain sense this was already true of Parisian architecture in the days of Saint Louis. With the gables and roses of the transept of Notre-Dame Paris offered architectural patterns which could be easily imitated, drawn on parchment and sent out all over Europe. The success of this Parisian model was fabulous. The list of imitations and variations is long and includes buildings as far away as the cathedrals of León in Castilia or Upsala in Sweden, Westminster Abbey or the Cistercian church of Ebrach in Franconia. It is under the spell of such new architectural brilliance and fame that Burchard of Hall spoke of the new church at Wimpfen as having been erected "accitòque peritissimo Architectoriae artis Latomo, qui tunc noviter de villa Parisiensi ...venerat, *opere Francigeno*."[58]

With the elegant forms of this façade, the gables and pinnacles, the rose and the rosaces, Paris had created around the middle of the thirteenth century a fashionable vocabulary, which was barely less successful than the "rocaille" in the century of Louis XV. It has sometimes been suggested that the elegant, clearly cut forms of the two transept façades of Notre-Dame could derive from metalwork.[59] I am afraid that this is a confusion of effect and cause. The thin gables of the tran-

sept-portals look like metalwork, but this does not mean that they are an imitation of models in the so-called minor arts. On the contrary, the decorative elegance of these monumental forms is such, their design is so neat and precise, that they will soon be repeated in reduced size on all kinds of smaller objects, on ivories and reliquary shrines, retables and tombstones. In the famous psalter of Saint Louis, a manuscript probably produced for the private use of the king in the last decade of his life between 1260 and 1270, all the biblical scenes are placed under arcades with roses and gables looking like the transept façades of the cathedral in the capital (Fig. 1–20). Paris has introduced a new vocabulary for sacred architecture and by the middle of the thirteenth century the fame of the French capital was such, that this vocabulary was imitated in all European countries and by all the artists—the goldsmiths and the painters, the ivory-cutters and the sculptors. The legend of Paris as a cosmopolitan center of the arts has become a reality for the first time in history.

The most famous building erected during the reign of Saint Louis was, needless to repeat, the Sainte-Chapelle in the royal palace on the Ile de la Cité (Fig. 1–21). The history of this famous monument is well known. In 1239 the king acquired from the imperial palace in Constantinople a relic, which could not have been more symbolic for a royal owner: the crown of thorns. Pope Innocent IV wrote on this occasion to Louis: "Nec immerito reputamus quod te Dominus in sua corona spinea, cuius custodiam tuae commisit excellentiae, coronavit," ("We don't think it unmerited, that the Lord has crowned you with his crown of thorns, which he has committed to your guard").[60] The acquisition of the crown of thorns by Saint Louis was the most spectacular success in the long series of efforts the Capetian kings undertook to create a sacred aura around the royal rulers of France. Now they were not only the successors of Charlemagne, the vassals of Saint-Denis, anointed with the celestial chrism of the "Sainte Ampoule," but in their royal treasury they also kept the crown of the passion of Christ. The special chapel for the new relic was built with stupendous speed—perhaps in four or five years—and with enormous funds: 40,000 pounds for the building and another 100,000 for the shrine housing the crown of thorns.[61] Local tradition and local pride since the XVIᵉ century attributed the design of Sainte-Chapelle to Pierre de Montereau, the famous Parisian architect, who had first worked at Saint-Germain-des-Prés and later at Notre-Dame, and who had been praised on his tombstone as the "Doctor lathomorum."[62] Modern scholarship has dissolved this local legend and has shown that the master of the Sainte-Chapelle came from the shop at Amiens and must be identical with Robert de Luzarches or with

Thomas de Cormont, the first or the second architect of this cathedral.[63] The energetic structure of the royal chapel is in fact very different from the delicate texture which characterizes the slightly later transept façades of the neighbouring Parisian cathedral. Paris as the capital of the kingdom becomes a challenge for the architects and the artists from the "provinces." In the Sainte-Chapelle the pure and cool vocabulary of the ambulatory chapels at Amiens has been ennobled and glamorized by the aura of the king. The walls of the dado, the quatrefoils and the responds were covered with glittering glass and shining gold. Louis as the builder of the Sainte-Chapelle in his royal palace acts like a new Solomon. "He covered the whole house in its interior with pure gold."[64] I am not sure that we should speak of a "Court Style" in French Gothic architecture as the late Robert Branner proposed in a book twenty-five years ago, which remains an admirable study.[65] There is, however, no doubt that the rise of Paris as an art center in the twelfth and thirteenth centuries has been closely connected with the growing importance of the Capetian kings. The Sainte-Chapelle is the most spectacular example of this connection. The engineering which had been developed in the shops of the great cathedrals was employed to visualize the mysticism of sacred kingship. Among the famous buildings of the French capital, let us say, between the "Panthéon" and the "Tour Eiffel," the Sainte-Chapelle has remained to this day a kind of "fairy tale." The Sainte-Chapelle has contributed more than any other monument to foster the legend of medieval Paris as a center of the arts. We have already mentioned Jean de Jandun's comparison between this shrine of stone and glass and one of the chambers of paradise.[66] More revealing still is the story of a chronicler who tells us that king Henry III of England (1216–1272) had been so enchanted by Louis' chapel that he wished to take it home to London on a pushcart with his own hands.[67] Even if this report should not be authentic, it would still remain a telling legend.

During the reign of Saint Louis, Paris had become the leading art center of medieval Europe and it retained this position until the reign of Philip the Fair. The France of Saint Louis had forged the first universal style in the history of European art and architecture since the downfall of the Roman Empire. Chapels "ad instar sacrae capellae Parisiensis" were erected at many places in France as late as the early sixteenth century.[68] If we believe the most recent studies, by 1250 Paris had become the leading center of French Gothic sculpture, and a great part of the most famous statues on the Western façade of the cathedral at Reims must be regarded as the works of masters coming from the capital.[69] Parisian sculptors created the models which enchanted great parts of Europe. The grace and the smile of the statue of

Dona Sancha in the cloisters at Burgos or of the marchioness Reglindis in the choir at Naumburg are a reaction to Parisian refinements. For the first time in history Paris shaped European taste. Under Philip the Fair the French capital became the foremost place where small objects of luxury—the "articles de Paris" —were produced and traded.[70] Among the most successful "articles de Paris" were the mirror-caskets in ivory showing scenes of courtly love on their covers (Fig. 1–22). We may again cite Eustache Deschamps. When the men "reviennent de Paris" what do the ladies ask from them? "Pigne, tressoir semblablement et miroir, pour soy ordonner, d'yvoire me devez donner." [71] Is this not like a medieval prelude to that eminently Parisian combination which more than six hundred years later Baudelaire called "Le Beau, la Mode et le Bonheur"? [72]

I have entitled this paper "Medieval Paris, Center of European Taste. Fame and Realities." It was not before the twelfth century that medieval Paris became an art center of more than regional importance. And it became so as the royal residence, which needed a new monumental aura, attracted artists and craftsmen, offered challenges. It was only after Bouvines and under the reign of Saint Louis that Paris began to set the tone in architecture, art, fashion, manners and language. Not before the century of Voltaire did European taste once again become so French, so Parisian as in the second half of the thirteenth century under the spell of the "Sainte-Chapelle" and the magnificent roses of Notre-Dame.

Willibald Sauerländer
Zentralinstitut für Kunstgeschichte, Munich

Notes

1 Victor Hugo, *Les Misérables*. Texte présenté avec les variantes des Misères, une introduction et des notes par M.–F. Guyard. Vol. I, Paris, 1963, pp. 700 f.

2 Paul Valéry, "Présence de Paris," in: *Oeuvres*, II, édition établie et annotée par J. Hytier (Bibliothèque de la Pléiade), pp. 1011 f.

3 See Charles Meryon, *Paris um 1850. Zeichnungen, Radierungen, Photographien*, Frankfurt, 1975/1976, p. 84, R 7.

4 On the restoration of the Sainte-Chapelle see F. de Guilhermy, *Description de la Sainte-*

Chapelle, Paris, 1867, and J.–M. Leniaud, *Jean-Baptiste Lassus (1807–1857) ou le temps retrouvé des cathédrales*, Geneva, 1980, pp. 59 ff, 191 ff.

5 On the restoration of the façade of Notre-Dame see D. D. Reiff, "Viollet-le-Duc and Historic Restoration. The West Portals of Notre-Dame." *Journal of the Society of Architectural Historians*, III (1971), pp. 17 ff.

6 Mark Twain, *The Innocents Abroad*. Signet Classic edition, 1980, pp. 95 ff.

7 Eustache Deschamps, "Balade (Paris)," in: *Poètes et romanciers du Moyen Age*. Edition établie et annotée par A. Pauphilet (Bibliothèque de la Pléiade), pp. 976 f.

8 *Ibid.*

9 *Ibid.*, pp. 977–978.

10 Dante, "Purgatorio," XI, 79–80, *Divina Commedia*.

11 Joannis Friderici Schannat, *Vindemiae literariae Collectio secunda*, Fulda et Lipsiae, 1724, p. 59. Burchardi de Hallis Chronicon ecclesiae Collegiatae S. Petri Winpiensis.

12 For this text see Le Roux de Lincy and L. M. Tisserand, *Paris et ses historiens aux XIV^e et XV^e siècles*, Paris, 1867, pp. 44 ff.

13 *Ibid.*, p. 46.

14 Paul Valéry, "Présence de Paris," p. 1015.

15 Caesar, *De Bello Gallico*, Book VI, 3–4.

16 For the capitals from Saint-Germain-des-Prés see L. Grodecki, "La sculpture du XIe siècle en France. Etat des questions," *Information d'histoire de l'art*, 1958, pp. 98 ff. For the manuscripts: Y. Delandres, "Les manuscrits décorés au XI^e siècle à Saint-Germain-des-Prés," *Scriptorium*, 1955, pp. 3 ff.

17 See L. Olschki, *Der ideale Mittelpunkt Frankreichs im Mittelalter in Wirklichkeit und Dichtung*, Heidelberg, 1913. See also R. H. Bautier, "Quand et comment Paris devint capitale," *Bulletin de la Société d'Histoire de Paris et de l'Ile-de-France*, CV (1978), pp. 17 ff.

18 The best survey of this new architectural movement and its political implications in connection with the rise of the Capetian monarchy is now D. Kimpel and R. Suckale, *Die gotische Architektur in Frankreich, 1130–1270*, Munich, 1985.

19 The inscription, which does not survive, is cited by G. Corrozet, *Les Antiquitez de Paris*, vol. 2, Paris, 1586, fols. 7ᵛ—8ʳ·

20 G. M. Paré, A. Brunet, P. Tremblay, *La renaissance du XIIᵉ siècle. Les écoles et l'enseignement.* Paris and Ottawa, 1933.

21 Citation from J. W. Baldwin, "Masters at Paris from 1179 to 1215. A Social Perspective," in: *Renaissance and Renewal in the Twelfth Century*, ed. by R. L. Benson and G. Constable, Cambridge, 1982, p. 138.

22 See J. Boussard, "De la fin du siège de 885–886 à la mort de Philippe Auguste," *Nouvelle Histoire de Paris*, vol. 6, Paris, 1976, pp. 197 ff.

23 *Ibid.*, p. 199.

24 *Ibid.*, p. 342.

25 J. Destrez, *La "pecia" dans les manuscrits universitaires du XIIIe et XIV siècles*, Paris, 1935; R. Branner, *Manuscript Painting in Paris During the Reign of Saint Louis*, Berkeley and Los Angeles, 1977.

26 Cited after H. Rashdall, *The Universities of Europe in the Middle Ages*, vol. I, Oxford, 1936, p. 432, note 1.

27 On Saint-Denis as a royal burial place see A. Erlande-Brandenburg, *Le Roi est mort. Etudes sur les funérailles, les sépultures et les tombeaux des Rois de France*, Paris and Geneva, 1975.

28 On the insignia in the treasury of Saint-Denis see P. E. Schramm, *Der König von Frankreich*, Darmstadt, 1960, second ed., vol. 1, pp. 133 f.

29 On the Oriflamme and the War-Cry "Montjoie" see L. H. Loomis, "The War-Cry 'Montjoie' in the Twelfth Century," in: *Studies in Art and Literature for Belle da Costa Greene*, Princeton, 1954, pp. 76 ff.

30 *Sugerii abbatis Sancti Dionysii liber de rebus administratione sua gestis*, XXXIV. See E. Panofsky, *Abbot Suger on the Abbey Church of Saint-Denis and its Art Treasures*, Princeton, 1979, (Second ed. by G. Panofsky-Soergel), pp. 72 f.

31 *Ibid.*, pp. 64–65.

32 O. von Simson, *The Gothic Cathedral. Origins of Gothic Architecture and the Medieval Concept of Order*, New York and Evanston, 1956 (Harper Torchbook edition, 1964, p. 95).

33 Cf. Panofsky, *Abbot Suger on the Abbey Church of Saint-Denis*, pp. 90–91. However, I have not followed literally the English translation of Panofsky.

34 *Ibid.*, pp. 90–91.

35 For the interpretation of the west portals of Saint-Denis see E. Kitzinger, "The Mosaics of the Cappella Palatina in Palermo. An Essay on the Choice and the Arrangement of Subjects," *The Art Bulletin*, XXXI (1949), pp. 291 ff. Further, A. Katzenellenbogen, *The Sculptural Programs of Chartres Cathedral*, Baltimore, 1959, especially the chapter "The Jamb Statues. Regnum et sacerdotium," pp. 27 ff. See now also K. Hoffman, "Zur Entstehung des Königsportals in Saint-Denis," *Zeitschrift für Kunstgeschichte*, 48 (1985), pp. 29 ff.

36 H. Focillon, *Art d'Occident*, 1938 (Edition de poche), vol. 2, p. 37.

37 See C. Bruzelius, "The Construction of Notre-Dame in Paris," *The Art Bulletin*, LXIX (1987), pp. 540 ff., who argues convincingly that the first campaign of Notre-Dame started in the early sixties.

38 For this not uncontested identification see J. Thirion, "Les plus anciennes sculptures de Notre-Dame de Paris." *Académie des Inscriptions et des Lettres, Compte Rendus*, 1970, pp. 85 ff.

39 See for this aspect of the tympanum's iconography W. Cahn, "The Tympanum of the Portal of Sainte-Anne at Notre-Dame de Paris and the Iconography of the Division of Powers in the Early Middle Ages," *Journal of the Warburg and Courtauld Institutes*, XXXII (1969) pp. 55 ff.

Cahn deals with this topic in a wider context and does stress the particular political constellation in twelfth century Capetian France. There is a recent paper on the portal by K. Horste, "A Child is Born: The Iconography of the Portal Ste.–Anne at Paris," *The Art Bulletin*, LXIX (1987), pp. 187 ff., which focusses on other aspects of the iconography.

40 See Bautier, "Quand et comment Paris devint capitale," pp. 40 f.

41 M. Guérard, *Cartulaire de Notre-Dame de Paris*, vol. 2, Paris, 1850, p. 402.

42 M. Fleury, "La cathédrale mérovingienne Saint-Etienne de Paris," in: *Landschaft und Geschichte. Festschrift Franz Petri*, 1970, pp. 211 ff.

43 I have developed some of the ideas in W. Sauerländer, "Abwegige Gedanken über frühgotische Architektur und 'The Renaissance of the Twelfth Century,'" in: *Etudes d'art médiéval offertes à Louis Grodecki*, Paris, 1981, pp. 167 ff.

44 J. Bony, *French Architecture of the 12th and the 13th Centuries*, University of California Press, Berkeley, 1983, p. 149.

45 Victor Hugo, *Notre-Dame de Paris 1482*. First published in 1831. Here cited from the pocket book edition, Garnier/Flammarion, 1967, pp. 131 f.

46 Cited here from A. Temko, *Notre-Dame of Paris*, New York, 1952, p. 173.

47 See G. Duby, *Le dimanche de Bouvines. 27 juillet 1214*, Editions Gallimard, 1973.

48 For this question see J. G. Prinz von Hohenzollern, *Die Königsgalerie der französischen Kathedrale*, Munich, 1965.

49 Paris, Bibliothèque Nationale, Ms. fr. 1553, fol. 514. I cite from Hohenzollern, *Die Königsgalerie*, p. 54.

50 F. Giscard d'Estaing, M. Fleury, A. Erlande-Brandenburg, *Les rois retrouvés*, 1977, p. 8.

51 *Ibid.*, p. 19.

52 A. Luchaire, *Philippe Auguste et son temps (1137–1226)*, Paris, 1902 (reprint, 1980, p. 219).

53 See W. Sauerländer, *Gotische Skulptur in Frankreich*, Munich, 1970, p. 137.

54 Olschki, *Der ideale Mittelpunkt Frankreichs im Mittelalter*, p. 34, note 4.

55 K. Vorländer, *Philosophie des Mittelalters*, Hamburg, 1964, pp. 81 f.

56 E. Viollet-le-Duc, *Dictionnaire raisonné de l'architecture française du XIe au XVI siècle*, Paris, 1867, vol. 8, p. 53.

57 See D. Kimpel, *Die Querhausarme von Notre-Dame in Paris und ihre Skulpturen*, Bonn, 1971.

58 See note 11 above.

59 See for instance, R. Branner, *Saint Louis and the Court Style*, London, 1965, p. 78.

60 S. J. Morand, *Histoire de la Sainte-Chapelle Royale du Palais*, Paris, 1790, p. 25.

61 These are the sums given in D. Kimpel, R. Suckale, *Die gotische Architektur in Frankreich*, p. 401.

62 See for this inscription Henri Stein, *Les architectes des cathédrales gothiques*, Paris, 1929, p. 51, note 1.

63 See R. Branner, *Saint Louis and the Court Style*, pp. 61 ff; D. Kimpel and R. Suckale, *Die gotische Architektur in Frankreich*, p. 404.

64 *First Book of Kings*, 6: 21.

65 See R. Branner, *Saint Louis and the Court Style*, p. 78.

66 *Ibid.*, p. 6.

67 I. Hacker-Sück, "La Sainte-Chapelle de Paris et les chapelles Palatines du Moyen-âge en France," *Cahiers archéologiques*, XIII (1962), pp. 217 ff.

68 *Ibid.*, pp. 242 ff.

69 See P. Kurmann, *La façade de la cathédrale de Reims*, Paris, 1987. Kurmann's arguments seem to me largely convincing. I shall deal with these problems in a forthcoming review.

70 See R. Koechlin, *Les ivoires gothiques français*,
 vol. 1, Paris, 1924, pp. 360 ff.

71 Cited from R. Koechlin, *Les ivoires gothiques*,
 p. 362.

72 Charles Baudelaire, "Le peintre de la vie mod-
 erne," cited from *Oeuvres*, texte établi et annoté
 par Y.–G. Dantec (Bibliothèque de la Pléiade),
 Paris, 1954, p. 881.

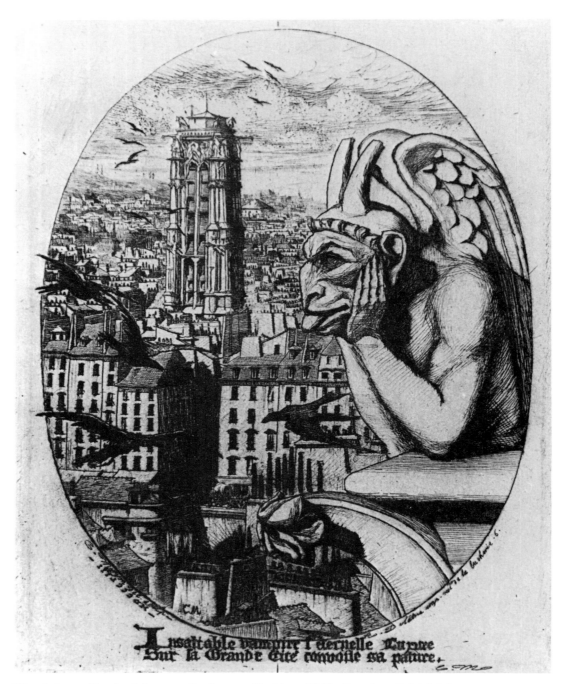

Fig. 1–2 Charles Meryon, *Le Stryge*. Etching, 1853. London, British Museum.

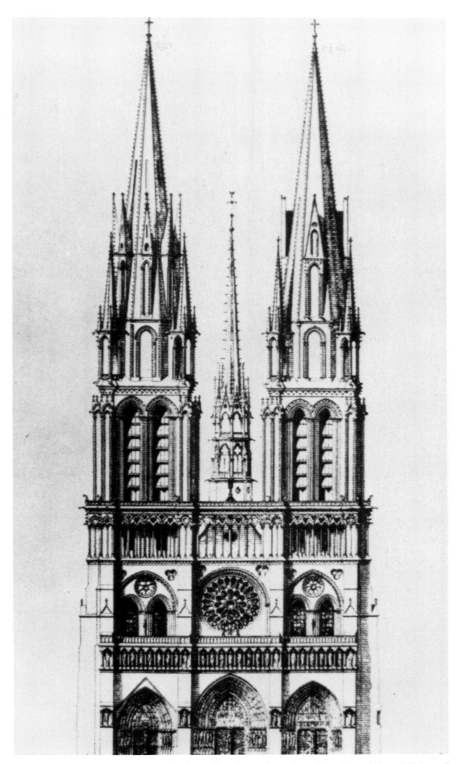

Fig. 1–3 Notre-Dame, Paris. Project for the façade with additional spires. From Sauvageot, *Cours d'architecture*.

Fig. 1–4 Chapel of the Hotel de Cluny. Lithograph by Nicolas Chapuy for *Les arts au Moyen Age*, by Alexandre du Sommerard.

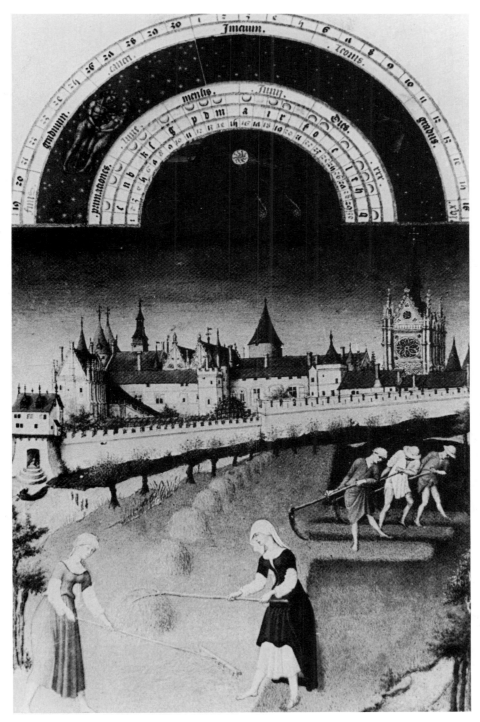

Fig. 1–5 Limbourg brothers, "Palais de la Cité," and "Sainte-Chapelle" in the early fifteenth century. *Très Riches Heures* of the Duke of Berry, fol. 6v. Chantilly, Musée Condé.

Fig. 1–6 Jean Fouquet, The "Ile de la Cité" and the façade of Notre-Dame in the fif-
teenth century. From the *Heures* of Etienne Chevalier. The Metropolitan
Musuem of Art, New York.

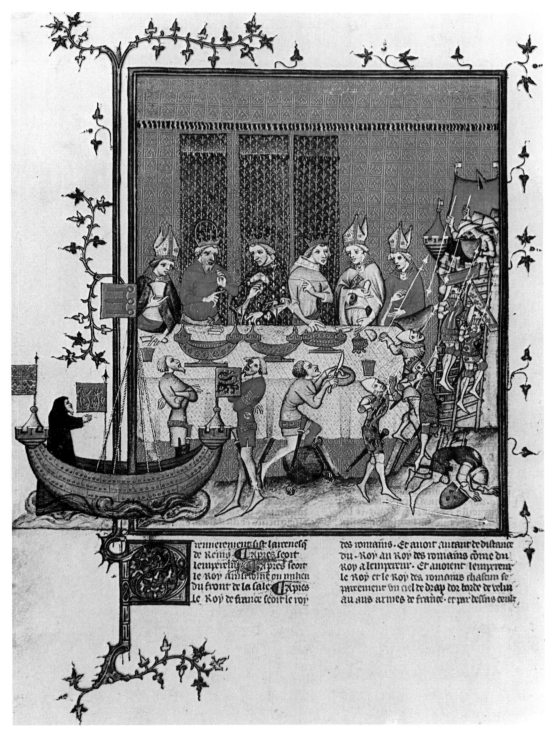

Fig. 1–7 Banquet in honor of the emperor Charles IV. *Grandes chroniques de France.* Paris, Bibliothèque Nationale, Ms. fr. 2813, fol. 473v.

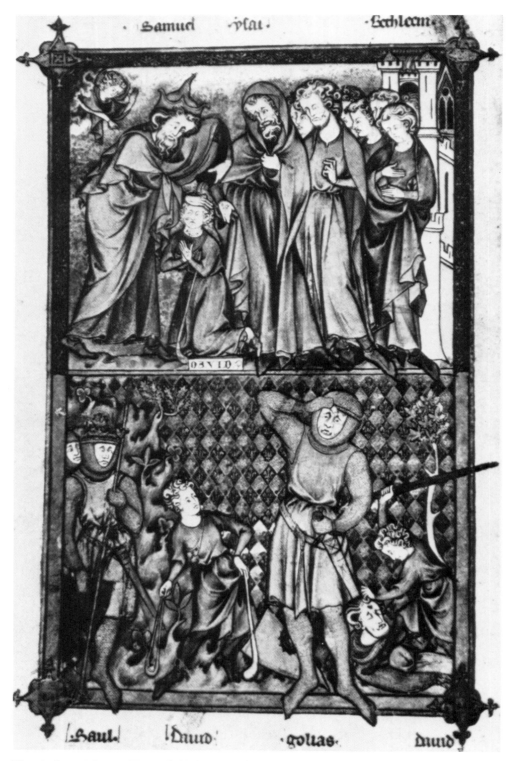

Fig. 1–8 Master Honoré, "The Annointing of David," and "David and Goliath," from the so-called Breviary of Philip the Fair. Paris, Bibliothèque Nationale, Ms. lat. 1023, fol. 7v.

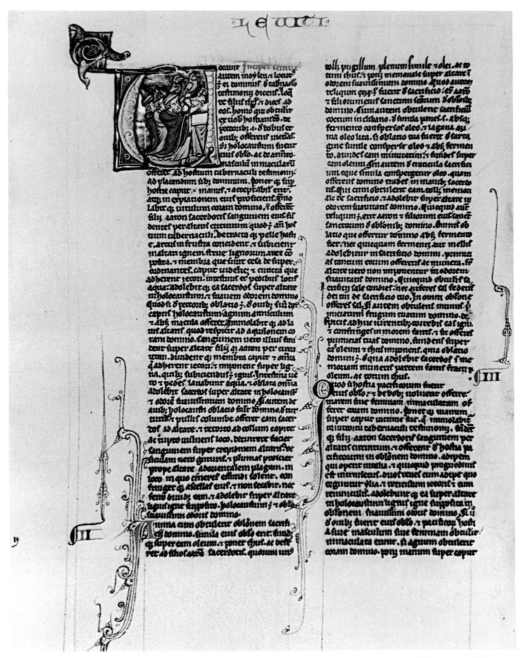

Fig. 1–9 Bible from Paris, second quarter of the thirteenth century. Pierpont Morgan Library, New York, Ms. 269, fol. 33v.

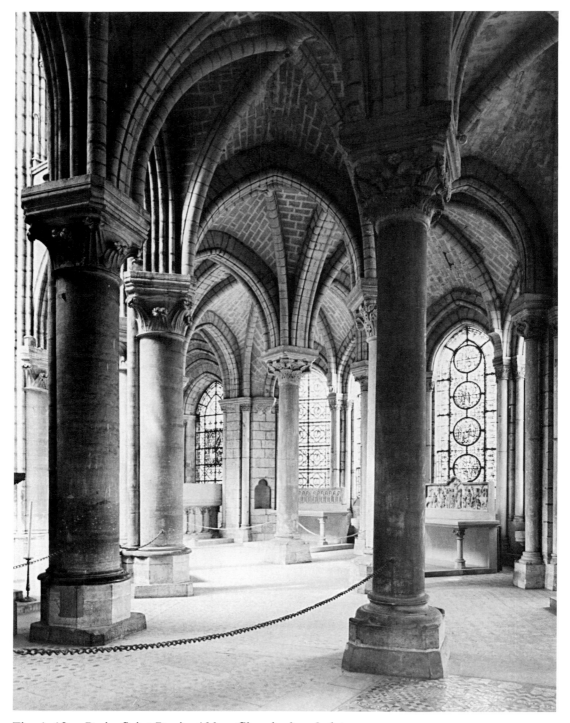

Fig. 1–10 Paris, Saint-Denis, Abbey Church, deambulatory.

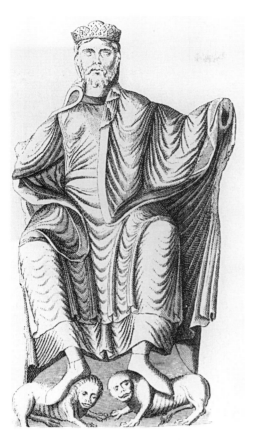

Fig. 1–11 Paris, Saint-Denis, statue of Dagobert. Engraving from Montfaucon, *Monuments de la monarchie françoise*, 1729.

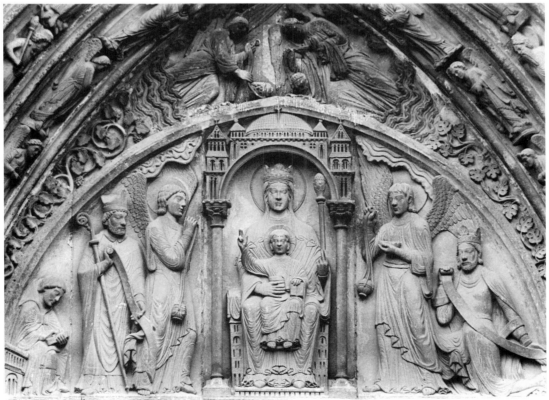

Fig. 1–12 Paris, Notre-Dame, Portal of Sainte Anne, tympanum.

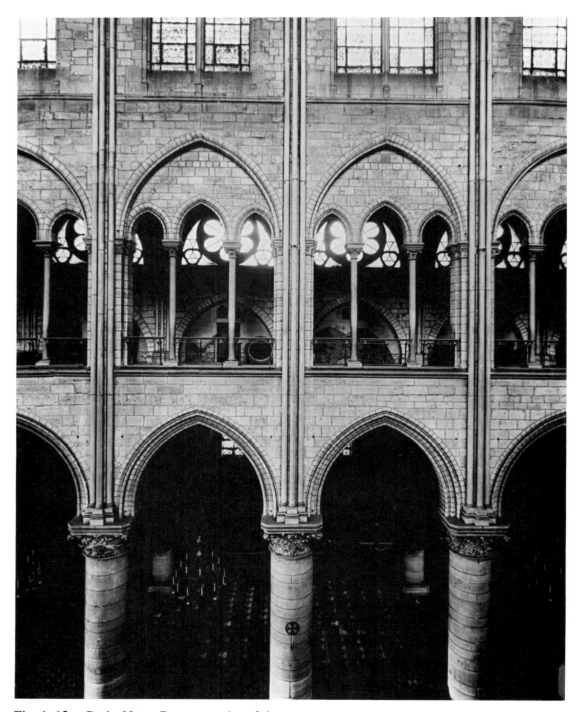

Fig. 1–13 Paris, Notre-Dame, arcades of the nave.

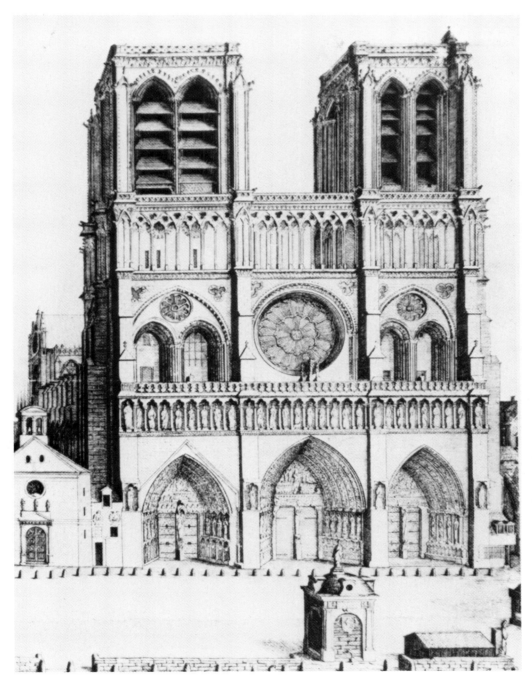

Fig. 1–14 Paris, Notre-Dame, seventeenth-century engraving of the façade.

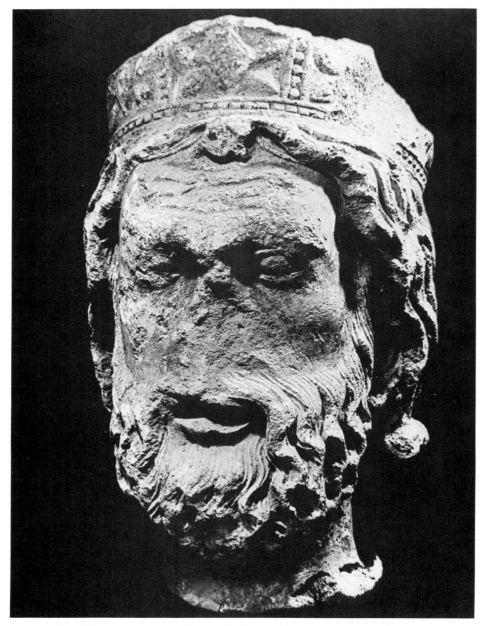

Fig. 1–15 Head from the King's Gallery of Notre-Dame. Paris, Musée de Cluny.

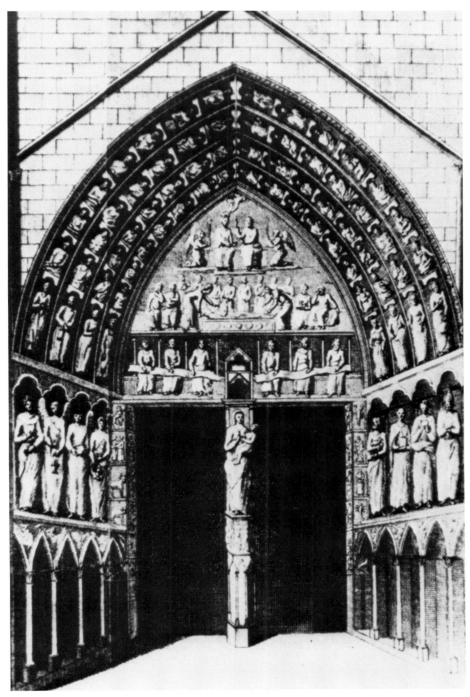

Fig. 1–16 Paris, Notre-Dame, eighteenth-century engraving of the Portal of the Virgin.

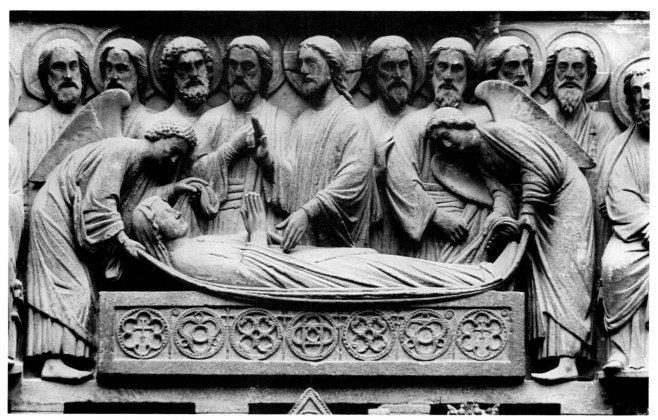

Fig. 1–17 Paris, Notre-Dame, detail of the Assumption of the Virgin from the Portal of the Virgin.

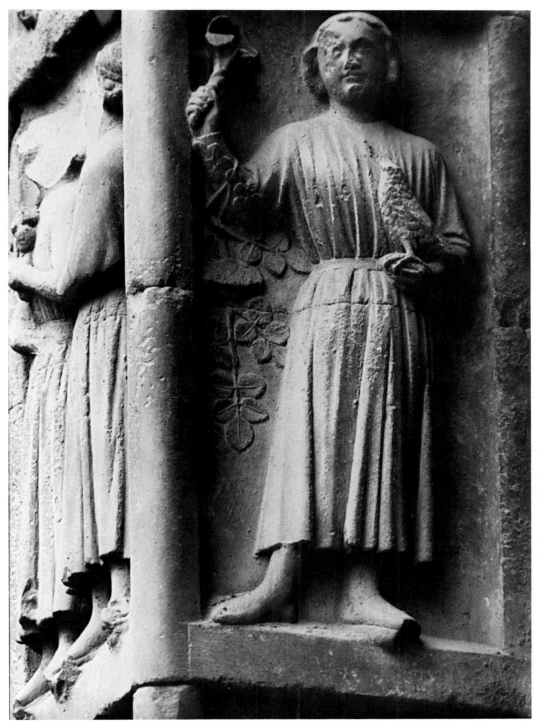

Fig. 1–18 Paris, Notre-Dame, detail of the month of May from the Portal of the Virgin.

Fig. 1–19 Paris, Notre-Dame, north transept.

Fig. 1–20 "The Destruction of Sodom and Gomorra," *Psalter of Saint-Louis*. Paris, Biblio-
thèque Nationale, Ms. lat. 10525.

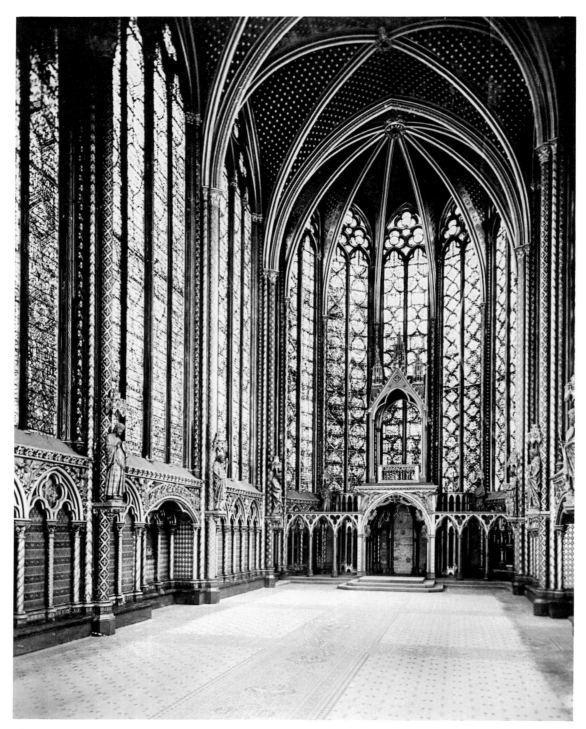

Fig. 1–21 Paris, Sainte-Chapelle, interior of the upper chapel.

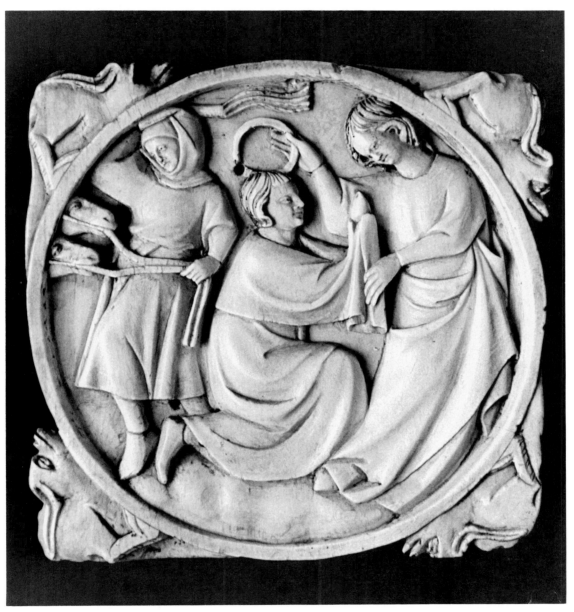

Fig. 1–22 "The Crowning of the Lover," detail from a mirror casket made in Paris, ca. 1300. London, Victoria and Albert Museum.

Fig. 2–1 Suger at the Feet of the Virgin, detail of the Annunciation, Infancy of Christ Window. Photo: Cothren. (All details illustrated in this article are originally from Saint-Denis, Abbey Church, ambulatory windows.)

Suger's Stained Glass Masters and their Workshop at Saint-Denis[*]

2

The twelfth-century stained glass windows of the Abbey of Saint-Denis are among the most important paintings produced during the Middle Ages. Conventionally, they have derived much of their significance from their illustrious context. They form an integral part of Abbot Suger's reconstruction of the church at Saint-Denis, particularly of his choir ambulatory, which was begun in 1140 and consecrated in 1144.[1] Credited with initiating a revolutionary style of architecture we now call Gothic, Suger's choir elevated stained glass to a position of singular importance in an architectural interior. Almost overnight, stained glass became the major medium of painting.

Although often evaluated as the decorative by-product of a change in the system of stone construction, the enhanced role played by stained glass may actually have inspired the architectural revolution with which Suger's windows have been associated. When discussing the completed choir in the account of his administration of the Abbey,[2] Suger reserved rhapsodizing commentary for filtered light,[3] for the ability of the luminous environment created by his stained glass windows to allow the viewer to be transported toward the Godhead. He described his new choir as "that elegant and praiseworthy extension, in the form of a circular string of chapels, by virtue of which the whole church would shine with the wonderful and uninterrupted light of most luminous windows, pervading the interior beauty."[4] Suger's documented interest in stained glass extends from the illuminating potential of the windows themselves to the artists who made them. Although he makes no reference to an architect or master mason, the abbot cites the glass painters on several occasions, singling them out with the metalworkers for special attention.[5]

Given the importance of the ambulatory glazing at Saint-Denis, the fragmentary preservation of the origi-

nal windows is especially frustrating. The abbey church has been much transformed in the eight centuries since Suger's abbacy, and the fragile stained glass has suffered greatly at the hands of reconstructors, revolutionaries, and restorers. In the 1230s, before Suger's church was even a century old, most of the choir was rebuilt, with only the ambulatory and its windows maintained as a valued relic.[6] During the French Revolution all the glass in the upper stories of the choir and the whole of the nave was sacrificed so that the lead that held the windows together could be made into bullets.[7] Although many of the twelfth-century ambulatory windows escaped this fate, others seem to have been destroyed earlier because of their objectionable subject matter.[8] Those that remained at the turn of the nineteenth century soon left the abbey in the hands of Charles Lenoir, for inclusion in his Musée des monumens français.[9] A contemporary newspaper account claims that some panels were destroyed by an accident in transit to the museum,[10] but others, which Lenoir chose not to exhibit, entered the art market. A number were sold across the Channel into England, where the burgeoning Gothic revival had already created a market for them.[11] The few panels that Lenoir actually exhibited were returned to the abbey at the liquidation of his museum and were subsequently transformed and supplemented in two heavy-handed restorations.[12] Eventually these meager remains of Suger's windows were incorporated within pastiche windows created as a part of the mid-nineteenth-century restoration of the abbey supervised by Viollet-le-Duc. Since it is these neo-Gothic windows that fill most ambulatory openings at Saint-Denis today, the glazing of the abbey is far removed from what Suger saw in 1144.

With close examination, however, it is relatively simple to distinguish the later accretions from the original sections that remain *in situ.*[13] Moreover, many al-

ienated panels have been located over the last four decades in public and private collections in France, Great Britain, and the United States.[14] Though fragmentary in certain instances, the dispersed panels provide sufficient evidence to support many conclusions concerning the original glazing of Saint-Denis, particularly when this primary evidence is coordinated with the contemporary testimony of Suger and reports—both written and graphic—of eighteenth-century witnesses like Bernard de Montfaucon[15] and Charles Percier,[16] both of whom saw the glazing of the ambulatory before it was dismantled by Lenoir. With this information six twelfth-century windows can be identified and partially reconstructed.[17] They were dedicated to the life of Moses,[18] the Allegories of Saint Paul (the so-called Anagogical window),[19] the Tree of Jesse,[20] the Infancy of Christ,[21] the life of Saint Benedict,[22] and the theme of Crusading.[23]

The creators of these six windows are the principal subject of this study, which seeks to demonstrate how, and to what extent, one might isolate the individual artists who produced these large paintings in lead and glass, and then speculate on how they organized their work at Saint-Denis.[24] None of the windows is signed,[25] and no contractual or financial records survive to document the labor of specific individuals.[26] Any attempt to discover artistic identities and to determine social organization and working procedures must rely on three forms of evidence: the written testimony of Suger, detailed analysis of the fragments that remain from the windows, and coordination of this primary evidence with what is known about contemporary practices elsewhere.

Suger cites the makers of his stained glass windows on three separate occasions in his written account of his administration. The first reference is to a material with which they worked and to their funding. When the abbot is thanking "the most liberal Lord" for his generosity in relation to the building project, he lists, as examples of God's beneficence, "the makers of the marvelous windows, a rich supply of sapphire glass, and ready funds of about seven hundred pounds."[27] It is interesting that when referring to lavish funding, Suger would single out the "sapphire" glass, as he does elsewhere in the text.[28] Quantitative chemical analysis has distinguished the blue glass at Saint-Denis from glass stained with other colors, a distinction paralleled in the twelfth-century windows of Chartres and York. The only contemporary counterparts for the chemical composition of this blue window glass are in glasses made in Rome.[29] If, as seems likely, the blue glass was imported, it would probably have been more precious and thus certainly worthy of special notice in the abbot's catalogue of divine munificence.

Suger's other two references to those who made the windows reveal something about the artists themselves. After introducing his discussion of how and why he altered the arrangement, size, furnishings, and appearance of the monks' choir, Suger reports that "we caused to be painted, by the exquisite hands of many masters from different regions a splendid variety of new windows."[30] Thus, there was more than one master glass painter at work at Saint-Denis, and the artistic community was international. Next Suger notes that because the windows were so valuable—in terms of both labor and material costs (again the blue glass is cited specifically)—he decided to appoint "an official master craftsman for their protection and repair."[31] He goes on to report that this permanently installed master was to be maintained from the revenues of the abbey. Thus, the community of glass painters was not entirely transient.

Detailed examination of the surviving work of Suger's glass masters confirms and elucidates this reading of Suger's text. It is possible through formal analysis, for instance, to discern the hands of several painters with distinctive styles among the remaining fragments. Attention will be focused here on three artists: a very active master who worked on the Jesse Tree, Infancy, Anagogical, Moses, and Crusading windows; his collaborator whose work can be found alongside that of the first master in the Infancy and Crusading windows; and a third painter whose extant work at Saint-Denis is confined to a single ensemble, the Saint Benedict window.

The first two masters can be isolated most expediently within the Infancy window. They are easily distinguished through comparisons of heads,[32] such as those of the well-preserved figure of Jeremiah (Fig. 2–2) and the sadly deteriorated Simeon (Fig. 2–3). Since facial typology is so similar in this comparison, the individual variations of articulation introduced by the two artists stand out with some clarity. The artist who painted Jeremiah defined eyes with two even curves, the lower one straighter than that delineating the top of the eye. In the head of Simeon, however, the lower defining line is more sharply bowed and is pulled tightly upward at the outside and closed with a quick, outward stroke. The latter artist—who, for convenience, can be designated the Simeon master—joined the upper bridge of the nose with an arc, connecting the eyebrows to form a continuous, undulating line above the fluid, bulbous eyes. His colleague—the Jeremiah master—left this area unarticulated, maintaining the rather brittle angularity that characterizes his treatment of the flattened eyes. This stiffness is reinforced by the relatively bold downward line that usually branches from their inward point, an area where the Jermiah master placed a soft, curving half-tone wash along a formal contour.

Similar contrasts characterize the way these two painters formed noses, substantial and broad in the case of Simeon, slender and elongated on Jeremiah. The Jeremiah master resolved the inward curve of the fleshy knob that defines the prophet's nostril with a relatively straight, flat line, whereas the Simeon master continued the curve of the nostril downward slightly as if to imply its completion as a circle. Jeremiah's lower lip is defined with a thick, squared bracket, whereas Simeon's is indicated parenthetically with a diminutive curve. In the treatment of hair, the Simeon master drew a single, spaghetti-like strand backwards just above the ear, breaking the regular pattern above and below it, whereas the Jeremiah master created an unbroken mass of hair from overlapping clusters of curved strands.

These two systems of articulation—revealed through subtle details of facial articulation and associated here with the work of two different artists—recur with remarkable consistency from head to head throughout the Infancy window, enabling us to partition much, if not all, of its execution between the Jeremiah and Simeon masters. The features associated with the head of Jeremiah reappear, for instance, in the heads of Herod (Fig. 2–4) and of a sleepy Magus (Fig. 2–5), in spite of the shifts in facial types and expressions, and—in the case of the Magus—in painting technique. The delineation of eyes, the blank area maintained on the bridges of the relatively slender noses, the flattened terminal line of the nostrils, and the squarely bracketed lower lips are comparable in all three heads. The head of Joseph (Fig. 2–6) from the Flight into Egypt, on the other hand, repeats the stylistic hallmarks of the Simeon master: the concave curve over the bridge of the weighty nose; the pinched outer form of the bulbous eye and its soft, half-tone underlining; the downward curving nostril knob; the curved and small lower lip; the strands of hair pulled around the head above the ear. These same distinctions separate the faces of beardless youths and children. The angel in the Magi's dream (Fig. 2–7) and an adoring Shepherd (Fig. 2–8) have facial features conforming to the style of the Jeremiah master, whereas the features of the Christ Child (Fig. 2–9) from the Flight into Egypt conform to the system of articulation used by the Simeon master.

It is relatively easy, then, to demonstrate with detailed photographs the coexistence within the Infancy window of two distinct styles, a situation that suggests the presence of two artists. Judging from the distribution of extant panels between the two painters, they divided their work on the window logically and regularly, with each taking full responsibility for roughly half of its figural panels, partitioned according to the way they would eventually be installed. The Jeremiah master executed the panels that make up roughly the bottom half of the window, the Simeon master those of the upper registers.[33]

What is not so easily reproduced in photographs is related, perhaps more conclusive, evidence that distinguishes the upper and lower registers of the Infancy window not only stylistically but also technically, by the two different ways the two painters have applied paint. The visual indications of this difference in painting technique are fully apparent only when panels can be examined dismounted under carefully manipulated surface light. Nonetheless, hints of the most salient distinctions can be seen even in black and white photographs. The Jeremiah master was a fussy painter (Fig. 2–10), employing short, precise strokes to build up the considerable detail with which he executed all features of his compositions. His technique seems to coincide with the brittle angularity of his style. The Simeon master used longer, broader, bolder, and more fluid brush strokes (Fig. 2–11) which reinforce the confident, curvilinear economy of his style. Since he applied paint more thickly than his colleague, it often bubbled up or fried when fired to create a relief-like quality on the surface of the glass.

Comparable stylistic and technical evidence suggests that the Simeon and Jeremiah masters also collaborated on the Crusading window at Saint-Denis. Here, however, instead of dividing their work panel by panel, they seem to have divided the execution of individual panels, piece by piece. Their collaboration on single panels is most evident in a medallion portraying nine martyred crusaders (Fig. 2–12). The central group of heads in this panel is an unrelated stopgap of thirteenth-century glass and has no bearing on an analysis of the twelfth-century panel itself. It is the flanking groups of heads that are of interest here. That to the right (Fig. 2–13) betrays the by now familiar stylistic signature of the Jeremiah master, while that at the left (Fig. 2–14) can be assigned to the Simeon master. Once again, technical observations reinforce this stylistic sorting.

Although somewhat more difficult to discern, the hands of both artists can also be distinguished in the one other panel that has survived from the Crusading window, a medallion portraying a king leading an army of crusaders. The style of the Jeremiah master, already seen in the right group of crowned figures (Fig. 2–13), reappears in one group of mounted warriors (Fig. 2–15) within this second panel. Note once more the flat terminal line for the profile nostril, the square-bracketed lower lip, the two-stroke eyes. Contrasting with this is the articulation of a second group of warriors (Fig.

2–16), which can be compared with the left group of crowned figures in the martyrs panel (Fig. 2–14), attributable to the Simeon master. The nostrils of the more substantial noses terminate with a downward curl implying circular closure, and the eyebrows continue over the bridge of the nose with a thin, downward-curving line. Though the paint is worn, many of the Simeon master's characteristic features in the delineation of eyes are still visible.

The remainder of this Crusading window is known only through the series of drawings made for Bernard de Montfaucon in the eighteenth century, before the window was dismantled and/or largely destroyed.[34] Although they must be used with extreme caution, the drawings do seem to disclose examples of these two painters' most striking stylistic mannerisms. Three heads from a panel depicting Byzantine envoys before Charlemagne (Fig. 2–17) are clearly related stylistically to the Jeremiah master's heads (Figs. 2–13, 2–15).[35] One of the most peculiar mannerisms of the Simeon master—the elevation of some moustaches high on the cheek as if they grew from the sides of nostrils rather than on the upper lip (Fig. 2–16)—is reproduced in one of the other drawings (Fig. 2–18). Other figures (Fig. 2–19) wear the more naturalistic moustaches and scalloped beards preferred by the Jeremiah mater (cf. Fig. 2–15). If the testimony of the drawings can be trusted for small details such as these, the collaboration of these artists seems to have extended to the execution of the entire window.

The form of collaboration revealed in the Infancy and Crusading windows, in which more than one artist worked on individual components of larger works of art, was not uncommon in the twelfth century. It is apparent on single leaves of illustrated manuscripts,[36] and has also been noted in stone sculpture,[37] a medium that does not lend itself easily to shared execution. Yet the evidence of collaboration on single panels of stained glass—or, more specifically, the internal stylistic incongruities that are its by-product at Saint-Denis in particular—has bothered art historians, especially in the case of the Crusading medallions. Every physical indicator of authenticity in medieval stained glass—the nature of glass, corrosion, paint and grozing—argues for the equal genuineness of the flanking groups of heads in the extant Crusading medallions (Figs. 2–12 through 2–16), but the disparate systems of facial articulation have led to persistent assertions that only one group could be original. It has been presumed that such stylistic dissonance must be the consequence of a recent restoration.[38] But internal stylistic variation resulting from contemporary artistic collaboration is quite logical given the nature of this craft. The panels that compose medieval

windows were assembled from many separate pieces of colored glass, which were painted individually and only later joined together with a network of lead to create a single composition. Thus the numerous components of one panel could easily have been distributed among two or more painters for execution.

Further examination of the mid-twelfth–century windows of Saint-Denis suggests that such work sharing was not restricted to figural panels. Considerable formal variation exists in borders, where individual motifs (confined to a single piece of glass) that make up larger ornamental designs (created when the pieces are leaded together) often differ within single panels. For example, within two sections of a border (Fig. 2–20), probably from the Moses window,[39] two distinct designs were employed for the articulation of the three-leaved buds at the base of the axial palmettes (Fig. 2–21) as well as for the extended leaf forms of the lateral palmettes (Fig. 2–22). In both cases, motifs that appear at the same point within the composition of the border were painted with distinct patterns. Taken with the evidence of the Crusading medallions, this suggests that once an overall scheme was established, individual painters were free to use personally conceived conventions for the articulation of foliage or faces within it.

Of the two artists who have thus far been isolated, only one—the Jeremiah master—can be discerned among the other figural panels that remain from the twelfth-century glazing at Saint-Denis. His style recurs in the Jesse Tree, Anagogical, and Moses windows. The heads of "Eclesia" (Fig. 2–23) and "Sinagoga" (Fig. 2–24) from the Anagogical window, for instance, conform to the character of his work in the previously examined windows (Figs. 2–2, 2–4, 2–5, 2–7, 2–8, 2–13, 2–15, 2–17). The most notable features include the two-stroke eyes underlined with a downward dash, the slender nose with flattened nostril knob, the prominent M–like upper lip and square-bracketed lower lip. A head of Christ (Fig. 2–25) from the Anagogical window closely resembles the head of Herod from the Infancy window (Fig. 2–4). Christ's beard and ears are similar to those of one of the martyred crusaders (Fig. 2–13, central head), even if the latter is executed somewhat more boldly. The similarities are even more striking when comparable facial types, such as those of angels from the Anagogical (Fig. 2–26) and Infancy (Fig. 2–7) windows are juxtaposed. Heads from the Moses window (Fig. 2–27), although they vary in pose and type, repeat the Jeremiah master's conventions for eyes, noses, and beards.

If what has survived from these windows is representative of the original wholes, the Jeremiah master

may well have worked essentially alone when he painted the Anagogical and Jesse Tree windows. There is no evidence of the kind of glaring stylistic and technical dichotomies revealed in the Infancy and Crusading windows. Subtle stylistic divergences are evident, but for them to represent collaboration, the artists involved would have to have painted in essentially the same mode and manner. In the Moses window, however, two heads within one medallion (e.g., Fig. 2–28) were clearly produced by someone other than the Jeremiah master. Their isolation within a single panel suggests that they could be either stopgaps or the work of a thirteenth-century restorer rather than a second twelfth-century artist.

The work of a third major twelfth-century painter, however, is clearly discernible in the Saint Benedict window.[40] At first glance his painting (Figs. 2–29 through 2–32) resembles that of the Simeon master (Figs. 2–3, 2–6, 2–9, 2–14, 2–16).[41] Both artists employed bold and rather simplified formulae for facial features and executed them with a fluid, sure sense of line. Somewhat similar conventions are used by both for the articulation of eyes. They are bulbous, have large, prominent pupils, and are pinched to the outside, concluding with lateral slashes. But there are fundamental distinctions between the work of these two artists in further details of facial delineation.

In the work of the Benedict master (Figs. 2–29 through 2–32), eyebrows are not connected over the nose (cf. Figs. 2–3, 2–6, 2–14), and the nose itself continues uninterrupted through the region of the brow with two straight lines. Mouths are flatter, broader, and more relaxed than those of figures painted by either of the other two artists. Noses are straighter, longer, and wider, the broad bridge often pinching the nostrils to create a beaklike effect (Figs. 2–29, 2–31). The prominent eyes are usually defined by two separate strokes, avoiding both the seeming one–stroke continuity of eyes painted by the Simeon master and the stiffness that characterizes the two-stroke eyes of the Jeremiah master. The no-nonsense hairdos in the Benedict window are fashioned with fewer, bolder, simpler lines. The Benedict master chose to emphasize facial hair—or evidence of trimmed facial hair—which the other two artists rarely signaled. Eyebrows are frequently quite bushy (Figs. 2–31 and 2–32), and surfaces that have been shaved—both cheeks (Figs. 2–29, 2–30, 2–31) and tonsures (Figs. 2–30, 2–32)—record the remaining stubble with a series of irregularly spaced slashes or dots.

Though once again difficult to detect in photographs, the Benedict master's painting technique is as distinctive as his style (Fig. 2–33). Like the Simeon master, he applied paint quickly and confidently to create fluid major strokes of articulation. But unlike his colleague, he did not layer paint so thickly that it fried in firing. Alongside, at times overlapping, these principal lines, the Benedict master added considerable detail with smaller, sketchy strokes like those used by the Jeremiah master. In photographs these features are most noticeable in eyebrows, but they are also visible on drapery and in props and plants.

To summarize, then, close stylistic and technical analysis of the panels and fragments that remain from six windows of the twelfth-century glazing of Saint-Denis reveals extensive work by three distinct masters. When more than one master shared the painting of a single window, the nature of their collaboration varied. In the Infancy window two artists apportioned execution of the narrative scenes panel by panel, but in at least one border and in the figural medallions of the Crusading window, collaboration is evident within single panels. In order to evaluate more fully and precisely the working relationships between these painters, the stylistic and technical evidence gleaned from the study of Saint-Denis should be coordinated with a broader understanding of the way artists organized their labor in the twelfth century—that is with current knowledge concerning the nature of medieval artists' workshops.

Unfortunately, information on this subject is severely limited. No contemporary textual documentation exists to outline the way stained glass masters like those at Saint-Denis organized their labor. Indeed, there is more evidence for Saint-Denis than for most sites. As already noted, Abbot Suger reports that his windows were painted by many masters from different regions. He offers no details, however, regarding their working relationship at Saint-Denis and provides no help to the historian who wonders if each master came with a traveling shop of assistants and trainees, or if, instead, all or several masters were called in either to form new shops from the resources of a local work force or to work together within a single collective workshop.

The best documentation for the medieval craft of stained glass is Theophilus Presbyter's *De Diversis Artibus*.[42] But this text, which dates from roughly two decades before the glazing of Saint-Denis,[43] is of limited use in reconstructing workshop practices. Theophilus outlines the steps by which a twelfth-century individual might go about making a window, but his only reference to the division of labor involves the manual assistance of a "boy" who is called on to carry cylinders of freshly-blown glass to the annealing furnace.[44] Theophilus does not explain how a group of individuals

would divide the labor of this complicated enterprise, nor how one might train to become a part of it.

The limitations imposed by the scarcity and nature of written documentation have not, however, prevented modern commentators from formulating and repeating stock conceptions of the nature of the workshop system that organized the production of stained glass windows during the twelfth and thirteenth centuries. That is, even though most of us acknowledge that we know very little with any certainty about the working procedures and social structure of these ateliers before the end of the fourteenth century,[45] we consistently rely on a series of assumptions when discussing workshop practices. Even a cursory review of recent literature reveals the following set of widely accepted postulates.[46]

Assumption 1
Style is the glue that holds the concept of the workshop together, and formal analysis, applied at various levels, is the tool used to isolate and investigate the working of these shops.[47]

Assumption 2
The character of a particular shop is easiest to determine through a study of ornament and overall window design[48] rather than narrative compositions,[49] but the distinguishing of "hands" working within the shops is sought in incidental variations in the details of articulation.[50]

Assumption 3
Individual workshops were usually dominated by the personality of a single master artist.[51] Only occasionally did they unite a small group of master artists adhering to a single stylistic vision.[52]

Assumption 4
Working under the master(s) was a team of variously skilled assistants.[53]

Assumption 5
Distinctions between painters working in a single shop are grounded in qualitative stylistic assessments;[54] the master is always assumed to be the "best" artist.[55] Assistants were generally occupied with what have been considered the less important tasks of making, cutting, and firing the glass.[56] Some of them (especially the "apprentices"—see Assumption 6) may have been allowed to paint ornament or secondary parts of figural compositions,[57] but the master always did the major figural painting, designed the window, and prepared the cartoons which the assistants followed slavishly when they actually participated in the painting. According to this model, the stylistic harmony or unity of a window whose execution was the result of a corporate effort of variously skilled workers is due to the careful supervision of a dominant master.[58] Imbedded in this rather complicated assumption are, of course, further assumptions, for instance that figural painting was more important than the painting of ornament[59] and that medieval windows were supposed to be unified stylistically.

Assumption 6
There was a hierarchy among the many assistants in the workshop. Some were apprentices[60]—masters in training—who gradually took on more and more responsibility for the execution of more and more important parts of the windows designed by their masters and who might eventually have workshops of their own, some inheriting that of the masters with whom they had trained,[61] others leaving to form new shops elsewhere.[62]

Assumption 7
Each shop or master possessed a model or pattern book containing not only standard shop formulae for drapery folds and facial types, but—perhaps more significantly—also designs for the overall composition of windows and the detailed articulation of ornamental motifs.[63] The transmission of model books explains the occasional precision in the transmission of stylistic influence.[64]

Assumption 8
Some workshops traveled, presumably intact, with masters, model books, and workers migrating together from site to site, job to job.[65] Others remained in one location over an extended period, sometimes working under the direction of a succession of masters, some of whom were themselves itinerant.[66]

Some of these assumptions are probably valid, but their uncritical origins and the way they are manipulated to arrive at conclusions are often suspect. Many—perhaps most—may drive from generalizing backwards, consciously or unconsciously, from what is known of artistic workshops in the late Middle Ages and the Renaissance. The problems with such a method are obvious; little else concerning works of art—their appearance, production, and function—remains constant from the twelfth through the sixteenth century. Retroactive reasoning also results in circular arguments buttressed only by a series of shaky assumptions. For example, we assume that there were apprentices, and we expect to find them practicing their work in passages of ornament because we also assume that ornament was less important than figures to the medieval artist and consumer. Consequently, any discovered variation in the design or quality of the articulation of ornament is cited as evidence that apprentices shared in its execution, which

simply recasts the original assumption as conclusion.[67] The questions that stimulated such arguments are generated by the works of art themselves, but the discourse that seeks to answer the questions is often removed both from the experience of the works and from the meager textual documentation surrounding their production. Instead it takes place in the realm of supposition.

Admittedly, arguments based on these widely-held assumptions lead to sensible conclusions grounded in straightforward, commonsense reasoning. Perhaps that explains why they are assimilated so easily and repeated so uncritically. The fundamental problem is to determine how similar modern common sense and the suppositions that support it are to those of medieval artists and patrons. Does the deployment of these sensible assumptions in current scholarship lead to conclusions about the working methods and expectations of medieval creators and consumers or only about those of modern critics and historians?

Significantly, at Saint-Denis the evidence provided by the works of art themselves is often at odds with the claims of modern common sense, notably when the latter argues from a hierarchical distinction between figures and ornament to posit hierarchical distinctions among artists in a medieval shop. The borders of Saint-Denis demonstrate the same assured artistic invention and are executed throughout with the same care and skill as the figural panels.[68] Indeed, because the borders are created from numerous small pieces of glass, each of which had first to be roughly cut out and then delicately grozed to arrive at the precise shape it assumed in the overall pattern (e.g., Fig. 2–20), just as much labor—if not more—may have been required to create ornament as to produce narrative scenes. If borders and other decorative fields had been less important, more economical designs could have been devised for them, as they were during the thirteenth century.[69] Clearly, works of art—the only substantial evidence we have about how artists and shops worked in the twelfth century—must be used to question or refine current working assumptions. Only then can we begin to sort out and relate notions like workshop and master, master and assistant, collaboration and influence.

The analysis of the Saint-Denis glazing may, in fact, provide the occasion for a critical reevaluation of assumptions about workshop practices on an even more fundamental level. It has been argued here that the execution of the Infancy and Crusading windows was entrusted to two artists with distinct personal styles who worked together in harmony. If this thesis is accepted, there is little, if any, justification for using stylistic differences of this sort to isolate workshops at Saint-Denis.

Conventionally, however, it has been assumed that each figure style represents the work of a single shop, although assessments of the level at which formal deviation becomes a significant boundary have varied considerably.[70] Once liberated from the restraining assumption that style is necessarily tied to and unified within the workshop unit, however, it becomes possible to envision a different scenario at Saint-Denis, one in which glass masters with distinct, personal styles worked together harmoniously within a single cooperative shop rather than heading a series of independent shops. This hypothesis is bolstered by more objective, material evidence drawn from further examination of the works themselves.

The physical character of the glass in the six windows produced by the three painters isolated here is identical. Bubbles are distributed within the fabric of the material in the same way. The type of corrosion that occurs on both front and back surfaces is comparable, as is the relative thickness of the glass and the peculiar texture and pervasive gentle undulation of its surfaces. This identity of materials from window to window, artist to artist, extends to the famous noncorrosive blue glass, which, as mentioned earlier, is chemically distinct from the other glass and may represent the expensive importation, possibly from Rome, of what Suger proudly refers to as "materiem saphirorum".[71]

The surviving panels further indicate that the three artists also shared pots of paint. The strokes used for articulation—either by blocking light or by modulating its transmission—are created with two distinct types of vitreous enamel, generally employed side by side on the same piece of glass. One of these paints is dark, dull brown in complexion, porous and velvety in character. The other, a shinier paint, has a reddish, rusty cast. It is the physical appearance of these paints which seems to remain constant from panel to panel. As emphasized earlier, the way the three painters applied the paints to the surface of the glass varies considerably and significantly and is important evidence in distinguishing their work. Perhaps the physical characteristics of paint and glass—factors that can be studied only under certain controlled conditions—are more significant evidence than stylistic or even technical variations in defining stained glass workshops,[72] even if style and technique may more clearly separate master from master, or at least painter from painter.[73]

This hypothesis of one large workshop sheltering many masters, rather than several masters heading several shops,[74] however, rests on a heretofore-unexpressed assumption that those who painted the glass and assembled the windows were those who fabricated the

materials from which they were made—that glass making, glass painting, and glazing were all activities performed in the proposed collective workshop. The question might be raised whether a separate workshop of glass makers—and perhaps another of paint makers—supplied several workshops of window painters and makers, each headed by one of Suger's many masters. If so, the nature of materials used would have little bearing on a discussion of how artistic labor was organized.

The idea that glass making, glass painting, and glazing were all activities of a single versatile workshop is not, however, grounded in retroactive reasoning or modern common sense—both of which would, in fact, argue for specialization. Rather, it is based on contemporary written testimony. When Theophilus describes how to make a stained glass window,[75] he instructs his readers to begin by making the glass, and only then to follow through with the designing, cutting, painting, firing, and assembling of the final product. He does not indicate a division of labor between the fabrication of materials, on the one hand, and artistic creation, on the other. Indeed, all that he says suggests that there was no such division that time.[76]

Before they can be generalized to any extent, both the hypothesis of a collective workshop sheltering many glass masters and its underlying assumption, rooted in Theophilus's testimony concerning the self-sufficiency of twelfth-century stained glass workshops, should be tested against the stylistic, technical, and physical evidence of windows produced elsewhere at this time, or slightly later. My own preliminary work on the early glazing of Rouen Cathedral as it survives in the "Belles Verrières" (ca. 1200–1202) has revealed indications of comparable procedures in at least one other case.[77] There, as at Saint-Denis, windows of differing styles appear to have been produced contemporaneously. Distinctions in painting technique, which underscore differences in style, suggest execution by more than one artist, but, as at Saint-Denis, the windows were made from the same materials. Unfortunately, the kind of study necessary to reach such conclusions is not possible for all windows. It requires examination from close range under carefully regulated lighting conditions. Since it can only be accomplished on dismounted panels, dispersed—or partially dispersed—windows, such as those from Saint-Denis and Rouen, are more accessible than those in situ, which can be studied only when they are removed for restoration.[78]

This investigation of three master painters from Saint-Denis, then, is offered as a modest, preliminary case study, demonstrating what can be learned about stained glass masters and workshops if, instead of using uncritically formulated and accepted assumptions to evaluate works of art, we use the works of art themselves to evaluate—indeed to establish—those assumptions. Unquestionably there was considerable collaboration on medieval stained glass windows, yet this need not have coincided with a hierarchical division of labor within workshops. It may have been a response to the desire for stylistic diversity. Internal formal variation, in other words, may not have been the unfortunate and unavoidable result of the means of production, or—as has recently been proposed—the price that had to be paid for hasty execution;[79] it may have been cultivated.

This taste for variety appears not to have been restricted to Saint-Denis or to twelfth-century windows. John James's breathtakingly detailed study of Chartres—even if divorced from his theories, conclusions, and interpretations—has called seriously into question, in the case of that monument, the myth that stylistic homogeneity of parts was dictated by a single dominant master or artist of genius in charge of the whole.[80] Indeed most—perhaps all—architectural complexes of the twelfth and thirteenth centuries are characterized by a staggering variety in the execution of details, which modern scholars often tend to evaluate as the unfortunate by-product of halted campaigns, later restoration, or misguided continuation. Perhaps it is time art historians ceased being uncomfortable with what may be evidence of enormous artistic vitality in the early Gothic period.[81]

Far from being troublesome to Suger, the stylistic diversity characterizing his windows was apparently a source of great pride. His esteem for variety—be it manifest in the quality of pearls or in the national origin of artists—runs through his discussions of the reconstruction of his choir like a leitmotif. Not only did he bother to mention the masters who painted his windows, he recorded for posterity two pieces of information about these artists—their number and the diversity of their origins. When viewed with eyes unclouded by specious assumptions, even individual windows support both of Suger's claims.

Michael W. Cothren
Swarthmore College

Notes

* The research for this article was generously supported by grants from the National Endowment for the Humanities, the J. Paul Getty Trust, and the Faculty Research Fund of Swarthmore College. The material presented was first delivered

at the Nineteenth International Congress of Medieval Studies (Kalamazoo, 1984) as part of an ICMA Symposium on Medieval Workshop Practices and subsequently reshaped for talks at Penn State, Mount Holyoke College, the University of Arkansas at Little Rock, Columbia University (The Robert Branner Forum for Medieval Art), and Hollins College. I have benefited greatly from lively discussions with auditors on each of these occasions, but I would like to single out my debt to Donald Royce-Roll who pointed out at Kalamazoo my own reliance on a then unexpressed and unevaluated assumption that medieval stained glass workshops made—as well as painted—glass. My study of Suger's texts in relation to what they reveal about the masters who created the windows has been guided by several valuable discussions with Thomas G. Waldman, who is currently preparing a new translation of *De Administratione*. As with all my work on the windows of Saint-Denis, this study would have been impossible without the cheerful cooperation of those who have provided access to the fragmentary remains of Suger's glazing: Lachlan Pitcairn, the Reverend Martin Pryke, Stephen Morely, and Joyce Bellinger at the Glencairn Museum; Jane Hayward and Timothy Husband at The Cloisters; Jean-Jacques Gruber, maître verrier; Catherine Brisac of the Ministère de la Culture; Jean-Marie Bettembourg at the Laboratoire des monuments historiques; Dennis and Michael King of King and Sons, Norwich; Peter Gibson of the York Glaziers Trust; D. Michael Archer and Agnes Cairnes at the Victoria and Albert Museum; the Reverend K. W. Bastock, vicar of Twycross; the Reverend J. L. G. Lever, former rector of Wilton; Linda Fraser and Robert Marks at the Burrell Collection; the Lord Barnard and Elizabeth Steele at Raby Castle. I am equally grateful for the advice and encouragement of a host of colleagues, especially Elizabeth A. R. Brown, Madeline Harrison Caviness, William W. Clark, and Jane Hayward. Close and perceptive readings of an earlier version of this text by friendly editors, Susan Lowry and Joan Vandergrift, are largely responsible for any grace and clarity of written expression in its current form.

1 For the architecture of Saint-Denis, see more recently Sumner McKnight Crosby, *The Royal Abbey of Saint-Denis from its Beginnings to the Death of Suger, 475–1151*, New Haven, 1987, esp. pp. 215–265, with references to the rather extensive previous bibliography.

2 For Suger's texts (until the appearance of a new edition and translation by Thomas G. Waldman), see *Abbot Suger on the Abbey Church of Saint-Denis and its Art Treasures*, ed. and trans. Erwin Panofsky, second edition ed. Gerda Panofsky-Soergel, Princeton, 1979.

3 The precise meaning of the "light" represented by these windows has received considerable scholarly attention lately. The traditional, face-value interpretation of the windows as conveyers of pervasive interior luminosity (e.g., Otto von Simson, *The Gothic Cathedral,* Princeton, 1962, pp. 21–58; and Louis Grodecki, *Le vitrail roman,* Fribourg, 1977, pp. 12–16) has been challenged by an assertion that the stained glass—especially the high concentration of blue glass—represented darkness, the embodiment of Pseudo-Dionysian divine gloom (John Gage, "Gothic Glass: Two Aspects of a Dionysian Aesthetic," *Art History,* 5, 1982, pp. 36–58; and Meredith Parsons Lillich, "Monastic Stained Glass: Patronage and Style," *Monasticism and the Arts*, ed. Timothy Gregory Verdon, Syracuse, New York, 1984, pp. 207–254). It might be worth considering as well the possibility that darkness and luminosity were juxtaposed in these windows, that the blue backgrounds represented a divine gloom out of which the mostly non-blue subjects (meant, according to Suger, to be "illuminating") would glow. Regardless of the value placed on the "light," however, the desire for windows per-se could have inspired the significant architectural advances. Crosby (*Royal Abbey of Saint-Denis from its Beginnings*, pp. 236–237) has pointed out that when viewed from Suger's position at the high altar, the architecture of the lower story would have practically disappeared, highlighting the series of chapel windows as a "crown of light."

4 *Abbot Suger on the Abbey Church*, ed. Panofsky, pp. 100–101: "illo urbano et approbato in circuit oratoriorum incremento, quo tota clarissimarum vitrearum luce mirabili et continua interiorem perlustrante pulchritudinem eniteret."

5 *Ibid.*, pp. 52–53, 72–77. In the first instance, Suger uses the word "operarius" for the makers of the windows. In the second passage, however, he refers to them as "magister", a title he employs elsewhere only in reference to the metalworkers. Suger also mentions "sculptores." In one instance they are the metalworkers who made the western doors (*ibid.*, pp. 46–47), and in

another a sculptor—also a metal worker—is credited with the transformation of the antique porphyry vase into an eagle (*ibid.*, pp. 78–79). In a third reference (*ibid.*, pp. 33–34), Suger couples sculptors—this time clearly workers in stone—with masons and stonecutters as "operarius," but in a fascinating recent study, C. R. Dodwell has argued that these "sculptores" should probably not be thought of as the carvers of the portal sculpture: "The Meaning of 'Sculptor' in the Romanesque Period," in *Romanesque and Gothic: Essays for George Zarnecki,* Woodbridge, England, 1987, pp. 49–61 (for Suger's references to sculptors, pp. 52–53, 56–57).

6 If there were stained glass windows in the upper story of Suger's choir, they may have disappeared at this point, though they could also have been adapted for reuse in the new Rayonnant openings. For the thirteenth-century architectural reconstruction, see Caroline Bruzelius, *The Thirteenth-Century Church at Saint-Denis,* New Haven, 1986; for its effect on the glazing, see Louis Grodecki, *Les vitraux de Saint-Denis, étude sur le vitrail au XIIe siècle* (Corpus Vitrearum Medii Aevi, France, Etudes, 1), Paris, 1976, pp. 29–32.

7 Grodecki, *Vitraux de Saint-Denis*, pp. 39–41.

8 In 1793 all "feudal" and royal imagery was ordered suppressed (*ibid.*, p. 39), and the series of medallions depicting the First Crusade doubtless disappeared at this point. For them, see Elizabeth A. R. Brown and Michael W. Cothren, "The Twelfth-Century Crusading Window of the Abbey of Saint-Denis: 'Praeteritorum enim Recordatio Futurorum est Exhibitio,'" *Journal of the Warburg and Courtauld Institutes,* 49, 1986, pp. 1–40.

9 Grodecki, *Vitraux de Saint-Denis,* pp. 42–46.

10 Reported anonymously in *Journal de Paris*, 8 pluviôse an X (January 17, 1802), pp. 766–767.

11 For the collusion of Lenoir and his glazier, Tailleur, with dealers, see Grodecki, *Vitraux de Saint-Denis*, pp. 45–46.

12 *Ibid.,* pp. 46–56.

13 This process was initiated by Louis Grodecki in the 1950s, and his own efforts are summarized in *Vitraux de Saint-Denis.*

14 For an inventory of what had been discovered by 1976, see *ibid.*, pp. 63–80. To this census should be added several panels from the Infancy of Christ and Benedict windows, for which, see Michael W. Cothren, "The Infancy of Christ Window from the Abbey of Saint-Denis: A Reconsideration of Its Design and Iconography," *Art Bulletin*, 68, 1986, pp. 398–420; and David O'Connor and Peter Gibson, "The Chapel Windows at Raby Castle, County Durham," *The Journal of Stained Glass*, 18/2, 1986–87, pp. 127–128.

15 Lost medallions from the Crusading window are discussed and reproduced with engravings in Bernard de Montfaucon, *Les monumens de la monarchie françoise, qui comprennent l'histoire de France, avec les figures de chaque règne que l'injure des tems a épargnes*, Paris, 1729–1733, vol. 1, pp. 277, 384–397, pls. XXIV–XXV, L–LIV. Even more important than the published engravings are eleven of the original drawings from which they were taken, made for Montfaucon before 1729 and now in Paris, Bibliothèque Nationale, MS fr. 15634, fols. 107, 150–151, 158–164, 166. For the drawings, see Brown and Cothren, "Crusading Window," esp. pp. 6–7, 39–40.

16 The invaluable drawings of Charles Percier were executed at Saint-Denis in 1795 and are now in the Bibliothèque municipale in Compiègne. On them, see Grodecki, *Vitraux de Saint-Denis,* pp. 40–41, and George Huard, "Percier de l'abbaye de Saint-Denis," *Les monuments historiques de la France*, 1, 1936, pp. 134–144, 173–182.

17 I am not including among these windows scenes of the martyrdom of Saint Vincent and the application of the Signum Tau which have traditionally figured in discussions of the twelfth-century glazing of Saint-Denis. See Grodecki, *Vitraux de Saint-Denis*, pp. 103–107; *idem*, "Un *Signum Tau* mosan à Saint-Denis," *Clio et son regard, Mélanges Jacques Stiennon*, Liège, 1983, pp. 337–356; and Jane Hayward, in Sumner McKnight Crosby, et al., *The Royal Abbey of Saint-Denis in the Time of Abbot Suger (1122–1151)*, exhibition catalogue, The Metropolitan Museum of Art, New York, 1981, pp. 92–93. These two panels were restored to Saint-Denis by Lenoir when his museum closed, but he returned a considerable amount of glass not originally from the abbey along with the panels he had removed from it, notably glass from

Saint-Germain-des-Prés and the Templar chapel at Sainte-Vaubourg. By excluding them from the discussion here, I am arguing not that the Saint-Vincent and Signum Tau panels do not come from Saint-Denis but simply admitting that nothing other than their current location associates them with the twelfth-century glazing of the abbey. In the case of the other six windows, on the other hand, in addition to the survival of numerous panels of glass, we also have either the contemporary testimony of Suger or the reports of prerevolutionary observers. For these reasons it seemed wise to set these two panels aside in the context of the current study.

18 All five scenes cited by Suger (*Abbot Suger on the Abbey Church,* ed. Panofsky, pp. 74–77) in the Moses window still survive at Saint-Denis, even if some are heavily restored. For this window, see Grodecki, *Vitraux de Saint-Denis,* pp. 93–98, and *idem,* "Vitraux allégoriques de Saint-Denis," *Art de France,* 1, 1961, pp. 19–46.

19 Only two medallions have survived from the Anagogical window, and both are now installed at Saint-Denis. This window is also cited by Suger (*Abbot Suger on the Abbey Church,* ed. Panofsky, pp. 74–75), and he documents four of the panels by recording their inscriptions. Of these four, one can be identified with an extant medallion. Its surviving companion is not cited by Suger, presumably because it does not have an elaborate inscription. For this window, see Grodecki, *Vitraux de Saint-Denis,* pp. 93–94, 98–102; *idem,* "Vitraux allégoriques;" and Konrad Hoffmann, "Suger's 'Anagogisches Fenster' in St. Denis," *Wallraf-Richartz-Jahrbuch,* 30, 1968, pp. 57–88.

20 Suger notes the inclusion of this window in his glazing program (*Abbot Suger on the Abbey Church,* ed. Panofsky, pp. 72–73), but unlike the Anagogical and Moses windows, he does not describe it. A substantial portion of the window is still installed at Saint-Denis, more than any of the other six windows discussed here. In addition, several figural and ornamental panels have been discovered elsewhere. One king is partially preserved within a panel now in the Musée des Beaux-Arts in Lyon, and two prophets are installed in the parish church of Saints Mary and Nicholas in Wilton, England. Practically all of the border and ornament of the current window are modern, and elsewhere only one border palmette has survived (London, Victoria and Albert Museum). Pieces of the ornament that filled the interstices created outside the half-medallions holding the prophets were drawn by Charles Winston in 1846 when they were in a private collection (London, British Library, Add. MS 35211, vol. 4, fol. 318), but they have since disappeared. For the Jesse Tree window, see Grodecki, *Vitraux de Saint-Denis,* pp. 71–80.

21 Unlike the previous three windows, Suger does not mention this one, although it contains a portrait of the abbot himself kneeling at the feet of the Virgin in the scene of her Annunciation. It is not inconceivable that it postdates his death by a few years (see Brown and Cothren, "Crusading Window," pp. 35–37; cf. Madeline Harrison Caviness, "Stained Glass at Saint-Denis: The State of Research," *Abbot Suger and Saint-Denis: A Symposium,* ed. Paula Lieber Gerson, New York, 1986, pp. 266–267), but there is no question that it dates from the original, mid twelfth-century glazing. Very little of the Infancy window remains today at Saint-Denis, but much of it has been found elsewhere. See Cothren, "Infancy of Christ Window."

22 No glass from this window remains at Saint-Denis, and it is not cited by Suger. Percier drew the lower portion of the window at the end of the eighteenth century, however, assuring its Dionysian provenance. This is the least thoroughly studied component of the Saint-Denis glazing, and no convincing reconstruction has yet emerged. In addition to several panels and fragments of the border, nine figural scenes or fragments of figural scenes remain. There are in France (two at Fougères and one in Paris at the Musée de Cluny), and six are in England (four at Twycross, one on loan from Christchurch Borough Council to the Victoria and Albert Museum, one only recently discovered at Raby Castle). A tenth figural fragment is known from a tracing made by Juste Lische, a glass painter working at Saint-Denis in the middle of the nineteenth century. For the Benedict window, see Grodecki, *Vitraux de Saint-Denis,* pp. 108–114. For the Raby panel, which was unknown to Grodecki, see O'Connor and Gibson, "The Chapel Windows at Raby Castle," pp. 127–128.

23 Only two panels have survived from the Crusading window, both now in the Glencairn Museum, Bryn Athen, PA. Twelve related medallions, however, were recorded by Montfaucon (see

note 15 above) before their destruction, presumably during the French Revolution when their "feudal" subjects were precisely what anti-royal iconoclasts found most objectionable. None of Percier's sketches can be coordinated convincingly with the ensemble. See Brown and Cothren, "Crusading Window," where it is argued, on iconographic evidence, that this Crusading window probably dates from the abbacy of Suger's successor, Odo of Deuil. Cf. Grodecki, *Vitraux de Saint-Denis,* pp. 115–121; *idem, Le vitrail roman,* pp. 95, 290; Hayward, in *The Royal Abbey of Saint-Denis in the Time of Abbot Suger,* pp. 94–97; and *idem,* in Jane Hayward and Walter Cahn, et al., *Radiance and Reflection. Medieval Art from the Raymond Pitcairn Collection,* exhibition catalogue, The Metropolitan Museum of Art, New York, 1982, pp. 90–95; where the fourteen known scenes are divided between two fourteen-panel windows that would have formed a diptych within the original Sugerian glazing, one side recounting the life of Charlemagne and the other the events of the First Crusade.

24 For the possibility that the glazing represented by these six windows extended into the 1150s under the abbacy of Suger's successor, Odo of Deuil, see Brown and Cothren, "Crusading Window."

25 Though uncommon, twelfth-century artists' signatures are known in various media. The best-known instance in glass is the inscribed self-portrait that identifies Gerlachus as the artist of the windows from the Abbey of Arnstein an der Lahn. See Grodecki, *Le vitrail roman,* pp. 151–160, 268–269, esp. figure 128.

26 Little information of this sort survives for artists during the twelfth century, though it does become available by the late thirteenth and is relatively rich for the fourteenth century. For documentation on glass painters, see the important article by Meredith Parsons Lillich, "Gothic Glaziers: Monks, Jews, Taxpayers, Bretons, Women," *Journal of Glass Studies,* 27, 1985, pp. 72–92.

27 "Qui enim inter alia majora etiam admirandarum vitrearum operarios, materiem saphirorum locupletem, promptissimos sumptus fere septingentarum librarum aut eo amplius administraverit, peragendorum supplementis liberalissimus Dominus deficere non sustinebit." *Abbot Suger on the Abbey Church,* ed. Panofsky, pp. 52–53.

28 E.g., *ibid.,* pp. 76–77. For the nature and significance of this "saphirorum materia" at Saint–Denis, see Gage, "Aspects of a Dionysian Aesthetic," pp. 42–46; and Lillich, "Monastic Stained Glass," pp. 222–225.

29 Robert H. Brill and Lynus Barnes, "Some Chemical Notes," in Crosby, et al., *Royal Abbey of Saint-Denis in the Time of Abbot Suger,* p. 81; and Cothren, "Infancy of Christ Window," pp. 407–408, esp. notes 37, 41.

30 "Vitrearum etiam novarum praeclaram varietatem, ab ea prima quae incipit a *Stirps Jesse* in capite ecclesiae usque ad eam quae superest principale portae in introitu ecclesiae, tam superius quam inferius magistrorum multorum de diversis nationibus manu exquisita depingi fecimus." *Abbot Suger on the Abbey Church,* ed. Panofsky, pp. 72–74.

31 "Unde, quia magni constant mirifico opere sumptuque profuso vitri vestiti et saphirorum materia, tuitioni et refectioni earum ministerialem magistrum ..." *Ibid,* pp. 76–77.

32 In this study I will concentrate almost exclusively on comparisons of facial articulation in documenting the stylistic distinctions between Suger's artists. The number of details that can be reproduced as illustrations here is limited, and the stylistic singularities are most salient with faces. The personal styles of the three artists do, however, extend to the delineation of drapery and the execution of ornamental detail, both in the character of line and in the design of systems of articulation.

33 The line that divides their work in the window runs between the register of the Adoration of the Magi and that of the Presentation in the Temple. See Cothren, "Infancy of Christ Window," fig. 20.

34 For these drawings, see note 15.

35 A further confirmation of the eighteenth-century draftsman's accuracy in reproducing medieval styles is provided by the head of Charlemagne in this same drawing, which is unlike the work of either the Jeremiah or the Simeon master but is stylistically equivalent to a head by a thirteenth-century restorer in one of the extant medallions. See Brown and Cothren, "Crusading Window," pp. 3–4, pl. 4a–b.

36 Robert Branner, *Manuscript Painting in Paris during the Reign of Saint Louis: A Study of Styles*, Berkeley, 1977, p. 11.

37 Sylvia Pressouyre, *Images d'un cloître disparu ... le cloître de Notre-Dame-en-Vaux à Châlons-sur-Marne*, Paris, 1976, p. 101.

38 Grodecki, *Vitraux de Saint-Denis,* pp. 120–121; Hayward, in *Royal Abbey of Saint-Denis in the Time of Abbot Suger*, p. 96; and *idem*, in *Radiance and Reflection,* p. 93. This discussion also involves a modern copy of the panel now in the Museo Civico in Turin. See Brown and Cothren, "Crusading Window," pp. 4–5.

39 For these borders and the previous bibliography discussing their affiliation with Saint-Denis and association with the Moses window, see *Stained Glass before 1700 in American Collections: Mid-Atlantic and Southeastern Seaboard States* (Corpus Vitrearum, United States, Checklist II), *Studies in the History of Art*, 23 (Monograph Series), Washington, 1987, p. 102.

40 It is quite possible that two painters, working in a very closely related style and technique, were responsible for this window. The clearest suggestion of variation appears in the best-preserved panel from the window, now in the Musée de Cluny, where one figure is painted with a delicacy and fluidity that contrasts subtly with his more stiffly and boldly articulated companion. Since this panel has not been made available to me for study, however, it is impossible to evaluate with any confidence whether this distinction most likely indicates the collaboration of two artists or variation within the work of a single artist. Here, therefore, I will discuss the window as the work of a single painter.

41 This superficial relationship has led to some interpretive confusion: Hayward, in *Royal Abbey of Saint-Denis in the Time of Abbot Suger*, p. 80.

42 This work has been published twice in English translation, in one instance (Dodwell) with a parallel edition of the Latin text: Theophilus, *On Divers Arts,* ed. and trans. John G. Hawthorne and Cyril Stanley Smith, Chicago, 1963 (reprinted New York, 1979); Theophilus, *De Diuersis Artibus. The Various Arts,* ed. and trans. C. R. Dodwell, London, 1961.

43 For the dating of Theophilus's treatise, see Lynn White, jr., "Theophilus Redivivus," *Technology and Culture*, 5, 1964, p. 224–233; and John Van Engen, "Theophilus Presbyter and Rupert of Deutz: The Manual Arts and Benedictine Theology in the Early Twelfth Century," *Viator*, 11, 1980, p. 147–163.

44 "... da puero, qui inducto ligno per foramen eius portabit in furnum refrigerii": *De Diuersis Artibus,* ed. and trans. Dodwell, p. 40.

45 For a good introduction to what is known and for references to the previous literature that discusses the documentation, see Lillich, "Gothic Glaziers." For examples of those who acknowledge the lack of documentation before proceeding to a discussion of particular workshop situations, see Madeline Harrison Caviness, *The Early Glass of Canterbury Cathedral*, Princeton, 1977, p. 37 note 3; Virginia Chieffo Raguin, "The Jesse Tree Prophet: In the Workshop Tradition of the Sainte-Chapelle," *Worcester Art Museum Journal*, 3, 1979–80, p. 31; *idem*, *Stained Glass in Thirteenth-Century Burgundy*, Princeton, 1982, p. 73; Louis Grodecki and Catherine Brisac, *Le vitrail gothique*, Fribourg, 1984, pp. 28–32. This situation is not confined to the study of stained glass: Lydwine Saulnier and Neil Stratford, *La sculpture oublié de Vézelay* (Bibliothèque de la Société française d'archéologie, 17), Paris, 1984, p. ix; Branner, *Manuscript Painting in Paris*, pp. 6, 11.

46 The citations in the following footnotes seek to document with specific examples instances where the assumptions catalogued have guided scholarly discussions of the relationship between workshop practices and the history of stained glass. There is no attempt whatsoever to be comprehensive. I intend, rather, to choose either from the work of those scholars (like Grodecki) who have established the principal assumptions or from the readily accessible work of others who, in the study of particular monuments, have addressed directly the problems of interpreting twelfth–and thirteenth–century stained glass workshops.

47 This identification of style with workshop was codified by Louis Grodecki in a path-breaking article outlining a method for the study of stained glass that has been used by most subsequent scholars: "A Stained Glass *Atelier* of the Thirteenth Century: A Study of the Windows in

the Cathedrals of Bourges, Chartres and Poitiers," *Journal of the Warburg and Courtauld Institutes,* 11, 1948, pp. 87–111 (republished in the original French in *idem, Le moyen age retrouvé, de l'an mil à l'an 1200,* Paris, 1986, pp. 437–476). For studies in which Grodecki puts his own method into practice, see "Le maître de saint Eustache de la cathédrale de Chartres," *Gedenkschrift Ernst Gall,* Munich, 1965, pp. 171–194 (reprinted in *Le moyen age retrouvé,* pp. 521–543); "Le 'maître du Bon Samaritain, de la cathédrale de Bourges," *The Year 1200: A Symposium,* New York, 1975, pp. 339–359 (reprinted in *Le moyen age retrouvé,* pp. 477–494). In his delineation and discussion of workshop style, Grodecki uses the words "maître" and "atelier" almost interchangeably. He does acknowledge that in some instances (cited below) a group of artists worked within an "atelier," but he rarely makes hierarchical distinctions between them by designating one as the "maître" of the "atelier" and the remainder as assistants. Grodecki's scholarly apprentices were not as circumspect. For examples of their work, grounded in the master's stylistic method, see Hayward, in *Radiance and Reflection* (e.g., pp. 152–155); *idem,* in *Royal Abbey of Saint-Denis at the Time of Abbot Suger,* pp. 65–67; Madeline H. Caviness and Virginia Raguin, "Another Dispersed Window from Soissons: A Tree of Jesse in the Sainte-Chapelle Style," *Gesta,* 20, 1981, pp. 191–198; Linda Morey Papanicolaou, "Stained Glass from the Cathedral of Tours: The Impact of the Sainte-Chapelle in the 1240s," *Metropolitan Museum Journal,* 15, 1981, pp. 53–66; Michael W. Cothren, "The Thirteenth- and Fourteenth-Century Glazing of the Choir of the Cathedral of Beauvais," Ph.D. Dissertation, Columbia University, New York, 1980, pp. 48, 147–148, 175–180, 268; *idem,* "The Seven Sleepers and the Seven Kneelers: Prolegomena to a Study of the 'Belles Verrières' of the Cathedral of Rouen," *Gesta,* 25, 1986, pp. 216–218. This use of style to define workshops (in the absence of any written documentation) is not, of course, peculiar to studies of medieval stained glass. See, for instance, Branner, *Manuscript Painting in Paris,* whose statement (p. 11) that "a style of painting constituted the tradition of an atelier. I regard this as a fundamental point, so much so that in fact I shall use the terms 'style' and 'atelier' almost interchangeably," characterizes Grodecki's method as well.

48 The basis for this seems to be the order and weight of discussion in Grodecki, "Stained Glass

Atelier." See Caviness, *Early Glass of Canterbury,* p. 41, where her statement "In tracing atelier traditions, ornament is often more useful than figure compositions and style" is undercut somewhat by her admission that "patterns may equally be passed from one shop to another without significant stylistic exchange." See also Raguin, *Thirteenth-Century Burgundy,* and the manifest destiny of this method in *ibid.,* p. 79, note 104. Cf. Michael W. Cothren, "The Choir Windows of Agnières (Somme) and a Regional Style of Gothic Glass Painting," *Journal of Glass Studies,* 28, 1986, pp. 47–65, where it is argued that two separate workshops shared ornament and window designs and are distinguished by stylistic features of a different sort.

49 The problems of seeking to define the character of a workshop principally through the stylistic analysis of figural scenes are articulated by Caviness in a penetrating discussion of the importance of filtering out the effect of iconographic source material and widely used traditional *moduli* before coming to conclusions concerning personal or workshop figure style: "Stained Glass at Saint-Denis," pp. 262–266.

50 E.g., Louis Grodecki, in Marcel Aubert, et al., *Les vitraux de Notre-Dame et de la Sainte-Chapelle de Paris* (Corpus Vitrearum Medii Aevi, France, I), Paris, 1959, pp. 92–93; Raguin, *Thirteenth-Century Burgundy,* p. 73; Linda Morey Papanicolaou, "Stained Glass Windows of the Choir of the Cathedral of Tours," Ph.D. Dissertation, New York University, New York, 1979, pp. 156–198; Cothren, "Choir of the Cathedral of Beauvais," pp. 79–81.

51 E.g., Grodecki, "Stained Glass *Atelier,*" p. 88; *idem,* "Le 'maître du Bon Samaritain'" (where he uses the terms "maître" and "atelier" interchangeably); Papanicolaou, "Choir of the Cathedral of Tours," pp. 156–159; Catherine Brisac and Jean-Jacques Gruber, "Le métier de maître verrier," *Métiers d'art,* 2, 1977, p. 27. See also note 55.

52 E.g., Grodecki in *Les vitraux de Notre-Dame,* pp. 92–93, where several "maîtres" within the "atelier principal" of the Sainte-Chapelle are distinguished through qualitative assessment of their work but without singling out any one as its head.

53 E.g., Grodecki and Brisac, *Le vitrail gothique,* pp. 31–32; Caviness, *Early Glass of Canterbury,*

pp. 36–37 (where it is argued that within a large shop several masters leading teams of assistants took responsibility for individual windows); Papanicolaou, "Choir of the Cathedral of Tours," pp. 156–159.

54 E.g., Grodecki, in *Les vitraux de Notre-Dame*, pp. 92–93; Cothren, "Choir of the Cathedral of Beauvais," pp. 175–178.

55 E.g., Caviness and Raguin, "Another Dispersed Window," p. 196; Papanicolaou, "Choir of the Cathedral of Tours," p. 156; Cothren, "Choir of the Cathedral of Beauvais," pp. 81, 175–178. The imposition of this seductive hierarchical assumption can lead to subtle (unconscious?) reinterpretation in citing the views of a previous author. See Caviness and Raguin, "Another Dispersed Window," p. 191, where in citing Grodecki's work on the Sainte-Chapelle (in *Les vitraux de Notre-Dame*, pp. 92–93), the artist he distinguished as the most talented of those working in the "atelier principal"—the Passion Master—is elevated to the rank of master of the workshop, his associates designated as assistants. Although he did distinguish these masters qualitatively, Grodecki assiduously avoided designating one of the hands working in the work as *the* master.

56 E.g., Raguin, "Jesse Tree Prophet," p. 31.

57 E.g., Hayward in *Royal Abbey of Saint-Denis at the Time of Abbot Suger*, p. 80; Raguin, *Thirteenth-Century Burgundy*, p. 73; *idem*, "Jesse Tree Prophet," p. 31.

58 E.g., Caviness and Raguin, "Another Dispersed Window," p. 196: "... one is tempted to suppose that the glass [at Soissons] was executed by minor painters from the atelier [of the Sainte-Chapelle], who, once removed from the dominance of the Master's personal expression, began to assert a stylistic independence that produced works at once more expressive ... and more banal"

59 E.g., Raguin, "Jesse Tree Prophet," p. 31: "An apprentice must have acquired his skill through the repetitive production of floral borders and decorative backgrounds before beginning to work on figural panels."

60 E.g., Hayward, in *Royal Abbey of Saint-Denis at the Time of Abbot Suger*, p. 67; Raguin, "Jesse Tree Prophet," p. 31; Meredith Parsons Lillich, "Bishops from Evron: Three Saints in the Pitcairn Collection and a Fourth in the Philadelphia Museum," in *Studies on Medieval Stained Glass. Selected Papers from the XIth International Colloquium of the Corpus Vitrearum, New York, 1— 6 June 1982* (Corpus Vitrearum, United States, Occasional Papers, 1), New York, 1985, p. 99.

61 E.g., Hayward, in *Radiance and Reflection,* pp. 95–97; Caviness, *Early Glass of Canterbury*, pp. 36–37; Cothren, "Choir of the Cathedral of Beauvais," p. 115.

62 E.g., Caviness and Raguin, "Another dispersed Window," p. 192; Raguin, *Thirteenth-Century Burgundy*, pp. 74, 112–113.

63 E.g., Grodecki, *Le vitrail roman*, p. 27; Caviness, *Early Glass of Canterbury* pp. 36, 85 ("'Atelier' should be defined here in the broadest sense, as artisans who shared the same pattern book."), 95 ("The cumulative experience of the Canterbury-Sens atelier was probably collected in model or motif books."); Caviness and Raguin, "Another Dispersed Window," pp. 192, 197 note 15; Raguin, *Thirteenth-Century Burgundy*, pp. 74, 112–113; *idem*, "Jesse Tree Prophet," p. 32 ("Although no pattern books survive from this period, it now appears certain that workshops possessed small-scale drawings on vellum that recorded specific drapery motifs, medallion designs, ornament, and facial types. These models abetted uniformity of design within a workshop, acquainted apprentices with prevailing traditions, and helped disseminate artistic ideas from site to site."). Cf. Cothren, "Choir Windows of Agnières," p. 51 and note 23, where, following the theory formulated by Branner in his study of thirteenth-century manuscript production (*Manuscript Painting in Paris*, pp. 19–21), visual memory formed by training and travel (of artists, not books) is proposed as an alternative to the hypothetical model book.

64 E.g., Raguin, *Thirteenth-Century Burgundy*, pp. 74, 112–113.

65 Grodecki, "Le maître de Saint Eustache," might be cited as a type study were he not clearly arguing for a traveling artist rather than a traveling workshop (cf. citation of this study in Virginia Raguin, "Windows of Saint-Germain-lès-Corbeil: A Traveling Glazing Atelier," *Gesta*, 15, 1976, p. 265). For traveling workshops, see

Brisac and Gruber, "Le métier," p. 28 (where traveling of artists and workshops seems to be conflated); Caviness, *Early Glass of Canterbury*, p. 85; Raguin, *Thirteenth-Century Burgundy*, pp. 52–58, 113; *idem*, "Jesse Tree Prophet;" Papanicolaou, "Stained Glass from the Cathedral of Tours," p. 63; *idem*, "St. Martin and the Beggar. A Stained Glass Workshop from the Lady Chapels of the Cathedrals of Le Mans and Tours," in *Studies on Medieval Stained Glass. Selected Papers from the XIth International Colloquium of the Corpus Vitrearum, New York, 1–6 June 1982* (Corpus Vitrearum, United States, Occasional Papers, 1), New York, 1985, pp. 60–69. For the suggestion that windows, rather than workshops, may have traveled, see Cothren, "Choir Windows of Agnières," p. 61 and note 49.

66 E.g., Grodecki, "Stained Glass *Atelier*," p. 87 (where it is argued that two of the Bourges ateliers were local institutions); Caviness, *Early Glass of Canterbury*, pp. 36–37; Raguin, *Thirteenth-Century Burgundy*, pp. 41–47; Lillich, "Bishops from Evron," p. 101.

67 In the evaluation of architectural forms and their relationship to workshop practices of masons, Michael Davis (*Speculum*, 62, 1987, p. 957) has pointed to a similar circularity in the work of John James.

68 The fragmentary remains of the borders are catalogued and illustrated in Grodecki, *Vitraux de Saint-Denis*, pp. 126–131, pls. 193–208.

69 Interestingly enough, variation in the articulation of ornamental motifs within a border design—such as that noted here in the Glencairn panels—is much less apparent in the more economically conceived borders that became fashionable at the middle of the thirteenth century, further highlighting both the importance accorded ornament at Saint-Denis and the aesthetic premium placed on its variety.

70 Jane Hayward, for example, has divided the six windows discussed here between four workshops, basing her distribution on stylistic analysis at several levels. She assigns the Jesse Tree to one shop; the Infancy and First Crusade/Charlemagne windows to a second; the Anagogical and Moses windows to a third; and the Benedict window to a fourth. See *Royal Abbey of Saint-Denis in the Time of Abbot Suger*, pp. 65–67. Louis Grodecki, on the other hand, grouped five

of the windows together as the product of a single shop. He recognized the formal distinctions that inspired Hayward to create further sub-divisions, but emphasized the underlying stylistic affinities that bind them and ascribed what he saw as incidental variations to group production by more than one master and many assistants working together in one shop. Because he saw its style as more fundamentally different, however, Grodecki assigned the Benedict window to a separate workshop. See *Le vitrail roman*, pp. 96–100; and "The Style of the Stained Glass Windows of Saint-Denis," *Abbot Suger and Saint-Denis: A Symposium*, ed. Paula Lieber Gerson, NewYork, 1986, pp. 273–281.

71 For this blue glass, see note 28.

72 For the interplay of style and technique in the interpretation of another workshop situation, see Cothren, "Choir Windows of Agnières," esp. pp. 60–61.

73 *Ibid.*, pp. 52–55, 60–61.

74 Although they do not invoke a discussion of physical evidence as stressed here, collective shops responsible for entire glazings and embracing artists (even "masters") of distinct stylistic character have been proposed at Saint-Père de Chartres (Meredith Parsons Lillich, *The Stained Glass of Saint-Père de Chartres*, Middletown, Connecticut, 1978, p. 192; *idem*, "Bishops from Evron," p. 101), Canterbury (Caviness, *Early Glass of Canterbury*, pp. 36–37), and the Sainte-Chapelle (Raguin, *Thirteenth-Century Burgundy*, p. 99 note 104).

75 For this text, see notes 42–43.

76 This assumption is not without problems. Jean Lafond (*Le vitrail: origines, technique, destinées*, Paris, 1978, pp. 54–55) has cautioned against generalizing from Theophilus's testimony that all medieval glass painters made their own glass, citing specifically the danger and awkwardness of constructing kilns and transporting heavy materials in an urban setting, especially since the transportation of the glass itself would have been relatively easy. In the case of abbeys close to forests and outside cities (such as that in which Theophilus lived, and presumably Saint-Denis as well) he allows for production of materials and creation of windows by the same people in the same place. One could

also imagine (though there is little evidence to support or refute the notion) that the same workers made the glass in one site and themselves transported it to another for painting and fabrication. The arguments of White and Van Engen (See note 43) that Theophilus's treatise—far from being simply a how-to-do-it craft manual—was principally intended as an argument for the position of the visual arts within monastic vocation, might initially seem to cast some doubt concerning the relationship of what he says to what actually transpired in twelfth-century artists' workshops, monastic or otherwise. Ultimately, however, this very convincing interpretation seems more logically to bolster the validity of his testimony. A distorted representation of prevailing labor practices would actually have detracted from the power of his argument.

77 The panels I have examined from a series of windows associated with a John the Baptist Master, for instance, are made from identical glass and painted with the same paint as the fragments that remain from a Saint Peter window, though stylistically and technically the latter window is strikingly different. See Cothren, "Seven Sleepers," esp. p. 225 note 90.

78 Among the prime candidates for future studies are the dispersed panels from a twelfth-century glazing associated with Troyes, from the early thirteenth-century glazing of Soissons, and the mid-thirteenth–century glazing of the Virgin Chapel of Saint-Germain-des-Prés. The nave aisle windows of Chartres—currently being restored a few at a time—would have been a very important and revealing case study, but they have not, unfortunately, been made accessible to scholars while dismounted.

79 Caviness, "Stained Glass at Saint-Denis," p. 267; Grodecki, "Style of the Stained Glass Windows of Saint-Denis," pp. 277–279.

80 John James, *The Contractors of Chartres*, 2 vols., Dooralong, Australia, 1979 and 1981. The basics of his method and its revelations, albeit coupled with some especially shaky interpretation grounded in questionable assumptions, is available more accessibly in *idem, Chartres, The Masons Who Built a Legend,* London, 1982. James's work has inspired considerable critical response. See, e.g., Lon Shelby, "The Contractors of Chartres," *Gesta,* 20, 1981, 173–178.

81 As pointed out by Shelby (*ibid.,* pp. 174–175), James himself is uncomfortable with the "messiness" of Chartres, excusing artistic license by the patrons' indifference. Shelby, however, even if he asserts (*ibid.,* p. 176) the free creativity of all workers in stone—regardless of the hierarchical workshop system, for which there is, apparently, more evidence in stone cutting than in window making—also feels the need to excuse formal variety by emphasizing its placement in out of the way places: "with the really formidable design problems which the master mason faced, he need not have concerned himself with every detail in the building, particularly those parts which were nonpublic and generally out of sight." (*ibid.,* p. 177) An assumption that without the controlling hand of a master artistic production veres into stylistic chaos presumes a premium on strict formal unity. It is worth questioning whether this interpretive model adequately assesses the aesthetic imperatives that lay behind medieval architectural complexes.

Fig. 2–2 Head of Jeremiah, Infancy of Christ Window (Glasgow, The Burrell Collection) Photo: Cothren.

Fig. 2–3 Head of Simeon in the Presentation in the Temple, Infancy of Christ Window (Twycross, Parish Church of Saint James). Photo: Cothren.

Fig. 2–4 Head of Herod, Infancy of Christ Window (Champs-sur-Marne, Dépôt des Monuments Historiques). Photo: Cothren.

Fig. 2–5 Head of a Magus in the Dream of the Magi, Infancy of Christ Window (Raby Castle, Collection of Lord Barnard). Photo: Cothren.

Fig. 2–6 Head of Joseph in the Flight into Egypt, Infancy of Christ Window (Bryn Athyn, PA, The Glencairn Musem). Photo: Cothren.

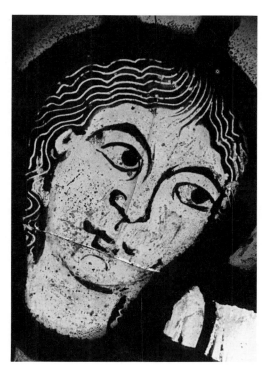

Fig. 2–7 Head of the Angel in the Dream of the Magi, Infancy of Christ Window (Raby Castle, Collection of Lord Barnard. Photo: Cothren.

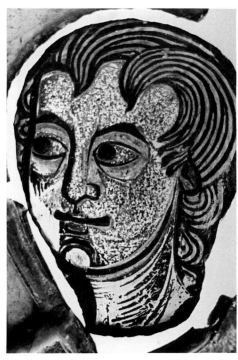

Fig. 2–8 Head of a Shepherd in the Annunciation to the Shepherds, Infancy of Christ Window (Christchurch Borough Council). Photo: Cothren.

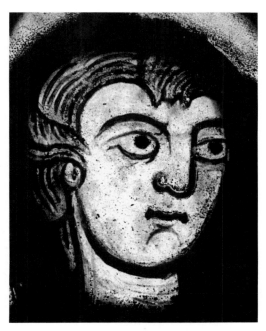

Fig. 2–9 Head of Christ in the Flight into Egypt, Infancy of Christ Window (Bryn Athyn, PA, The Glencairn Museum). Photo: Cothren.

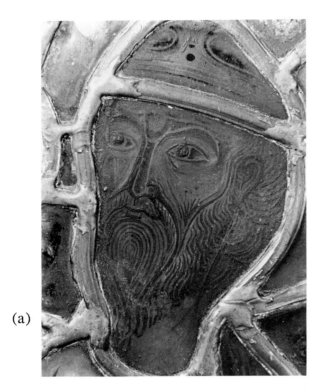

(a)

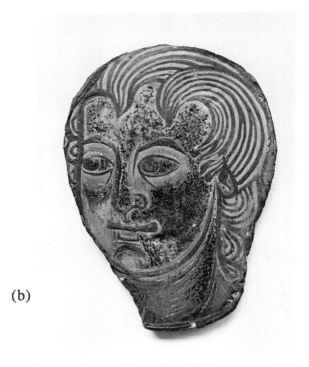

(b)

Fig. 2–10 Heads from the Infancy of Christ Window photographed with surface light to reveal the character of the painting technique: (a) Head in Fig. 2–2; (b) Head in Fig. 2–8. Photos: Cothren.

(a)

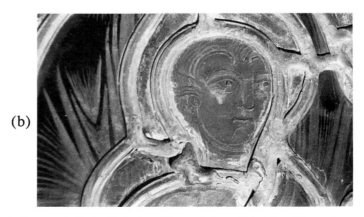

(b)

Fig. 2–11 Heads from the Flight into Egypt, Infancy of Christ Window (Bryn Athyn, PA, The Glencairn Museum), photographed with surface light to reveal the character of the painting technique. Photos: Cothren.

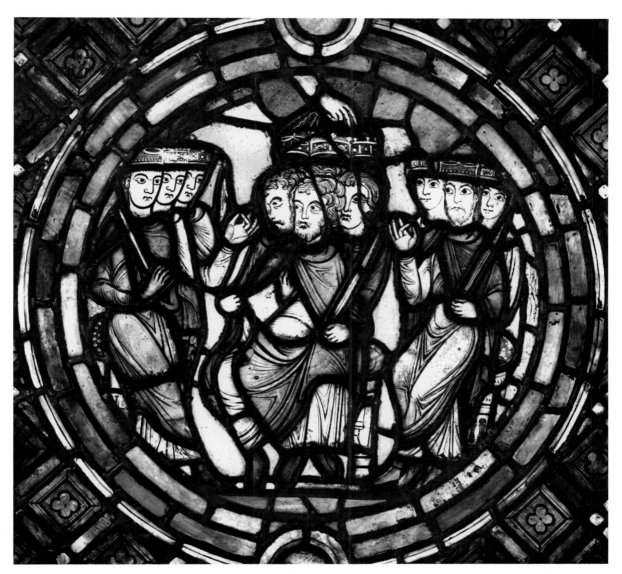

Fig. 2–12 Nine Martyred Crusaders, Crusading Window (Bryn Athyn, PA, The Glencairn Museum). Photo: Metropolitan Museum of Art.

Fig. 2–13 Heads of Martyred Crusaders, detail of Fig. 2–12. Photo: Cothren.

Fig. 2–14 Heads of Martyred Crusaders, detail of Fig. 2–12. Photo: Cothren.

Fig. 2–15 Heads of Warriors from a scene of Marching Crusaders, Crusading Window (Bryn Athyn, PA, The Glencairn Museum). Photo: Cothren.

Fig. 2–16 Heads of Warriors from a scene of Marching Crusaders, Crusading Window (Bryn Athyn, PA, The Glencairn Museum). Photo: Cothren.

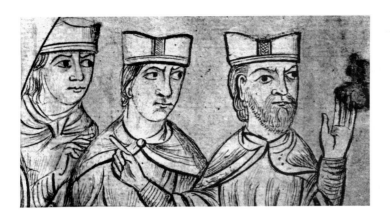

Fig. 2–17 Eighteenth-Century Drawing of Heads of Byzantine Envoys in the scene of their arrival before Charlemagne, lost panel from the Crusading Window (Paris, Bibliothèque Nationale, MS fr. 15634, fol. 107). Photo: BN.

Fig. 2–18 Eighteenth-Century Drawing of Heads of Warriors, lost panel from the Crusading Window (Paris, Bibliothèque Nationale, MS fr. 15634, fol. 159). Photo: BN.

Fig. 2–19 Eighteenth-Century Drawing of Heads of Warriors, lost panel from the Crusading Window (Paris, Bibliothèque Nationale, MS fr. 15634, fol. 158) (photo: BN)

Fig. 2–20 Two panels from the border of the Moses (?) Window (Bryn Athyn, Pa, The Glencairn Musem). Photo: Cothren.

Fig. 2–21 Details of Fig. 2–20. Fig. 2–22 Details of Fig. 2–20.

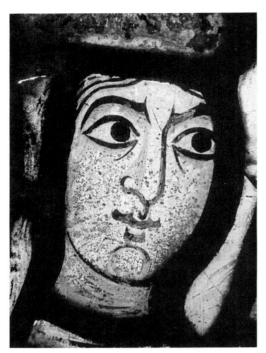

Fig. 2–23 Head of "Eclesia," Anagogical Window (panel installed at Saint-Denis). Photo: Cothren.

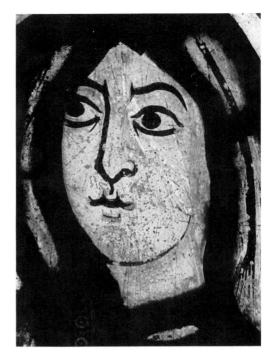

Fig. 2–24 Head of "Sinagoga," Angogical Window (panel installed at Saint-Denis). Photo: Cothren.

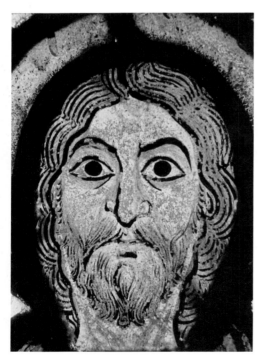

Fig. 2–25 Head of Christ, Anagogical Window (panel installed at Saint-Denis). Photo: Cothren.

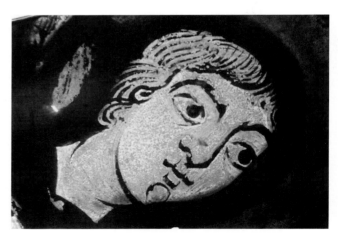

Fig. 2–26 Head of an Angel, Anagogical Window (panel installed at Saint-Denis). Photo: Cothren.

(a)

(b)

Fig. 2–27 Heads of figures adoring the Brazen Serpent (a) and crossing through the Red Sea (b), Moses Window (panels installed at Saint-Denis). Photos: Cothren.

Fig. 2–28 Head of a figure from the Moses Window (panel installed at Saint-Denis). Photo: Cothren.

Fig. 2–30 Head of Saint Benedict, Saint Benedict Window (Twycross, Parish Church of Saint James). Photo: Cothren.

Fig. 2–29 Head of Saint Benedict, Saint Benedict Window (Raby Castle, Collection of Lord Barnard). Photo: Cothren.

Fig. 2–31 Head of Saint Benedict, Saint Benedict Window (Twycross, Parish Church of Saint James). Photo: Cothren.

Fig. 2–32 Head of a monk, Saint Benedict Window (Twycross, Parish Church of St. James). Photo: Cothren.

(a)

Fig. 2–33 Heads from the Saint Benedict Window (Christchurch Borough Council) photographed with surface light to reveal the character of the painting technique. Photos: Cothren.

(b)

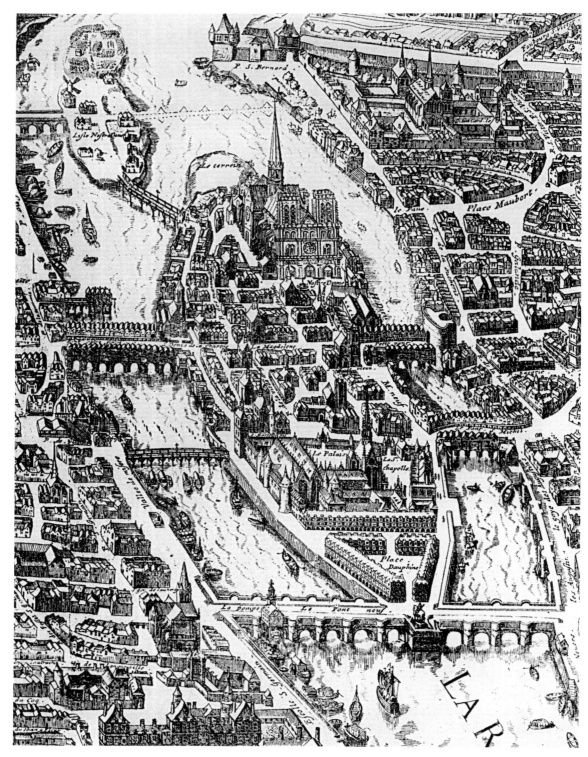

Fig. 3–1 Detail, Plan of Paris, c. 1635 (Tavernier).

Reconstructions of Notre-Dame: Archaeology, Technology and Culture*

3

The 1832 edition of Victor Hugo's *Notre-Dame de Paris* (first published in the previous year) contains an additional section (Book III) comprising two chapters which, according to Hugo in a lengthy "note," had somehow been mislaid from the original manuscript. The second of the chapters, entitled "Bird's-eye View of Paris," recreates the fifteenth-century panorama seen from the roof of the cathedral:

> ... quand, après avoir tâtonné longtemps dans la ténébreuse spirale ... on débouchait enfin brusquement sur l'une des deux hautes plates-formes, inondées de jour et d'air, c'était un beau tableau que celui qui se déroulait à la fois de toutes parts sous vos yeux; un spectacle *sui generis* ... refaites le Paris du quinzième siècle, reconstruisez-le dans votre pensée, regardez le jour à travers cette haie surprenante d'aiguilles, de tours et de clochers ... détachez nettement sur un horizon d'azur le profil gothique de ce vieux Paris [Fig. 3–1]....[1]

The other chapter, entitled simply, "Notre-Dame," emphasizes Hugo's concern with the state of the fabric of the cathedral in the author's own time:

> Mais qui a jeté bas les deux rangs de statues?... qui a taillé au beau milieu du portail central cette ogive neuve et bâtarde?... Et qui a mis de froides vitres blanches à la place de ces vitraux << hauts en couleur >> qui faisaient hésiter l'oeil émerveillé de nos pères?... Et si nous montons sur la cathédrale sans nous arrêter à mille barbaries de tout genre, qu'a-t-on fait de ce charmant petit clocher qui s'appuyait sur le point d'intersection de la croisée?... C'est ainsi que l'art merveilleux du moyen âge a été traité presque en tout pays, surtout en France.... Les modes ont fait plus de mal que les révolutions. Elles ont tranché dans le vif, elles ont attaqué la charpente osseuse de l'art, elles ont coupé, taillé, désorganisé, tué l'édifice, dans la forme comme dans le symbole, dans sa logique comme dans sa beauté [Figs. 3–2 and 3–3].[2]

Hugo also classifies Notre-Dame in this chapter as "an edifice of the transition period" with the "erection of the first pillars of the nave ... completed by the Saxon [sic] architect.... Timid and inexperienced at the start, [the Cathedral] sweeps out, grows larger, restrains itself, and dares no longer to dart upwards in spires and lancet windows, as it did later on, in so many mavelous cathedrals." And, as if to forestall a possible argument about the artistic value of a "transitional" building, he adds that "these edifices of transition from the Romanesque to the Gothic are no less precious for study than the pure types. They express a shade of art which would be lost without them."[3]

Literary Roots of the Monuments Historiques

The initial publication of *Notre-Dame* followed almost immediately on the installation, after the revolution of July, 1830, of the "liberal" régime of Louis-Philippe. The new government was anxious to display generosity towards the arts, and undoubtedly, the great success of Hugo's novel helped in inaugurating the newly-established office of Inspector-General of Historic Monuments. It may also be a measure of the influence of Hugo's *writing* that political-*literary* connections seem to have prevailed in the selection of candidates for this post rather than concern for technical knowledge of construction.[4] The first occupant (1831–1834) was Ludovic Vitet, a writer of historical plays; and the second was Prosper Mérimée, now better known as the author of

Carmen.[5] In 1837, the office of the inspector-general was expanded with the creation of the Commission des Monuments Historiques, with Mérimée as secretary and Vitet among its members.

The Parisian literary coterie, from which Mérimée and Vitet were drawn, included, in addition to Hugo, such lights as Henri Beyle (Stendhal) and Alexandre Dumas. But for the direction of our discussion, its most important member was Étienne-Jean Delécluze, a painter as well as art critic, who has gained recognition, particularly from historians of French culture, for the biography of his former teacher, David.[6] The group frequently gathered at a *salon* hosted by Delécluze, where both Mérimée and Vitet gave first readings of their early works.[7] And it was through Delécluze, or more specifically through his nephew and protégé, Eugene Emmanuel Viollet-le-Duc (1814–1879), that the final link in the circle between literary concern for the state of Notre-Dame and the undertaking of a project to renew its fabric was closed.

Although Viollet-le-Duc lacked formal architectural training (by his own and his uncle's will), his extensive travel and independent studies of historic sites provided the basis for an appointment in 1838 to a junior post at the Monuments Historiques. In 1840, he was sent to Vézelay to take charge of extensive repairs to the crumbling abbey church, and the great success of this project helped him to win in 1844 (together with the architect, Jean-Baptiste Lassus, d. 1857) the commission to restore Notre-Dame.[8] The restoration of the Cathedral (Figs. 3–4 through 3–6) continued until 1865, but during that period, Viollet-le-Duc accepted several other major commissions for medieval building restoration and he was also able to complete his ten-volume encyclopedia, *Dictionnaire raisonnée de l' architecture française du XIe au XVIe siècle* (1854–1861).

Because he has often come under attack both for his taste (but not for his building skills) in restoration and for his theories of architecture, the real merit of Viollet-le-Duc's historical studies has tended to be obscured.[9] In fact, though, during the interval between the appearance of Hugo's *Notre-Dame* and the publication of the *Dictionnaire,* knowledge of the history of medieval architecture and particularly details of medieval building construction advanced immensely; and much of this progress was due to the archaeological studies that accompanied Viollet-le-Duc's restorations.

At Notre-Dame, Lassus and Viollet-le-Duc were able to determine that the original building belonged mostly to the second half of the twelfth century and that a later campaign of construction was responsible for major structural alterations. From their examination of the extant fabric and from stone fragments found in the vicinity of the cathedral, they were able to reconstruct the original four-story interior elevations of the choir and nave—that were then used in their own restoration as a pattern for several bays of the transepts and of the choir and nave immediately adjacent (Fig. 3–7). Viollet-le-Duc also proposed schemes for the form of the original buttressing systems of both the nave (Fig. 3–8) and choir, and these have been generally accepted as being valid until only very recently.

The Nave of Notre-Dame

The early structure of the nave of Notre-Dame (now dated to c. 1180) is of singular historical importance because the height of its vaults was a leap of a full one-third over any earlier Gothic church; it is also almost two meters taller than the Cathedral choir, whose construction was begun about two decades before the nave.[10] This was to be the largest incremental height increase of the entire era for a new Gothic church over an earlier building.

Before the development of the analytical-scientific methods of structural analysis used today to predict building behavior, structural design had to be based almost entirely on e*xperience* with earlier, similar buildings. In effect, an earlier building usually acted as a "model" to confirm the stability of a new design. But with its great increment in height, this approach may have been inadequate for the planning of Notre-Dame. The builders would have been concerned not only with supporting the extremely high vaults; they would also have to contend with a new environmental realm associated mainly with tall buildings: large lateral forces caused by high winds. Wind speeds are significantly greater at higher elevations, and since wind pressures (and suctions on the leeward side of a building) are proportional to the square of the wind speed, earlier experience with lower-profiled churches (which also present smaller "sail areas" to the wind) would not have fully prepared the builders of Notre-Dame for this new design problem.

The builders of the nave also seem to have reacted to the decrease in the amount of light reaching the floor of the church from the much higher clerestory windows. (Light-intensity is governed by an inverse-square relationship with the length of the light-path from a light source (the windows) to a lighted surface.) Indeed, this concern led to ingenious innovation. The ramping up of the gallery vaults allowed a great enlargement of the window openings as well as the *direct* lighting of the

nave floor from the upper regions of the gallery windows. Taken together with their concern about wind loading, it appears also to have led to the introduction of the exposed flying buttress in the nave of Notre-Dame de Paris. Unfortunately, there is only indirect evidence for the details of this first example of the new structural device. Extensive rebuilding altered the entire buttressing system as early as the 1220s, and other partial reconstruction seems to have taken place in the late thirteenth century.

Because of the importance of the introduction of the flying buttress, both to the history of architecture and, as will be demonstrated, to the history of technology, Wm. W. Clark of Queens College (CUNY) and I undertook a new study to reconstruct the original nave structure. It is only recently that the application of modern tools of structural analysis, such as photoelastic and numerical computer modeling, have served to broaden our understanding of the structural intentions of the early builders.[11] It goes without saying that the original form of the nave buttress, proposed well over a century ago by Viollet-le-Duc, could not have relied on similar technical understanding. The new reconstruction (Fig. 3–9), whose derivation is reported on in footnote 12, is then based on: a) an assessment of the archaeological evidence surviving in the building as well as in other contemporaneous buildings in the Paris region; b) early photographs taken of the Cathedral before the progress of its nineteenth-century restoration; c) other documentary evidence preserved by Lassus and Viollet-le-Duc during their restoration, and; d) structural modeling.

All of the evidence suggests a much simpler configuration for the first flying buttresses than that proposed by Viollet-le-Duc. The major archaeological grounds for our reconstruction, still preserved in the building fabric, can be seen on the back side of the terminal wall buttress of the twelfth-century transept (Fig. 3–10). This region of the Cathedral had escaped destruction because of its protected location. Yet, the evidence remained undetected because the transept had not had flying buttresses at least since the thirteenth-century rebuilding. The quadrant arch embedded in the transept buttress, while it has never been open in the manner of the arch of a true flying buttress, nonetheless reflects the disposition of the open flyer arches that existed in the adjacent bay of the nave clerestory.

Historians previously studying Notre-Dame de Paris, and focusing only on the problem of light, assumed that the changes in the nave gallery were insufficient to raise the interior light level.[13] Hence, they argue, it was this failure that led to the decision in the thirteenth century to enlarge the clerestory windows to their present size—even though the clerestory enlarge-

ment was accompanied by a reduction in the size of the gallery windows which, since they are closer to the floor of the church, were in some ways a more effective source of light. Changes to the structural system were then interpreted only as a by-product of the need to change the window design. Inherent structural problems within the original design had never been considered in spite of the fact that anyone visiting the Cathedral today will experience that the benefit of the larger clerestory windows has been overrated—Notre-Dame remains a dark building. Indications of a possible structural rationale for the alteration of the first buttressing system did emerge, however, as a result of our model study.

Initially undertaken to confirm the technological validity of the new archaeological reconstruction, photoelastic modeling revealed some unanticipated, critically-stressed regions in the wall fabric (Fig. 3–11). Based on loadings simulating the distributed dead weight and the effects of high winds on the Cathedral walls and roof, the scaled-model results indicated that the structure of the nave of Notre-Dame would have been subjected to only moderate levels of compressive stress (which *pushes* individual stones together). But two local regions of tension (tending to *pull* stones apart) were also indicated on the windward buttressing, both occurring at points of abutment where the upper ends of the flyer arches rested against the clerestory and gallery walls. During heavy storms, such as modern records indicate could have taken place from time to time during the forty-odd years of life of the original configuration, some cracking in the weak, lime-mortar grouted joints would have become apparent. Because these tensions were highly localized, however, it is doubtful that *major* problems with the fabric would have arisen. On the other hand, repairs, including the re-pointing of all the affected joints, would have to be made promptly after every great storm to prevent more general deterioration—despite the lack of easy accessibility to the affected regions. Their need for constant observation and regular maintenance suggests that it was more than accidental coincidence that these very regions were eliminated in the thirteenth-century rebuilding of the nave buttressing.

Notre-Dame and Gothic Structural Development

Further confirmation for this explanation of the thirteenth-century reconstruction is provided by examining the buttress details of other buildings constructed contemporaneously or somewhat later than Notre-Dame (Fig. 3–12). The evidence of, among others, the giant

cathedrals of Bourges and Chartres, begun in 1194–1195, suggests that the problem we have identified at Paris was recognized quite early on by the other builders. Notre-Dame was shown to be the initial model for determining the subsequent modifications in the configurations of each of their buttressing systems. And in turn, benefitting from those experiences, were the modifications incorporated into the buttressing of the nave of Notre-Dame itself in the 1220s (the buttressing illustrated in Figure 3–4).

It had long been thought that the design of Chartres was established by the realization of the full potential of the flying buttresses. From a modern technological vantage point, however, the Chartres buttressing has been seen as relatively ponderous, even clumsy; moreover, a tier of unsubstantial, largely ineffective upper flyers was hastily erected during the last stages of construction, c. 1220 (Fig. 3–13).[14] The buttressing of Bourges, on the other hand, was shown to be simple, light, even daring, but structurally sound.

Archaeological analysis of the choir of Bourges revealed that its original buttressing scheme was also altered during the course of construction. The steep upper tier of flyers supporting the high clerestory was apparently an addition made around 1210.[15] We concluded that these efficient, highly-sloped flying buttresses (Fig. 3–14) were brought into being as part of a pragmatic redesign of the Cathedral structure in response to an awareness of wind effects on tall buildings. Such knowledge, before the full rising of Chartres or of Bourges itself, would only have come from Paris.

If not fully effective themselves, the upper flyers of Chartres appear in turn to have pointed the way for efficacious flying buttress placement in the mature High Gothic churches—a first, lower tier of flyers positioned to resist the outward thrust of the stone vaulting over the nave, and a second upper tier of flyers bracing the high clerestory walls and the tall timber roof above the vaults against wind loadings—as exemplified in that next vast essay in Gothic architecture begun in 1210, the Cathedral of Reims (Fig. 3–15). Furthermore, the apparent aftermath of a new experience with lighter construction at very large scale has a parallel in our own time. When it opened in July, 1940, the main span of the suspension bridge over the Tacoma Narrows in Washington State was the third-longest and by far the lightest of any long-span bridge construction. Four months later, a fairly steady but moderate cross-wind blowing against the span produced twisting oscillations that induced a catastrophic collapse. In reponse, many long-span suspension bridges were quickly stiffened, usually by adding heavy trusses to the roadway decks. And all of the fol-

lowing generation of American suspension bridges incorporated deep stiffening trusses along their roadways—not unlike the addition of upper flyers to many Gothic churches in the first half of the thirteenth century.

From this vantage point, then, the construction of the Cathedral of Notre-Dame de Paris appears also as a landmark in the history of building technology. If Notre-Dame was not "transitional" in just the sense that Victor Hugo used that term, as a daring experiment in tall-building design, it stands at the very center of the development of High Gothic structure.

Robert Mark
Princeton University

Notes

* The modeling of Notre-Dame was supported by grants from the National Endowment for the Humanities and the Andrew W. Mellon and Alfred P. Sloan Foundations. The author is indebted as well to W.W. Clark and J. Herschman for photographic contributions and for advising on the early photographs of Notre-Dame.

1 Victor Hugo, *Notre-Dame de Paris,* Paris, 1975, pp. 114, 115, 136: "When after having groped one's way up the dark spiral [staircase of the west belltower] ... one emeged, at last abruptly, upon one of the lofty platforms inundated with light and air—that was, in fact, a fine picture which spread out, on all sides at once before the eye; a spectacle *sui generis....* Reconstruct the Paris of the fifteenth century, call it up before you in thought; look at the sky athwart that surprising forest of spires, towers and belfries ... project clearly against an azure horizon the Gothic profile of this ancient Paris." [Translations are from the 1888 edition of *Notre-Dame de Paris* published by Thomas Y. Crowell, New York.]

2 *Ibid.,* pp. 108, 109: "Who has thrown down the two rows of statues [from the façade] ... who has cut [for a procession], in the very middle of the central portal that new and bastard arch ... who put the cold white panes in the place of those windows, "high in color," which caused the astonished eyes of our fathers to hesitate ... and if we ascend the cathedral, without mentioning a

thousand barbarisms of every sort—what has become of that charming little bell tower which rested upon the point of intersection of the cross-roofs?... 'Tis thus that the marvelous art of the middle ages has been treated in nearly every country, especially in France.... Fashions have wrought more harm than revolutions. They have cut to the quick; they have attacked the very bone and framework of art; they have cut, slashed, disorganized, killed the edifice, in form as in symbol, in its consistency as well as in its beauty."

3 *Ibid.*, p. 111. Background on Hugo's writing in a medieval architectural context, together with the artistic and literary roots of the Gothic revival, are found in G. Germann, *Gothic Revival in Europe and Britain: Sources, Influences and Ideas*, Cambridge, Massachusetts, 1972 (trans. by G. Onn), pp. 45–47 *et passim*.

4 These appointments might appear consistent with Hugo's further observation (in Book Five, Chapter II, entitled "This Will Kill That") that the printed word had come to replace architecture as the principal expression of man: "During the first six thousand years of the world, from the most immemorial pagoda of Hindustan, to the cathedral of Cologne, architecture was the great handwriting of the human race. And this is so true, that not only every religious symbol, but every human thought, has its page and its monument in that immense book.... Thus, down to the time of Gutenberg, architecture is the ... universal writing.... In the fifteenth century everything changes. Human thought discovers a mode of perpetuating itself, not only more durable and more resisting than architecture, but still more simple and easy.... *The book is about to kill the edifice.* The invention of printing is the greatest event in history. It is the mother of revolution" (*ibid.*, pp. 177, 180, 182).

5 See A.W. Rait, *Prosper Mérimée*, London, 1970, pp. 137ff. Political appointees with literary backgrounds were not confined to the Inspector-General's office. Rait recounts a contemporary editorial: "M. Prosper Mérimée, author of ... several distinguished works, has just been appointed principal officer of the General Secretariat of the Navy. There is said to be a vacant place in the literary department of the Ministry of the Interior. We hope it will be given to a naval officer" (*op. cit.*, p. 100). In this context, it is only fair to note that Mérimée had been

trained in law and that later on he was most diligent and effective in his direction of French historic restoration. Vitet, too, was especially knowledgeable about archaeology.

6 E.-J. Delécluze, *Louis David, son école et son temps, souvenirs*, Paris, 1855.

7 Rait, *op. cit.*, pp. 38 ff.

8 According to Rait, "So great was the risk of failure [at Vézelay] that even Caristie and Duban, the two architects who sat on the commission, both refused to have anything to do with it ... [and] at first, Mérimée was reluctant, lest a failure, however honorable, should irrevocably compromise the young man's future" (*ibid.*, p. 152).

9 See R. Mark, "Robert Willis, Viollet-le-Duc, and the Structural Approach to Gothic Architecture," *Architectura*, 7.1, 1977, pp. 52–64.

10 The higher elevation of the nave vaulting was drawn to my attention by L. T. Courtenay during an investigation in the summer of 1985 of the early, timber roof framing of the Cathedral. The nave vessel is also appreciably wider and lighter in construction than the choir (see W. W. Clark and R. Mark, "The First Flying Buttresses: A New Reconstruction of the Nave of Notre-Dame de Paris," *The Art Bulletin*, LXVII, March, 1984, p. 53).

11 Details of the modeling techniques may be found in: R. Mark, *Experiments in Gothic Structure*, Cambridge, Masachusetts, 1982.

12 Background on the historiography of Notre-Dame and details of the new reconstruction of the nave buttressing are found in: W. W. Clark and R. Mark, *op. cit.*, pp. 47-65. A useful, more general background source is P. du Colombier, *Notre-Dame de Paris; Mémorial de la France*, Paris, 1966.

13 See, for example, P. Frankl, *Gothic Architecture*, Baltimore, 1962, p. 46.

14 See R. Mark, "The Structural Analysis of Gothic Cathedrals: Chartres vs. Bourges," *Scientific American*, 227, November, 1972, pp. 90–99.

15 R. Branner, *La Cathédrale de Bourges et sa place dans l'architecture gothique*, Paris/Bourges, 1962, pp. 52–53.

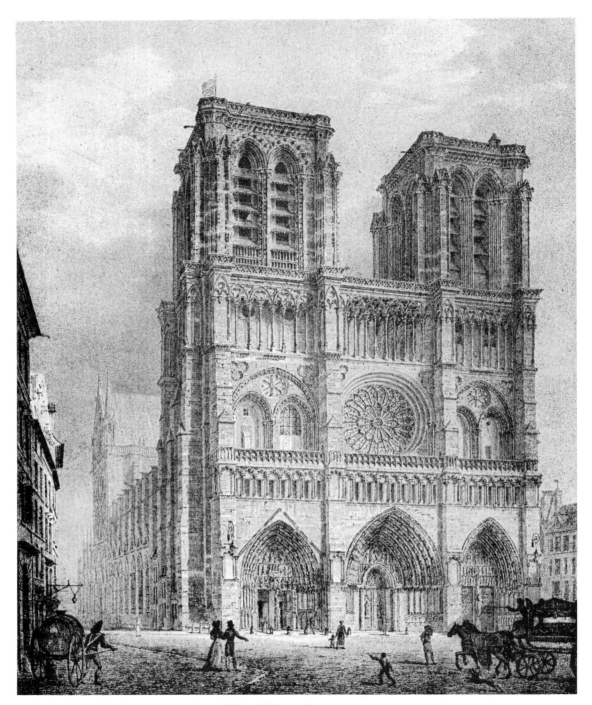

Fig. 3–2 Notre-Dame de Paris, 1826 (Chapuy).

Fig. 3–3 "The Baptism of the Comte de Paris," 1841 (Viollet-le-Duc): interior of
the nave of Notre-Dame before mid-19th-century restoration.

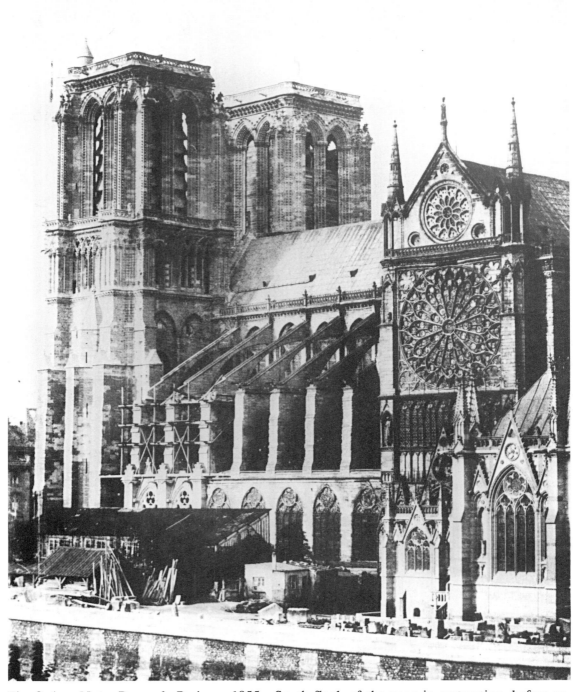

Fig. 3–4 Notre-Dame de Paris, c. 1855. South flank of the nave in restoration, before removal of the 13th-century flying buttresses. Photo: CNMHS / SPADEM / ARS.

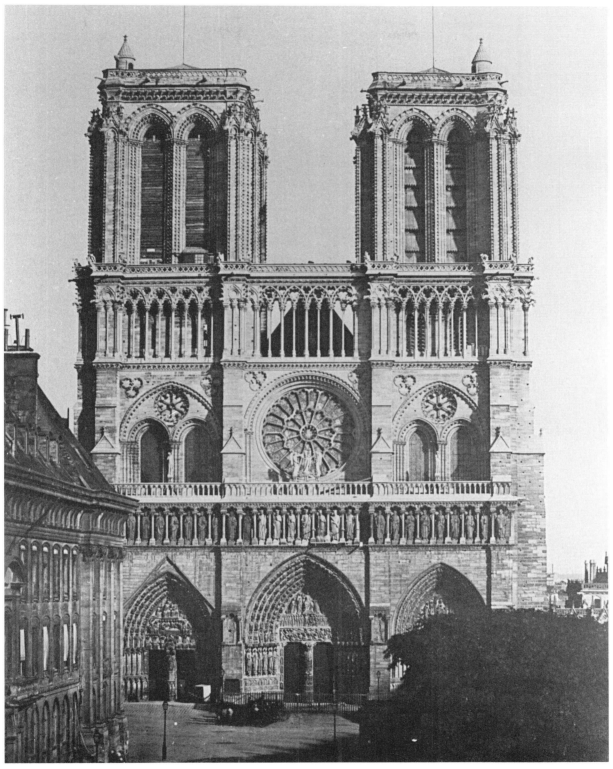

Fig. 3–5 Notre-Dame de Paris, c. 1855. West front in restoration. Photo: Baldus / J. Paul Getty Musem.

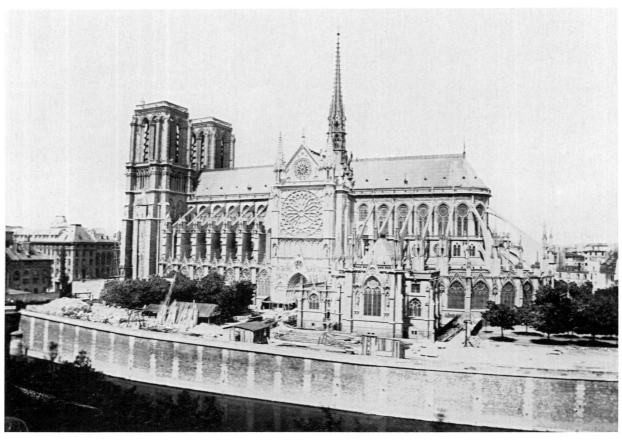

Fig. 3–6 Notre-Dame de Paris, c. 1860. South-east flank during the later stage of restoration, with new flèche in place. Photo: Bibliothèque Nationale, Paris.

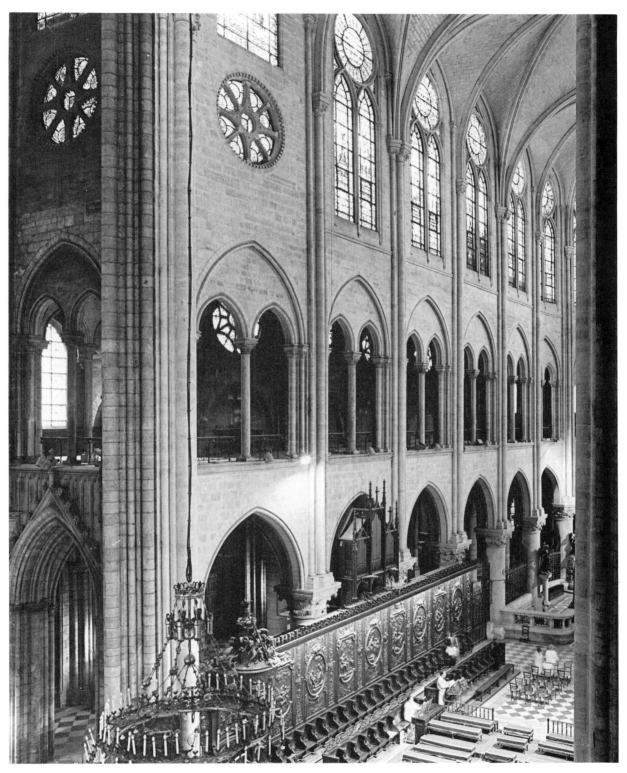

Fig. 3–7 Notre-Dame de Paris. Interior elevation of the north transept and choir. Photo: Herschman.

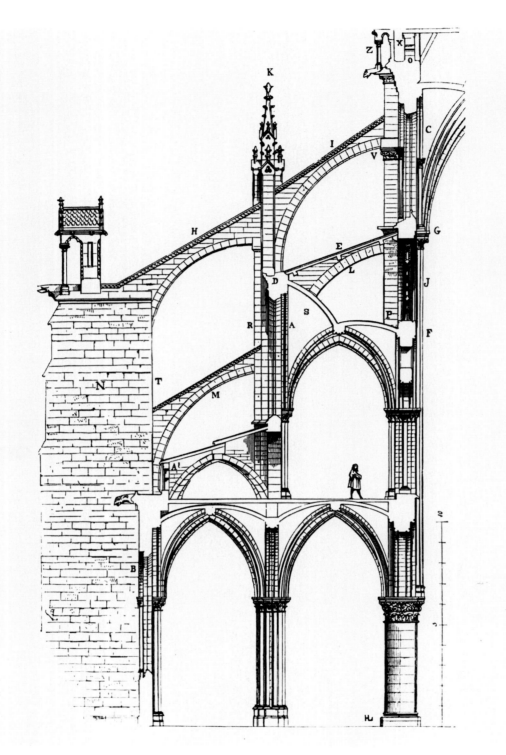

Fig. 3–8 Reconstruction of the original Notre-Dame nave structure by Viollet-le-Duc, c. 1850.

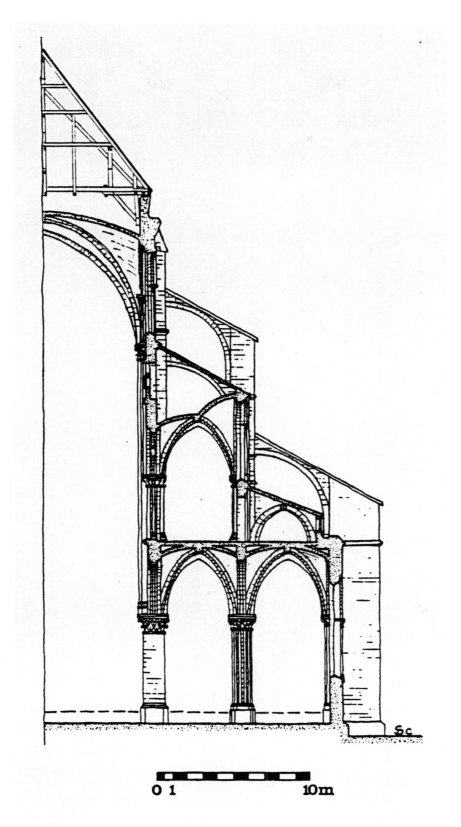

Fig. 3–9 Reconstruction of the original Notre-Dame nave structure by
Clark and Mark, 1984.

Fig. 3–10 Notre-Dame de Paris. Original quadrant arch in south transept buttress. Photo: Clark.

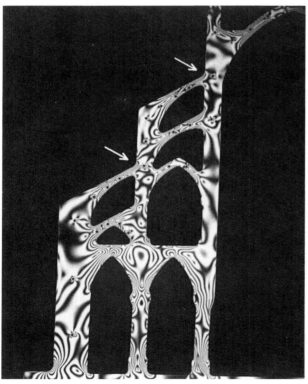

Fig. 3–11 Interference pattern in photoelastic model of reconstructed Notre-Dame nave structure under simulated wind loading. Photo: Mark.

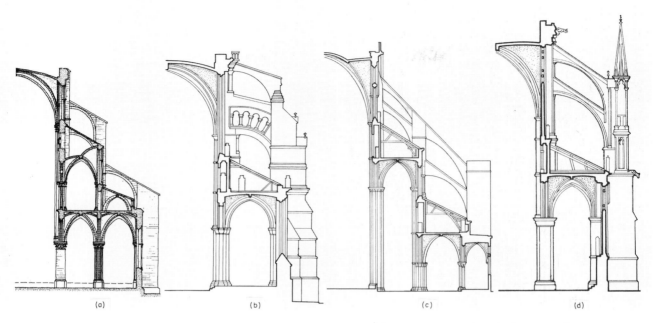

Fig. 3–12 Comparative cross-sections: (a) Notre-Dame de Paris nave, c. 1180; (b) Chartres Cathedral nave, c. 1220; (c) Bourges Cathedral choir, c. 1210; and (d) Reims Cathedral nave, mid-13th century.

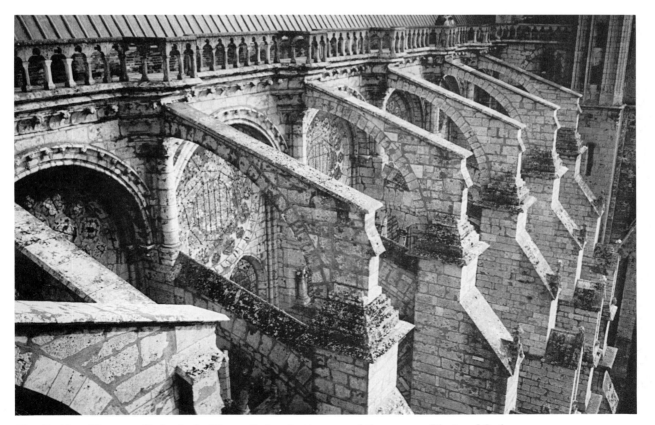

Fig. 3–13 Chartres Cathedral. Upper flying buttresses of the nave. Photo: Mark.

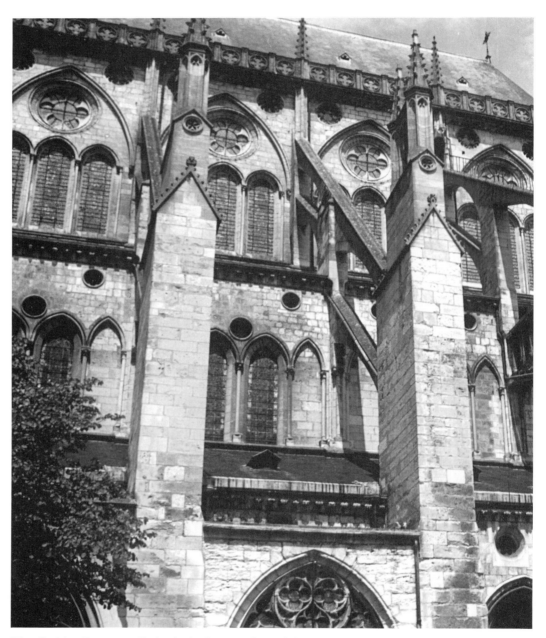

Fig. 3–14 Bourges Cathedral. Buttressing of the choir. Photo: Mark.

Fig. 3–15 Reims Cathedral. Buttressing of the nave. Photo: Mark.

Fig. 4–14 Elisabeth Louise Vigée Le Brun. *Hubert Robert*, 1788. Musée du Louvre, Paris.

Vigée Le Brun and the Classical Practice of Imitation

4

In course of time, Vigée Le Brun has come to be recognized as one of the most prolific and versatile artists of her age. Indeed, to those familiar with her work, her powers of invention seem almost inexhaustible: her portraiture is characterized by a rich variety of poses, costumes, and color schemes. Yet hardly has it ever been recognized to what extent she was a virtuoso of the pastiche and the paraphrase. To my knowledge, the only critical reference to the subject was made—albeit disparagingly—by Albert Pomme de Mirimonde who, in an article published in 1967 in the *Revue du Louvre,* remarked: "En fait, il arrivait à Mme Lebrun de manquer un peu d'imagination. Elle se référait alors volontiers à un précédent. Il y aurait un petit article à consacrer aux pastiches et plagiats de Mme Lebrun, mais nous nous garderons bien de l'écrire pour ne pas contrister l'ombre d'une aussi jolie femme."[1] It seems to me that in this simplistic analysis de Mirimonde has entirely missed the point. He has failed to recognize that by "referring to a precedent," Vigée Le Brun was in fact adhering to the time-hallowed humanist tradition of Imitation.

Once, when faced with the complex and altogether daunting task of composing the large dynastic *Portrait of Marie Antoinette and her Children* (Fig. 4–1), Vigée Le Brun inquired of Louis David how she ought to proceed. David was himself a past master in the art of cleverly recasting the ideas of others into his own pictures, and his profitable advice to her was to base her composition on the triangular configurations of a raphaelesque prototype.

> Madame Vigée Le Brun lui parla [à David] un jour de l'embarras où elle se trouvait pour composer le tableau en pied de la Reine *Marie-Antoinette*, ayant sur les genoux le Dauphin, et près d'elle, Madame, depuis duchesse d'Angoulême. "Votre mari a dans sa biblio-thèque des oeuvres de Raphaël, lui dit David, faites apporter ces gravures et nous allons trouver votre affaire." En effet, David choisit la *Sainte Famille,* et la montrant à Madame le Brun: "Voilà votre tableau, s'écria-t-il, la Vierge sera la Reine; l'enfant Jésus, le Dauphin; et le Saint Jean, la Princesse." "Mais, mon cher David, lui objecta Madame Le Brun, ne craignez-vous pas qu'on ne me reproche d'avoir pillé?" Bah! faites comme Molière, prenez votre bien où vous le trouvez. Je vous certifie que, quand vous aurez ajusté tout cela avec des habillements à la mode, et des meubles de cette époque, personne ne pourra se douter qu'une composition de Raphaël vous ait servi de modèle." Ainsi que l'avait prédit David, personne ne s'aperçut de ce plagiat.[2]

In the eighteenth century, it would have been absurd for artists to imagine that they had to grope along blindly in the dark when there existed innumerable masterworks to illuminate their task. In those ages that revered graeco-roman tradition, it was a given that even the greatest works of the past had not been self-engendered and that few, if any, were simply the result of their creators' direct experience of nature. Artists, however unusual their conceptions were, inevitably had to depend upon antecedents, if only to distance themselves from them. Appropriating forms and ideas found in the antique, in the works of the old masters, and even in contemporary art is a phenomenon that runs through the entire history of western art, and the practice became especially prevalent following the Renaissance. As a matter of course, artists systematically seized upon one another's designs as a method of study, as a means of solving technical or formal problems, as homage to an illustrious precursor and, perhaps especially, as a form of emulation.

In her youth, Elisabeth Louise Vigée received little formal artistic preparation. She was denied the rigorous instruction provided in the schools of the Académie Royale de Peinture et de Sculpture, these being the unique preserve of male students. By the same token she was unable to fully participate in the apprenticeship system operating in the studios of established painters.[3] Nevertheless, she was highly motivated, disciplined and resourceful, and it is entirely to her credit that, in order to compensate for the inadequacies of her training, whenever and wherever she could, she drew and copied from antique statuary and from the paintings and drawings of old and modern masters with which she managed to come in contact. Among those she mentions by name in this regard are Raphael, Rubens, Rembrandt, Van Dyck, and Greuze. Moreover, she visited contemporary artists' studios, attended the biennial Salon exhibitions held in the Louvre, and was allowed access to many of the finest private collections in Paris: "Dès que j'entrais dans une de ces riches galeries, on pouvait exactement me comparer à l'abeille, tant j'y récoltais de connaissances et de souvenirs utiles à mon art tout en m'enivrant de jouissances dans la contemplation des grands maîtres."[4] After her marriage in 1776 to the dealer Jean Baptiste Pierre Le Brun (Fig. 4–2), she was exposed to the unending flow of works of art that found their way into his storerooms, and she admits that in terms of practical experience, it was to her husband that she owed the greatest debt.[5]

Despite the deficiencies of her education, Vigée Le Brun nourished lofty ambitions. In her memoirs, she bitterly lamented the fact that as a younger woman she had not been able to devote herself more wholeheartedly to the *grand genre*: "...tantôt le besoin de gagner de l'argent...; tantôt la faiblesse de mon caractère, me faisait [*sic*] prendre des engagemens, et je me séchais à la portraiture. Il en résulte qu'après avoir dévoué ma jeunesse au travail, avec une constance, une assiduité, assez rares dans une femme, aimant mon art autant que ma vie, je puis à peine compter quatre ouvrages (portraits compris) dont je sois réellement contente."[6] As a result, she aspired to elevate the portrait—one of the inferior genres according to the current scale of values—to the rank of history painting. Endowed with a keen visual memory, the young Madame Le Brun retained what she saw and brilliantly improvised on it. No slavish imitator, her response to this type of stimulus was invariably creative. From various works of art she managed to cull a whole battery of themes, compositions, and techniques which she was able to draw upon at will and translate into her own idiom.

One of the main goals of the retrospective exhibition of works by Vigée Le Brun mounted in 1982 at the Kimbell Art Museum was to place the artist within the classical tradition to which she belonged. By indicating the precise, or in some instances the most likely, iconographic sources of the exhibited paintings in which Madame Le Brun's debt to other artists could be ascertained with some conviction, I attempted to accomplish this very thing in some of the catalogue entries.[7] What I propose to do in the present context is to pair off a number of key pictures—all but one dating from the most creative decade of her career, the 1780s—with those precedents which, in my opinion, constituted her points of departure. In so doing, I hope to clarify how, by reinterpreting the works of others, predecessors and contemporaries alike, she was able to impart a new vitality to her art.

* * * *

From a purely technical standpoint, it was Vigée Le Brun's contact with Rubens that had the strongest impact on her mature style. Rubens himself had frequently plundered the art of the past for his own use. Scores of his drawings, painted sketches, and full-size copies after works of Antiquity and the Renaissance have come down to us, and it is obvious that he impressed the mark of his own forceful personality on all of them. With Rubens, the line between copy and free interpretation is always tenuous, for even his copies are never exact reproductions of the originals. It seems thus appropriate to begin a discussion of specific sources for the art of Vigée Le Brun with the only pastiche which she openly avowed, a work that illustrates, perhaps better than any other, the nature of her "plagiarisms." I am referring to her masterful portrait of herself wearing a straw hat (Fig. 4–3).

In the summer of 1782, in the company of her husband, Madame Le Brun toured the Low Countries. Returning from Holland, the couple stopped in Antwerp for the express purpose of viewing the paintings of Rubens, *in situ* as it were. In the collection of Jean Michel Joseph van Havre, she came upon Rubens's portrait of his sister-in-law, Suzanne Fourment, a painting often inaccurately entitled "le chapeau de paille" (Fig. 4–4). In her memoirs, Vigée Le Brun waxed rhapsodic over this portrait, enthusiastically describing the impression it made on her.

> ...à Anvers, je trouvai chez un particulier le fameux *chapeau de paille....* Cet admirable tableau représente une des femmes de Rubens [*sic*]; son grand effet réside dans les deux différentes lumières que donnent le simple jour et la lueur du soleil (les clairs sont au soleil; ce

qu'il me faut appeler les ombres, faute d'un autre mot, est le jour), et peut-être faut-il être peintre pour juger tout le mérite d'exécution qu'a déployé là Rubens. Ce tableau me ravit et m'inspira au point que je fis mon portrait à Bruxelles en cherchant le même effet. Je me peignis portant sur la tête un chapeau de paille, une plume et une guirlande de fleurs des champs, et tenant ma palette à la main.[8]

Vigée Le Brun, a beautiful and sensual woman, undoubtedly felt a spontaneous affinity with Rubens's painting. She was seduced by the tactile qualities of the brushwork, the textural variety in the rendering of flesh, hair, fabrics, and plumes, and the provocativeness expressed both by the wide-eyed coquettish look on the model's face and the daring decolletage. In short, what she responded to was the sheer physicality of the image. In her self-portrait, which she executed on a wooden panel in imitation of the Rubens painting—she would make consistent use of this support over the next seven years—she borrowed elements of pose, costume, setting, and lighting; but she toned these down and made them conform to a more chastened, less earthy, and less robust ideal of female beauty and fashion.[9] Vigée Le Brun's self portrait *au chapeau de paille,* with its bold coloristic effects and its sensitive handling of light, shadow, and colored reflections, was at one and the same time a discreet tribute to the great Flemish master and an advertisement of the young French woman's talent and physical attractions.

Soon after its completion, the panel entered the collection of Madame Le Brun's patron, friend, and putative lover, the Comte de Vaudreuil. In the early part of 1783, the new owner allowed the picture to be exhibited at the Salon de la Correspondance. It was this very work that convinced Vigée Le Brun's mentor, Joseph Vernet, to propose her for membership in the Académie Royale. After her official reception, the painting was lent to the Salon, where it aroused considerable commentary. It was far enough removed from its Flemish source that none of the many reviewers were aware of its debt to Rubens—in truth, only the best travelled connoisseurs had ever seen the portrait of Suzanne Fourment—and it was generally thought that the artist was treading a new path. Reported one observer: "Le meilleur de ses portraits est le sien. On peut reprendre quelque chose dans le ciel et les draperis, mais le chapeau est d'une grande vérité, rien n'est plus beau, la lumière rend la paille transparente et il y a des effets que les plus grands maîtres se feroient gloire d'avoir trouvés."[10]

By her pose, Vigée Le Brun's three-quarter length *Bacchante* (Fig. 4–5), shown at the Salon of 1785, puts one more in mind of a Venus Anadyomene than a female follower of the god of wine. In the lists she drew up of her own works, the artist included the painting among her history pictures. The voluptuous young maenad tilts her body forward. Raising her right arm in an arc partially framing her head, in a gesture that traditionally connotes sleep, she weaves bunches of grapes into the heavy tresses of her black hair. The leopard skin and transparent white fabric clinging to her thighs are meant to accentuate her nudity. This exact posture occurs nowhere else in Vigée Le Brun's oeuvre, and one could search in vain for its derivation in a painted prototype, although it does have a remote connection with one of the sirens in Raphael's *Birth of Galatea.* The closest equivalent to this figure that I have managed to locate is the marble statue of a nymph wringing out her wet hair (Fig. 4–6) by the French sculptor, Louis Claude Vassé.[11] This piece was commissioned from Vassé by the Duc de Chevreuse to decorate the entrance-hall of his Château de Dampierre, located about half-way between Versailles and Rambouillet, and it was put into place as early as 1763. It is highly probable that Vigée Le Brun saw it there in the early 1780s on one of her many excursions to the estates of the nobility to which she devotes several chapters of her memoirs.[12]

The anatomical kinship between the two full and very curvacious figures is, to say the least, remarkable. The entire torso of Vassé's nymph is repeated with hardly a variation in Vigée Le Brun's *Bacchante.* In each case, the model's breasts are placed high; there is a softness in the contours, the head is small in relation to the body, the waist is thick and the abdomen dense and somewhat protruding. The flow of hair at the upper right is counterweighted in both works by a fall of drapery at the lower left. The very features of the models bear resemblance to each other. There are, of course, differences in composition. The nymph stands and her left arm rests on a vase and juts forward into space while the bacchante is seated and her left arm is upraised so that her hand can fondle her hair. More significant is the contrast in mood between the two figures. Whereas Vassé has given his nymph an expression of cold detachment, Vigée Le Brun's bacchante has an enticingly sensual presence—she radiates warmth and even humor.

A comparison of the two works almost certainly establishes that Vigée Le Brun modelled her bacchante on a nearly contemporary piece of sculpture, Vassé's *Nymph.* France's art establishment was less tolerant than its English counterpart towards women who tried to compete in the arena of history painting. And it is a fact that of the works sent by Madame Le Brun to the Salons of the 1780s, her subject pictures were those most often singled out for criticism. The *Bacchante* was

no exception, and the figure was roundly denounced for not looking bacchic enough. It is certain, noted the author of the *Mémoires secrets*, "que la tête en est charmante au possible, pleine de finesse, de malice & de gaieté. Le corps largement peint, d'une carnation admirable & séduisant par sa nudité lubrique: mais à la peau de tigre [*sic*] près, parfaitement imitée, on la prendroit plutôt pour une beauté de sérail que pour une prêtresse de Bacchus."[13] The very astute Monsieur de Vilette, in his critique of the Salon, simply queried: "La marque d'un grand talent n'est pas de tout embelir [*sic*], mais d'imprimer un caractère. Une bacchante doit-elle avoir l'air d'une *nymphe*?"[14]

In *Le deuxième sexe*, Simone de Beauvoir complained: "...Mme Vigée-Lebrun ne se lasse pas de fixer sur ses toiles sa souriante maternité."[15] The criticism is decidedly unfair, since Vigée Le Brun painted only two portraits of herself with her daughter, Julie. These paintings, her so-called "maternités," were executed at an interval of three years (Figs. 4–7 and 4–9). They have been admired and reproduced in one form or another more than any of the artist's works and are consequently the best known. This fact accounts, at least in part, for de Beauvoir's irritation. From her marxist-feminist point of view, the representation of the self on the part of a woman could be interpreted as nothing more than gratuitous narcissism. "Certes," she wrote, "le moi n'est past toujours haïssable. Peu de livres sont plus passionnants que certaines confessions: mais il faut qu'elles soient sincères et que l'auteur ait quelque chose à confesser. Le narcissisme de la femme au lieu de l'enrichir l'appauvrit; à force de ne faire rien d'autre que se contempler, elle s'anéantit; l'amour même qu'elle se porte se stéréotypie: elle ne découvre pas dans ses [oeuvres] son authentique expérience, mais une idole imaginaire bâtie avec des clichés"[16] In the case of Vigée Le Brun's self-portraiture, the crime is compounded by the artist's glorification of her own motherhood, motherhood being for Simone de Beauvoir a major stumbling block to a woman's "true" affirmation of self and to her unrestricted freedom of action.

The author never considered in her peremptory condemnation that Vigée Le Brun's main purpose in painting these maternal images may have been a professional one, i.e. the renewal of her art by the establishment of a link between herself and the painter whom she, and most contemporary opinion, regarded as the supreme genius of all times, Raphael. The self-portrait of 1786 (Fig. 4–7) is obviously a secular paraphrase of a sacred subject, and it is one of the truly superlative examples of neo-raphaelism in French painting.[17] Vigée Le Brun conceived the portrait along the lines of the *Madonna della sedia* (Fig. 4–8), the most revered of Raphael's Madonna and Child paintings, which was known in

France through numerous engravings and copies. One of the most plausible sources in this particular instance is Van Schuppen's print of 1661 in which Virgin and Child are seen in reverse, for it is thus that the two figures are presented in Madame Le Brun's free improvisation. Vigée Le Brun indulged here in a very conspicious—one is tempted to say "rococo"—display of painterly technique in her treatment of figures and costume. And as was often the case in her work, the scintillating color combinations constitute the most original feature of the portrait. Once again Vigée Le Brun adhered only loosely to the archetypal design and gave herself free reign to readjust its rhythms and its symbols to fit her own aesthetic. The solemn piety of the Raphael is here transformed into overt sentimentality. Madame Le Brun's painting reflects the late eighteenth-century ideal of contented motherhood which had been propounded, among others, by Jean Jacques Rousseau.

The artist's portrait of herself with her daughter was included by her in her contribution to the Salon of 1787. The reviewers of the exhibition failed to associate her adaptation with its raphaelesque origin. Nevertheless, one major critic must have instinctively felt a Renaissance connection when he wrote: "...celui [de ses] portraits qui réunit universellement les suffrages, est le sien, tenant sa fille dans ses bras. La tendresse maternelle, ce sentiment délicat, cette douce affection de l'âme, est rendue avec un art si admirable, que ce Tableau peut être comparé à ce que les Grands Maîtres de l'Ecole de l'Italie, ont produit de plus sublime."[18]

At the Salon of 1787 Vigée Le Brun exhibited three likenesses of her daughter: the one included in the self-portrait just discussed; the portrait of the little girl holding a mirror (Fig. 4–10), a picture which elsewhere I have related to Ribera's allegory of sight;[19] and the delightful picture in which the child is portrayed resting her head on an open Bible (Fig. 4–11). These compositions were all variations on themes found in paintings by other artists. With respect to the last-mentioned portrait, Vigée Le Brun seems to have fallen under the spell of her contemporary, Greuze, among whose early compositions she must have known the *School Boy with a Lessonbook* of 1757, which had been engraved by Levasseur (Fig. 4–13). Even more relevant here, however, is Greuze's *Boy who has Fallen Asleep on his Book* (Fig. 4–12).[20] In Vigée Le Brun's youth, the owner of that painting had been the Duc de Choiseul-Praslin, and the artist states in her memoirs that the Praslin collection was one of those through which she was permitted to browse freely as a student.

In the summer of 1788, Vigée Le Brun and members of her family were invited to spend a month at Moulin-Joli, a country retreat built earlier in the century

on an island in the Seine by the tax-farmer, Claude Henri Watelet. Moulin-Joli had just been acquired by a wealthy merchant from Marseilles, a certain Monsieur Gaudran, Madame Le Brun's host. She was soon joined by her friend and fellow academician, the painter of ruins, Hubert Robert. Recalling her walks with Robert on the grounds of Moulin-Joli, she states that it was in this idyllic setting that she awoke to the enchantments of nature, and that it was there that she painted a picture which she herself acknowledged as one of her finest achievements, her half-length portrait of Hubert Robert (Fig. 4-14; see p. 94).[21] This painting demonstrates Vigée Le Brun's ability to powerfully characterize a sitter for whom she felt great empathy and whose lively personality both challenged and exhilarated her.

De tous les artistes que j'ai connus, Robert était le plus répandu dans le monde, que du reste il aimait beaucoup. Amateur de tous les plaisirs, sans an excepter celui de la table, il était recherché généralement, et je ne crois pas qu'il dînât chez lui trois fois dans l'année. Spectacles, bals, repas, concerts, parties de campagne, rien n'était refusé par lui, car tout le temps qu'il n'employait point au travail, il le passait à s'amuser.

Il avait de l'esprit naturel, beaucoup d'instruction, sans aucune pédanterie, et l'intarissable gaieté de son caractère le rendait l'homme le plus aimable qu'on put voir en société.[22]

In 1788 Hubert Robert was fifty-five years old. He was a short, stocky man; his face was fleshy, and he had already lost a good deal of hair. He had bushy eyebrows, a ruddy complexion, a thick neck, and a capacious belly. His hands were as plump and round as the rest of him; altogether he presented a stubby, ungainly figure. Uncompromisingly, Vigée Le Brun took all his physical features into account in her portrayal, but by an emphatic pose, dramatic lighting, the subtlest use of color, and absolute control of her brushwork, she infused them with a vitality and an emotional content that transcends and idealizes the most veristic details. This transmutation resulted in an image that borders on the heroic.

Robert is not depicted in his everyday surroundings. Here, there are no distracting details of furniture or costume. Moreover, Vigée Le Brun has elected to paint him simply attired, with none of the elegant velvets, laces, and powdered periwigs that are in evidence in much of her male portraiture of the prerevolutionary period. Over a yellow vest Hubert Robert wears a gray coat with a red velvet collar. A white scarf is tied rak-

ishly around his neck. Clutching a palette and paint-stained brushes in his right hand, he leans on a stone parapet, which adds an element of foreground and installs more distance between subject and viewer.

Did Vigée Le Brun invent from scratch, as it were, this dynamic composition, or did she derive it from some as yet undetected source or sources? My first contention with respect to the *Hubert Robert* is that she must have looked at one or more of Jean Honoré Fragonard's *Portraits de fantaisie,* which had been painted around 1770.[23] There is little documentary evidence to suggest that Vigée Le Brun had even a remote acquaintance with Fragonard, a painter some twenty-three years her senior.[24] Never once does she mention his name in her memoirs. And yet there was ample opportunity for their paths to cross in the Paris of the 1780s, where they were both immensely successful artists, enjoying the patronage of a wealthy, often aristocratic clientele. We know that the dealer Le Brun, Vigée Le Brun's husband, bought and sold numbers of Fragonard's works. Professional rivalry did not divide the two painters: Madme Le Brun was almost exclusively a portraitist, whereas portraiture was a genre that Fragonard cultivated only sporadically and in the most unorthodox manner. More importantly, she and Fragonard each had close ties with Hubert Robert. Fragonard had befriended the latter during their student days in Rome in the mid-1750s. After her marriage in 1776, Vigée Le Brun moved in the same social sphere as Robert, and they were both members of the Académie.

It should therefore come as no surprise that Vigée Le Brun should have sought inspiration in the work of Fragonard. A number of the master's aptly named Fantasy Portraits—specifically those of male figures—display features also found in Vigée Le Brun's *Hubert Robert.* They are seen close to the picture plane, in half-length, and a number of them lean on stone ledges. By their theatrical stance and purposeful facial expressions they celebrate the eighteenth-century cult of the sublime as expressed in writings of the *philosophes* or in some of the more bombastic poetry of the French Enlightenment. The subjects of many of Fragonard's Fantasy Portraits appear to be possessed by an inner force that compels them turn their heads, in obedience to the imperious command of their personal genius. Their hair is tousled, as if windswept; their eyes sparkle and cast a far-off look. One must consider these figures, and at the same time Vigée Le Brun's portrait of Hubert Robert, in terms of nascent Romanticism.

Nothing factual is known about the original location, or locations, of Fragonard's Fantasy Portraits, so we can only speculate as to how Madame Le Brun could have come into contact with them.[25] The most satisfac-

tory hypothesis is that she saw a number of them in the collection of the Abbé de Saint-Non, one of the most distinguished connoisseurs of his day, and himself the model for one of the paintings (Fig. 4–15). It has been convincingly argued that Fragonard painted a set of such portraits for Saint-Non, who was not only a close associate of Hubert Robert, but also an intimate of Watelet, the creator of the estate of Moulin-Joli where, it should be recalled, Vigée Le Brun states that she painted the portrait of Robert.[26]

Fragonard could boast that he had dashed off his Fantasy Figures in one short sitting.[27] By its very nature, there is something unreal, fleeting, and intemporal about such rapidly executed portraiture, if it can in truth even qualify as portraiture. The models are so many mummers dressed for a theatrical performance or a masquerade. In these pictures, there is a distinct disparity in mood with respect to Vigée Le Brun's *Hubert Robert* which, far removed from a fanciful or imaginary portrait, is a permanent monument to artistic genius, solidly anchored in reality. The difference is explicable uniquely in terms of style. This has lead me to conclude that Fragonard may not have been Vigée Le Brun's only source.

Another that comes readily to mind is Jean Antoine Houdon's electrifying portrait of Giuseppe Balsamo, the Sicilian adventurer who styled himself Count Cagliostro. The original bust was sculpted in Paris in 1786— two years before the *Robert* was executed—and Vigée Le Brun could have seen it in any one of several examples that were produced in Houdon's studio that same year. The finest extant version of the piece is the signed and dated marble in the Samuel H. Kress collection at the National Gallery (Fig. 4–16). Like Robert, Cagliostro was short, thickset, brawny, and balding. Houdon represented him casually attired but dramatically poised, with an intense gaze, a look of divine inspiration. In the portrait of Robert, the movement of the head is virtually identical to that of Cagliostro. It is thus my second contention that Houdon's bust of the famous charlatan provided yet an additional precedent for Vigée Le Brun's portrait of Hubert Robert.

In 1974, the Gemäldegalerie in Berlin acquired one of Madame Vigée Le Brun's most classicizing works, the portrait of an eleven-year-old Polish noble, Prince Henryk Lubomirski (Fig. 4–17). The picture, which first appeared in the artist's record book under the year 1788, was commissioned by the sitter's aunt and guardian, Princess Isabella Lubomirska. Residing in a suite of luxurious apartments at the Palais Royal, this lady was perhaps the wealthiest foreigner in the French capital during the final years of the *ancien régime*. When

the portrait was finished, the Princess was so pleased that she sent the artist 24,000 *livres*, a staggeringly large sum of money at the time for a contemporary work of art and the single highest payment Vigée Le Brun would ever receive.

The mythological motif was dictated by the boy's personal history; his beauty was such that he was nicknamed "Amour." In Rome two years earlier, the child had been coldly immortalized as Cupid in a marble statue by Antonio Canova. There he had also posed nude for a saccharin portrait of himself as the same deity in the studio of the Swiss artist, Angelika Kauffmann. In Vigée Le Brun's warm and very sensuous likeness of him, the hermaphroditic young prince is shown as the Genius of Fame, holding a wreath of laurel and naked save for a wisp of drapery covering his loins. On his back, he appears to have sprouted the silvery wings of a dove, which are treated by the artist with an ultra-scrupulous attention to detail, almost like elements in a still-life painting. These, together with the quiver of arrows lying at the youth's feet, designate Henryk Lubomirski as the god of love. The theme of pubescent boys in erotic guise was one dear to Greuze, who resorted to it on more than one occasion, notably in a *Cupid Holding a Wreath of Flowers* that was engraved by Henriquez (Fig. 4–18). Indeed, in Vigée Le Brun's portrait of Lubomirski, the influence of Greuze is manifest in the handling of the flesh tones and the curly hair, and there is a typically greuzian emphasis on the sweetly sentimental expression of the eyes and the full mouth.

However, as has been pointed out by Henning Bock,[28] behind this figure of a kneeling boy, with legs flexed and his weight bearing on his right foot, lies the formal structure of a Hellenistic sculpture, the so-called *Crouching Aphrodite* (Fig. 4–19), the lost original of which has been commonly attributed to a ficitious third-century B.C. sculptor, Doidalsas. The statue had been famous throughout the classical world and existed in eighteenth-century Europe in ancient and modern copies executed in all sizes and media. What was considered the prime example of the piece was then located in Rome at the Palazzo Medici (it is today part of the antique collections of the Uffizi). In France, Coysevox's free imitation of the *Crouching Aphrodite* was displayed for all to see in the gardens of Versailles and Marly. The figure was thus easily accessible to Vigée Le Brun in any number of forms.[29]

In her memoirs, Madame Le Brun says that soon after finishing the Lubomirski portrait, she gave her celebrated "Greek Supper" at which many of her guests were decked out in antique costumes.[30] One of the

props used was Prince Henryk's laurel wreath. Among those in attendance that evening was the young neoclassical sculptor, Antoine Denis Chaudet, a protégé of Madame Le Brun's longtime friend, the history painter Ménageot, who at the time was serving as Director of the French Academy in Rome. Chaudet had himself recently returned to Paris from a stay at the Palazzo Medici where he had undoubtedly seen and studied the *Aphrodite*. (Some thirteen years later, he would use an identical pose for his own statue of *Cupid*, now in the Louvre). It is possible that it was Chaudet who counselled Vigée Le Brun to adapt the pose of this ancient sculpted figure in her portrayal of Prince Lubomirski.

The Louvre houses the finest examples of Vigée Le Brun's mother-and-child imagery, the two self-portraits of the artist embracing her daughter previously discussed, and the *Portrait of Madame Rousseau and her Daughter* (Fig. 4–20), executed in 1789. We must deplore the fact that this last work is never on display in the museum's galleries, for it can be argued that it is the most beautifully painted and subtly evocative of the three. The subjects are the wife and daughter of Pierre Rousseau, an architect whose most famous accomplishments were the Hôtel de Salm in Paris (the present-day Palais de la Légion d'Honneur is a reconstruction of this famous townhouse) and the public theater at Amiens.[31] While it hung in the Salon Carré of the Louvre during the Académie's exhibition of 1789, the double portrait was extolled both for its consummate technique and for the delicacy of the emotions it expressed: "...toute la magie de l'art de Madame Le Brun se retrouve dans un tableau représentant l'amour maternel. L'expression en est douce, aimable et bien sentie, et il y règne une harmonie enchanteresse. On y remarque un coup d'ombre sur la figure, qui rappelle celui de Madame Le Brun dans son portrait peint par elle-même" (i.e. the self-portrait "au chapeau de paille," Fig. 4–3).[32]

Vigée Le Brun never surpassed in refinement the color harmonies of this panel. Madame Rousseau and her child stand out against a warm ochre background over which the artist has applied a bluish-gray scumble. The little girl is dressed in a dark blue short-sleeved frock, caught up around the chest with a sash and bordered at the neckline with a linen collerette. Madame Rousseau's apparel is one of Vigée Le Brun's more picturesque adaptations of an historic fashion.[33] Over a white linen chemise she wears a long-sleeved gown of deep crimson satin, gaping open on the upper arms and laced at the rear. The dress is complemented by a veridian green scarf draped over the shoulders and around the arms before it trails down the back, where it is tied into a loose knot. The top curls of the woman's long dark hair are bound, turban-like, into a gold-bordered muslin kerchief. Vigée Le Brun had seen this type of rustic

costume in Flemish and Italian paintings of the early seventeenth century. Suzanne Fourment is similarly attired in Rubens's portrait of her (Fig. 4–4), as is Orazio Gentileschi's model for the female *Lute Player* in the National Gallery, Washington, to cite only two noteworthy examples.

The motif of a child standing full-length on a narrow ledge beside its mother had found a quintessential expression in the young Titian's so-called "Gipsy Madonna" (Fig. 4–21).[34] However, that seminal work had been part of the Imperial collections in Vienna since at least the mid-seventeenth century, and Vigée Le Brun could have had no firsthand knowledge of it. But she could well have borrowed the poses from a contemporary improvisation on the theme, Joshua Reynolds's *Countess Spencer and her Daughter* (Spencer collection, Althorp), painted ca. 1760 and widely distributed in prints by James Watson, R. Purcell, and J. Paul. In the latter's mezzotint (Fig. 4–22), the mother and child are seen in reverse of the way they appear in Reynolds's original, but in the same direction as *Madame Rousseau and her Daughter*. Sentiments that are straightforward and rather prosaically treated in the Reynolds, become exquisitely poetic under the brush of Vigée Le Brun who, by 1789, was at the height of her powers. The young Madame Rousseau, her body in partial profile, looks over her shoulder appealingly at the spectator as she presses her little girl to her bosom. In this exquisite painting, Madame Le Brun succeeds in recapturing some of the mysterious charm of Titian's classic exemplar.

I would like to conclude this discussion where it began, with the discernible influence of Rubens on Vigée Le Brun. The Wallace Collection's panel portrait of *Madame Perregaux* (Fig. 4–23) dates from the first half of the year 1789. The fair-haired sitter was the wife of the artist's banker and neighbor, Jean Frédéric Perregaux who, under Bonaparte, was to become the first regent of the Banque de France. This splendidly theatrical image has all the excitement of the *Hubert Robert*. The sitter's costume is a fanciful recreation of seventeenth-century "Spanish" dress—a black velvet skirt and jacket with red silk épaulettes and piping, a sheer white undergarment with fluted ruff and cuffs edged with lace, and a large black béret adorned with a bouquet of billowy red plumes—which has much in common with the accoutrements worn by the female protagonists in Fragonard's series of Fantasy Figures.

The portrait is related to a rubensian prototype which Vigée Le Brun may have seen in Flanders earlier in the decade or known through one of numerous versions, the half-length portrait of the Infanta Isabella Clara Eugenia of Spain (Fig. 4–24).[35] In a heavy black

dress, the Infanta stands before a balustrade upon which she rests her hand. In her interpretation, Vigée Le Brun avoids the stiff, hieratic formality of the court portrait by making her pert little model appear as if she were in motion. Her head is turned towards the right and her large eyes look expectantly in the same direction. Her body leans forward and her right hand presses on the ledge, while with her left she draws aside a curtain. The dramatic content of the image, its instantaneity, allow the viewer to feel almost like a participant in some unfolding narrative.

Vigée Le Brun must have greatly prized the Perregaux portrait, for she attempted to secure its loan for the Salon of 1789.[36] If it was not shown that year, it was undoubtedly for political reasons. Madame Perregaux was the wife of a financier, and in France in the early years of the Revolution financiers were more unpopular and had a more negative press than even the nobility. Two years later, while Vigée Le Brun was living safely abroad in Italy, *Madame Perregaux* was sent to the Salon (n° 738 in the 1791 handbook where, thanks to her exotic costume, the lady could be deliberately misidentified as "une Dame Espagnole"). One friendly critic characterized the picture as "d'une grâce & d'une finesse de ton rares, qui marquent combien cette artiste sait varier son talent selon les différentes natures."[37]

Another painting in which Rubens's inspiration is absolutely unmistakable is Madame Le Brun's portrait of a French courtesan, Hyacinthe Gabrielle Roland (Fig. 4–25), which dates from the artist's Italian sojourn. The sitter was at the time the mistress of Richard Wellesley, Earl of Mornington, elder brother of the future Duke of Wellington. (Mademoiselle Roland, as she is called in Vigée Le Brun's memoirs, would eventually marry her lover and become Countess of Mornington.) She is shown in half-length, her body in profile and her head almost full-face. Her right arm is raised and in her hand she clutches a mass of her long chestnut brown hair which cascades over her left shoulder and falls below her waist. The source for the pose is Rubens's so-called *Het Pelsken*, the semi-nude portrait of his second wife, Hélène Fourment, partially draped in a fur-lined coat (Fig. 4–26). It is a matter of conjecture how, by 1791 and while still in Italy, Vigée Le Brun had come to be acquainted with a painting that had been in the Hapsburg collections in Vienna since at least 1730. She would not travel to Austria until 1792 and therefore could only have known the composition from a print (the picture was in fact etched during the first half of the eighteenth century by both F. van Stampart and A. J. Prenner) or from a painted copy in an Italian collection.[38]

* * * *

In the last half of the eighteenth century, the most outspoken proponent of the practice of Imitation was the theorist of the Grand Manner in portraiture, Sir Joshua Reynolds who, incidentally, was the only English artist for whom Vigée Le Brun ever evinced admiration.[39] In his Sixth Discourse, Reynolds expounded at length on the subject.

> A MIND enriched by an assemblage of all the treasures of ancient and modern art, will be more elevated and fruitful in resources in proportion to the number of ideas which have been carefully collected and thoroughly digested. There can be no doubt that he who has the most materials has the greatest means of invention; and if he has not yet the power of using them, it must proceed from a feebleness of intellect; or from the confused manner in which those collections have been laid up in his mind.

> THE addition of other men's judgment is so far from weakening our own, as is the opinion of many, that it will fashion and consolidate those ideas of excellence which lay in embryo, feeble, ill-shaped, and confused, but which are finished and put in order by the authority and practice of those, whose works may be said to have been consecrated by having stood the test of ages.[40]

Elswhere in this disquisition, Reynolds advised that Imitation should not be a procedure reserved for the training of students. He advocated instead that it should become a standard exercise for an artist throughout his or her career.[41]

> For my own part, I confess, I am not only very much disposed to maintain the absolute necessity of imitation in the first stages of the art; but am of opinion, that the study of other masters, which I here call imitation, may be extended throughout our whole lives, without any danger of the inconveniencies with which it is charged, of enfeebling the mind, or preventing us from giving that original air which every work undoubtedly ought always to have.

> I AM on the contrary persuaded, that by imitation only, variety, and even originality of invention, is produced. I will go further; even genius, at least what generally is so called, is the child of imitation.[42]

Vigée Le Brun could never have articulated her aesthetic convictions with the eloquence of a Joshua Reynolds, but the principle upheld in the Sixth Discourse is

one to which she wholeheartedly subscribed. If she instinctively adhered to it, it is because she felt that it was only by imitating what was accepted as great and enduring art, that she could raise portraiture to the dignity of history painting, the noblest of genres.

Joseph Baillio
New York City

Notes

* The present article is based on a lecture first delivered in June 1982 at the symposium on late eighteenth-century European portraiture which inaugurated the Kimbell Museum's Vigée Le Brun restrospective. Since that time it has undergone extensive revision and expansion.

1 A.-P. de Mirimonde, "Musiciens isolés et portraits de l'école française du XVIIIᵉ siècle dans les collections françaises," *Revue du Louvre*, No. 2, 1967, p. 83.

2 M. Miette de Villars, *Mémoires de David, peintre et député de la Convention*, Paris, 1850, pp. 87–88. On the genesis of this royal portrait, see J. Baillio, "Le Dossier d'une oeuvre d'actualité politique: *Marie-Antoinette et ses enfants* par Mme Vigée Le Brun," *L'Oeil*, No. 308, March 1981, pp. 34–41, 74–75 and No. 310, May 1981, pp. 53–60, 90–91.

3 By her own account, she was permitted to draw from the model in the studio of her father, the pastellist Louis Vigée, who died when she was only twelve. For a short period she studied in the little "académie féminine" organized by the mother of her childhood companion, Rosalie Bocquet. Later she took a few desultory drawing lessons in the studio at the Louvre of the history painter Gabriel Briard. The portrait and genre painter Davesne taught her to set up her palette. Finally, she listened avidly to the advice given her by the academic painters Gabriel François Doyen and Joseph Vernet.

4 E. L. Vigée Le Brun, *Souvenirs*, Paris, 1835–1837, I, p. 19.

5 "Mon beau-père s'étant retiré du commece, nous allâmes loger à l'hôtel Lubert, rue de Cléry. M. Lebrun venait d'acheter cette maison; il l'habitait, et dès que nous fûmes établis, j'allai voir les magnifiques tableaux de toutes les écoles, dont son appartement était rempli. J'étais enchantée d'un voisinage qui me mettait à même de consulter les chefs-d'oeuvre des maîtres. M. Lebrun me témoignait une extrême obligeance en me prêtant, pour les copier, des tableaux d'une beauté admirable et d'un grand prix. Je lui devais ainsi les plus fortes leçons que je pusse prendre, lorsque au bout de six mois il me demanda en mariage." (*Souvenirs, op. cit.*, pp. 47–48.)

6 *Souvenirs*, pp. 142–143.

7 J. Baillio, *Elisabeth Louise Vigée Le Brun*, Kimbell Museum of Art, Fort Worth, 1982.

8 *Ibid.*, p. 83. A year earlier, in 1781, Joshua Reynolds had visited the van Havre collection, but he was somewhat less effusive in his appraisal of the picture: "M. Van Haveren [*sic*] has an admirable portrait by Rubens, known by the name of Chapeau de Paile, from her having on her head a hat and a feather, airily put on; it has a wonderful transparency of colour, as if seen in the open air: it is upon the whole a very striking portrait; but her breasts are as ill drawn as they are finely coloured." ("Journey to Flanders and Holland, in the Year MCCCLXXXI," in *The Literary Work of Sir Joshua Reynolds*, ed. by H. W. Beechey, London, 1852, p. 187.) Vigée Le Brun lived to see Rubens's masterpiece sold in 1824 to Sir Robert Peel who, a year later, commissioned from Sir Thomas Lawrence another free and stylish imitation of the painting, the portrait of Lady Julia Peel which is today in the Frick Collection, New York.

9 The prime example of this painting is the signed and dated panel portrait the artist says she executed during her stay in Brussels and which today is unfortunately accessible to only a privileged few (Fig. 4–3). The attribution to Vigée Le Brun of the version on canvas in the National Gallery of Art in London has in the past been challenged by a number of writers, including myself. I had to change my opinion in 1987 when I saw the picture freshly cleaned, and I now consider it to be an autograph but undistinguished replica.

10 Critique of the Salon of 1783 in the *Journal Encyclopédique* (ms. copy of text in Paris, Bibliothèque Nationale, Cabinet des Estampes, *Collection Deloynes*, L, No. 1343, pp. 246–247).

11 See F. Souchal, "A Statue by L.-C. Vassé: The Nymph of Dampierre," *Apollo*, CVI, No. 189, November 1977, pp. 406–410.

12 *Souvenirs*, I, pp. 141–182.

13 L. Petit de Bachaumont and followers, "Seconde lettre sur les peintures, sculptures et gravures exposée au Salon du Louvre le 25 août 1785," *Mémoires secrets*, 1785, p. 162. Italics are mine.

14 *Lettre de M. de Vilette sur le Salon de 1785* (Paris, Bibliothèque Nationale, Cabinet des Estampes, *Collection Deloynes*, L, No. 1349, pp. 320–321).

15 S. de Beauvoir, *Le deuxième sexe*, Paris, Editions Gallimard, 1977, II, p. 70.

16 *Ibid.*

17 See exhibition catalogue: Paris, Galeries Nationales du Grand Palais, *Raphael et l'art français*, 1983–1984, p. 178 (entry by J.-P. Cuzin).

18 *L'Année Littéraire*, 1787, pp. 6–7.

19 J. Baillio, 1982, *op. cit.*, p. 74.

20 Edgar Wind, in his 1935 essay entitled "'Borrowed Attitudes' in Reynolds and Hogarth" (reprinted in E. Wild, *Hume and the Heroic Portrait: Studies in Eighteenth-Century Imagery*, ed. J. Anderson, Oxford, 1986, p. 73), points to a similar use of greuzian invention in the work of Joshua Reynolds.

21 Vigée Le Brun, *Souvenirs*, I, p. 152.

22 *Ibid.*, I, pp. 234–235.

23 For the best discussions of the origins and significance of these paintings, consult M. D. Sheriff, "Invention, Resemblance, and Fragonard's *Portraits de Fantaisie*," *Art Bulletin*, LXIX, No. 1, March 1987, pp. 77–87 and J.-P. Cuzin, *Jean-Honoré Fragonard, vie et oeuvre*, Fribourg, 1987, pp. 102–123.

24 To my knowledge, the only document associating the two is a petition drawn up in 1797 to allow Madame Le Brun to return to France from exile. Among the almost 170 signatories of this document—the names read like a roll-call of France's most celebrated artists, writers and scientists—was Fragonard.

25 See discussion by J. Vilain, in exhibition catalogue: *French Painting—the Revolutionary Decades, 1760–1830*, Sidney and Melbourne, Australia, 1980–1981, pp. 87–88.

26 Saint-Non engraved a series of views of Moulin-Joli. See L. Guimbaud, *Saint-Non et Fragonard*, Paris, 1928, p. 191.

27 The reverse of the canvas upon which Fragonard executed his portrait of the Abbé de Saint-Non (Fig. 4–16) bears an old paper label, the inscription of which reads: "Portrait de Mr l'abbé de St Non, peint par fragonard en 1769. en une heure de temps." Vigée Le Brun attempted to emulate Fragonard's *fa–presto* technique in her 1787 portrait of the actor Joseph Caillot, which she executed in a single sitting of three hours (*Souvenirs*, I, p. 136).

28 H. Bock, "Ein Bildnis von Prinz Heinrich Lubomirski als Genius des Ruhms von Elisabeth Vigée-Lebrun," *Niederdeutsche Beiträge zur Kunstgeschichte*, XVI, 1977, pp. 87–88.

29 On the metamorphoses of this antique statue in European art, see S. Holo, "A Note on the Afterlife of the *Crouching Aphrodite* in the Renaissance," *The J. Paul Getty Museum Journal*, No. 6/7, 1978–1979, pp. 23–25 and F. Haskell and N. Penny, *Taste and the Antique: The Lure of Classical Sculpture, 1500–1900*, New Haven and London, 1981, pp. 321–323.

30 *Souvenirs, op. cit.*, I, pp. 97–102.

31 Pierre Rousseau, a native of Nantes, was a pupil of the architect N.-M. Potain, whose daughter he married. In 1785, Louis XVI made him Inspector of the Royal Buildings at Fontainebleau. The following year he designed the Hôtel de Salm-Kibourg, and in 1791 the church of Saint-Germain-en-Laye. His portrait by François André Vincent (1777) is in the Musée de Sandelin, Saint-Omer.

32 *Mercure de France* (ms. copy of text in *Collection Deloynes, op. cit.*, XVI, No. 423, p. 381.)

33 "Comme j'avais horreur du costume que les femmes portaient alors, je faisais tous mes ef-

forts pour le rendre un peu plus pittoresque, et j'étais ravie, quand j'obtenais la confiance de mes modèles, de pouvoir draper à ma fantaisie. On ne portait point encore de schals; mais je disposais de larges écharpes, légèrement entrelacées autour du corps et sur les bras, avec lesquelles je tâchais d'imiter le beau style des draperies de Raphaël et du Dominicain...." (*Souvenirs*, I, pp. 52–53.)

34 I am sincerely grateful to Robert Rosenblum for pointing out the relationship between Titian's *Gipsy Madonna* and Vigée Le Brun's *Madame Rousseau and her Daughter*.

35 See H. Vlieghe, *Rubens Portraits of Identified Sitters Painted in Antwerp (Corpus Rubenianum Ludwig Burchad*, XIX), New York, 1987, pp. 41–43, no. 65. In the case of the Perregaux portrait, a secondary and more contemporary source of inspiration for Mme Le Brun may have been Greuze's *Une jeune fille qui envoie un baiser par la fenêtre* (Salon of 1769), now in a private collection, Switzerland.

36 Her letter to Madame Perregaux requesting the loan is quoted in-extenso in J. Baillio, 1982, *op. cit.*, p. 134.

37 [J. B. P. Le Brun], *Sallon de peinture*, 1791, p. 10.

38 H. Vlieghe, *Rubens Portraits...*, *op. cit.*, pp. 91–93, no. 97.

39 *Souvenirs*, III, pp. 165–166.

40 Sir Joshua Reynolds, *Discourses on Art* (ed. R. R. Wark), New Haven and London, 1981, pp. 99–100.

41 On Reynolds's own borrowings from the works of other artists, see J. Newman, "Reynolds and Hone—'The Conjuror' Unmasked," in exhibition catalogue: London, Royal Academy of Arts, *Reynolds*, 1986, pp. 344–354.

42 Reynolds, *Discourses...*, *op. cit.*, p. 96.

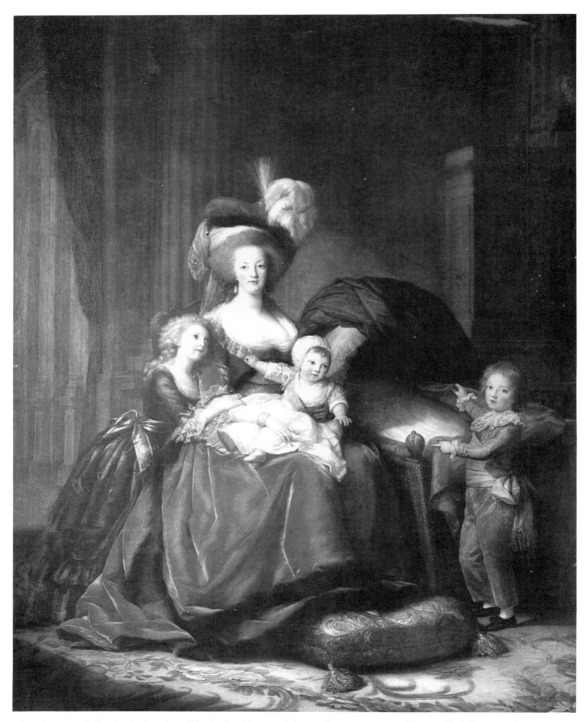

Fig. 4–1 Elisabeth Louise Vigée Le Brun. *Marie Antoinette and Her Children*, 1787. Musée National du Château de Versailles.

Fig. 4–2 Jean Baptistie Pierre Le Brun. *Self-Portrait*, 1796. Private Collection, New York.

Fig. 4–3 Elisabeth Louise Vigée Le Brun. *Self-Portrait*, 1782. Private collection, Switzerland.

Fig. 4–4 Peter Paul Rubens. *Suzanne Fourment*, 1620–1625. National Gallery, London.

Fig. 4–5 Elisabeth Louise Vigée Le Brun. *Bacchante,* 1785. Musée Camondo, Paris.

Fig. 4–6 Louis Claude Vassé. *The Nymph of Dampierre* (detail), ca. 1763. The Metropolitan Museum of Art, New York.

Fig. 4–9 Elisabeth Louise Vigée Le Brun. *The Artist with her Daughter*, 1789. Musée du Louvre, Paris.

Fig. 4–8 Raphael. *Madonna della sedia*, ca. 1515. Palazzo Pitti, Florence.

Fig. 4–7 Elisabeth Louise Vigée Le Brun. *The Artist with her Daughter*, 1786.
Musée du Louvre, Paris.

Fig. 4–10 Elisabeth Louise Vigée Le Brun. *Julie Le Brun Holding a Mirror*, 1787. Private collection, New York.

Fig. 4–11 Elisabeth Louise Vigée Le Brun. *Julie Le Brun Resting Her Head on an Open Bible*, 1787. Private collection.

LA JEUNESSE STUDIEUSE.

Fig. 4–13 C. Le Vasseur after Jean Baptiste Greuze. *La Jeunesse studieuse*, 1757.

Fig. 4–12 Jean Baptiste Greuze. *Boy who has Fallen Asleep on his Book*, c. 1755. Musée Fabre, Montpellier.

Fig. 4–14 Elisabeth Louise Vigée Le Brun. *Hubert Robert*, 1788. Musée du Louvre, Paris. (See also colorplate on p. 94.)

Fig. 4–15 Jean Honoré Fragonard. *The Abbé de Saint-Non*, 1769. Musée du Louvre, Paris.

Fig. 4–16 Jean Antoine Houdon. *Giuseppe Balsamo, "Count Cagliostro,"* 1786. National Gallery of Art, Washington.

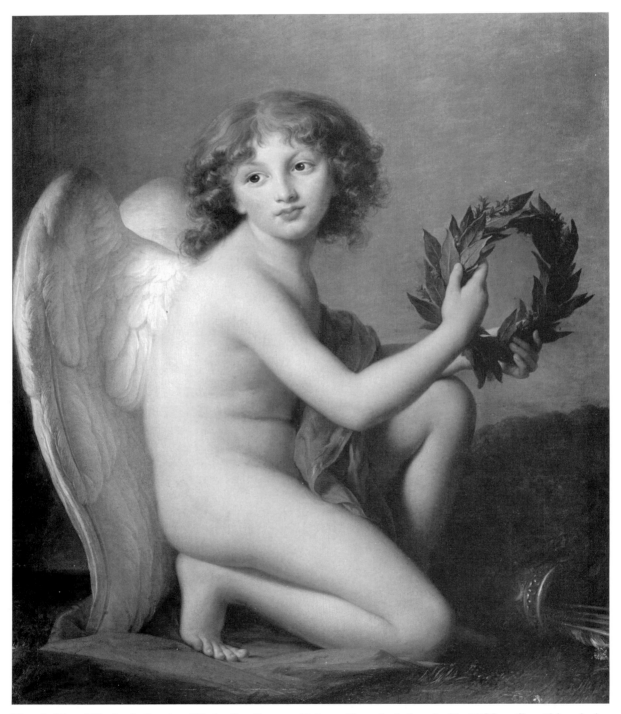

Fig. 4–17 Elisabeth Louise Vigée Le Brun. *Prince Henryk Lubomirski*, 1788. Gemäldegalerie, Berlin.

L'Amour
Au Beau

Dedié
Sexe

Fig. 4–18 B. L. Henriquez after Jean Baptiste Greuze. *L'Amour.*

Fig. 4–19 Roman copy. *Crouching Aphrodite.* The Metropolitan Museum of Art, New York.

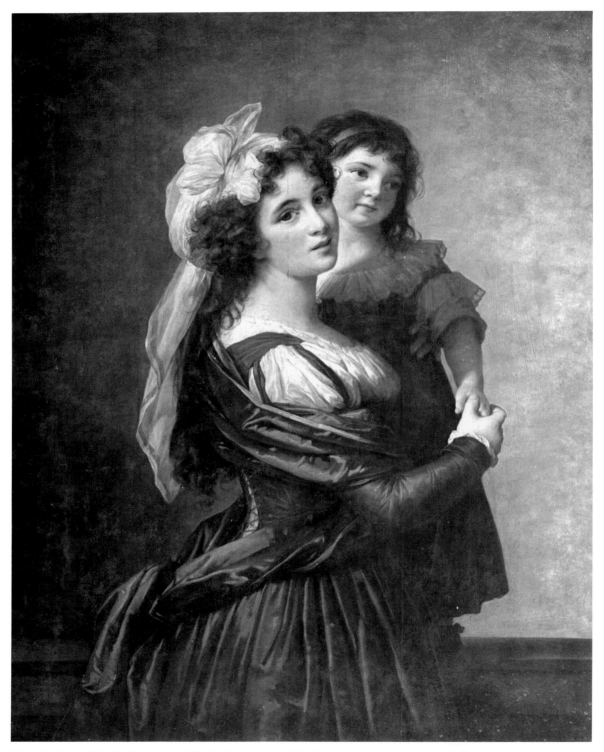

Fig. 4–20 Elisabeth Louise Vigée Le Brun. *Madame Pierre Rousseau and her Daughter*, 1789. Musée du Louvre, Paris.

Fig. 4–21 Titian. *Madonna and Child* ("*La Zingarella*" or "*Gipsy Madonna*"), ca. 1508–1511. Kunsthistorisches Musem, Vienna.

Fig. 4–22 J. Paul after Joshua Reynolds. *Countess Spencer and her Daughter*, ca. 1760.

Fig. 4–23 Elisabeth Louise Vigée Le Brun. *Madame Perregaux*, 1789. Wallace Collection, London.

Fig. 4–24 Attributed to Peter Paul Rubens. *Infanta Isabella of Spain*, ca. 1615. Musées Royaux, Brussels.

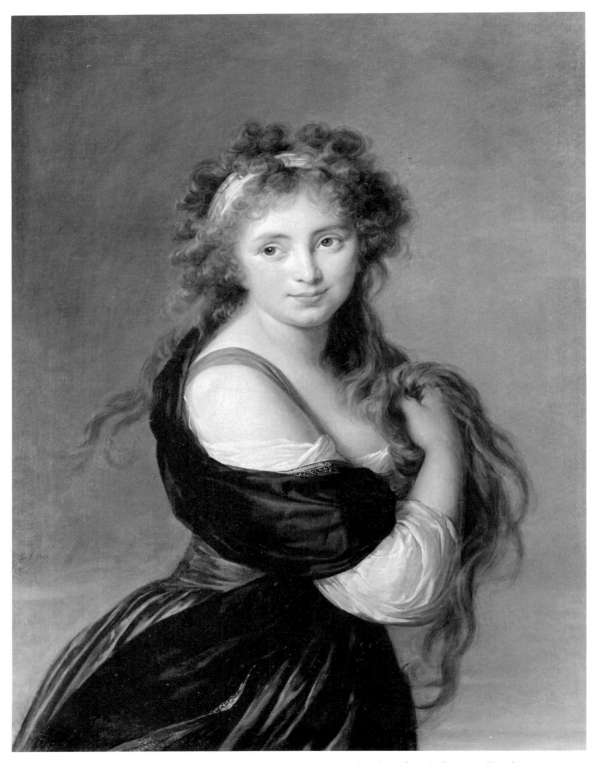

Fig. 4–25 Elisabeth Louise Vigée Le Brun. *Hyacinthe Roland*, 1791. Private collection.

Fig. 4–26 Peter Paul Rubens. *Hélène Fourment in a Fur Coat* (*"Het Pelsken,"* detail), 1635–1640. Kunsthistorisches Museum, Vienna.

CONVERSATIONS.

Fig. 5–1 Sébastien Le Clerc, View of Galerie des Glaces, Versailles. Engraving from M. de Scudéry, *Conversations nouvelles sur divers sujets, dédiées au Roy*, Paris, 1684. Photo: Bibliothèque Nationale, Paris.

Tourists During the Reign of the Sun King: Access to the Louvre and Versailles and the Anatomy of Guidebooks and Other Printed Aids

<div style="text-align: right;">

5

</div>

To James Ackerman on his 70th birthday

Art historians usually study guidebooks to gain information about works of art: their existence by a certain date, the names of their creators and patrons, and descriptions or interpretations that may aid in the task of art-historical analysis. But the study of guidebooks can also help to inform us about the audience of a work of art—what that audience could know about the art, and how people during a particular historical period were instructed or expected to think about what they were looking at (something we may call "viewer psychology"). For an exploration of these matters I have chosen the era of Louis XIV and the Sun King's palaces in Paris and Versailles. My findings and conclusions should not be regarded as "definitive," but rather as the results of a preliminary foray into largely unexplored territory.

Louis XIV's most important châteaux—the Louvre and Tuileries in Paris and the palace of Versailles—were residences for the King and the royal family as well as centers for court and governmental activities. On occasion the buildings served for the receptions of heads of state, foreign ambassadors, and other dignitaries. But it is important to realize that the wider public of Louis XIV's time also could gain access to the interiors of these buildings and their gardens. For an important purpose of the royal residences was to impress Frenchman and foreigner alike with the political glory, material splendor, and artistic taste of the monarch, who symbolized the French nation itself. The poet Jean de La Fontaine justified Louis XIV's building mania and pointed out its importance for the national psychology in the following passage published in 1669:

...Jupiter alone can constantly apply himself to the running of the universe; men need some relaxation. Alexander engaged in debauchery, Augustus played games, Scipio and Laelius of-

ten amused themselves by throwing flat stones on water; our monarch diverts himself by building palaces: this is worthy of a king. There is even a general usefulness, because, by this means, the citizens can share in the prince's pleasures and gaze with admiration upon that which isn't made for them. So many beautiful gardens and sumptuous buildings are the glory of their land. And what won't the foreigners say! What won't posterity say when it shall see these masterpieces of all the arts![1]

Under what conditions could the public gain access to the Louvre, the Tuileries, and Versailles? Let us turn to the Parisian buildings first. In the time of Louis XIV, the Louvre was linked by the still-extant Galerie du Bord de l'Eau to the Tuileries Palace to the west, thus forming one interconnected complex. All of the exterior façades of the Louvre, Tuileries, and Galerie were, of course, an important Parisian spectacle, visually accessible to all. But the public could also penetrate into the Square Court of the Louvre. Here could be seen the sixteenth-century Renaissance façades of Lescot and their later continuation (and modification) around all four sides of the court. On certain days the public would be barred from the Square Court, for example at the times of an ambassadorial reception or a court festivity. But such events were exceptional; on most days the masses could freely enter the courtyard as well as certain of the palatial interiors, even when the King was in residence. The parts of the interior that could be visited regularly are indicated by the guidebooks themselves (about which more anon) and by the accounts of travellers. The general itinerary was as follows:

After viewing the Square Court, the visitor entered the still-extant Salle des Cariatides on the ground floor of Lescot's original wing, with its famous portico by

Goujon. In the seventeenth century this hall was called the Salle des Cent Suisses, indicating that it held a contingent of royal guards, but it also housed certain Antique sculptures of the royal collection, a function that has been continued in the organization of the Louvre Museum. At the south end of this Salle, the visitor passed through the so-called "Tribunal" into the Summer Apartment of the Queen Mother, Anne of Austria, vacant since her death in 1666. These rooms occupied the ground floor of the south side of the Square Court and the ground floor of the Petite Galerie. Today, several ceilings remain covering galleries devoted to Greek and Roman antiquities. A room off the Petite Galerie, open to visitors, was the Salle des Antiques, with additional ancient objects (the present Salle d'Auguste). After viewing these rooms (which must have been attended by a sprinkling of soldiers, forerunners of the museum guards of today), the tourist ascended to the *premier étage*, probably by means of the small spiral stair at the north end of the Petite Galerie, opening off the Rotonde de Mars. This led to the most dazzling room in the entire château, the Galerie d'Apollon, with painted and sculptured decorations designed by Le Brun (executed between 1663 and 1677). Next came the cabinet of the King's pictures, where hung choice masterpieces from the royal collection.[2] The visitor was then free to walk westward down the Grande Galerie (the present Grande Galerie de Peinture), its vault decorated between 1668 and 1678 by the Boullogne (*père et fils*), with designs based on Poussin's and their own invention (non-extant). This led to the Tuileries Palace (destroyed in the nineteenth century save for its two end pavilions), where the major features open to tourists were the main staircase, the Galerie des Ambassadeurs (Galerie des Audiences), the apartments of the King, Queen, and Dauphin, the chapel, and the theatre (the Salle des Machines).

Other parts of the Louvre regularly open to visitors were the hall of the Académie Française, a room with models of staircases for the Louvre, the Imprimerie Royale (located on the ground floor of the Galerie du Bord de l'Eau), and, especially, the studios of royal artists, housed in the same location and in other rooms around the Square Court. One gains the impression that these artists welcomed visitors, even while at work, and the guidebooks particularly recommended a visit to the sculptor Girardon's gallery, where could be seen an Egyptian mummy.

The King's and Queen's apartments in the Louvre were located on the *premier étage* of the south-west corner of the Square Court, reached by the Escalier Henri II. (These rooms are now occupied by Greek, Etruscan, Roman, and Egyptian objects). The Parisian guidebooks do not describe these apartments, suggesting that they were off-limits to tourists. On the other hand, the English philosopher John Locke reported visiting them in 1677.[3] Perhaps the royal apartments were only rarely open for viewing (although by 1677 the King was seldom in residence at the Louvre).

Stretching westwards from the Tuileries Palace along the Seine was (and still is) the garden of the Tuileries. Begun in 1563 under Catherine de' Medici, the garden was open to the public from its inception, even though it was a royal park. By permitting public access to the Jardin des Tuileries—the first green space of any consequence within the French capital—Catherine de' Medici apparently transferred to her adopted country the *lex hortorum* of Latium, whereby the gardens of villas, beginning in the later fifteenth century, were opened to all, with inscriptions proclaiming the hospitality of the owner sometimes set into special public entrances.[4] At the Tuileries, free access by the public was briefly threatened about 1680 when Colbert—Louis XIV's Superintendent of the King's Buildings—considered closing the garden. The situation was saved by Charles Perrault, at the time Colbert's chief clerk, who has vividly recounted the incident in his memoirs. Perrault's arguments suggest an enlightened understanding of the importance of green recreational space within an urban fabric:

> When the garden of the Tuileries was finished in its replanting and put in the condition that you see [a reference to Le Nôtre's recent remodelling, 1664–1679/80],[5] Colbert said to me 'Let us go to the Tuileries and block up the gates. We must conserve this garden for the King and not let it be ruined by the people, who, in no time at all, will have ruined it entirely.' The decision seemed to me very severe and very unfortunate for all of Paris. When he was in the *grande allée*, I said to him: 'You would not believe, Monsieur, the respect that everyone, even the most *petit bourgeois*, has for this garden. Not only do the women and little children never think of plucking any flower, but they even do not touch them; they stroll here as if they were all very proper people. The gardeners, Monsieur, can testify to that. This will be a public vexation to not be able any more to come here to walk, particularly now when one no longer can enter at the Luxembourg or the Hôtel de Guise. —'Only loiterers come here,' he said to me.—'There come here, I replied to him, persons who are recovering from illness, to take the air; people come here to talk of business, of marriages, and

of everything that is more conveniently dealt with in a garden than in a church, when it will be necessary to make a future rendez-vous. I am convinced, I continued, that the gardens of kings are so large and spacious only so that all their children can promenade there.' He smiled at this discourse, and since at the same moment most of the gardeners of the Tuileries were assembled before him, he asked them if the people didn't do a lot of damage in their garden. 'None at all, Monseigneur, they replied almost all at the same time; they are happy to stroll about and look around.' —'These gentlemen, I replied, even find this to their advantage, because the grass does not grow back so easily in the *allées*.' Monsieur made a tour of the garden, gave his orders and didn't speak at all about closing the entrance to anyone. I had a lot of joy in having in some way prevented the closing of that promenade to the public. If M. Colbert had once had the Tuileries closed, I don't know when they would have re-opened it. This action would have been praised by the entire court, which never fails to applaud ministers, especially when there appears to be some zeal for the prince's pleasure.[6]

After a visit to Paris, the tourist of Louis XIV's time (like those of today) inevitably set out to see the wonders of Versailles. By the end of the Sun King's reign (he died in 1715), travel to Versailles had become a flourishing service industry. For 5 *sols* one could take a public coach that left twice a day from the rue Saint-Nicaise at the Louvre and which took about two hours to reach Versailles.[7] Horses and post chaises were also available. For only 4 *sols* one could board a barge at 8 o'clock in the morning at the Pont Royal; this went as far as Sèvres and then one continued on by land. Other small boats were ready all day long on the Seine for the same price.[8]

Versailles was even more open to the public in some respects than the Louvre and Tuileries. Turning first to the gardens, they seem to have been freely accessible from the 1660s on, when Le Nôtre began his remodelling and expansion of the old park of Louis XIII. During the earlier years of the reign of the Sun King, the public could promenade even while the King was in the garden, as attested by John Locke, then tutor to the son of a London merchant, whom he accompanied in 1677:

We had the honour to see them (the waterworks) with the King, who walked about with Madam Montespan from one to another, after

haveing driven her & 2 other Ladys in the coach with him about a good part of the garden in a coach & 6 horses.[9]

And:

The king seemed to be mightily well pleased with his water works and severall changes were made then to which he himself gave sign with his cane....[10]

By 1685 the number of visitors must have been considerable, for the Marquis de Dangeau wrote in his journal for that year as follows:

The King, no longer able to stroll in his gardens without being crushed by the multitude of people who come from all directions and especially from Paris, ordered the guards to only grant entrance to the people of the court and those whom they bring with them; the riffraff [*la canaille*] who promenade there have much ruined the statues and vases.[11]

I doubt whether this suspension of the *lex hortorum Ludovici* was long in effect. Of course, visitors of distinction continued to tour the park, as did the Swedish architect Nicodemus Tessin the Younger in 1687 (he was personally escorted by Le Nôtre)[12] and the English M. P., Major Richard Ferrier (also in 1687).[13] By 1699 the King again was moved to take measures against vandalism in the gardens, for on 11 February he ordered Hardouin-Mansart to "Put in place [*établir*] a vigorous, vigilant, and faithful man [*un homme vigoureux, vigilant et fidèle*] to allow no one into the *bosquets* of Versailles, who shall take care that nothing is spoiled or broken, and who shall make a report every day."[14] In 1704, however, Dangeau noted that "The King ... has ordered that all the grilles enclosing all the *bosquets* be removed, and wishes that all the gardens and all the fountains be for the public,"[15] and that the King "... is having many new *allées* in his *bosquets* opened, which will very much embellish the garden which he is abandoning to the public; there will be nothing more shut up except the Labyrinth."[16] Furthermore, a guidebook first published in 1718 and again in 1727, but reporting conditions at the end of the Sun King's reign, stated that "The park of Versailles is open day and night, and everyone has the right to enter it for enjoyment, without distinction of age, sex, or station [*condition*],"[17] but that "When the King was in the park, no one except the people of his suite had the right to enter, and the Swiss guards warned the other people present that they had to leave"[18]—a stricture that contrasted with the earlier part of his reign, as we have seen.

It should be noted that the Grand Parc was enclosed by a wall that still exists in part, punctuated by a few entrances undoubtedly manned by guards.[19] But main, direct access was from the town via the Cent Marches flanking the Orangerie parterre or via the extant Porte du Dragon, leading to the Neptune Basin.[20]

Most tourists arriving at Versailles made directly for the château, as they still do. The King and court were regularly absent from September to November, when residence was established at Fontainebleau, where there was excellent hunting in the Fall. During those months the interiors of Versailles could be extensively toured. But even when His Majesty was living in the palace, the more public rooms could frequently be traversed. These included the Grands Appartements,[21] the Galerie des Glaces and its salons, and the chapel. The Escalier des Ambassadeurs (destroyed) could only be glimpsed from its vestibule off the Cour Royale, for it was generally used only for official receptions.[22] I am not certain how tourists reached the *premier étage*; perhaps the Esclaier de la Reine or the Petit Escalier du Roi were used. But on the *rez-de-chaussée*, the Galerie Basse (recently restored) and the Appartement des Bains (non-extant) were the main attractions.

The German traveler Nemeitz, who was in France in 1713 and 1714[23] —that is, at the very end of the Sun King's reign—reported that the Galerie des Glaces was filled daily with cavaliers, courtiers, and foreigners "because it was the route followed by the King to and from Mass."[24] Nemeitz also wrote—and this is surprising—that visitors could sometimes view the Lever and Coucher du Roi and dine at the King's table if there was room![25] Yet much earlier—in 1687—the English M.P. Major Richard Ferrier reported being able to view the King, his brother, and the Dauphin at dinner. Ferrier noted in his journal: "The dinner y^e King had was but ordinary, there being a dish of soupe, some chickens & a quarter of lamb, of all which he made no scruple to eat though on a Friday."[26] The Major continued:

Before our entrance into y^e Chamber we had a caution given us by one of y^e company to take care of our pocketts, though y^e same person, before he stir'd out of y^e Chamber, had six or seven guineas & a louis do'r [*sic*] taken out of his.[27]

These, then, were the approximate conditions of public access to the royal residences in Paris and Versailles during the reign of *le roi-soleil*. We should imagine a public composed of Frenchmen and foreigners, and a social scale ranging from the *petite bourgeoisie* to the aristocracy. The peasantry never had the means or leisure to leave their lands to gawk at these palatial wonders. As for the urban proletariat of Paris, their visits to the Louvre and the Tuileries are a question mark. Of course, no representatives of peasantry or proletariat—basically illiterate classes—have left written accounts of their visits, as have members of the higher social strata.

Artistic knowledge and perception varied greatly among classes and individuals, then as now. There are recorded instances of errors in iconographic identification by people of the period. For example, in 1679 the Baron de Vuoerdan (a military man) thought that the Fountain of Apollo at Versailles depicted Pluto and that the Latona Fountain (Fig. 5–17) there portrayed "the fable of Niobe" (even though he correctly noted that peasants were being turned into frogs).[28] In order to orient the traveler and correctly inform him about the objects he was looking at, guidebooks were written, and it is to these that we now turn.

It is important to distinguish a guidebook from a historical account. The latter unfolds chronologically, and is meant to be read in the study—hence its frequently oversized or thick format. A guidebook, by contrast, is arranged topographically to accompany an actual itinerary in the field, and is meant to be carried easily in the hand or pocket. So-called "guidebooks" to Paris of the sixteenth and early seventeenth centuries—such as the books by Corrozet, Du Breul, and du Chesne[29]—are really histories of Paris with some attention paid to prominent architectural landmarks. Physically, these volumes (in some editions) are too thick to be easily portable. The first Parisian guidebook in the modern sense is by Germain Brice, first published in two volumes in 1684 with the title *Description nouvelle de ce qu'il y a de plus remarquable dans la ville de Paris*. In his prefatory "Avertissement," Brice noted that foreigners in particular had complained about the lack of a suitable "description" which could instruct them about the French capital. Brice had clearly recognized a real need, and his guidebook went through nine editions, the last being of 1752; the first six editions (1684–1713) were published during the reign of Louis XIV.[30] The only competition during this period was furnished by C. Le Maire's *Paris ancien et nouveau* (1685, 3 vols.), published one year after Brice's first edition and reprinted in 1698.[31] But the organization of Le Maire's text was *retardataire* in that it grouped monuments typologically (churches, schools, hospitals, etc.) rather than topographically, like Brice's and later guides. Both Brice and Le Maire provided accounts, of course, of the Louvre and Tuileries.

Who were these writers? Nothing is known about Le Maire. Brice, however, is a tangible figure. He was

born about 1653 and lived in Paris as a *cicérone* to foreigners, including some German princes; he also privately taught history, geography, heraldry, and French for foreigners. In order to heighten his aura of erudition, he dressed as an ecclesiastic, although he never took orders; hence he is sometimes referred to as "l'abbé Brice." He became economically well-off as a result of his teaching and publications, and died in Paris in 1727. He is said to have visited Italy.

Now both Brice and Le Maire undertook their publishing ventures in the spirit of private initiative, like earlier writers on Paris. Neither Brice, Le Maire, nor any of the previous authors going back to Corrozet in the sixteenth century was in a privileged position to gain special information about works of art, particularly those sponsored by the Crown. They informed themselves as best they could, and Brice, at least, probably held conversations with artists. For example, in the second edition of his guide (1687, reprinted 1694), Brice, in discussing Le Brun's Galerie d'Apollon in the Louvre, revealed that the unexecuted central painting was to depict "the sun pulled in his chariot, with all the attributes appropriate to him and which the poets ordinarily give him."[32] Brice may have obtained this information from Le Brun directly or from one of the artist's assistants, and its accuracy is confirmed by Nivelon, Le Brun's biographer.[33]

When we turn to the guidebooks to Versailles and their writers, we encounter a dramatically different situation.[34] First of all, the books are numerous and varied when compared with the Parisian ones. Between 1672 and 1703 there appeared four comprehensive guides to the château and gardens and four publications specially devoted to individual features, namely, the Grotto of Tethys, the Labyrinth, and the Galerie des Glaces (two books on the latter). Many of these books were reprinted or issued in revised editions during the era of Louis XIV.[35] Second, most of the writers had official, privileged positions within the royal art establishment: André Félibien was a distinguished writer on art, the official historiographer of the King's buildings (since 1666), and secretary (since 1671) of the Royal Academy of Architecture.[36] Charles Perrault, when his book on the Labyrinth appeared in 1677, was the first clerk to Colbert in the Royal Building Administration and a member (and secretary) of the Petite Académie, a small group of intellectuals concerned with medals, panegyrical writings, and royal iconography. François Charpentier was another member of the Petite Académie, as was Pierre Rainssant, who was also the Royal Keeper of Medals. In addition, the Abbé Laurent Morellet's comprehensive guidebook of 1681—although written at the request of two unidentified court ladies[37]—was read and

approved for publication by four artists active at Versailles: the painters Noël Coypel and Antoine Paillette (Paillet) and the sculptors Thomas Regnaudin and Antoine Coysevox. There is an explicit statement to this effect printed in the book.[38] Of the later guidebook writers, Jean François Félibien, the son of André, succeeded to his father's post of historiographer of the King's buildings in 1695, upon the death of André; the younger Félibien's guidebook of 1703 bears an "approbation" by the Abbé Paul Tallement, a member of the Académie royale des Inscriptions et Médailles (the new name, since 1701, of the Petite Académie).[39] Only Piganiol de La Force was not associated with royal artistic circles, but was an independent and highly-respected topographical writer.[40]

This array of authors as well as the instance of a printed approval by artists strongly suggest that, unlike the Parisian guidebooks, most of those on Versailles were semi-official publications, some directly commissioned by the Crown. This situation reflects the King's passionate involvement with Versailles and his neglect of the Louvre and Tuileries from the decade of the 1670s on. Perrault's guide to the Labyrinth (1677, reprinted 1679) was published by the Imprimerie Royale, as were the later illustrated editions of 1676 and 1679 of André Félibien's guide to the Grotto. Furthermore, the two guides to the paintings of the Galerie des Glaces (Charpentier's of 1684, Rainssant's of 1687) were written "Par ordre exprés de sa Majesté," as stated on their title pages. Most interesting is a notice in the *Mercure galant* in 1685 that copies of Charpentier's book had been ordered by the King to be placed in the Galerie itself for consultation.[41] There is also a piece of evidence that suggests that guidebooks were reviewed and edited before publication by the Petite Académie: In a letter to Colbert of 1668, Chapelain, the director of the Académie, wrote that André Félibien's "relation de la feste de Versailles" had been revised by order of Colbert by the Petite Académie.[42] This must be a reference to Félibien's *Relation de la feste de Versailles du 18 juillet 1668* (1st edition Paris, 1668). Strictly speaking, this was a festival book rather than a guidebook, but containing descriptions of the permanent garden decorations as well as the ephemeral ones devised for the *fête*, which celebrated the Treaty of Aix-la-Chapelle.

Before we examine certain aspects of the guidebooks, another source of information, particularly about Versailles, must be mentioned, namely, the *Mercure galant*. Founded privately in 1672 as a literary magazine by the writer Jean Donneau de Visé, it became an extremely successful monthly catering to a mainly female audience.[43] It regularly carried notices about the visual arts, and between 1680 and 1687 it was filled

with long articles describing Paris and, especially, Versailles.[44] These dispatches were mainly intended to inform people in Paris, the provinces, and abroad about the latest artistic triumphs of the Paris and Versailles of Louis XIV, but since the accounts were written topographically, in guidebook fashion, and published in a format that was conveniently portable, it is entirely possible that tourists of the period occasionally used the *Mercure* on their promenades.

The descriptions in the *Mercure* of the Louvre, Tuileries (and other Parisian monuments) as well as Versailles are rarely dependent on the guidebooks (some of the long Parisian accounts in the *Mercure* were published before Brice's first edition of 1684, in any case).[45] Furthermore, they are frequently much more detailed than the guidebooks, and display considerable knowledge. Who were the writers? Only one of these long articles is signed—the one on the paintings of the Galerie des Glaces published in the December 1684 issue. But that writer, who identified himself as the painter "Lorne," is totally unknown. The *Mercure* was edited until 1682 by Donneau de Visé and from that date on he collaborated with Thomas Corneille, a dramatist like Donneau.[46] They may have been the writers, but in that case they must have been supplied detailed information by anonymous, outside "authorities," who frequently had considerable (and accurate) iconographic and architectural knowledge.[47] In a talk delivered at the Colloque Versailles (1985), Thomas Hedin has suggested that the sculptor Etienne Le Hongre supplied the *Mercure* its information on sculpture, and that the long descriptions of the Orangerie and the Colonnade at Versailles in the November 1686 issue must have been based on accounts supplied by the architect, Jules Hardouin-Mansart, or by one of his assistants.[48]

I should now like to turn to the "anatomy" of the guidebooks and the *Mercure galant*. What could readers glean from these publications about the Louvre, the Tuileries, and Versailles? In general it can be said that the writers are mainly concerned with basic factual information (the name of a work of art and the artist), simple description (which might include measurements and an enumeration of materials), and—especially in the case of Versailles—iconography. Stylistic and aesthetic observations of any consequence are relatively rare; indeed, some of the writings have virtually nothing to say about such matters. This is true of the guidebooks on the Galerie des Glaces by Charpentier and Rainssant, as well as the unknown painter Lorne's long article in the *Mercure galant* (1684) on the same decorations. All are exclusively concerned with subject-matter and its explication. At the end of his text, however, Rainssant excuses this imbalance by stating: "The order that we have received, in explaining [the paintings], to

confine ourselves to a simple exposition of subject and arrangement [*ordonnance*], have not allowed us to expatiate on the gracefulness of the coloring, nor on the nobility of the expressions, nor on the power and grandeur of the design."[49] Such concerns, however, rarely manifest themselves in these publications, where the hackneyed use of adjectives such as "beau" and "magnifique" suggest an underdeveloped aesthetic vocabulary. Yet most of the authors concerned with Versailles, at least, occasionally offer a few telling aesthetic observations. Here are a few:

André Félibien (1674) on the Allée d'Eau (Figs. 5-2, 5-3): "One of the great beauties of this Allée is that being at the bottom near the Dragon Fountain and looking up, one sees all these groups of children forming a pleasant perspective whose *point de veuë* ends in that great waterfall which is at the end [the Bain de Diane] and which has still above it the Fountain of the Pyramid, whose waters form wonderful effects. And likewise when one is at the foot of the Pyramid, one regards with pleasure the Dragon Fountain, which terminates the other extremity of this same Allée."[50]

Perrault (1677) on the Labyrinth (Fig. 5-4): "...in order that those who get lost there can get lost in an agreeable manner, there is no detour that doesn't present a view of several fountains at the same time, so that at every step one is surprised by some new object."[51]

The *Mercure galant* (1686) on the Orangerie (Fig. 5-5): "The exterior decoration is nothing other than *bossages* of the height of a module, or a half-diameter of the columns. They are Tuscan, four and one-half feet in diameter, being in height seven times their thickness. There are only three *avant-corps*, the one at the rear of eight coupled columns, and the two others of four columns each. There are also two columns at the royal gate to the salon or vestibule, which are of the same order, but of smaller diameter. These columns carry their normal entablature."[52]

Finally, Jean François Félibien (1703) on the courtside view of the château (Fig. 5-6): "And in the condition that the Château is in today, the arrangement of the buildings, and the view that they offer on the side of the great Place Royale in all the width of the *avant-cour* seem to form a magnificent theatre scene by the slope of the land, and by the diminution in perspective of the width of the courts, of the height and size of the buildings which become smaller and closer as they are farther from the main entrance."[53]

Yet such observations are relatively rare. Indeed, in the Parisian guidebooks of Brice and Le Maire, aesthetic comments on the Louvre and Tuileries are rather

minimal. Typical are Brice's remarks about Goujon's caryatid gallery in the Louvre ("of so regular and so well-imagined a design")[54] and about the Colonnade ("of a very beautiful grandeur").[55] It is only in the first of the Versailles guidebooks—André Félibien's *Description de la grotte de Versailles* of 1672—that we find loving, detailed aesthetic analyses throughout, penned by one of the period's major writers on art. Félibien devotes many pages to the main sculptural group of the grotto, the *Apollo Bathed by the Nymphs of Tethys* (Fig. 5–7) by Girardon and Regnaudin.[56] He begins by noting that although the two foreground figures kneel to allow easy viewing of the rear sculptures, the composition seems natural and unaffected; the poses are varied, providing an agreeable contrast. Apollo's long hair suggests the effusion of his light; his body is not as material as that of ordinary mortals, so much so that he scarcely seems seated: "It seems that he supports himself, and in the extended leg and arm, one sees an easy and fluent action, unlike that of a mere man."[57]

The two kneeling nymphs receive Félibien's most extended analyses. He begins with the one at the right who wipes Apollo's foot:

Her eyes and activity make known her respect for him. A very light drapery, turned up at the rear of her waist, covers her from her hips on down, yet without hiding the shape of her thighs and legs. But one notices in that which is revealed so much beauty and so much gracefulness, that it is difficult to imagine that the most esteemed figures of Antiquity were more perfect and more accomplished. The parts that form a well-shaped back and which, in leaving in the center a certain hollow, mark the position of the spine, rise from the latter with much delicacy [*tendresse*] from the hips to the height of the shoulders, and are worked with so much knowledge and craft, that one thinks one sees all the muscles of the back and the sides as if through a firm flesh and a delicate skin. But as plumpness covers all of them equally, the places which separate these different muscles from one another (and which are called interstices) can scarcely be perceived, and it is necessary to use special light to discover the beauty of the workmanship, because there is so much smoothness [*douceur*] that the shadows are imperceptible.[58]

And:

As for the other nymph who also has a knee on the ground, she is arranged in such a way that one sees all of her back. Her garment falls from her from her waist on down, and all the rest of her body is bare. Her action is contrary to the one I have just spoken about, and instead of lowering her head, she raises it, and even straightens it, as if to speak. Thus one sees in her back and shoulders effects entirely different from those of the other figure, because there appears a certain hollow above the waist where the body bends, causing the spine to curve like a bow, thus producing in the disposition of the muscles effects entirely contrary to those which appear when the head is lowered and the back is entirely curved: because the muscles, being relaxed, are more apparent, and one discovers more easily the places where they are separated one from another.[59]

So much for style. What do the guidebooks tell us about subject-matter, and specifically about the intricate iconographic content inherent in some of the royal art of Louis XIV at the Louvre, the Tuileries, and Versailles? The Parisian writers—Brice and Le Maire— tell us virtually nothing. Only Le Maire offers a description and verse interpretation of a statue of *Time Revealing Truth* by Pietro Francavilla, carved in 1609 and subsequently set up in the Jardin des Tuileries (now in ruined condition in the park of the Château de Pontchartrain). Le Maire's verses interpret the group as an allegory of France defeating her enemies by the power of the sun (Louis XIV)—obviously an *ex post facto* interpretation.[60]

When we turn to the Versailles guidebooks, we find, in marked contrast to the Parisian books, a plethora of iconographic explication. This should not surprise us, for we have already noted that most of the Versailles guides of the Sun King's era were semi-official publications, written by authors with "insider" information, precisely in the area of iconography. Surveying their guides as a whole, it is possible to discern three broad approaches. In the first, the guidebook reader is supplied with a complete, detailed account of the iconographic content of the work of art, so that virtually all questions or puzzles are fully answered and solved. An example is provided by the following text from Rainssant's book of 1687 on the Galerie des Glaces and its salons. The author here describes the painting in the gallery by Le Brun with the title *The King Arms on Land and Sea, 1672* (Fig. 5–8; a scene concerning the beginning of the Dutch War):

The King stands in the center of the painting, giving orders on all sides. Foresight is next to him seated on a cloud, holding in her hand a

compass and an open book, in order to show that he always takes correct measures and that he does nothing except with knowledge and mature deliberation. Neptune, in a chariot pulled by sea-horses, and followed by a troupe of Tritons, approaches the shore in order to show this prince that he can make use of the empire of the sea. He presents his trident to him and shows him vessels all ready to set sail, and others being prepared. Mars, on the other side of the painting, also arrives in his chariot pulled by two battle-horses, and brings to him officers and soldiers. Mercury presents him with a rich shield. Vulcan gives him a cuirass and bundles of swords and pikes carried by a Cyclops, and Minerva, in the center of the sky, holds a golden helmet that she is going to put on his head. Apollo, the god of architecture, also comes forward and watches a large number of workers who build vessels and fortresses or who are busy with military works. Pluto [at the top, center] who in the opinion of some is the same as Plutus, god of riches, takes no less part in his glory and has already spread his treasures at the feet of this prince, where, among instruments and machines of war one notices magnificent vases filled with gold coins. The goddess of the harvest [Ceres] also appears in the sky, sickle in hand. She has left her chariot in the sky and approaches, followed by Abundance, to offer him everything necessary for the subsistance of his armies. Vigilance is seen in the highest part of the painting, from where she conducts the entire enterprise. She is painted with wings, and she holds in her hand an hourglass and in her other a cock and spur, symbols of her activity.[61]

Detailed explanations such as this can be found throughout Rainssant's guidebook as well as Charpentier's on the same room (1684). The same sort of extensive iconographic exegeses are found in the *Mercure galant*'s descriptions of the Escalier des Ambassadeurs (1680) and the Galerie des Glaces (1684).[62] This basic approach also underlies André Félibien's guide to the Grotto of Tethys (1st edition 1672), although that author's primary emphasis is on aesthetic qualities, as we have seen.

A second approach found in the guidebooks is that of partial, or open-ended explanation. Here, the spectator himself is expected to decipher the deeper meaning of the image in a process of associative viewing. This can be studied in the Grand Appartement du Roi. In each salon of the Appartement, dedicated to a particular

"planet," there is a painting in the center of the ceiling which depicts the planetary deity in his or her chariot, accompanied by divinities and personifications. The central painting is accompanied by secondary scenes drawn from ancient history. The paintings of the Grand Appartement du Roi were finished by 1681, when Morellet published his guidebook, which identifies the subjects of the central and subsidiary pictures. The latter scenes—narratives concerning great men of Antiquity—were supposed to constitute ancient parallels to the glorious deeds of Louis XIV. But neither Morellet, nor the *Mercure galant* in 1682, nor Piganiol de La Force in 1701 indicated which of the King's actions were alluded to; this mental act was left to the spectator. André Félibien in his guidebook of 1674 (published before the completion of these paintings), alerted his readers as follows:

> And since the Sun is the emblem of the King, they have taken the seven planets to serve as the subjects of the paintings in the seven rooms of that apartment [the Grand Appartement du Roi]. So that in each they must depict the actions of heroes of Antiquity, which shall relate to each of the planets and to the actions of His Majesty.[63]

And Charles Perrault in 1688 (*Parallèle des anciens et des modernes*, vol. I), paraphrasing Félibien, added that the actions of the greatest men of Antiquity depicted in the secondary paintings "...are also so similar to those of His Majesty, that one sees there in some way the entire history of his reign without his person being represented." [64]

The visual habits expected of an educated visitor of the seventeenth century who penetrated these rooms are indicated by Perrault in the first volume of his *Parallèle* (1688). In the Salon de Mars (or Salle des Gardes; Fig. 5–9),[65] the Abbé, the Chevalier, and the Président are studying the central paintings of *Mars in his Chariot Drawn by Wolves*, an *Allegory of Fury*, and an *Allegory of Victory*. These paintings are accompanied by the following small scenes (in monochrome), drawn from ancient history: *Cyrus Assembling His Army, Caesar (or Cyrus) Haranguing His Troops, Demetrius Poliorcetes Capturing a City*, the *Triumph of Constantine, Marc Antony Making Albinus Consul*, and *Alexander Severus Reproaching an Officer*. The Abbé remarks to his companions about this last group of pictures: "You were able to see heroes who defeat their enemies, others who capture cities, and others who return in triumph. It is still easier to link them [to Louis XIV]." [66] The Abbé does not inform us about which parallel actions of the King he has in mind, but evidently each spectator was at liberty to make his own associations.

Continuing their tour into the next room, the Salon de Mercure, the trio of friends admires the following four secondary scenes: *Alexander the Great and the Gymnosophists* (Fig. 5–10), *Ptolemy, King of Egypt, Conversing with Scholars in a Library* (Fig. 5–11), *Augustus Receiving the Indian Ambassadors* (Fig. 5–12), and *Alexander the Great Providing Aristotle with Animals* (Fig. 5–13). The Président speaks:

> There is Augustus who receives that famous embassy of Indians, when they presented to him animals that had not yet been seen in Rome. I see implied there the famous embassies that the King has received from the most distant regions. There is Ptolemy in the midst of scholars and Alexander who here orders Aristotle to write the Natural History; they cause one to think about the graces that His Majesty bestows upon men of letters and about everything that He has done for the advancement of the sciences.[67]

Between 1681 (publication date of Morellet's guide) and 1703, visitors to the Grand Appartement du Roi were free to form their own interpretations of the subsidiary ceiling paintings. This "participatory viewing," as it may be called, was entirely congenial to the culture of the Ancien Régime, which delighted in intellectual-visual games like the "enigma," as Jennifer Montagu has explained to us.[68] But it would be a mistake, I believe, to imagine wildly speculative associations in the minds of those viewers who took the time to consider these pictures. For the deeds of Louis XIV were well-known to Frenchman and foreigner, and it did not require excessive ingenuity to make an appropriate connection between the ancient scene before one's eyes and a recent action of the King. Most visitors who thought about these paintings probably thought much as the Abbé and the Président did in Perrault's *Parallèle*. In 1703, however, the younger Félibien, Jean François, published his own guidebook to Versailles, and proceeded to give interpretations to almost all of the secondary paintings in the King's Grand Appartement. For the most part his comments do not surprise us. For example (remaining in the Salon de Mercure), the scenes of Ptolemy with scholars in a library and Alexander and Aristotle are taken as references to the Bibliothèque Royale, the Royal Academies, and the King's protection of learning. The two other paintings, showing Alexander and the Gymnosophists and Augustus and the Indian Ambassadors, are simply thought of as offering "... an idea of the nations that have been seen to come from the extremities of the earth to render homage to the grandeur and to the virtues of the King."[69] And in the Salon de Mars, each of the monochromatic roundels is

linked to acts of the King, some specific, some general.[70] The only surprising interpretation concerns a painting in the Salle des Gardes de la Reine (formerly in the King's Salon de Jupiter, a room in his original Grand Appartement)—*Ptolemy Philadelphus Freeing Jewish Slaves* (Fig. 5–14). The scene refers to a historical ordinance of Ptolemy II Philadelphus, a third-century B.C. Hellenistic ruler of Palestine; versions of his decree are contained in the *Letter of Aristeas* and in Josephus's *Jewish Antiquities*, both available in published editions in the seventeenth century.[71] Now in linking this scene to Louis XIV, we would naturally try to find some favorable action of the monarch towards the Jews of France. But Félibien startles us by declaring that the painting refers to Louis XIV's freeing of Christian slaves from the Turks, and that a better ancient subject to suggest this meaning could scarcely be found![72]

We may wonder about how many viewers before 1703 thought about this painting in these terms. But aside from this curious instance, the secondary scenes in the Grand Appartement were not difficult to understand in relation to Louis XIV. The 1703 guidebook of Félibien *fils* further articulated the iconography of the interior of the château, a part of Versailles rather fully and clearly explained by the guidebooks.

"Versailles expliqué"—but not entirely. For when we turn to the gardens, we encounter a "Versailles mystérieux," at least as far as a few key works are concerned, and this leads us to a third approach to hidden meanings found in the guidebooks, namely, purposeful lack of explanation. A striking example is provided by the Dragon Fountain (Fig. 5–15).[73] Recent research has established that this fountain is an allegory of the defeat of the Fronde (the mid-century civil disturbances aimed at ousting Mazarin and limiting the growing power of the Crown); yet the true nature of the fountain remained masked even by its official name. The dragon is really the Python, established since the 1650s as the symbol of the Fronde; the putti and dolphins indicate that it is the young Louis XIV who slays the monster, and the swans—the attributes of Apollo—help to identify the young hero. But the guidebooks of the era never disclose these symbolic identifications; only Piganiol de La Force (the one writer of the Louis XIV period not connected with the court) called it in 1701 "la Fontaine du Dragon ou Serpent Pithon."[74] Yet in 1688, Charles Perrault, in his *Parallèle* (not a guidebook), revealed that the dragon is the Python, and in a painting by Jean Cotelle the Younger (circa 1690; Fig. 5–16), Apollo is seen slaying the beast, with a view in the middle distance of the Dragon Fountain.[75] One can only speculate as to why the guidebook writers chose not to reveal this

allegory. Certainly André Félibien understood it; yet even in an account of the halt in front of the fountain by the King and Queen during their tour of the park in 1668, Félibien described the dragon, the putti, the swans and dolphins, without one word about the true identity of the central monster or the symbolic or allegorical meaning of the forms.[76] I am tempted to conclude that this particular silence is related to the political nature of this allegory, and this would seem to be confirmed by the failure of the writers to explain the real meaning of the Latona Fountain (Fig. 5–17)—another allegory of the Fronde, as Nathan Whitman has brilliantly revealed.[77] Yet whereas the meaning of the dragon was kept strictly veiled in the guides (with the exception of Piganiol de La Force), the allegory of the Latona Fountain was at least very indirectly alluded to by one of the authors, Morellet. After relating the mythological story of Latona and the Lycian peasants which the fountain illustrates, Morellet wrote: "One would really have to be a peasant not to admire beauty, above all that which is cherished and loved by the Sovereign; and one must be prepared to become a frog if one forgets oneself to that extent."[78] The word "la beauté" here is undoubtedly a reference to Louis XIV's mother, Anne of Austria (i.e. Latona), considered to have been a beautiful woman during her younger years. Furthermore, in describing the two *Sphinxes with Putti* (Fig. 5–18)[79] which formerly flanked the stairs overlooking the Latona Fountain, Morellet explained that:

They have the face and bosom of a woman, which bears a royal ribbon, and the rest of the body is a dog's, on which there is a putto. The womanly part indicates the power of kings, and the dog's body [denotes] the faithfulness of subjects, to which must be joined the love of the same subjects toward their sovereign.[80]

Thus these sculptures introduced the theme of obedience of the subject to the ruler, the theme violated by the *frondeurs*, depicted as peasants being metamorphosed into frogs in the adjacent Latona Fountain.[81]

Although the subject of the Fronde is never cited in the guidebooks, it is directly referred to once by the *Mercure galant* in explaining the painted image of Apollo and the slain Python on the vault of the Escalier des Ambassadeurs (Fig. 5–19):

[His Majesty] has ended the civil wars, and prevented the secret rebellions which enemies have wanted to engender in France. These rebellions are depicted by the serpent Python because he took his origin only from the gross impurities of the earth, and was pierced almost

at birth by the arrows of Apollo, who represents the person of the King in this subject-matter....[82]

This passage in the *Mercure* of September, 1680 is from a very long and detailed description of the Escalier. I believe that the *Mercure*—written (or at least edited) by Donneau de Visé, an individual outside of the circle of court intellectuals who wrote most of the guidebooks—here inadvertently broke the "code of silence" about the Fronde and its imagery at Versailles. That such a code existed is confirmed by passages on the Escalier decorations in the younger Félibien's 1703 guidebook. Félibien, in discussing the paintings at the centers of the lower parts of the long sides of the vault, explains clearly that in one, the Hydra represents the united enemies of France, crushed by the King's valor (Hercules) and wisdom (Minerva) (Fig. 5–20).[83] But in the immediately preceding paragraph on the corresponding group painted on the opposite side of the vault (Fig. 5–19), Félibien mentions "le Serpent Python percé de fléches" with Apollo standing above with his bow in hand, but no interpretation of the Python as the Fronde is offered.[84]

Thus the meanings of the Dragon and Latona Fountains (as well as the Apollo-Python episode in the Escalier) were never given by the guidebooks. The comprehension by tourists of the iconography of these features is unrecorded in travel accounts known to me, and would have depended upon familiarity with court art (including the *ballet de cour*) and its diffusion from the 1650s on.

The art of Versailles was in the main a public-oriented art, meant to be iconographically readable by a large audience. Previous French royal art did not always have this orientation, for there was an older, alternate tradition of the work of art as a cryptic mystery, to be unravelled only by a courtly or erudite elite.[85] But this was not the approach of Louis XIV. Symptomatic of the Sun King's policy of intelligibility was the decision by the Petite Académie in the 1680s to replace the proposed Latin titles for the paintings in the Galerie des Glaces with French ones, written on cartouches beneath each of the main scenes (Fig. 5–8).[86] I believe, therefore, that the Dragon and Latona Fountains (and the Escalier scene) were intended to be understood not only by the few, but by the wider public as well, because the allegories embodied in these works referred to recent history and taught lessons that the King surely wanted his subjects to remember and heed. But their messages—dealing with a most painful episode in the life of the young Louis XIV—were not to be spelled out in books; even the word "Python" was avoided in the designation

of the Dragon Fountain. The visitor was meant to look, reflect in silence, and move on to view the next wonder of Versailles, just as Louis XIV and Marie-Thérèse did in 1668 before the Dragon Fountain.

The guidebooks to Paris and Versailles are the descendants of numerous examples of the genre, tracing their origins back to the pilgrims' guides of the Middle Ages and, beyond that, to Pausanias in Antiquity. But I would venture to suggest that the guidebooks to Versailles, at least, constitute the first attempt in the history of art by a political regime to publicize its official art and shape viewer response on a comprehensive scale. All that is eminently Ludovican. In their modest way, the guidebooks to Versailles reveal the Sun King's understanding of the power of the media—all media—in the service of the State.

<div align="center">

Robert W. Berger
Brookline, Massachusetts

</div>

Notes

1 J. de La Fontaine, *Les amours de Psyché et de Cupidon*, Paris, 1669 in H. Regnier, ed., *Oeuvres de J. de La Fontaine*, Paris, 1892, vol. VIII, p. 30.

2 The present Salon Carré (now hung with French paintings of the fifteenth and sixteenth centuries) and adjacent rooms to the north. In 1681 the King's Cabinet des Tableaux was described as consisting of seven rooms in the Louvre and four in the nearby Hôtel de Gramont (*Le Mercure galant*, December 1681, pp. 237–238).

3 J. Locke, *Locke's Travels in France 1675–1679*, ed. J. Lough, Cambridge, 1953, p. 156. Locke also visited the Dauphin's apartment, located on the top floor of Lescot's west wing.

4 See D. R. Coffin, "The 'Lex Hortorum' and Access to Gardens of Latium during the Renaissance," *Journal of Garden History*, vol. II, no. 3, 1982, pp. 201–232. This tradition first appeared at the Villa Carafa on the Quirinal Hill in Rome, built shortly before 1476.

5 See F.H. Hazlehurst, *Gardens of Illusion. The Genius of André Le Nostre*, Nashville, 1980, chap. 6.

6 Ch. Perrault, *Mémoires de ma vie* (ca. 1700), ed. P. Bonnefon, Paris, 1909, pp. 125–126.

7 G. L. Le Rouge, *Les curiositez de Paris...*, Paris, 1716, p. 312; J. C. Nemeitz, *Séjour de Paris...*, 2nd ed., Leiden, 1727 (reprinted in A. Franklin, ed., *La vie privée d'autrefois*, Paris, 1897, ser. 2, vol. XXI, p. 269). The first edition of Nemeitz (in German) appeared in 1718. Nemeitz (p. 271, n. 2) gives the price of the rue Saint-Nicaise coach as 25 *sols* per person.

8 Le Rouge, *Les curiositez de Paris*, p. 312.

9 Locke, *Locke's Travels*, p. 152.

10 *Ibid.*

11 E. Soulié *et al.*, eds., *Journal du marquis de Dangeau*, Paris, 1854, vol. I, p. 153 [13 April, 1685].

12 P. Francastel, ed., "Relation de la visite de Nicodème Tessin à Marly, Versailles, Clagny, Rueil et Saint-Cloud en 1687," *Revue de l'histoire de Versailles et de Seine-et-Oise*, vol. XXVIII, 1926, pp. 154ff.

13 R. F. E. Ferrier and J. A. H. Ferrier, compilers, "The Journal of Major Richard Ferrier, M. P., While Travelling in France in the Year 1687," *The Camden Miscellany*, London, 1895, vol. IX, pp. 25–26 (New series LIII).

14 *Registre où sont écrits par dattes les Ordres que le Roy a donnez à Monsieur Mansart Sur-Intendant des Bâtimens de sa Majesté...*, Paris, Archives Nationales, O¹ 1809, fol. 4r.

15 Soulié *et al.*, eds., *Journal du marquis de Dangeau*, Paris, 1857, vol. X, p. 179 [16 November, 1704].

16 *Ibid.*, vol. X, p. 189 [29 November, 1704]. Dangeau's journal entries of 1704 are noted by A. and J. Marie, who continue (*Versailles au temps de Louis XIV*, Paris, 1976, p. 432): "C'est à ce moment que l'on ouvre trois allées et trois portes nouvelles dans la Colonnade et une dans le Bosquet des Dômes. L'ouverture des bosquets au public est certainement en rapport avec les séjours de plus en plus nombreux et longs que Louis XIV fait soit à Trianon, soit à Marly où les jardins sont fermés et ne sont ouverts qu'aux courtisans invités."

17 Nemeitz (as in n. 7), p. 277.

18 *Ibid.*, p. 278.

19 The much larger area of the *parc de chasse* was also walled, with monumental gateways. Here, the main purpose of the wall was to contain the game animals. See C. Waltisperger, "La clôture du grand parc [*sic*] de Versailles," *Revue de l'art*, no. 65, 1984, pp. 14–17.

20 A MS guide of ca. 1699–1702 begins a tour of the park at the Porte du Dragon (*Estat present des figures qui sont dans le petit parc de Versailles...*, Versailles, Bibliothèque Municipale, MS 22M; there is a copy in Paris, Bibliothèque Mazarine, MS 3362, wrongly ascribed to André Félibien).

21 In 1677 Locke was able to visit the Grands Appartements du Roi et de la Reine in their original condition (before the alterations began in 1678), and reported viewing the Grand Canal from the King's rooms (which included his most intimate ones facing west) (*Locke's Travels*, p. 152).

In 1682 a medal was struck commemorating the King's generosity in opening the interiors of Versailles to the public. The main inscription reads HILARITATI. PVBLICAE. APERTA. REGIA, and in the exergue COMITAS. ET. MAGNIFICENTIA.PRINCIPIS.M.DC.LXXXII (C.F. Menestrier, *Histoire du roy Louis Le Grand par les medailles...*, Paris, 1689, pl. 26, upper right). Menestrier (*loc. cit.*) gives the following explanation: "le Roy pour faire gouster a ses sujets les douceurs de la Paix, OUVRIT LES APPARTEMENS DE VERSAILLES A LA JOYE PVBLIQUE, y donnant le plaisir de la Musique, du Jeu, des Rafraichissemens, etc. Mercure avec un Echiquier, Apollon avec sa Lyre, et Vertumne avec ses fruits, y font remarquer LA BONTÉ ET LA MAGNIFICENCE DV PRINCE."

22 Tessin ascended it in 1687 (Francastel, ed., "Relation de la visite de Nicodème Tessin," pp. 274ff.), but he was a special visitor, escorted (at least around the park) by Le Nôtre.

23 M. Dumolin, "Notes sur les vieux guides de Paris," *Mémoires de la société de l'histoire de Paris et de l'Ile-de-France*, vol. XLVII, 1924, p. 257.

24 Nemeitz (as in n. 7), p. 276.

25 *Ibid.*, pp. 273–276.

26 Ferrier and Ferrier, compilers, "The Journal of Major Richard Ferrier," p. 26.

27 *Ibid.*

28 M. Sautai, "Une visite à Versailles et à Saint-Cloud en 1679. Le grand Condé à Chantilly," *Les marches de l'est*, vol. IV, 1913, p. 776. See also note 67, below, for errors in *Le Mercure galant* in 1682. For other examples of deviant interpretations, see my article "Versailles in Verse: Some Notes on Claude Denis' 'Explication,'" *Journal of Garden History*, vol. IV, 1984, pp. 127–138.

29 G. Corrozet, *La fleur des antiquitez...*, 1st ed. Paris, 1532, *idem, Les antiquitez, histoires et singularitez de Paris...*, 1st ed. Paris, 1550; J. Du Breul, *Les antiquitez et choses plus remarquables de Paris...*, 1st ed. Paris, 1608, *idem, Le théâtre des antiquitez de Paris...*, 1st ed. Paris, 1612: A. Du Chesne, *Les antiquitez et recherches des villes, chasteaux et places plus remarquables de toute la France...*, 1st ed. Paris, 1609. The last includes a section on Paris.

In Du Breul's *Théâtre* (eds. 1612, 1639), a step is taken towards a topographical grouping by the division of the book into "La Cité," "L'Université," "Ville de Paris" (the Right Bank) and *faubourgs*, and the surrounding towns in the diocese of Paris. This progressive feature of Du Breul's books was pointed out to me by Dr. Hilary Ballon. On these and other guidebooks to Paris, see Dumolin (as in n. 23), pp. 209–285. For guidebooks in general, see E. S. de Beer, "The Development of the Guide-Book until the Early Nineteenth Century," *The Journal of the British Archaeological Association*, 3rd ser., vol. XV, 1952, pp. 35–46.

30 For details about Brice and the various editions, see G. Brice, *Description de la ville de Paris...*, ed. P. Codet, Geneva and Paris, 1971; this contains a facsimile of the last (9th) edition of 1752. An English translation of Brice (*A New Description of Paris...*) appeared in London in 1687. Reviews of Brice's guide appeared in the *Journal des sçavans*: 1 May, 1684, p. 97; 7 April, 1698, pp. 136–138; 2 May, 1707, pp. 257–264; 4 September, 1713, pp. 567–575.

31 Le Maire's guide bears a *privilège* dated 26 May, 1684. The volumes are dedicated to Henri

de Fourcy, comte de Chessy, Prévôt des Marchands de Paris. The 1685 edition was published by Theodore Girard, the 1698 reprint by Nicolas Le Clerc. A notice of publication and a description of Le Maire's guide appeared in *Le Mercure galant*, May 1685, pp. 23–27; the *Mercure* stated (pp. 26–27) that "...ces trois Volumes...font un éloge d'autant plus grand de ce Prince [Louis XIV], sans luy donner pourtant aucune loüange, que les choses [the new buildings of Paris] par lesquelles on auroit pû le loüer parlent elles-mesmes & n'ont pas besoin que l'on ajoûte qu'elles sont autant d'effets de sa bonté pour ses Peuples, & de sa magnificence."

32 G. Brice, *Description nouvelle de ce qu'il y a de plus remarquable dans la ville de Paris*, 2nd ed., Paris, 1694, vol. I, p. 19.

33 J. Montagu has identified a drawing in the Louvre as Le Brun's sketch for this painting ("Le Brun et Delacroix dans la Galerie d'Apollon," *La revue du Louvre et des musées de France*, vol. XII, 1962, pp. 233, 234, fig. 1).

34 I know of no general study of the Versailles guidebooks, but those that describe the Galerie des Glaces have been recently discussed in an interesting paper by G. Sabatier ("Versailles, ou le sens perdu: Manière de montrer la Galerie des Glaces aux 17ᵉ et 18ᵉ siècles"), read at the Colloque Versailles (1985) and to be published in the Actes du Colloque Versailles. Sabatier is particularly interested in the changing sequences of viewing the vault paintings that the guidebooks indicate.

Another "aid" to viewers were inscriptions. At Versailles, these appeared prominently in the Labyrinth and in the Galerie des Glaces (Fig. 5–8). On the Labyrinth, see R. W. Berger, *In the Garden of the Sun King: Studies on the Park of Versailles under Louis XIV*, Washington, D.C., 1985, chap. 4; the inscriptions in the Galerie were the subject of a paper by J. Jacquiot ("Remarques critiques sur les inscriptions de la Galerie de Versailles, par Boileau-Despréaux"), read at the Colloque Versailles (1985) and to be published in the Actes du Colloque Versailles.

35 The printed guidebooks to Versailles (era of Louis XIV): *Comprehensive*:

A. Félibien, *Description sommaire du chasteau de Versailles*, Paris, G. Desprez, 1674. Printed on 30 December, 1673. Map at end of volume. Reprinted in *idem, Recueïl de descriptions de peintures et d'autres ouvrages faits pour le Roy*, Paris, Vᵛᵉ de S. Mabre-Cramoisy, 1689; *idem, Description du château de Versailles, de ses peintures, et d'autres ouvrages faits pour le Roy*, Paris, Mariette, 1696.

Le sieur Combes [Laurent Morellet], *Explication historique, de ce qu'il y a de plus remarquable dans la maison royale de Versailles, et en celle de Monsieur à Saint Cloud*, Paris, C. Nego, 1681. *Privilège du roi*: 7 November, 1680. Dedicated to Madame la Dauphine (Marie-Anne-Christine-Victoire de Bavière). Approved by the painters Noël Coypel and Antoine Paillette (Paillet) on 30 October, 1680; approved by the sculptors Thomas Regnaudin and Antoine Coysevox on 2 November, 1680. Second French edition: Paris, F. Pralard fils, 1695. English edition: *An Historical Explanation of What There is Most Remarkable in That Wonder of the World the French King's House at Versailles*, London, Matthew Turner, 1684.

J. A. Piganiol de La Force, *Nouvelle description des chasteaux et parcs de Versailles et de Marly*, Paris, F. & P. Delaulne, 1701. *Privilège du roi*: 22 December, 1700. Dedicated to the Comte de Toulouse. Later editions: 1707, 1713, 1717, 1724, 1730, 1738, 1751, 1764.

J. F. Félibien, *Description sommaire de Versailles ancienne et nouvelle*, Paris, A. Chrétien, 1703. "Approbation" (10 March, 1703) by the Abbé Paul Tallement (printed at end of volume). Notice of publication and description in *Le Mercure galant*, August 1703, pp. 201–202.

Individual Features:

A. Félibien, *Description de la grotte de Versailles*, Paris, S. Mabre-Cramoisy, 1672. Unillustrated. Reprinted 1674. Re-issued with engravings (in-folio) by the Imprimerie Royale in 1676 and 1679. Reprinted (without engravings) in *idem, Recueïl de descriptions de peintures et d'autres ouvrages faits pour le Roy*, Paris, Vᵛᵉ de S. Mabre-Cramoisy, 1689; *idem, Description du château de Versailles, de ses peintures, et d'autres ouvrages faits pour le Roy*, Paris, Mariette, 1696.

[Ch. Perrault], *Labyrinte de Versailles*, Paris, Imprimerie Royale, 1677. Illustrated. Reprinted

in 1679. Facsimile: Paris, Moniteur, 1982, with a postface by M. Conan. Multilingual edition: *Labyrinte de Versailles. The Labyrinth of Versailles. Der Irr-garte zu Versailles. 't Dool-hof tot Versailles*, Amsterdam, 1682? German edition: J.U. Krauss, *Der Irrgarten von Versailles oder Führung durch Äsops Labyrinth der Psyche*, Augsburg? 1690? Facsimile: ed. H. Eisendle, Berlin-Erlangen, 1975.

F. Charpentier, *Explication des tableaux de la galerie de Versailles*, Paris, F. Muguet, 1684. Title page: "Par ordre exprés de sa Majesté." Continued in: Versailles, Bibliothèque Municipale, MS 138G, fols. 121v–126v (descriptions of paintings in the gallery executed after publication of Charpentier's book in 1684).

P. Rainssant, *Explication des tableaux de la galerie de Versailles, et de ses deux salons*, Versailles, F. Muguet, 1687. Title page: "Par ordre exprés de sa Majesté."

Excluded from this list are two literary descriptions: J. de La Fontaine, *Les amours de Psyché et de Cupidon*, Paris, 1669, and M. de Scudéry, *La promenade de Versailles*, Paris, 1669.

36 A recent contribution on this writer is J. Thuillier, "Pour André Félibien," *XVIIe siècle,* no. 138, 1983, pp. 67–95.

Two payments by the Crown to Félibien indicate special recompense for his publishing, although it is impossible to determine exactly which of his books were subsidized: "28 décembre [1674]: au sᵣ Félibien, historiographe des bastimens, pour l'impression et relieure de plusieurs livres qu'il a faits...300 [livres]"; [6 April, 1681]: "au sᵣ Félibien, en considération de divers ouvrages qu'il donne au public...1200 [livres]" (J. Guiffrey, ed., *Comptes des bâtiments du roi sous le règne de Louis XIV*, Paris, 1881, vol. I, cols. 781, 1344). Félibien received an annual salary of 1200 *livres* as *historiographe du roi.*

37 Combes [Morellet], *Explication historique,* "Avis au Lecteur."

38 Laurent Morellet (or de Morellet) (b. 1636) was the *doyen* of the church of S. Denis, Nuys. In addition to Versailles, he wrote on the château and gardens of Saint-Cloud, owned by the King's brother, Philippe d'Orléans, whom he

served as chaplain (see the second half of the *Explication historique* as well as: *Saint-Clou et les devises du Salon...*, Paris, 1681; *Tableau de morale pour l'éducation des princes, tiré des peintures de la galerie de S. Clou...*, Paris, 1686; and *Lettre à S.A.R. Monsieur, frere unique du roi*, Dijon, 1700). He is also the author of a theological work: *De la génération éternelle du verbe incarné Jesus-Christ...*, Nuys, 1720. On Morellet, see P. Papillon, *Bibliothèque des auteurs de Bourgogne*, Dijon, 1745, vol. II, pp. 94–95.

39 On J. F. Félibien, see R. D. Middleton in the *Macmillan Encyclopedia of Architects,* New York and London, vol. II, p. 50.

40 On Piganiol, see Abbé Chaumeil, *Biographie des personnages remarquables de la Haute-Auvergne...*, Saint-Flour, 1867, pp. 208–209 (reprint: Geneva, 1971).

41 *Le Mercure galant,* January 1685, p. 107: "Ce travail a reçeu de Sa Majesté tous les agrémens que l'Autheur en pouvoit espérer; & les Exemplaires imprimez de cet Ouvrage, que le Roy a fait mettre dans la Galerie de Versailles, ont obtenu les applaudissemens de toute la Cour."

42 "M. Perrault vous aura rendu compte de la révision que nous avons faite par vos ordres de l'épitre dédicatoire de M. Valois au Roy et de la relation de la feste de Versailles, écrite par M. Félibien, et je n'ay rien à ajouter" (P. Clément, ed., *Lettres, instructions et mémoires de Colbert,* Paris, 1868, vol. V, p. 635, no. 6 [letter of 29 July, 1668]).

43 See P. Mélèse, *Un homme de lettres au temps du Grand Roi: Donneau de Visé, fondateur du Mercure Galant*, Paris, 1936.

44 Major article on the Louvre and Tuileries in *Le Mercure galant*: September 1686, part II, pp. 339–356 (visit of the Siamese Ambassadors).

Major articles on Versailles in *Le Mercure galant*: September 1680, part II, pp. 276–320 (Escalier des Ambassadeurs). December 1682, pp. 6–42 (Galerie des Glaces; Grand Appartement du Roi). December 1684, pp. 3–85 (article on the Galerie des Glaces by Lorne, a painter). November 1686, part II, pp. 103–230 (Gardens—Visit of the Siamese Ambassadors); pp. 272–308 (Château interiors—Visit of the Sia-

mese Ambassadors). December 1686, part II, pp. 6–58 (Service buildings—Visit of the Siamese Ambassadors). April 1687, pp. 16–57 (Salon de la Guerre, Salon de la Paix).

45 An instance of the *Mercure* repeating Morellet's (le sieur Combes's) list (which contains an error) of the twenty-four statues of Colbert's *grande commande* of 1674 was cited by T. F. Hedin in a talk delivered at the Colloque Versailles (1985) ("In the Gardens with the *Mercure Galant*: The Promenade of the Siamese Ambassadors"), to be published in the Actes du Colloque Versailles.

46 Mélèse, *Un homme de lettres*, pp. 163ff.

47 In 1677 and 1678, Donneau de Visé appealed to his readers to contribute to the *Mercure* because of his lack of knowledge about "certaines choses" (Mélèse, *Un homme de lettres*, pp. 138–139, 141; see also pp. 147–148). But the articles listed in note 44, above, are so lengthy, detailed, and sophisticated (particularly in iconographic and architectural information), that the possibility of casual contributors must be excluded.

Mélèse points out (*ibid.*, p. 174) that as a result of the publication in the *Mercure* (August 1683) of a very long obituary of Queen Marie-Thérèse, Louis XIV, beginning in 1684, granted Donneau de Visé 6,000 *livres* as an annuity (doubled in 1692). As a consequence of the King's munificence, the *Mercure* became a semi-official chronicle of French military and naval events, of the King's visit to Paris in 1687 after recovery from illness, etc. (these accounts were sometimes printed separately). The description of the visit of the Siamese ambassadors (1686)—so full of details about Paris and Versailles—can be included among these publications (Mélèse, *Un homme de lettres*, pp. 183ff.).

48 Hedin (as in note 45, above). But Hedin also makes the important point that some descriptions in the *Mercure* of 1686 of the gardens of Versailles contain errors, because the editors used faulty engravings and inscriptions, particularly those by Perelle.

49 Rainssant, *Explication*, p. 117.

50 A. Félibien, *Description sommaire*, p. 65.

51 [Perrault], *Labyrinte de Versailles*, pp. 3–4.

52 *Le Mercure galant*, November 1686, part II, pp. 122–123. This may be based on information supplied by Hardouin-Mansart himself or an assistant (see text, above).

53 J. F. Félibien, *Description sommaire*, pp. 35–36

54 Brice, *Description nouvelle*, Paris, 1684, vol. I, p. 9.

55 *Ibid.*, vol. I, p. 11.

56 A. Félibien, *Recueïl de descriptions*, pp. 370ff.

57 *Ibid.*, p. 374.

58 *Ibid.*, pp. 375–376.

59 *Ibid.*, pp. 377–378.

60 Le Maire, *Paris ancien et nouveau*, Paris, 1685, vol. III, pp. 196–197. The sculptural group is illustrated in R. de Francqueville, *Pierre de Francqueville, sculpteur des Médicis et du roi Henri IV (1548–1615)*. Paris, 1968, pl. XXIV, fig. 41.

61 Rainssant, *Explication*, pp. 13–16. A very full series of Le Brun's preparatory drawings for this painting is published in [Musée du Louvre, Paris, Cabinet des Dessins], *Le Brun à Versailles*, Paris, 1985, pp. 40–46. The artist's oil sketch is in Auxerre, Musée des Beaux-Arts (illustrated in *Charles Le Brun, 1619–1690, peintre et dessinateur*, Versailles, 1963, p. 112).

62 See note 44, above.

63 A. Félibien, *Description sommaire*, pp. 33–34.

64 Ch. Perrault, *Parallèle des anciens et des modernes en ce qui regarde les arts et les sciences*, Paris, 1688, vol. I, p. 117.

65 The major and secondary paintings of this room are by Claude II Audran, René Antoine Houasse, and Jean Jouvenet. For the precise attributions, see R.W. Berger, *Versailles: The Château of Louis XIV*, University Park and London, 1985, p. 69.

66 Perrault, *Parallèle*, vol. I, pp. 117–118.

67 *Ibid.*, vol. I, p. 117. By 1688 (publication date of the first volume of Perrault's *Parallèle*), three of the four secondary paintings in the Salon de Mercure had been described in only one guidebook—Morellet's [Combes's] *Explication historique* of 1681. Here are the latter's descriptions of the three paintings analyzed by the Président:

[*Augustus Receiving the Indian Ambassadors*]: "... c'est Auguste qui reçoit une Ambassade d'Indiens, où, un Philosophe nommé Calanus, aprés qu'il luy eût fait sa Harangue, se mit sur un bucher & se brûle, pour faire parade de sa constance, & en même temps honneur à cét Empereur. Apparemment ce Philosophe, en faisant cette action, cassa un Vaze de terre, qui ne pouvoit guere plus servir" (pp. 40–41). The episode concerning Calanus is depicted at the extreme right of Fig. 5–12 (not visible in the reproduction).

[*Ptolemy, King of Egypt, Conversing with Scholars in a Library*]: "Le troisiéme...est Ptolomée Roy d'Egypte, qui fait construire une Bibliotheque, lequel est accompagné de Philosophes & d'autres Sçavans" (p. 41).

[*Alexander the Great Providing Aristotle with Animals*]: "... Alexandre le Grand, lors qu'il fit apporter plusieurs especes d'animaux, afin que le Philosophe Aristote parlât de leur nature, & qu'il en fist l'Anatomie" (p. 40).

The subject–matter of these paintings was not grasped at all by the anonymous writer for *Le Mercure galant,* December 1682, p. 18: "Quatre grands Tableaux accompagnent ce milieu, & représentent des Princes qui ont vaincu leurs Ennemis par adresse, & qui par leur industrie ont mérité une gloire immortelle."

Explanations of the subjects of all four paintings are given in Piganiol de La Force, *Nouvelle description*, Paris, 1701, pp. 46–48.

68 J. Montagu, "The Painted Enigma and French Seventeenth-Century Art," *Journal of the Warburg and Courtauld Institutes*, vol. XXXI, 1968, pp. 307–335.

69 J. F. Félibien, *Description sommaire*, pp. 138–139.

70 *Ibid.*, pp. 134–136.

71 M. Hadas, ed. and trans., *Aristeas to Philocrates (Letter of Aristeas)*, New York, 1951, pp. 99–109 [12–27]; Josephus, *Jewish Antiquities*, XII.17ff. A Latin version of Aristeas was available: *Aristeas ad Philocratem*, Rome, [ca. 1471]; Josephus was available in many editions.

72 J. F. Félibien, *Description sommaire*, p. 191. An allegorical painting on the theme of *Louis XIV Buying Christian Captives from the Turks* (Saint-Lô, Musée) was executed by Nicolas Rabon in 1666–67 as a competition piece for the Académie Royale de Peinture et de Sculpture (see Montagu, "The Painted Enigma," p. 327).

73 By the Marsy brothers. See T. Hedin, *The Sculpture of Gaspard and Balthazard Marsy*, Columbia, 1983, pp. 39–40; Berger, *In the Garden of the Sun King*, pp. 24ff.

74 Piganiol de La Force, *Nouvelle description*, p. 181.

75 On Perrault's text and Cotelle's painting, see Berger, *In the Garden of the Sun King*, p. 25.

76 A. Félibien, *Relation de la feste de Versailles du 18 juillet 1668*, Paris, 1679, p. 5.

77 By the Marsy brothers. See N. Whitman, "Myth and Politics: Versailles and the Fountain of Latona" in J. C. Rule, ed., *Louis XIV and the Craft of Kingship*, Columbus, 1969, pp. 286–301. See also Hedin, *Marsy*, pp. 52ff.; Berger, *In the Garden of the Sun King*, pp. 26ff.

78 Combes [Morellet], *Explication historique*, pp. 121–122.

79 On their authorship and dating, see Berger, *In the Garden of the Sun King*, p. 88, n. 75.

80 Combes [Morellet], *Explication historique*, pp. 128–129.

81 See Berger, *In the Garden of the Sun King*, p. 28.

82 *Le Mercure galant*, September 1680, part II, pp. 309–310.

83 J. F. Félibien, *Description sommaire*, p. 94.

84 *Ibid.* A ceiling painting (1674–75; destroyed) by Jean Le Moyne de Paris and Jean Le Moyne Le Lorrain in the Cabinet des Mois (Salon Octogone) of the Appartement des Bains at Versailles was described by Combes [Morellet] (*Explication historique*, pp. 22–23) as follows: "... le Tableau ... represente un Appollon, chassant à coups de fleches les tempêtes & les orages. Par les fleches d'Appollon on entend les rayons du Soleil, qui dissipent les nuages & les brouïllards; Cela fait allusion au Roy, qui par sa prudence, sa justice & sa puissance, extermine de son Royaume, les erreurs, les crimes & les seditions, que la malice & l'ignorance y pourroient former." The theme of the Fronde is suggested by Morellet's last sentence but not by the image of Apollo shooting arrows at tempests and storms. Since the early 1650s the Fronde was regularly symbolized by the Python (see Berger, *In the Garden of the Sun King*, pp. 10ff.).

85 E.g., the sixteenth-century fresco cycle by Il Rosso in the Galerie François I at Fontainebleau.

86 See Jacquiot (as in note 34, above).

Fig. 5–2 Allée d'Eau, Versailles. Photo: R. Berger.

Fig. 5–3 Allée d'Eau, Versailles. Photo: R. Berger.

Fig. 5–4 .Fountain of the Kite and the Birds, Labyrinth, Versailles. Engraving by Sébastien Le Clerc from [Charles Perrault], *Labyrinte de Versailles*, Paris, 1677. Photo: Houghton Library, Harvard University, Cambridge, Massachusetts.

Fig. 5–5 Orangerie, Versailles. Photo: Réunion des Musées Nationaux, Paris.

Fig. 5–6 Château, Versailles, Entrance Side. Engraving by Israel Silvestre, 1674. Photo: Bibliothèque Nationale, Paris.

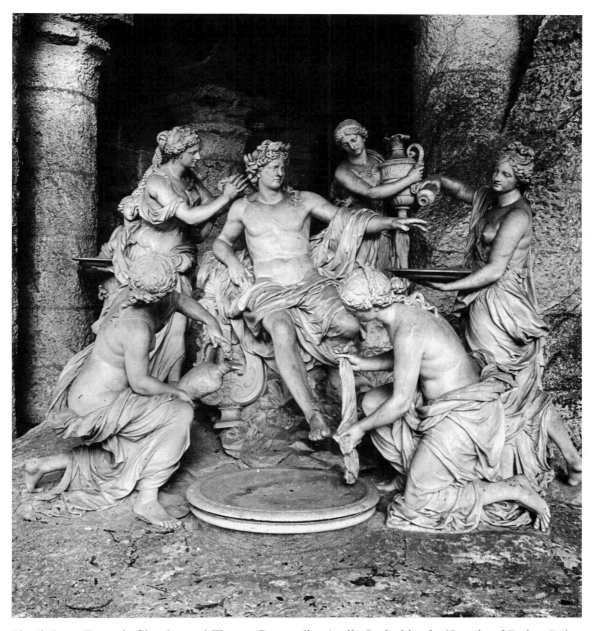

Fig. 5–7 François Girardon and Thomas Regnaudin, *Apollo Bathed by the Nymphs of Tethys*. Bains d'Apollon, Versailles. Photo: Giraudon/Art Resource, New York.

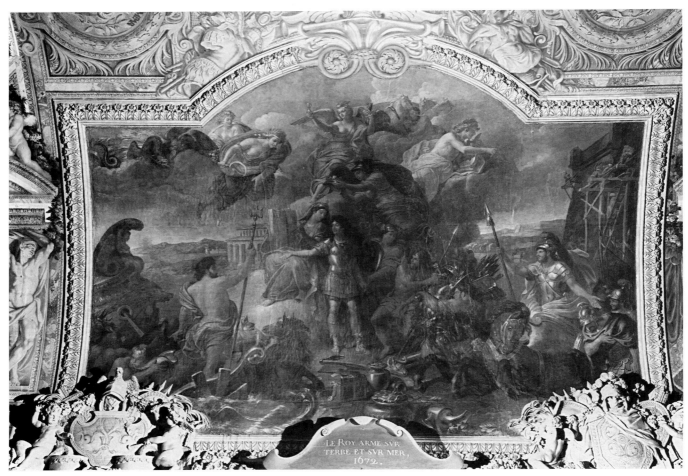

Fig. 5–8 Charles Le Brun, *The King Arms on Land and Sea, 1672*. Galerie des Glaces, Versailles. Photo: Giraudon /Art Resource, New York.

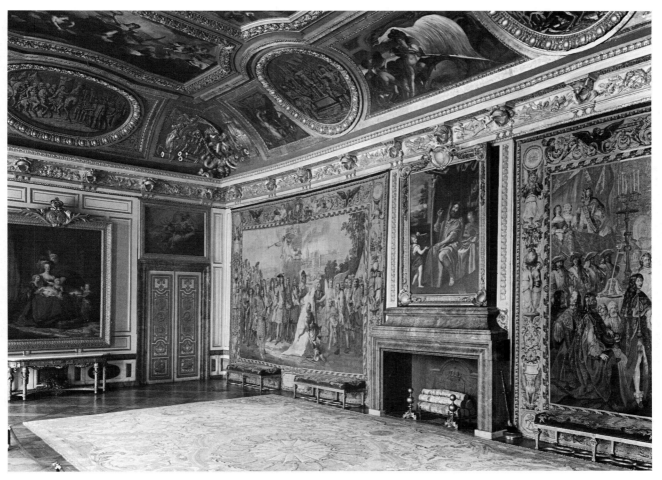

Fig. 5–9 Salon de Mars, Versailles. Photo: Réunion des Musées Nationaux, Paris.

Fig. 5–10 Jean Baptiste de Champaigne, *Alexander the Great and the Gymnosophists.* Salon de Mercure, Versailles. Photo: Réunion des Musées Nationaux, Paris.

Fig. 5–11 Jean Baptiste de Champaigne, *Ptolemy, King of Egypt, Conversing with Scholars in a Library.* Salon de Mercure, Versailles. Photo: Réunion des Musées Nationaux, Paris.

Fig. 5–12 Jean Baptiste de Champaigne, *Augustus Receiving the Indian Ambassadors.* Salon de Mercure, Versailles. Photo: Réunion des Musées Nationaux, Paris.

Fig. 5–13 Jean Baptiste de Champaigne, *Alexander the Great Providing Aristotle with Animals.* Salon de Mercure, Versailles. Photo: Réunion des Musées Nationaux, Paris.

Fig. 5–14 Noël Coypel, *Ptolemy Philadelphus Freeing Jewish Slaves.* Salle des Gardes de la Reine, Versailles. Photo: R. Berger.

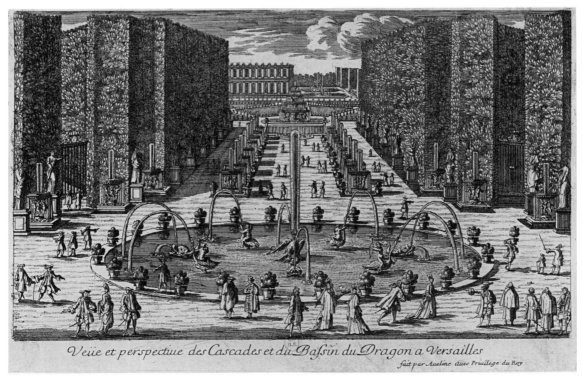

Fig. 5–15 Gaspard Marsy and Balthazar Marsy, Dragon Fountain, Versailles. Engraving by Pierre Aveline. Photo: Bibliothèque Nationale, Paris.

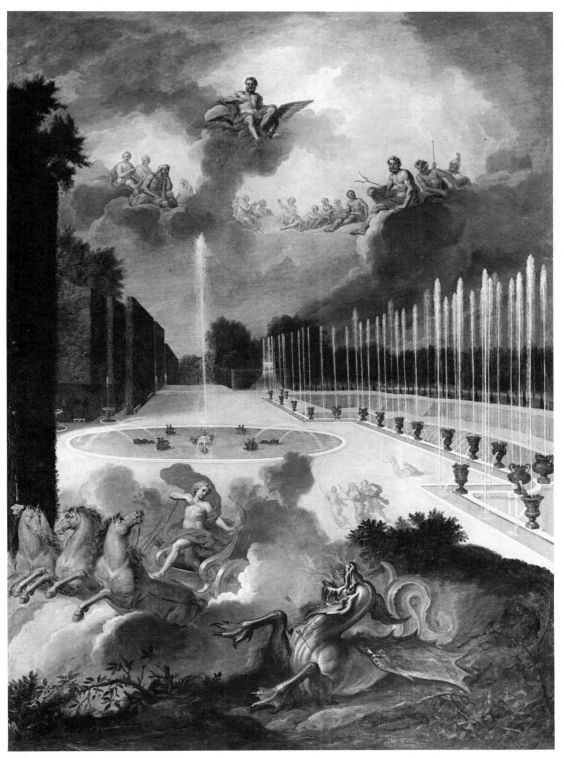

Fig. 5–16 Jean Cotelle the Younger, *Apollo Slaying Python*. Grand Trianon, Versailles. Photo: Réunion des Musées Nationaux, Paris.

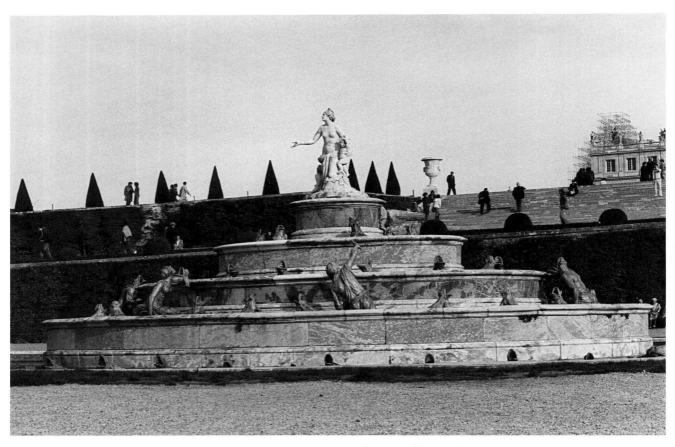

Fig. 5–17 Gaspard Marsy and Balthazar Marsy, Latona Fountain, Versailles. Photo: R. Berger.

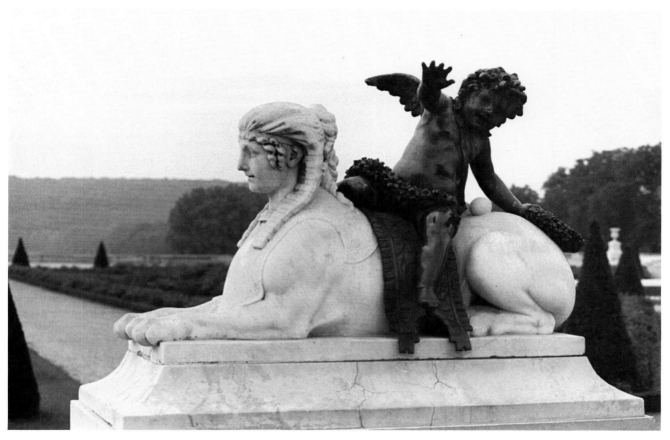

Fig. 5–18 Jacques Sarrazin, Louis Lerambert, and Jacques Houzeau (?), *Sphinx with Putto*. Parterre du Sud, Versailles. Photo: R. Berger.

Fig. 5–19 Charles Le Brun, Escalier des Ambassadeurs, Versailles. Detail of Vault. Engraving by E. Baudet from [L.C. Le Fevre] *Grand escalier du château de Versailles, dit Escalier des Ambassadeurs*, Paris, 1725.

Fig. 5–20 Charles Le Brun, Escalier des Ambassadeurs, Versailles. Detail of Vault. Engraving by E. Baudet from [L.C. Le Fevre] *Grand escalier du château de Versailles, dit Escalier des Ambassadeurs*, Paris, 1725.

Fig. 6–1 Girodet, *Ossian*, Château de La Malmaison.

A Newly Discovered Project of Girodet: Originality, Ossian, and England

6

No French artist—in any historical period—has ever been more singlemindedly preoccupied with the idea of originality than the painter Anne-Louis Girodet (1767–1824).[1] In fact, this fascination ran so deep that, according to one of his biographers, he is reported to have kept repeating to his students, almost as a leitmotif: "je préfère le bizarre au plat," that is, between two kinds of aesthetic fallacies he would rather chose the bizarre over the insipid.[2]

At the beginning of the nineteenth century a few artists and critics wrote about originality, but not one of them attached to this concept more importance than Girodet.[3] Publicly—or, more exactly, officially—his ideas on the subject are developed in *De l'Originalité dans les arts du dessin*, an essay that he read on April 24, 1817, at one of the sessions of the *Quatre Académies*, and was published in 1829 in his *OEuvres posthumes*.[4] It is a rather ponderous piece, but one can extract from it two basic ideas. First, it makes a distinction between true originality, that is, the natural originality of artists like Michelangelo and Rubens, and the artificial originality that is deliberately attempted by artists, lacking in real talent, but who are devoured by ambition. Secondly, it asserts that the whims, and even the excesses of originality can be stimulating and interesting, since we need to be moved, even if we must recur to ugliness, insofar as it can offer to us the attraction of novelty.

The confusing, pedantic, often self-contradictory explanations that characterize this essay are totally absent from the unguardedly enthusiastic letters in which Girodet speaks of his own works. In 1791, in Rome, at the time he was working on his *Sleep of Endymion* (Louvre), Girodet writes to his friend, Dr. Trioson, of his will "to do something new, something that does not suggest mere manual work."[5] In another letter, addressed to the same friend during the same period, he writes that in order to reach his goal "I want to distance myself from the art of David [Jacques-Louis David, his teacher] as much as I can and, toward this end, I spare no effort, no study, no model, no casts."[6] A few months later, when the finished *Sleep of Endymion* is acclaimed for its poetic originality, Girodet triumphantly exclaims, in a third letter to Dr. Trioson: "What, above all, gave me special pleasure is that everybody agreed that I showed no resemblance whatsoever to the art of M. David."[7]

Let us take another example. Shortly after 1802, following the exhibition of his *Ossian* (now in the Château de La Malmaison) at the Salon—a painting that was criticized for mingling Ossianic mythology and contemporary politics—Girodet writes to Bernardin de Saint-Pierre, the celebrated author of *Paul et Virginie*:

It is this painting that, despite the faults [noted by the critics] ... gave me, nevertheless, the most confidence in my small abilities, because it was completely created by me, in all its parts, without having followed any model, neither for its drawing, nor for its colors, nor for its effect, and even less for its conception ...

... Why should one not be allowed to extend still further the effects and limits known by these great men [Raphael and Poussin]? It is true that one loses oneself in space, one no longer follows any known roads. Well! If one fails, it is beautiful to fall from the sky. Icarus could not sustain himself in the sky, but he gave his name to the Icarian sea, and his fall was almost triumph.[8]

One can see that we are very far from the rather pious categorizations of *De l'Originalité dans les arts du dessin*. In his spontaneously personal statements on the *Sleep of Endymion* and *Ossian*, Girodet appears to be guilty of the very errors that he will castigate in his essay of 1817. In the midst of his effusive enthusiasm and poetic imagery, one clearly recognizes the signs of an enormous ambition and the unequivocal admission of a deliberate decision to be original.

How can an artist become original? It is evident that one cannot seriously believe that Girodet could have achieved this goal by merely distancing himself from David. This method, per se, could not have offered him a working recipe, for, obviously, there were many ways to be different from David. Generally speaking, it is certain that in looking at Girodet's works, one can observe that in order to arrive at something really new, that is, original, he was ready to take the greatest risks, tending to rely on something that could be truly surprising and unexpected.

Girodet's works that are particularly striking by their originality, such as the *Sleep of Endymion* and *Ossian*, reveal the complexity of the problem: one must acknowledge the undeniable existence of many overlapping aspects. However, in the context of this paper, forgoing the discussion of some important factors, such as Girodet's use of chiaroscuro, one must limit oneself to what is unquestionably the central focus of his approach to originality: iconography.

In well-known, historically established subjects, Girodet performs a dramatic iconographic metamorphosis, through a process of allusive and arresting substitutions. In his *Sleep of Endymion*, for instance, he eliminates the figure of Endymion's lover, the moon goddess Diana, who is one of the essential protagonists of the traditional versions of this mythological theme, and replaces her by a ray of moonlight cast on the body of the sleeping Endymion. Sometimes, in subjects actually "invented" by Girodet, arresting substitutions are combined with unexpected juxtapositions. It is particularly evident in the case of his *Ossian*, (Fig. 6–1), where the conception is derived from Rubens' *Arrival of Marie de Médicis to Marseilles* (Louvre), and where, among a number of substitutions, grimacing rebellious Ossianic warriors and sensuous beauties replace Rubens' Neptune and his cohort. Even more surprisingly, and independently from Rubens, Girodet's *Ossian* is dominated by the bizarrely anachronistic juxtapositions of two totally distinct iconographical themes: Ossianic mythology and the apotheosis of French military heroes.

In the context of the present paper, this painting deserves special attention. It must be pointed out that,

at the time of Girodet's work, the interest in Ossian was not truly new. It was rooted, of course, in one of the most famous forgeries of modern times: a group of poems, ascribed to Celtic bards of the third century, which actually, for the most part were composed around 1760 and 1780 by two Scottish eighteenth-century writers: James Macpherson and Reverend John Smith. Translated into French by Pierre Letourneur, these poems enjoyed immense success and were enthusiastically received by practically everybody in France, including Bonaparte. In fact, the profile of the blind bard Ossian appears alongside effigies of the greatest poets of all time, such as Homer, in the library of the Château of La Malmaison, the First Consul's "country house."[9] In the Salon of 1802, François Gérard and Girodet exhibited two paintings, based on Ossian themes, which were specifically commissioned to decorate this château.

Gérard's composition, *Ossian évoque les fantômes au son de la harpe sur les bords du Lora* (Kunsthalle, Hamburg), is essentially a synoptic interpretation of Ossianic poetry, and its characters are exclusively limited to the heroes of the poem. One can see, bathing in a mysteriously Romantic chiaroscuro mist, the old bard, accompanied by the members of his family, his friends, and the ghosts of his ancestors.[10] Girodet's painting is very far from such an orthodox Ossianism. Its novelty is underlined in its very title: *Hommage offert à Napoléon Bonaparte, par A. L. Girodet, du tableau dans lequel il a représenté l'apothéose des héros français morts pour la Patrie pendant la guerre de la Liberté* (Château de La Malmaison). Girodet is politicizing the Ossianic mythology. Ghosts of Ossianic heroes, led by their bard, welcome to their Walhalla-like paradise in the clouds the ghosts of French generals and soldiers who fell during the Revolutionary wars. It is an unmistakable allusion to the peace of Lunéville, signed in 1801, between France and the Austrian Empire. At the top of the composition, two allegorical birds, the Austrian eagle fleeing before the French rooster, symbolize the French victory that brought this peace, and below, a group of rebellious Ossianic warriors refers to the agitations of Great Britain which did everything in its power to prevent the signing of the treaty of Lunéville. In other words, through the strange idea of a Franco-Ossianic peace, the painting glorifies Bonaparte as a triumphant general as well as a peacemaker. We have discussed elsewhere the ramifications of this bizarre iconography, juxtaposing French soldiers and Ossianic warriors,[11] and we shall see that this subject—with the specially negative part given to the British—will play an important role in our subsequent discussions.

Let us emphasize, once more, that Ossianic poetry is subjected to radical transformations, and Girodet's

unquenchable thirst for originality not only leads him to the invention of a new subject, but to a new subject laced with direct allusions to contemporary political events. Thus, for Girodet, the search for originality often takes the form of a search for a new iconography. Following a literary genre traceable to Philostratus, and already illustrated in more recent times by Caylus, Dandré-Bardon, and Diderot,[12] the painter constantly jots down descriptions of possible new subjects. Nineteen of such descriptions are included in the *Sujets de Tableaux,* published in his *OEuvres posthumes.*[13] Some of them are very short and very simple: for instance, an old man and a child fighting for a doll.[14] Some of the others are lengthy and complicated, such as the theme of ambition, which, according to Girodet, must be developed into a succession of different compositions.[15] In general, these new subjects have classical, emblematic resonances, and very few of the preserved descriptions have anything to do with Ossian or contemporary events.[16]

In this regard, it is interesting to note the recent discovery of three unpublished, handwritten texts that extend our knowledge of Girodet's Ossianic subject searching. They appear in a note-book, actually a small in-quarto, dated 1806–1808.[17] We shall come back to this question of dates.

Two of these texts are simply copied from one of the two editions of Letourneur's translations of the Ossianic poetry of Macpherson and Smith (1799 or 1810?): the poems of "Duthona" and "Trathal."[18] In reproducing excerpts of these poems, Girodet, from descriptions abounding with heroes, battles, abductions, and treacheries, selects passages in which the bard Ossian, staged in a wild, rocky landscape, evokes ghosts, ponders on his own death, and describes his vision of lovers in the clouds. These passages are so vague that they could be used at will to interpret practically any orthodox Ossianic representation (such as, for instance, the *Ossian* of Gérard). It is evident that Girodet owned an edition of Letourneur's translation of *Ossian.* Nevertheless, in reading the text, he extracted particularly promising passages that he reproduced in his note-book to make them easily available when needed. Girodet collected subjects as one collects butterflies.

The third Ossianic text, from the same note-book, is of a far greater interest, and it deserves to be quoted in its entirety:

The ghost of Ossian welcomes in the clouds
the ghosts of Pope, Dryden, Shakespeare,
Milton, Thomson, etc.

––––––––––––––––––

All these poets lean from their clouds to
listen to the harmony of the harp of Ossian.
Malvina accompanies him with her singing—
varied and contrasted expressions of these poets.

––––––––––––––––––

To the harmonious sounds of the harp of
Ossian and the Bards, the ghosts of the English
poets and the French poets embrace each other in
the aerial castles. Some heroes of the two
nations are doing the same. Jean-Jacques Rousseau
is sulking in a corner. Frederick plays the
flute. Milton was blind.[19]

In the midst of these rather sketchy descriptions, hastily jotted down by Girodet, one can discern at least three subjects: (1) the welcoming of the ghosts of English poets by Ossian; (2) the reaction of these English poets to the music of Ossian's harp and Malvina's singing; and (3) the reconciliation between the English and the French poets, paralleled by the reconciliation between English and French heroes. An intimation of other themes is given by the sulking of Jean-Jacques Rousseau, the flute playing of Frederick (Frederick the Great), and the blindness of Milton, mentioned at the very end of the text. Naturally, it is quite possible that the blind Milton was to face the blind Ossian in (1), and that Jean-Jacques Rousseau and Frederick the Great were to be included in (3). The two lines dividing this text suggest three separate subjects, but it is not impossible to think that these subjects were meant to be combined together in some manner. It is difficult to come to a conclusion in this matter, since these ideas did not give birth to a known composition. However, one thing is completely certain: this text, in many ways recalling the theme of Girodet's Ossianic painting of 1802, is conceived as its diametric opposite. Indeed, in the *Ossian* of La Malmaison, the English are the villains, for they are trying to prevent the reconciliation between France and Austria, while in the text of the note-book, one finds an antithetical situation, glorifying the reconciliation between France and Great Britain, on a literary as well, if one notes the heroes of the two nations, as on a political plane.[20]

The latter point raises a question of chronology. The arbitrary dating of this text, 1806–1808, is probably based on the date, 1806, appearing on one of Girodet's drawings of the note-book. If this date is to be accepted, Girodet would have conceived the subject of an Anglo-French reconciliation only one year after the French defeat of Trafalgar, at the very time of the French blockade of the British isles and the ferocious hostilities that raged between the two nations. During this period, the Anglophilia of his theme would have been considered as openly seditious, if not treacherous.

In this context, one must remember that, regardless of his personal opinion of English literature (he could not read English) and of England, Girodet was extremely cautious in political matters.

Let us return to the previously mentioned dated drawing found in the note-book. It shows a highly ornate ewer, with a palette on one side and a guitar on the other. There is little doubt that this drawing, symbolizing the union of painting and music, commemorates the idea of a long and tender friendship, "*d'une amitié sans fin*," as one can read on the inscription. Most likely, these words allude to the well-known platonic love between Girodet and the popular actress-musician, Julie Candeille (which explains the palette and the guitar). It is established by their correspondence that this relationship began in 1806—the date on the drawing—and lasted until the death of the painter. Since this love affair probably started in a rather more conventional, far less platonic manner,[21] it is difficult to believe that such a commemorative drawing, in which the painter speaks of an endless friendship, could correspond to the beginning of the liaison, in 1806. Most probably, this date is introduced as a memento, and the drawing was actually executed at a much later date.

This interpretation seems to be verified by another drawing from the same note-book. It shows a group of physiognomical studies that bring to mind some of the characteristically English caricatures, engraved by such artists as George Cruikshank and Richard Dighton, caricatures that became extremely popular in France, at the beginning of the Bourbon Restoration, after 1815.

It must be admitted that the note-book cannot be situated in time with more precision. But, it is almost unnecessary to point out that the hypothesis of a later date, corresponding to a totally different political state of affairs—after the fall of Napoleon, Great Britain is no longer the enemy—can explain and justify, much more convincingly, Girodet's Ossianic glorification of England, with its surprising reversal of the idea of the 1802 *Ossian*. This reversal, with its substitutions, shows that Girodet's approach to the search for originality remains essentially unchanged during the later period of his career, when he came to be known as a staunch champion of the Classical tradition against the rising tide of Romanticism.

In fact, through the previously noted mechanism, Girodet's new Ossianic idea, giving such an important place to the substitution of soldiers by poets, is verging on the conception of a literary Parnassus, devoted to a common celebration of great *hommes de lettres* of different countries. It is quite different from the nationalistic, almost chauvinistic conception of *Le Parnasse*

François of Titon du Tillet, sculpted in 1718 by Louis Garnier (Versailles)—a conception intended to glorify Louis XIV by glorifying French writers, exclusively.[22] It is closer to the sixteenth-century *Parnassus* of Raphael (Vatican) which includes writers of three nationalities. In France, one must await Ingres' *Apotheosis of Homer* of 1827 (Louvre) to bring in Shakespeare alongside the French, in such a glorification.[23]

In any case, Girodet's new Ossianic theme of the note-book constitutes a triumph of Anglophilia; and, before anything else, the painter's anglophile enthusiasm echoes the radically changed cultural climate in Paris, after Waterloo. A passage in the memoirs of Jean Nicolas Bouilly, *Mes Récapitulations* (1836–1837),[24] relating the reception given during the Bourbon Restoration to the English actor John Philip Kemble by the French actor François-Joseph Talma, can give some idea of the French enthusiasm for England and English culture, after the fall of Napoleon. Talma organized a reception with a *souper* for one hundred people. The guests predictably included the leading actors and singers of Paris. But they also included many artists, such as the sculptors Bozio, Cartellier, and Charles Dupaty, as well as painters such as Gros, Guérin, and Girodet himself,[25] who, we shall see, played an important part in the proceedings.

The festivities were enlivened by several theatrical performances. One of them was given by the actor Beaupré, in the role of the ghost of a grenadier of the imperial guard, who went to heaven after having been killed on the battlefield. However, according to the play, the same grenadier was eventually expelled from paradise because of unbecoming conduct, and Beaupré addressing himself to Talma from the stage, begged to be recommended for a place in the veteran rest home of the Invalides. This theatrical episode is directly reminiscent of some details of Girodet's 1802 *Ossian* of La Malmaison, showing ghosts of soldiers indulging in smoking, drinking, and courting Ossianic beauties in a most disreputable manner (all this long before Raffet's *grognards*!). Because of Girodet's highly important role in the reception, one may well believe that his painting was deliberately alluded to in Beaupré's performance.

The evening was graced by many speeches and many toasts. While toasting "l'art dramatique anglais" and "l'immortel Shakespeare," Talma unexpectedly unveiled a full-length portrait of the latter, and offered it to Kemble. On the frame, one could read: "A son digne interprète! Au célèbre Kemble, par les artistes français." At this point, Girodet rose and, addressing himself to Kemble, declared: " 'It is we [pointing to the other painters] who, wanting to help our friend Talma to

celebrate your presence among us, have combined our brushes to pay you homage.' " Talma added: "Each one of our great artists wanted to participate in this masterpiece." [26]

Unfortunately, the present location of this curious collective portrait of Shakespeare is unknown. The same is true for its exact date. One may recall, nevertheless, that, according to Bouilly, Talma's reception took place during the Bourbon Restoration, the period with which one can plausibly associate Girodet's notebook. In this regard, Bouilly's account of the reception given to Kemble by Talma, with Beaupré's allusion to Girodet's *Ossian* of 1802 and the enthusiastic celebration of the Anglo-French friendship, seems to recapture the feeling of the cultural climate of the time and eloquently explains the anglophile mood that prevails in the recently discovered Ossianic text of Girodet's notebook.

In concluding, it is important to point out, once more, Girodet's deep fascination for the Ossianic poems. Considering the great number of drawings and sketches devoted to these poems, one can affirm that this fascination, beginning with the great *Ossian* of La Malmaison, lasted throughout the rest of his life. Girodet found in these strange poems the ideal context for the expression of his search for originality, an expression that, on more than one occasion, bordered on the bizarre. This search, in turn, often led him to infuse his Ossianism with anachronistic references to contemporary cultural and political developments. It is, of course, dangerous to rationalize the past, but one can venture to state that, in this regard, the emergence of an anglophile conception of Ossianic themes in Girodet's note-book, at the end of his career, was almost predictable.

George Levitine
University of Maryland

Notes

1 For Girodet see: A. L. Girodet-Trioson, *OEuvres posthumes*, edited by P. A. Coupin, Paris, 1829; J. Pruvost-Auzas, *Girodet 1767–1824*, Exposition du deuxième centenaire, Montargis, 1967; B. Bernier, *Anne-Louis Girodet, 1767–1824*, *Prix de Rome*, 1789, Brussels, 1975; G. Levitine, *Girodet-Trioson: an Iconographical Study*, New York & London, 1978. These publications can clarify the questions pertaining to Girodet which are not discussed in the present article. All the translations are mine.

2 Quoted by Coupin in Girodet, *OEuvres posthumes*, I, pp. xlv–xlv.

3 See, for instance, J. J. Taillasson, *Observations sur quelques grands peintres, dans lesquelles on cherche à fixer les caractères distinctifs de leur talent...*, Paris, 1807, p. 39; J. F. Sobry, *Poétique des arts ou Cours de peinture et de littérature comparées*, Paris, 1810, p. 440; and J. Droz, *Etudes sur le beau dans les arts*, Paris, 1815, pp. 99–115, and pp. 100–103.

4 Girodet, *OEuvres posthumes*, II, pp. 187–210.

5 "Le désir de faire quelque chose de neuf et qui ne sentit pas simplement l'ouvrier." Letter of April 19, 1791, published in Girodet, O*Euvres posthumes*, II, p. 387.

6 "Je tâche de m'éloigner de son genre le plus qu'il m'est possible, et je n'épargne, ni peines, ni études, ni modèles, ni plâtres." Letter of June 23, 1791, published in Girodet, *OEuvres posthumes*, II, p. 392.

7 "ce qui m'a surtout fait plaisir, c'est qu'il n'y a eu qu'une voix pour dire que je ne ressemblais en rien à M. David." Letter of October 24, 1791, published in Girodet, *OEuvres posthumes*, II, p. 396.

8 "C'est ce tableau qui, malgré les défauts qu'on a pu lui reprocher ... m'a cependant le plus donné de confiance dans mon peu de forces, parce qu'il est tout-à-fait de ma création, dans toutes ses parties, sans que je me sois inspiré d'aucun modèle, ni pour le dessin, ni pour la couleur, ni pour les effets, encore moins pour la conception ... Pourquoi ne seroit-il pas permis d'esayer d'étendre plus loin encore les effets et les bornes que ces grands hommes [Raphael and Poussin] ont connus? Mais on s'égare dans l'espace, on ne suit plus de routes certaines. Eh bien! quand on échouerait, il est beau de tomber des cieux. Icare ne put s'y soutenir, mais il donna son nom à la mer Icarienne, et sa chute fut presque un triomphe." Undated letter written after 1802 and before 1806, published in Girodet, *OEuvres posthumes*, II, pp. 277–279.

9 For the diffusion of the popularity of Ossianic poetry see: P. van Tieghem, *Ossian en France*, Paris, 1917; and H. Hohl and H. Toussaint, *Ossian*, Exposition du Grand Palais, Paris, 1974.

10 *Ossian*, Exposition, pp. 78–82.

11 For a detailed discussion of this subject see our article "L'*Ossian* de Girodet et l'actualité politique sous le Consulat," *Gazette des Beaux-Arts*. October 1956, pp. 39–56.

12 [comte de Caylus] *Nouveaux sujets de peinture et de sculpture*, Paris, 1955; M.-F Dandré-Bardon, *Discours sur l'utilité d'une histoire universelle, traitée relativement aux arts de peindre et de sculpter*, given at the Académie Royale, September 4, 1756, and *l'Histoire universelle, traitée relativement aux arts de sculpter*, Paris, 1769; D. Diderot, *Salons*, edited by J. Seznec and J. Adhémar, Oxford, 1963, III, *Salon de 1767*, pp. 129–167.

13 Girodet, *OEuvres posthumes*, II, *Sujets de tableaux et allégories*, pp. 259–265.

14 *Ibid.*, p. 259.

15 *Ibid.*, pp. 257–258.

16 Naturally, a number of Ossianic themes recur in a variety of Girodet's drawings, sketches, and lithographs (see *Ossian*. Exposition du Grand Palais, pp. 82–97).

17 Girodet – autographes et dessins – MS. 513 – petit quarto – 1806–1808, Institut d'art et d'archéologie, Paris. This document is referred to in the present article as Girodet's note-book.

18 *Ossian fils de Fingal, barde du 3e siècle ... traduites sur l'anglais de Macherson, par Letourneur*, Paris, 1810, I (*Duthona*), pp. 382–405, II (*Trathal*), pp. 376–388. In Girodet's note-book, these anotations appear on p. 5 verso and p. 6 recto.

19 "L'ombre d'Ossian reçoit dans les nuages les ombres de Pope, de Dryden, de Shakespeare, de Milton, de Thomson, etc.

 Tous ces poètes se penchent sur leur nuages pour entendre les accords de la harpe d'Ossian. Malvina l'accompagne de sa voix—expressions variées et contrastées de ces poètes.

 Aux accords de la harpe d'Ossian et des Bardes, les ombres des poètes anglais et des poètes français s'embrassent dans les palais aériens. Quelques héros des deux nations en font autant. J. J. Rousseau boude dans un coin, Frédéric joue de la flute. Milton était aveugle."

 Girodet's note-book, p. 5 verso.

20 One must note that Jean-Jacques Rousseau is the only French writer specifically mentioned by Girodet, while the names of the "heroes of the two nations" are totally omitted.

21 For this aspect of Girodet's relationship with Julie Candeille, see Bernier, pp. 122–126.

22 See J. Colton, *The Parnasse François, Titon du Tillet and the Origins of the Monuments to Genius*, New Haven and London, 1979.

23 One may observe that, as in the case of the *Parnasse François*, artists are not included in Girodet's glorification. In this sense, Girodet is less "progressive" than Ingres or F. J. Overbeck, in Germany, who, in his 1832 *Triumph of Religion in the Arts* (Hamburg, Kunsthalle), will include painters, sculptors, and architects. Apparently, Girodet implicitly subscribes to the notion of the cultural subservience of the artist to the writer. In fact, Girodet became almost exclusively a man of letters in his later years.

24 Paris, 1836–1837, III, pp. 77–98.

25 *Ibid.*, p. 88.

26 "'C'est nous', dit alors Girodet en se levant et désignant les autres peintres dont il est l'interprète; 'c'est nous qui, voulant. seconder notre ami Talma, à célébrer votre présence parmi nous, avons réuni nos pinceaux pour vous rendre un hommage' ... 'Chacun de nos grands artistes a voulu mettre la main à ce chef-d'oeuvre,' ajoute Talma." Bouilly, *Mes Récapitulations*, III, pp. 92–93.

Fig. 7–2 Théodore Géricault, *Couple Embracing and Fleeing Woman*, pen and wash, 307 x 216 mm. Bayonne, Musée Bonnat.

Passion and Violence in Géricault's Drawings

During his relatively short career Géricault led a life that would have filled several normal artists' lives. In 1812 his decision to paint the *Charging Chasseur* and to submit the large canvas to the jury of the Salon was a daring adventure; the acceptance of the painting alone was remarkable for such a young artist. Even the similarly precocious Delacroix entered the Salon when he was three years older than Géricault. The often-quoted exclamation by David "D'où cela sort-il? Je ne reconnais pas cette touche"[1] shows the surprise of a "chef d'école" who was accustomed to recognizing the newcomers in the sacred halls of the Salon, since the leading artists followed the careers of the more talented students of other *ateliers* as well as of their own.

Our knowledge of Géricault's life in 1813 and 1814, following the limited success of the *Chasseur*, is very restricted; the young painter exhibited three items at the Salon of 1814 : again the *Chasseur*, the lost *Exercice à feu dans la plaine de Grenelle*, and the *Wounded Cuirassier*. Toward the end of the year Géricault joined the Grey Musketeers, and then in March, 1815 accompanied the King of France to Belgium. This incident seems to be more relevant to the painter's development than a simple military adventure would ordinarily have been. Moreover, in the light of Géricault's Napoleonic ideals after 1817 this royalist engagement turned out to be ephemeral and hasty. Lorenz Eitner believes Géricault was much more attracted by the horses of the royal troupe and the military glitter than by the impact of a political conviction.[2]

Around the same time, perhaps connected with his military involvement, Géricault fell in love with his aunt Alexandrine-Modeste Caruel, six years older than her now twenty-three year old nephew. The affair, known only since the publication of related documents in 1976 by the archivist Michel Le Pesant,[3] deeply affected Géricault's life. His trip to Italy from October 1816 to October 1817 was also a flight from the ill-fated relationship with Alexandrine-Modeste. Charles Clément, the most reliable source for the artist's life and cataloguer of his work in the nineteenth century, knew the story, but withheld his knowledge because of its implications for the still living members of the families Caruel and Géricault. In a very discreet manner Clément passed over these months: "Une affectation par tagée, irrégulière, orageuse, et qu'il ne pouvait avouer, où il avait apporté toute la violence de son caractère et de son tempérament, ... le troublait jusqu'au fond."[4] New research in French archives has enabled Germain Bazin to tell the whole story in detail. Bazin puts the beginning of the liaison in early 1814; moreover, Géricault's enlistment in the Grey Musketeers may have been the first flight from the turbulences of love.[5]

During the one and a half years between the enrollment in the Musketeers and the departure to Italy, a new and spectacular group of drawings can be connected with Géricault's private life.[6] These drawings, which until now have not been dealt with in a larger context, are mainly from the period 1815–1817, corresponding to the time before and during his stay in Italy. The iconography of these drawings covers an area of violent action between human beings, including rape, slaughter, murder and torture, but also more pastoral motifs of Satyr and Nymph. Prior to the years 1815-1816, Géricault limited action in his art to military scenes, such as single charging officers or battles, which were at this time very popular motifs. The eruption of the new iconography shows no parallels in contemporary French art; only Goya, and some decades earlier, Fuseli, created similar works.

One of the difficulties in dealing with the group is the titles of the drawings. Charles Clément already had problems in cataloging the related items.[7] They are

scattered throughout the roughly chronologically arranged catalogue and bear such titles as "Croquis divers" (Clément no. 79), "Demons" (Clément no. 105) or "La Rixe" (Clément no. 166). For Clément it was even difficult to understand how an artist could create a drawing without describing a traditional subject. For Géricault to follow his own thoughts or dreams in creating such fantastic motifs, was outside the realm of artistic tradition. We may assume that the pressing love affair affected the already shaken character of the artist and opened the door to new orbits in artistic creation.

The drawings in question may be divided chronologically into two groups, one created in 1815–1816 in Paris, and the other in 1816–1817 in Italy. The earlier cluster contains about twenty sheets, today in various museums and private collections. Stylistically they correspond to a return to classicism, but in a way very different from the products of contemporary academism. Lorenz Eitner characterized this change as an "explosion of energy, like that produced by a flow of lava into a bed of ice."[8] Some of the drawings are still connected with classical themes such as the *Venus and Cupid* (Fig. 7–1); one group revolves around the subject of Centaurs carrying off women (Figs. 7–7 and 7–8);[9] another depicts Leda and the Swan.[10] A third group comprises pictures with no decipherable titles, showing coupled men and women, usually fighting and torturing each other (Figs. 7–2, 7–3, 7–4, 7–6). The several known drawings of satyrs and nymphs (Fig. 7–5)[11] linked with the sculpture *Satyr and Nymph* (Rouen, Museum), lack the original power of the untitled groups.

Lorenz Eitner dates the Centaur and Leda drawings to the years 1816 and 1817 and sees them as a sublimation of "the earlier, darker fantasies."[12] There is, in fact, not only an iconographical change, but also a different control of pen and pencil; the earlier drawings show strong contours and violent contrasts in lights and shadows. In the second group, the more sculptural effects have been replaced by a more painterly handling of the outlines and the plasticity of the body-volumes (Figs. 7–7, 7–8). The mythologically defined works, however, are based essentially on the earlier ones, and their mastery would not have been possible without the previous experience.

Until 1815 Géricault, as we have observed, did not depict much action. Suddenly, during his stay in Rome and until 1820, action and violence seem temporarily to dominate his artistic work. The *Race of the Barberi* and the *Cattle Market*, both conceived in Italy and documented in drawings and small oil paintings, demonstrate humans and animals in full movement, often fighting one another. Géricault's Italian projects for a large

painting, probably intended for the next Salon, never entered the stage of realization and the artist, after his return to Paris in late autumn of 1817, still had to decide on a suitable theme for his next public appearance. One of the *affaires célèbres* during the Restoration was the murder of Antoine-Bernardin Fualdès, former chief prosecutor then businessman in the town of Rodez in southern France. Fualdès was attacked, abducted and murdered on March 19, 1817. There were two trials of the suspects, one in August / September 1817, the other in March 1818. The seven members of the gang were sentenced to death on May 4, 1818, and executed on June 3 of that year (Fig 7–10).

The trials were widely discussed in France because of the horrible story itself, and because the suspects were believed to be involved in a Royalist revenge action. Géricault made seven drawings describing the attack on Fualdès from the first meeting of the malefactors to the final disposal of the corpse in the Aveyron river and the flight of the culprits (Fig. 7–9). The drawings show different degrees of finish, ranging from rather hasty pen-and-ink sketches to very elaborate compositions in black chalk and wash.[13] Two of the pen drawings show rather amusing details: in *Fualdès Dragged into the Murder House* the doll-like expression of the surprised victim is in striking contrast to the seriousness of the gang members, and in *The Assassination* a pig licks the blood of Fualdès, one of the widely published tragi-comic facts revealed during the trials. The two finished drawings, on the other hand, fulfill in style and composition every demand of a large-scale history painting. Never before had the description of a personal and ultimately trivial event been transposed into scenes of an antique tragedy. Nevertheless, Géricault abandoned his project of a painted Fualdès representation; Charles Clément explains this decision as a result of the popular prints devoted to the story, but I must agree with Lorenz Eitner, that the subject was too poor to serve for a monumental painting.

The full story of the shipwrecked frigate *Medusa* was published by the two survivors Savigny and Corréard in November 1817. It combined every nightmare of a sailor with general human tragedy, and the whole affair was exploited against the actual regime of the Bourbons. In a way the *Medusa* story bears one important similarity to the Fualdès murder: sudden and unexpected calamity in life. In the multiplication of death, and in the prolonged suffering of the passengers on the raft for thirteen days, the event presented much greater potential for the exercise of Géricault's imagination than did a single death. The adventures of the survivors held many opportunities for the dramatic depiction of frenzy and Géricault, in the development of his

final composition, followed nearly all the tumultuous episodes and incidents on the raft. With the iconographical and compositional work for the *Raft of the Medusa* Géricault seems to have exhausted this interest, and neither his lithographs nor the themes he treated in England show similar aspects of vehement action.

The personalization of Géricault's iconography at the beginning of the nineteenth century is exceptional. One could object that the artist made the drawings in 1815–1816 only for his private pleasure and one would be correct, but the main issue lies elsewhere and seems to reside in the extraordinary character of the artist. In examining the few personal reports of Géricault's life we receive the impression of a fierce and easily aroused temper. His attraction to horses and wild rides, which finally led to his early death, is all too well known to require discussion here. One of his most typical character traits emerged in changes of mood, from the deepest depression to exuberant high spirits. A good example of this behavior is contained in a letter of Th. Lebrun to Feuillet de Conches[14] which tells of a not-so-funny story about a visit by Lebrun to Géricault's apartment. Géricault had put curlers in his hair, and as Lebrun told him about cancelling their joint trip to Italy, Géricault believed his uncommon appearance must be the reason for the change of plan. Lebrun could convince him of the futility of this argument only with the greatest difficulty. Another example is given by Géricault's close friend Charlet: Géricault tried to kill himself one evening in an English hotel but was saved by Charlet. After a short discussion Géricault burst into laughter and promised his friend not to repeat the attempt.[15]

* * * *

The issue of Géricault's relationship to women is still unclear. The affair with Alexandrine-Modeste continued after the artist's return from Italy and caused further havoc in his life. I refer here to the biography by Lorenz Eitner and his excellent description of this clandestine and tragic love. With the birth of a son in August 1818 Alexandrine-Modeste was forced to abandon her family, and we know nothing about further meetings. On the other hand, Géricault was now living in the "Nouvelle Athènes" quarter close to his friends, the painter Horace Vernet and the old Royalist Colonel de Bro.[16] Denise Aimé-Azam gives a vivid picture of the wealthy life at the Rue des Martyrs and identified—before the publication by Le Pesant—Madame L'Allemand, the beautiful wife of a temporarily exiled Napoleonic general, as a mistress of Géricault. The discovery by Le Pesant clarifies the mystery in the family, but it does not exclude other liaisons, especially after

the birth of Georges-Hyppolite. A passionate correspondence between Géricault and a hitherto unknown woman, revealed for the first time in letters that came to light at a Paris auction in 1985, gives us another important clue to this issue.[17] Added to this are minor stories such as that of the long-known letter to an anonymous female addressee; the correspondence again reveals a hot-tempered personality consistent with our knowledge of the artist.[18]

Compared to other contemporary masters, Géricault created only a few drawings and no paintings at all of the female nude. The identity of the models has aroused some discussion, albeit without conclusion. If we omit the nudes shown either in a group or as couples, we have a small number of beautiful drawings of single women which leads to other riddles about when and where they were drawn and whom they represent. One drawing with two figures, obviously depicting the same young girl (Paris, Ecole des Beaux-arts; Fig. 7–11), may serve as an example: in a tracing of the same women in the so-called Calman sketch-book we see a third figure in the form of a winged, dangerous looking male (Fig. 7–12); obviously the copyist, Alexandre Colin, traced a now lost original. The connection between the figures is dubious; does the male observe the naked body of the girl or is he just an added sketch, perhaps in a contrast between beauty and ugliness? [19]

Similar mysteries occur in the portraits. Although they do not cover an important part of the *oeuvre* (the few portraits are intimately related to the life of Géricault), they almost always represent the artist's close friends. We can deal here only in passing remarks with a very small group of female heads; the most interesting one is in the Béziers Museum (Fig. 7–13) and was identified by Clément as a model who lived on the Rue de la Lune called "La grosse Suzanne." Some ten years later the catalogue of the Walferdin sale in 1880 lists the painting as *Tête de femme: Sa Maîtresse*, and Lee Johnson attempted in 1981 to shed light on this puzzle, comparing the painting in Béziers with drawings of models in a previously undiscovered sketch-book by an unknown artist done around 1820.[20] In agreement with Lorenz Eitner I am inclined to identify the lady as Alexandrine-Modeste Caruel, the same sitter as in the beautiful drawing from the sketch-book by Géricault in the Kunsthaus, Zurich (fol. 47 recto; Fig. 7–14). The likeness has already been mentioned by Johnson. If we look at the life and work of Géricault in general, nothing would be more alien to character than to bring to life the features of a professional model in such a personal and tender interpretation. The Zurich sketchbook (fol. 17 recto) shows another female portrait with a more direct and realistic approach to the sitter (Fig. 7–16). This

drawing bears a striking resemblance to the full-length portrait of a seated woman (in oil) representing Laure Bro, the wife of Colonel Bro,[21] Géricault's neighbor in La Nouvelle Athènes (Fig. 7–15). The two portraits of Laure Bro give an excellent example of the distance within the range of respect and friendship, while the painting in Béziers and the related drawing in Zurich presumably representing Alexandrine-Modeste Caruel show, in my opinion, a spiritualized tenderness which is lacking in both portraits of Laure Bro.

After the birth of his illegitimate son in 1818, the pictorial expression of tender feelings forms a leitmotiv in Géricault's work. In contrast to the motif of mother and child, the one of father and child appears several times in important compositions or sketches for projects, the best known example of which is the father and child group in the *Raft of the Medusa*. With the exception of the *Medusa* we have to look at drawings, where the theme appears for the first time in connection with the *Wounded Cuirassier* in 1814.[22] The next related drawing belongs to the Roman period, the *Roman Peasant* with a child in his arms.[23] After the *Raft of the Medusa* Géricault also used the motif in the study for the monumental composition *Liberation of the Prisoners of the Spanish Inquisition;*[24] other related drawings and a single sketch on the verso of the aforementioned study show the importance of the small group for the artist himself.

Even if the use of autobiographical elements in art seems to be commonplace in the Romantic era, the case of Géricault constitutes an extreme position. The artist lived through his own experiences in such an intense and passionate way that we should always examine his work in view of a possible intermingling with his private life. Géricault's temperament is revealed in many aspects of his *oeuvre* and can even be found in a highly polished composition such as the *Raft of the Medusa*. The interpretation of hitherto mysterious motifs[25] may benefit from further discoveries about Géricault's life which, in many ways, still forms a mystery in itself.

Hans A. Lüthy
Schweizerisches Institut
für Kunstwissenschaft, Zurich

Notes

* An earlier version of this essay was written for the catalogue of the exhibition "Théodore Géricault," organized by the Salander-O'Reilly Galleries, New York, 1987. The present text is updated and newly illustrated.

1 Lorenz Eitner, *Géricault, His Life and Work*, Cornell University Press, 1983, pp. 11 and 36.

2 Eitner, *Géricault* (1983), p. 74.

3 *Revue de l'Art*, 31, 1976, pp. 73 ff.

4 Charles Clément, *Géricault, Etude biographique et critique*, 3rd edition, Paris, 1879, pp. 77–78.

5 Germain Bazin, *Théodore Géricault*, vol. I, Paris, 1987, pp. 153–163. Of the five volumes projected only two have been published (1987); volumes III to V are expected in Fall 1988.

6 Eitner, *Géricault*, (1983), figs. 63–65; cf. also endnotes to chapter II, pp. 110 and 111; Eitner, *Géricault*, exhibition catalogue, 1971–1972, Los Angeles, catalogue number 25; Philippe Grunchec, *Master Drawings by Géricault*, International Exhibitions Foundation, Washington, D. C., 1985, catalogue number 26.

7 Clément's catalogue of the drawings is much less complete than the catalogue of the paintings; the author obviously considered many drawings as negligible study material. In addition to the 197 (180 plus 17 in the supplement) listed items Clément frequently mentions additional drawings and several groups of drawings in footnotes without giving full particulars as he does in the catalogue.

8 Eitner, *Géricault* (1983), p. 80.

9 *Ibid.*, pp. 104–105, illustrations 88–90.

10 *Ibid.*, p. 104, illustration 87.

11 *Ibid.*, illustration 66; Grunchec, *Master Drawings by Géricault*, catalogue number 20 recto.

12 Eitner, *Géricault* (1983), pp. 104–105, illustrations 88–90; Grunchec, *Master Drawings*, catalogue number 39.

13 Eitner, *Géricault* (1983), p. 157, endnotes 61 and 62; first published by Klaus Berger, *Géricault und sein Werk*, Vienna, 1952, figs. 54–59. Eitner, *op. cit.*, fig. 145, shows an additional drawing. His fig. 147 belongs to the Lille Museum, not to the one in Rouen.

14 Cf. M. Tourneux, "Particularités intimes sur la vie et l'oeuvre de Géricault," *Bulletin de la société de l'Histoire de l'Art Français*, 1912, pp. 56 ff.

15 Cf. Pierre Courthion, *Géricault raconté par lui-même et par ses amis*, Vesénaz-Genève, 1947, p. 232 with an argument about the truth of the incident; cf. also Eitner, *Géricault* (1983), p. 214; Bazin, *op. cit.*, doc. 180.

16 Cf. Exhibition catalogue *La Nouvelle Athènes*, Musée Renan-Scheffer, Paris, 19 Juin—21 Octobre 1984; Denise Aimé-Azam, *Mazeppa, Géricault et son Temps*, Paris 1956, pp. 147 ff.

17 Bazin, *op. cit.*, I, doc. 228bis. Bazin reprints the text of the catalogue (*Vente Autographes et Documents*, Hôtel Drouot, Paris, 19 décembre 1985, No. 35), as he did not see the letters himself.

18 Bazin, *op. cit.*, doc. 228, with facsimile of the letter.

19 Bazin, *op. cit.*, II, numbers 172 and 172B. (The illustrations numbered 172 and number 172A are confused). Another drawing with the winged figure is in the Rouen Museum; see *Gazette des Beaux-Arts*, 1954, II, p. 112, fig. 16.

20 Lee Johnson, " 'La grosse Suzanne' Uncovered," *The Burlington Magazine*, April 1981, pp. 218 ff.; Eitner, *Géricault* (1983), p. 93, fig. 77; Philippe Grunchec, *Tout l'Oeuvre peint de Géricault*, Paris, 1978, catalogue number 120.

21 Grunchec, *Tout l'Oeuvre*, catalogue number 217.

22 Grunchec, *Master Drawings by Géricault*, catalogue number 7 verso; cf. Hans A. Lüthy, "Master Drawings by Géricault," in *Master Drawings*, vol. 24, 1986, p. 565.

23 Grunchec, *Master Drawings by Géricault*, catalogue number 35 verso and fig. 35a; the motif here is obviously inspired by a real scene.

24 Eitner, *Géricault* (1983), fig. 219; Grunchec, *Master Drawings by Géricault*, catalogue number 61 recto and verso.

25 Cf. Grunchec, *Master Drawings by Géricault*, catalogue number 21 and the related remarks in the reviews of Lorenz Eitner in *The Burlington Magazine*, January 1986, pp. 55–59, and Hans A. Lüthy, in *Master Drawings*, *op. cit.*, p. 565.

Fig. 7–1 Théodore Géricault, *Venus and Cupid*, pen, brown ink and watercolor, 195 x 260 mm. Sotheby's, London, November 26, 1985.

Fig. 7–3 Théodore Géricault, *Executioner Strangling a Prisoner*, watercolor, pen and white wash, 134 x 208 mm. Bayonne, Musée Bonnat.

Fig. 7–4 Théodore Géricault, *Struggle Between Two Men*, chalk, 210 x 279 mm. Bayonne, Musée Bonnat.

Fig. 7–5 Théodore Géricault, *Satyr and Nymph*, pen and wash, 211 x 132 cm. Paris, private collection.

Fig. 7–6 Théodore Géricault, *Sketches with Abduction of Women*, pen, 228 x 176 cm. Exhibition of early drawings, Ch. Powney, London, July 1978, catalogue number 37.

Fig. 7–7 Théodore Géricault, *Centaur Abducting a Nymph*, pen and ink, white gouache on oil-impregnated paper. Rouen, Musée des Beaux-Arts.

Fig. 7–8 Théodore Géricault, *Centaur Abducting a Nymph*, pen and ink, white gouache on oil-impregnated paper. Rouen, Musée des Beaux-Arts.

Fig. 7–9 Théodore Géricault, *Escape of the Assassins of Fualdès*, pen and wash, 200 x 260 mm. Rouen, Musée des Beaux-Arts.

Fig. 7–10 L. Rüllmann, "Pronouncement of the Death Penalty, 1818" (Fualdès Trial in Paris). Lithograph, 220 x 290 mm.

Fig. 7–11 Théodore Géricault, *Two Women Standing*, pen, 223 x 200 mm. Paris, Ecole des Beaux-Arts.

Fig. 7–12 Unknown copyist (Alexandre Colin?) after Théodore Géricault, *Two Women Standing with Standing Male Figure*, pen, 194 x 283 mm. Zurich, private collection.

Fig. 7–13 Théodore Géricault, *Portrait of a Young Woman (Alexandrine-Modeste Caruel?)*, oil on canvas, 460 x 381 mm. Béziers, Musée des Beaux-Arts.

Fig. 7–14 Théodore Géricault, *Page of the Zurich Sketchbook with Bust of Young Woman (Alexandrine-Modeste Caruel?)*, fol. 47 recto, chalk and white gouache, 270 x 210 mm. Zurich, Kunsthaus.

Fig. 7–15 Théodore Géricault, *Portrait of Laure Bro*, oil on canvas, 450 x 550 mm. Paris, private collection.

Fig. 7–16 Théodore Géricault, *Page of the Zurich Sketchbook with Female Portrait (Laure Bro?)*, fol. 17 recto, pencil, 270 x 210 mm. Zurich, Kunsthaus.

Fig. 8–12 Paul Cézanne, *La Lecture chez Zola*, 1867–1869. Private collection.

Parisian Writers and the Early Works of Cézanne

8

For George Mauner: scholar, teacher and friend.

In a short story written in the late 1860's, Edmund Duranty, art critic and novelist of the realist movement, told of an artist who was much discussed in Paris as being "very odd." From pure inquisitiveness, yet with some trepidation, the narrator of the story paid a visit to this painter's studio. "Enter," he heard in a voice redolent of the south of France. What he saw there was the room of a rag picker, a *chiffonier*. Dust, garbage, old clothes and pieces of broken dishes were piled everywhere; a smell of mold permeated his nostrils. Then he saw the painter called Maillobert. He was bald with a great beard, and gave the impression of being both young and old at the same time, somehow personifying the symbolic divinity of his own studio—indescribable and sordid. He gave the visitor a grand salute accompanied by a smile that was indefinable; it might have been either bantering or idiotic. At that moment the narrator's eyes were assailed by enormous canvases flung in every direction, so horribly painted, so wildly colored, that he stood petrified. "Aah," said Maillobert, with his slow, exaggerated Marseillaise accent. "Monsieur is a lover of painting! Observe! These are merely the *small* scraps from my palette," and he pointed to the huge sketches thrown about the room.[1]

It was generally understood then, as it is now, that Duranty's somewhat harsh caricature represented Paul Cézanne.[2] Duranty met regularly with the circle of artists and writers known as *Le Group des Batignolles,* which included the painters Manet, Renoir, Fantin-Latour, Degas and Monet, and the writer Émile Zola, at the Café Guerbois in Paris. It was there that he, as the others, was surely witness to the peculiar behaviour of the artist from Aix. It was true that people heard more about Cézanne than they saw, but much of the popular legend was accurate: he was at once violent and gentle, timid and proud; he did paint and exhibit "odd" pictures; and, perhaps most significant for the artistic circle, he was the old boyhood friend of Émile Zola.

Cézanne, nearly thirty in 1867—the time of Duranty's story—was tall, thin and bearded. He had knotty joints and a powerful forehead. He wore a battered felt hat, an enormous overcoat that the rain had streaked green, and below his short trousers bright blue stockings could be seen protruding from huge laced boots. He had a nervous shudder that was to become habitual. When Cézanne did come to the Café Guerbois he seldom entered into conversation with the group. His first glance was usually mistrustful; then he would quickly shake hands all around. But in the presence of the urbane Manet, he would remove his hat and then apologize: "I do not shake your hand, M. Manet. I have not washed for a week." Taking himself off to a corner he would show little concern for the conversation around him, but when he heard an opinion different from his own, he would stomp out of the Café, not to be seen again for days.

Cézanne's ill-kempt exterior, crude language, and scowling face, although bold attempts to express his distain for convention, were little more than a thin veil which covered great tenderness and insecurity. He had a keen intellect; he was a scholar who knew Lucretius, Cicero, and Apuleius, and called Plato the "supreme philosopher." He wrote his own verse in Greek and Latin. Gauguin was to speak of him as "a man of the south of France who passes entire days on the summit of the mountains, reading Vergil and looking at the sky."[3] He avidly read the works of Victor Hugo, Alfred de Musset, Balzac, Stendahl, Gustave Flaubert and the brothers Goncourt. He was the first to whom Zola presented copies of his criticism and his novels. Baudelaire was his favorite poet. Cézanne's copy of Baudelaire's *Les Fleurs du mal* was worn to tatters, and

from this volume he knew "Une Charogne" from memory, never missing a word.[4] Of all composers, he particularly admired Beethoven and, like many artists in Paris, was enraptured by the music of Wagner, especially his opera, *Tannhäuser*.[5]

Cézanne's so-called "black" pictures, those early works from the decade of the 1860s, were seldom appreciated and less understood, even by his friends and fellow artists. To shock and insult the august jury of the Salon, he submitted canvases for six consecutive years— 1864–1869. Anticipating rejection, he was never disappointed. A portrait of his friend Valabrègue, entered in 1866, was judged as having been painted not only with a knife but with a pistol as well.[6] Others works elicited public jeers and laughter. Manet was said to find Cézanne's still-lifes powerful, but later mitigated his remark by noting that Cézanne was not much more than an interesting colorist.[7] When he saw *L'Aprés-midi à Naples,* also submitted to the Salon that year, Manet's distain was fully evident. He asked the painter Guillemet, one of Cézanne's staunch supporters, "How can you abide such foul painting?"[8]

These paintings and drawings from the '60s are usually considered only as the outpourings of the youthful artist's dark moods and impetuous nature, but the interested observer is compelled to seek elsewhere the foundations of their eccentric and sensational subject matter. Among the most fertile sources for clues to these troubled works are Cézanne's letters and poems, written to Émile Zola when the future novelist left his boyhood home in Aix-en-Provence to live in Paris. In romantic effusions to his friend we find Cézanne's fond references to their youthful camaraderie interspersed with descriptions of macabre dreams and fantasies—these centering, almost without exception, on his family and on women.

Cézanne's friendship with Zola began in 1852 when the two met at the College Bourbon in Aix. Strong and burly, Cézanne took the puny, slightly younger Zola under his protection. We were opposites by nature, Zola was to recall later, but we became united forever, attracted by secret affinities.[9] When free from school, the boys roamed the country-side, hunting, fishing, swimming, reading, and writing their own poetry. "Victor Hugo's dramas haunted us, like magnificent visions. When we were dismissed from classes, our memories frozen from the classical tirades we had to learn by heart, we experienced an orgy replete with thrills and ecstasy, warmed by reciting scenes from *Hernani* and *Ruy Blas*. Victor Hugo reigned as monarch until one morning we discovered Alfred de Musset. Reading Musset was for us the awakening of our own hearts. We

trembled. He became our religion; his tears won us over when we read aloud, for perhaps the twentieth time, 'Rolla' and 'Les Nuits'."[10]

Each boy believed the other to have extraordinary destinies, particularly concerning artistic questions. In 1860, Cézanne wrote to Zola that painting began to appeal to him more and more; Zola longed to write.[11] It was his idea for a great artistic collaboration. "I had a dream the other day. I had written a beautiful book, a wonderful book, which you had illustrated with beautiful, wonderful pictures. Both our names shown in letters of gold on the first page, and, inseparable in this fraternity of genius, they were passed on to posterity."[12]

It was Zola who demanded that Cézanne resist his father's wish that he study law. Although he himself hated the city, he convinced Paul that to explore all aspects of art, and to be free to realize his dreams, he must be in Paris. Cézanne finally arrived in the capitol in April 1861. He was later to admit that this first stay in the city was one of the most unhappy periods of his life. In spite of Zola's presence, he was constantly disillusioned and unproductive. He returned to Aix-en-Provence in September, discarding his dream of painting to work in his father's bank. But discouraged again, denouncing the bank, sensing the isolation of Aix, and possessed anew by the "demon" painting, he was back in Paris the following summer, thereby setting up a pattern, for the next forty years, of travel back and forth. He had, in all, twenty different residences in the city.[13]

The friends' separation in 1861 was cold. It seemed that by then Zola was questioning whether their friendship needed the sun of Provence for it to persist.[14] But if Cézanne was vacillating professionally, by the mid-1860s Zola was deeply involved with his own literary projects. The group of young artists who rallied around Manet after the Salon des Refusés in 1863 found in Zola a champion who expressed his opinions in plain, sincere language. His publications on art gave him an important place with the Batignolles artists. In a series of articles published in the newspaper *L'Evènement,* he defended the painters as the official Salon rejected them. But it is curious that in all of Zola's reviews of his friends' rejected works—those of Pissarro, Monet, and especially Manet whom he particularly admired—he never once discussed any of Cézanne's canvases.[15] It was apparent that he could appreciate Manet's more naturalistic approach than the romantic, seemingly crude and moody scenes that Cézanne was painting at the time. As such an outspoken proponent of this "new art," Zola was severely criticized and was virtually forced to give up his contributions to the newspaper.

But in the Spring of 1866, he immediately reprinted his articles in a pamphlet entitled "*Mon Salon.*" Its long dedication, to "Mon Ami, Paul Cézanne," was a tribute to friendship, a public avowal of Zola's affection for the artist; it apparently was *never* an appreciation of the painter. These sentiments are clear from the beginning where Zola wrote:

Happy are they who have memories! I envisage you role in my life as that of the pale young man of whom Musset speaks. You are my whole youth; I find you mingled with all my joys, with all my sufferings. Our minds, in brotherhood, have developed side by side. We have faith in ourselves because we have penetrated each others hearts and flesh.[16]

In poignant terms, Zola seemed to express a farewell to Cézanne, an end to an era of fond happiness never hinted at again. The years may have dulled Zola's youthful enthusiasm for Cézanne's artistic endeavors. He continually felt that, to that cause, Cézanne's best was not good enough.[17]

Even if Zola could never appreciate Cézanne's painting, it is apparent in his novels that he reveals a great deal about his friend as an individual *and* as an artist. From his many notes, beginning as early as 1868, for the construction of the monumental Rougon-Macquart cycle, it becomes clear that Zola had Cézanne in mind as the central character, Claude Lantier. And it is from these sketches that we learn of his conception of the "intense psychological process of an artist's temperament and the terrible tragedy of an intelligence that consumes itself."[18] His setting for the novels was Aix (which he called Plassans); the patriarch of the family was obviously based on Cézanne's father (mocking, bourgeois, cold, stingy).[19] Thus in the memories of his youth, Zola made use of his friend, and in truth it is in this way that the two become inseparably linked.

It is not surprising, then, that even in works published before the Rougon-Macquart series—particularly the novels *Thérèse Raquin* (1867) and *Madeleine Férat* (1868)—allusions to Cézanne and to Zola himself cannot but be acknowledged. When the so-called triangles in these stories are analyzed, it is clear that one of the young men is ineffectual, unattractive and effeminate. He lacks a parent, as did Zola, and is usually dependent on a stronger, more virile comrade who befriended him at a provincial school.[20] Zola persists with realism and autobiography in *Thérèse Racquin*—Thérèse, the desired object of both her lover and her husband.[21] She and the vigorous artist, Laurent, conspire to carry out the murder of the pale, weak-willed and mother-domi-

nated Camille. The similarities between Laurent and Cézanne are too marked to be merely coincidental: both are from Provence, both are painters, both are impoverished by wealthy fathers who disapprove of their careers. Zola characterized the adulterers as "des brutes humaines, rien de plus."[22] In his novel *Madeleine Férat*, the triangle appears again, the temperaments of the men repeated. But here the woman, Madeleine, becomes a more strongly developed character, powerfully willed and bodied, bold and emasculating.[23] As late as 1890, in the novel Zola names *La Bête humaine*, there are *two* trios and three murders; one of the victims is a man, two are women. The story seems a likely sequel to both *Thérèse Raquin* and *Madeleine Férat*, reiterated and embellished twenty-five years later.[24]

What was the nature of Cézanne's artistic production during those years? Several of his paintings from the mid-sixties were gifts to Zola: the bizarre *L'Enlèvement*, a scene of rape which appears to take place in the shadow of the Mt. Sainte Victoire, near Aix; the enigmatic *La Pendule Noire*, where heavy geometric shapes contrast with sensuous, bright undulations.[25] But several other of Cézanne's figure paintings and drawings reveal clear parallels to the violent themes which are explicit in Zola's novels. These portray physical struggles with a cast of characters that is nearly always constant. As in Zola's work, there is again a threesome. But for Cézanne this trio consists of an attacker, always a male; a victim, always a female; and an observer/accomplice who may be either male or female. Only the woman/victim's part varies. At first she appears as seductress, but later relinquishes this role as she becomes progressively terrorized, unconscious, and ultimately lifeless. Throughout this development, the fate of the beleaguered heroine is brutally evident. We wonder if she is meant to be getting her just desserts.

Even if the figures play different roles, their types are often repeated. In all of these pictures, the males are ungainly and distorted. There is the huge bronze man in *L'Enlèvement*, the lunging knife-wielder in *Le Meurtre*, (Fig. 8–1) and the murderer's accomplice who assumes the role of the strangler in *La Femme étranglée* (Fig. 8–2).[26] The woman's form, in each case, is largely indistinguishable. Hidden by the man's body or by lumpy clothing, she is, nevertheless, always prominent because of her flowing mane of wavy hair: black, red, or golden, as the case may be. Cézanne reinforces the notion of a narrative, or an allegory, by setting two of these scenes on a stage, the drama disclosed by parted curtains.[27]

The same bestiality described by Zola seems present here, and indeed our revulsion is incited by the "attackers" who advance on all fours toward their victim.

Zola writes, in *La Bête humaine*, of Roubaud's hands moving uncontrollably to take Séverine by the throat, of Jacques' obsession to possess, then kill a woman. But whereas the painter only alludes to a sexual motive in these encounters, Zola emphasizes the link between sexual union and death, making one either the reason for, or result of, the other. Surely this is the case in *Thérèse Raquin* when she and Laurent contemplate Camille's demise as a means of making their passion "legitimate."

The three actors differ slightly in paintings wherein Cézanne dwells on death. The artist scarcely disguises his own presence in *L'Autopsie* (Fig. 8–3) where he is recognizable by his bald pate, framed by hair that is particularly long at the back and by his revolutionary beard.[28] Curiously, he has taken the pose of the accomplice in *Le Meurtre*, but he performs no funereal task. His arms and hands appear to be motionless as he contemplates the white body, an exception in this case, as the victim is a male.

It seems that in such representations of the watchers and the dead, Cézanne is never far from Zola's imagery. The artist Laurent, in *Thérèse Raquin*, becomes almost an inhabitant of the morgue, examining bodies daily, searching for Camille's corpse not yet recovered from the river at the scene of the "accident." At last he found him:

> In front of him, on a slab, he saw Camille, stretched on his back, head elevated, eyes half open. Laurent stayed immobile for five minutes, lost in unconscious contemplation, engraving on the depths of his memory all the horrible lines, the dirty colors, of the picture which he had under his eyes.[29]

The connection between painting and novel is even more fascinating when we recall how closely Laurent's characteristics were based on Cézanne.[30] It seems to me that similarities such as these not only indicate affinities in the psychological make-up of the two friends at this time, but an obvious relationship in their artistic production as well. Which came first—painting or novel, or why the artist played a pivotal role in either "tableau"—can be only a matter of conjecture.[31]

* * * *

In the most enigmatic of Cézanne's early, so-called "romantic" pieces, *La Tentation de Saint Antoine* (Fig. 8–4), the artist's overt participation is perhaps never questioned.[32] He is both actor, barely disguised as the bald Saint at the left margin, and observer, joining our position as spectators of the scene. The theme of the painting seems connected, even having a spiritual link, with Flaubert's novel, *La Tentation de Saint Antoine*, and it appears that the "subconscious and rebellious capacity for suffering" that Baudelaire sensed in Flaubert's work was to permeate Cézanne's painting as well.[33] Only excerpts from Flaubert's first version of *La Tentation* had been in print—these in *L'Artiste*,[34] a journal with which Cézanne was very familiar. A complete and revised version of the story was published in 1874, and Cézanne's return to the subject in the same year showed a more explicit depiction of the Saint beset by a seductive woman.[35] In light of several suggestions made by John Lapp and Theodore Reff concerning parallels between Cézanne's earlier *Tentation* and Zola's novel, *Madeleine Férat* (both 1869), as well as the profound personal content revealed in each work, this painting may actually be the closer graphic counterpart of Zola's novel than of the work by Flaubert.[36]

The often-noted peculiarities of Cézanne's composition are clearly calculated. Saint Antony, the subject of the painting, is relegated to the margin where he is confronted by his temptress. The three other starkly lit and isolated nudes are unbalanced in arrangement. If we follow the deliberate parallel vertical and diagonal directives, two emphases are apparent: the standing frontal figure with drapery and the opposing images of the Saint and the fire. Although opposites in position, color and intensity of illumination, they are given equal space and like proportions, thereby suggesting their thematic importance in the composition. These, too, are the components that separate the painting from representations of a Judgment of Paris where there are always three nudes and a melancholic, contemplative figure.[37] But it is the fire that is the most important key to the interpretation of the painting.

The ascetic monk supposedly portrayed in Cézanne's canvas is Antony, father of monasticism and founder of the *vita contemplativa*,[38] celebrated as protector against demons, the plague and other evils. In a cult which was popular during the Middle Ages, particularly in the eastern provinces of France, he was revered for his healing powers over *Herpes zoster*, a disease which came to be known as "Saint Antony's fire." In the region of Vienne, the relics of the Saint are said to be preserved in the abbey, and are associated with the hospital named for this healing patron. The nosology of "Saint Antony's fire," or *ignis sacer*, is at once vague and specific.[39] Since the Middle Ages the term was identified with such varied diseases as erysipelas, ergotism, shingles, and later, in the sixteenth century, with syphilis. But in the context of our painting, a scene of lust, temptation, contemplation and naked flesh, its association with the latter ailment would be immediately

suspect. If Cézanne were depicting Saint Antony, his fire and a victim (or victims) of disease, his presentation is very different from well-known works which could be prototypes. Unless prints or engravings had been available to him, he could not have known the terrifying *Temptation* in Grunewald's Isenheim Altarpiece nor the abstruse symbolism in the Lisbon triptych by Bosch where the afflicted are shown in the ultimate throes of erysipelas or ergotism.[40] Unlike either of these works, the fire in Cézanne's painting serves only to outline the torso, from breast to upper thigh, of his reclining melancholic nude. There is no visual evidence of any disease.

André Chastel's premise that the Lisbon triptych expresses Bosch's cosmic symbolism—its unity linked to the manifestation of the four elements while at the same time accentuating its saturnine character[41]—suggests a thematic connection with our picture. We presumably see Saint Antony, tempted not by demons *per se*, but by four robust nudes. The pose of three may be read as sensual or seductive, but the figure resting near the fire is obviously melancholic and contemplative or saturnine, and in this respect may offer a parallel to the Lisbon painting. Nevertheless, if we could suppose our pensive nude to be a representation of one of the four temperaments, an examination of older images shows that the saturnine humor is never associated with fire.[42] This element is usually an attribute of the choleric humor. Therefore, the two interpretations of the earlier works would not be satisfactory for our *Tentation*: the figure is not diseased nor does one of its obvious attributes, the fire, coincide with the image of the melancholic.

In a more recent study of the *Temptation* in Lisbon, Madeleine Bergman hypothesizes that the important pictorial elements in Bosch's work may belong within an alchemical as well as an astrological framework.[43] The aspect of fire, in this sense, seems to allow further penetration into the meaning of the corner figure. Its androgynous features have led scholars to question its role in the *Temptation*. If it were indeed a "tempting" female, it would serve as part of the Saint's hallucination. Yet in Cézanne's other works, this contemplative posture is usually linked with male figures. Were it not for this nude's bulbous breasts and rounded abdomen, those characteristics delineated by the fire, it too would seem to exhibit only masculine traits.[44] Essentially, then, we may recognize here an hermaphrodite, a figure with male and female attributes, one often seen in ancient art although never in this posture.[45]

In alchemy, the raw material, the Saturnine *materia prima*, must be "hermaphroditic" and contain both male (the *spiritus*) and female (the *anima*) substances. The

flames of fire symbolize the union of the elements. Such a fusion was first related in the *Symposium*, where Plato treats the theme of love, strongly accenting the homosexual practises in aristocratic Athenian life.[46] The question of the hermaphrodite appears in Aristophanes' monologue. It tells an extraordinary and humorous account of "the constitution of man and the modifications which it has undergone." Aristophanes describes man's genesis at a time when there were three sexes: male, female and the hermaphrodite (which partook of the nature of both). In an attempt to have the three coexist harmoniously, Zeus bisected each one with the hope that their behaviour would improve. But each broken part longed desperately for its other half, and searched continuously for its corresponding fraction or opposite—male and female; female and female; male and male. The last-named coupling is favored by Aristophanes because it forms a union which he believes to be the epitome of "manliness and virility."

Whenever the lover of boys—or any other person for that matter—has the good fortune to encounter his own actual other half, affection and kinship and love combined inspire in him an emotion which is quite overwhelming, and such a pair practically refuse ever to be separated even for a moment. It is people like these who form lifelong partnerships, although they would find it difficult to say what they hope to gain from one another's society. No one can suppose that it is mere physical enjoyment which causes the one to take such an intense delight in the company of the other. It is clear that the soul of each has some other longing which it cannot express, but can only surmise and obscurely hint at. Suppose Hephaestus with his tools were to visit them as they lie together, and stand over them and ask: "What is it, mortals, that you hope to gain from one another?" Suppose too that when they could not answer he repeated his question in these terms: 'Is the object of your desire to be always together as much as possible, and never to be separated from one another day or night? If that is what you want, I am ready to melt and weld you together, so that, instead of two, you shall be one flesh; as long as you live a common life, and when you die, you shall suffer a common death, and be still one, not two, even in the next world. Would such a fate as this content you, and satisfy your longings?' We know what their answer would be; no one would refuse the offer; it would be plain that this is what everybody wants, and everybody would regard it as

the precise expression of the desire which he had long felt but had been unable to formulate, that he should melt into his beloved, and that henceforth they should be one being instead of two. The reason is that this was our primitive condition when we were wholes, and love is simply the name for the desire and pursuit of the whole.[47]

From what we know of Cézanne's education, and of his literary pursuits, it may be that he was familiar with an emblem in the seventeenth-century treatise of Michael Maier, *Atalanta Fugiens*. (Fig. 8–5).[48] The image is so remarkably close to both Aristophanes' description and Cézanne's corner nude in *La Tentation de Saint Antoine* that some knowledge of its type or concept could scarcely be over-ruled.[49] To what, then, can we attribute the entry of this "dual," puzzling figure into Cézanne's painting? It has been proposed that the artist subliminally revealed himself in this being on an even more profound level than in his enactment of the Saint himself. There is a clue which may disclose its identity or meaning: the remarkable similarity of the head with Cézanne's early portrait of Zola (Fig. 8–6).[50] Both visages closely correspond to the description of a studio photograph taken when the writer was about twenty:

> Thick dark hair and what used to be called a Newgate frill—a fringe of beard running from ear to ear but scraped away from the cheeks and chin—encircle a sad little face, almost feminine in its wistfulness; the eyes gaze soulfully, the corners of the mouth are drawn down to give an expression not so much of grimness as of resigned melancholy.[51]

As for the ambivalent physique, the brothers Goncourt, never noted for their flattery, described Zola at twenty-eight:

> [He had an] ambiguous, almost hermaphroditic appearance; at once burly and frail, he looked more youthful than he was, with the delicate moulding of fine porcelain in his features, in the arch of his eyebrows. Rather like the weak-willed, easily dominated heroes of some of his early novels, he seemed like an amalgam of male and female traits, with the latter dominant,...[52]

Why would Cézanne introduce Zola into the picture? Or (as Schapiro has intimated) in the case of the novelist whose invented characters seemed to portray facets of both himself and Cézanne,[53] could the painter have transposed and/or merged the two identities into one image? Any discussion of their intimate relationship is beyond the scope of this paper, but consideration of Zola's sexual preferences and behaviour, inevitably raises questions about the nature of their friendship.[54]

If we re-examine the painting in the light of Zola's "portrait," we find a closer correspondence between Cézanne's *Saint Antoine* and Zola's *Madeleine Férat*. For if Cézanne/Antony appears to be afraid of the seductive female, the melancholy, androgynous nude/Zola maintains a passive role. Actually, the Saint seems to turn his body, head and arm in order to shrink from even visual contact with his temptress, looking around her toward his correspondant who rests near the fire in the opposite corner. We may detect also an equation of the Saint's distaste with that of Guillaume in *Madeleine*: "his fear, his repugnance seem to be the products of a nearly pathological horror of flesh...."[55]

In this scene, Cézanne may have separated two facets of one character—the fear and the ennui in response to female flesh—and portrayed each in two different characters. This may be the first occasion which alludes to the artist's dual personality, or alter ego, described in two forms: the hermit/monk and the hermaphrodite. We might surmise that Cézanne had injected his own feelings into the image of another person, in this case, Zola. Such an idea is strengthened by Schapiro's observation of the conflated name of Sandoz in *L'Oeuvre*, by Badt's comment on the men's "inner interdependence," by Rewald who senses Zola's own blood flowing in the veins of Claude Lantier, and in Zola's own words, "...nous avons pénétré nos coeurs et nos chairs."[56] From their positions as marginal figures, they watch the temptation as outsiders, each enduring his own anguish. Between them are three nudes who separate, as it were, the dual temperaments.[57] If they tell of opposing attitudes toward women, the timorous monk defers to the indifferent or meditative androgyne. The latter is ascendant by means of its monopoly of the right foreground and its extended body, accented by the fire. The concept of the *vita contemplativa*, hallmark of Saint Antony, is projected into this hermaphrodite whose pensive brooding recalls the figure of Paris himself in the Judgment. Its mood and gesture are transposed to the self-portrayed artist in two contemporary works, *Le Déjeuner sur l'herbe* and *Pastorale*, where a similar question of choice becomes the predominant theme. On one count, this selection will also refer to the mythological one where woman represents the philosophical qualities of virtue or vice. But it also occurs on a second, more personal level where the contest again hints at a matter of sexual identity.[58]

Each of the nudes in *La Tentation* has been called "Everywoman, *L'Eternel féminin*,"[59] suggesting that their overall masculinity and particularly the stature,

white skin and blue drapery of the central figure, and the red hair of the monk's seducer, are attributes of Zola's Madeleine.

> The blue peignoir separated to reveal nude flesh, warmly caressed by the fire. Yet her face was unsettling, hard and thickenened like that of a satiated woman. All her physiognomy assumed an air of cruelty. Along her cheeks and neck abundant red curls, still damp with rain, fell in heavy masses, framing the figure with flowing lines. Flames from the dancing fire created the fearsome illusion of touches of blood on her round breasts and bare legs.[60]

In Zola's description of Guillaume confronting the woman near the fire, we clearly recognize the courtesan, the *femme fatale.*

A depiction of the blonde nude, squatting on her haunches with legs splayed backward, may come from another of Zola's novels, *La Curée.* Published serially in 1871, possibly two years after Cézanne completed his painting, we could again suppose earlier shared interests, easily finding Zola's imagery in the painting.[61] Renée, her hair the color of *beurre fin,* is prepared for a night of passion. She incarnates the Sphinx, fiercest of all manifestations of the Fatal Woman, as she emasculates her lover/step-son, Maxime.[62]

> He saw Renée kneeling, bent over, with her eyes staring, a savage posture which frightened him. Her hair loosened, her shoulders bare, she leaned on her fists, her back stretched out like a huge cat with luminescent eyes.... They spent a night of wild love. Renée took the rôle of the man, the passionate and active will personified. Maxime surrendered. This neutral being, blonde and pretty, his virility affected since childhood, became, in the curious arms of this woman, a big girl with hairless limbs, his slimness graceful like a Roman youth.[63]

If each of the central nudes in Cézanne's *Tentation* represents—or prefigures—Zola's response to *une belle dame sans merci,* their single effect on the two corner figures becomes apparent. One is intimidated, afraid; the other contemplative, unaroused. They manifest a complex personal, psychological presentation in the painting. Cézanne seems to have summarized his own subconscious feelings toward women, finding in each one, as perhaps did Zola, a terrifying masculinity scarcely disguised in the voluptuous exterior of a courtesan or fatal woman. It is the reaction of each man to the aggressor that is different.

The motivation for Cézanne to paint this particular scene of temptation is usually, and no doubt correctly, attributed to his fear of women. Nevertheless, an incident central to Cézanne's personal life took place concurrently with his work on this composition, and it may account in some ways for its puzzling imagery.

> Cézanne returned to Paris at the beginning of 1869. It is about this time that he met a young model, Hortense Fiquet, who was then nineteen....[She was] a tall and handsome brunette with large black eyes and sallow complexion. Cézanne, eleven years older than she, fell in love with her and persuaded her to live with him....This change in [his] emotional life does not appear to have influenced either his art or his relationship to his friends.[64]

I would suggest that the so-called *Tentation de Saint Antoine*—and the contemporary *Le Déjeuner sur l'herbe* to be discussed below—are indeed manifestations of a remarkable emotional change that took place in Cézanne's life and his art. This was simply a physical attachment to a woman. His daydreams of beautiful women and of romantic encounters need not be reiterated here. Nevertheless, the impression that emerges from his erotic verbiage is one of chasteness, even virginity. It is true that he was ten years younger when he wrote to Zola of love:

> "(Unutterable, let us not go into that corrupting subject): Our still candid soul, walking with timid step, has not as yet encountered the edge of the abyss into which one so often slips in these corrupt times. I've not yet raised to my innocent lips the cup of pleasure from which amorous souls drink their fill."[65]

Even as late as 1886, in *L'Oeuvre,* Zola was to recall Claude/Cézanne:

> This was his chaste passion for the flesh of a woman, a foolish love of nudity desired and never possessed, an impotence to satisfy himself, to create this flesh so much that he dreamed of holding it in his two bewildered arms. These women whom he drove away from his atelier, he adored in his paintings—there he caressed them and violated them, desperate that through his tears he would not have the power to make them as beautiful and vibrant as he desired.[66]

The book was to end their friendship.

In fact, in *La Tentation*, Cézanne may have told us a great deal about the emotional and psychological conflict that his affair with Hortense brought him, the conflict which achieved sublimation in the years to come.

Although Zola describes the visages of his own "fatal women"—"une face dure prenait un air de cruauté;" "les yeux fixées et phosphorescents"—we see none of this in Cézanne's picture. Both the blonde and the redhead have their backs turned to the observer. But the dark-haired, dark-eyed figure who is placed vertically erect and just slightly to the right of center, shows her face with lowered eyes, head tilted toward her right shoulder, in an attitude we may even call demure. The pose has great affinity with several portraits of Hortense Fiquet/Madame Cézanne in which her head inclines right and downward and her hair is pulled behind her ears, revealing a particular grace and elegance.[67] Nevertheless, this gesture does not permit the figure to forego its role as a temptress. In the exact center of the canvas, the blue drapery which delineates the right side of her body develops into an almost frenzied serpentine shape as it nears the ground. This is a motif found in several of Cézanne's early works as well as later paintings of bathers. It leads here to another glimpse of Zola's Madeleine, seen through the eyes of her embittered, aged servant, Geneviève.

> This creature came from Satan, heaven had put her on earth for the damnation of men. [Geneviève] looked at her, writhing and dishevelled, as she would have looked at the trunk of a serpent stirring in the grass.[68]

The likeness between Hortense and the standing nude in *La Tentation* may seem merely coincidental; but in the series of bather studies preparatory for *Cinq Baigneuses* in Basel, a figure posed similarly again occupies the center.[69] Several sheets of preliminary sketches exist for this bather and it is there that a continuing remembrance of Hortense may be found. On one sheet (Fig. 8–7), on which nudes stand side by side across the page,[70] we see Cézanne's process of working with posture, gesture and even with sexual attributes. Only heads are drawn at either end of the page. At the left is one quickly rendered and small in proportion to the bodies. At the right, carefully drawn, is a large head of Madame Cézanne which appears to initiate this series of bathing figures. In the culminating painting in Basel, and its preparatory squared drawing, this same figure has been moved to the right edge of the composition and, as in *La Tentation*, turns her head to look over her shoulder (here the left one). Her face has become dis-torted, her complexion swarthy with heavily rouged cheeks. Faceted planes of gray-green modelling lend the visage a mask-like appearance. Could this too be Zola's Madeleine?

> This icy mask, this face of death, these gray eyes and red lips which no smile could brighten, astonished the young man, filling him with uneasiness.[71]

Only the figure's origin is a pictorial reminder of one who may have been her first incarnation—Hortense Fiquet.

* * * *

Around 1869–1870, at the same time that he conceived *La Tentation*, Cézanne painted *Le Déjeuner sur l'herbe* (Fig. 8–8)[72] What at first glance appears to be a group of friends casually gathered around a white cloth for an afternoon's pleasure, upon closer scrutiny takes on a contrived, even sinister aspect. The food is sparse—three pieces of fruit; the libation is discarded—a bottle lying on the grass; the postures and gestures of the figures calculated and emphasized—a pointing finger, a hand raised to the lips, arms folded to the breast.

That it was Cézanne's intention to recall older pastorale scenes is obvious. He sketched Giorgione's *Concert champêtre* in the Louvre,[73] where he also no doubt encountered the amorous couplings and cosmic landscape of Watteau's *L'Embarquement pour l'ile de Cythére*.[74] Cézanne's debt to Manet's "scandalous" *Le Déjeuner sur l'herbe* has always been acknowledged: the group of four in a wooded setting, the still-life, the shed clothing. Monet's life-sized "picnic" (1865), and Bazille's *La Famille de l'artiste à Montpelier*, exhibited at the Salon of 1868, were undoubtedly familiar.[75] But Cézanne denies the lyricism and unity of the older works, isolating, even enclosing, each figure in its own space. The landscape is imagined or artificial, unlike Monet's sensitive rendering of the Forest of Fontainebleau. The fashionable display of elegantly dressed men and women in Monet's and Bazille's paintings seemed not to capture Cézanne's fancy. His women are clad in simple, unadorned dresses, the men in white shirts except for the self-portrayed artist who is clothed in a contemporary frock coat and light breeches (how different from the descriptions of his normal attire!).

Because of his somber, contemplative presence, we sense a personal testimony to the weightiness of the subject, somehow substituting a part of his imagination for a piece of nature.[76] Comfortable in scale (and nearly identical in size to *La Tentation de Saint*

Antoine), Cézanne's *Déjeuner* must be realized within this intimate framework, not as the monumental salon pieces of which Monet's and Bazille's works speak. Growing out of his own earlier scenes of violent physical contact, lust and sensuality, this sedate, social occasion presents an abrupt change in mood but not, I believe, on the level of personal involvement.

Cézanne's first letters to Zola tell of his fondness for clever word games and charades. He begged his friend to rhyme everything, and he in turn would puzzle over Zola's riddles.[77] He would then reply with a rebus, which would require Zola to divine the mystery of its combination of letters (pronouns) and vignettes (portraits, a scythe, and buildings).[78] It seems likely then, that *Le Déjeuner sur l'herbe* may be another of Cézanne's games of this sort wherein he has indicated his intention with disparate people and things, but without words. The persons and objects may all serve as keys to the contrived arrangement of the picture.

Two isolated pieces of fruit, illuminated and emphasized by the circular sweep of the white cloth, locate the exact center of the canvas. The relationship of the other parts is deliberate. The actual convergence of the action is found at a point below the lower edge of the canvas from which radiating lines indicate a gesture or glance: for example, Cézanne's pointing finger, the lighted face of the blonde man, and the standing woman's gaze. This construction sets up a "tableau" which seems to involve the four (or five, if the observer in the rear is included) central characters in a primary story, and suggests that the departing couple may represent a subsequent action.[79]

If we have a two-part narrative, what has taken place in the first instance to warrant the second? In Cézanne's arrangement of the four principal figures, we seem to have a confrontation, a game as it were, in which the figures placed across from each other are in opposition: male vs. male; female vs. female. This premise may have a great deal in common with Cézanne's later series of *Les Joueurs de cartes* in which he varies the number of players and observers, one of whom stands in the rear, as does our figure, smoking a pipe.[80] We could consider the stakes in this game, the "picnic," as the pieces of fruit, one held by the woman in blue, the others central and highlighted. Because they are isolated from the other trappings they appear to be the object of contemplation, even dread, for the persons who surround them. In spite of their orange color, I like to think of them as apples, not merely because this fruit has become synonymous with Cézanne's work, but because of its association with what I believe is the theme of the painting: temptation.

Standing at the left and silhouetted against the dark forest, the blonde woman holds an apple; her face seems to express perplexity as if to determine whether to take a bite of the fruit or to offer it to the artist at whom she looks. If she were pondering either alternative, we could see her role as a temptress, even as an Eve. Cézanne has given her the air of an enticing female. She has strongly modelled breasts, a small waist, and an elongated form emphasized by serpentine curves which accent the folds and hem of her skirt. Her blonde hair is loose, unlike the more decorous chignons worn by women of the day, (actually recalling the unbound tresses of the female victims discussed earlier, as well as three of the nudes in *La Tentation of Saint Antoine*). We are reminded of Zola's description of Thérèse Raquin, distraught by guilt:

> She was clothed like a prostitute, in a long trailing dress; she strutted on the sidewalk in a provocative fashion, looking at the men; ... she moved slowly, her head slightly turned, her hair hanging down her back.[81]

An antithesis to this vertical figure is the crouching woman whose neatly coiffed head is outlined against the blue sky. She raises her left hand to her lips as if to stifle a gasp or give a warning, possibly in response to her counterpart's gesture. Her position near the artist may give a clue to her identity. She bears a striking resemblance to Cézanne's elder sister, Marie, whom he portrayed seated at the piano in *Ouverture de Tannhäuser* (Fig. 8-9).[82] Cézanne lived with her and his mother even after his marriage.

The figure which must take precedence as the subject of the painting is, of course, that of the artist. Although his back is turned to the observer, he is impressive on several counts: his bulk near the center of the canvas; the fact that he is framed by objects found on the grass; and his pointing gesture whose direction is reinforced by his bent leg. The description of such a man seated on the grass (although with arms reversed) is found in Zola's *L'Oeuvre*. where it is the writer Sandoz/Zola who poses for the artist Claude/Cézanne.

> For the first sketch, the painter needed a dark contrast. It was done simply and satisfactorily by placing there a man clothed in a plain velour coat. The figure turned his back, showing only his left hand on which he leaned in the grass. ... the hand, was prominent, creating a very interesting detail, a pleasant freshness of tone which strongly lightened the somber brush strokes of the black coat.[83]

When we understand the close friendship of the two men during the years before 1870, it is possible that Zola may have been Cézanne's model for his own self portrait. (Can we recognize again the conflation of images and personalities which occurred in *La Tentation de Saint Antoine*?)

Reclining with one knee drawn up toward his body, a young man faces the observer and the artist. Though no more handsome than the other figures, he seems, in comparison, to be idealized, even set apart from his companions because of his golden hair, luminous pink complexion, and air of feminity. He rests his chin on his right hand in the standard pose of the melancholic. A white clay pipe lies on the cloth near his left hand Closer observation shows that his posture is the same, but in reverse, of that of the artist, a correspondence pressed on us by the articulated pointing finger which pierces the whiteness of the picnic cloth and directs attention to Cézanne's antagonist.[84]

Who, then, is the young man directly aligned with the artist's left hand? Their opposing features are more distinctive than those of the two women. Cézanne is somber, his hair is dark and sparse, his complexion sallow, his coat black. The other, his blonde hair falling over his forehead, smiles faintly; his skin is fair, his shirt white. Why would this figure be a pendant to the artist? When Zola wrote about Cézanne in *Mon Salon* (1866), "...Je te vois dans ma vie comme ce pâle jeune homme dont parle Musset," he left an indication of the source not only for the man's countenance and his posture, but for his melancholic pose as well.[85]

The "pale young man" of whom Zola writes comes from "La Nuit de décembre," by Alfred de Musset, the poet who awakened the boys' hearts, who became their "religion."

Who are you whom I always see in my path?
I cannot believe that, in your melancholy, you
are my evil destiny.
You smile sweetly with great patience
Your tears are full of pity...

Who are you then? You are not my good angel
You never come to change me; you watch me
 suffer.
For twenty years you walked in my path
You smile at me without partaking of my joy,
You pity me without consoling me.

Who are you, then, gloomy and pale visage,
Somber portrait clothed in black...
Is this a vain dream, is this my real image
That I see in this mirror?[86]

Can the self-portrayed Cézanne see in the other man the many moods of his alter ego, his *Doppelgänger,* the "fair-haired boy" he had hoped to be?[87] Does the painting show a bisecting, or separation, of Musset's character: smiling, melancholy, patient as well as gloomy, somber, dressed in black? If this is his mirror-image, as suggested in the poem, it must return his likeness in spirit rather than in reality.

To suppose that Cézanne painted his "double" is further supported by another story written by Duranty about 1869, the date of our painting. "La Double vue de Louis Séguin"[88] concerns a group of artists who gather at the Café Barbois (a thinly veiled reference to the artists' Café Guerbois) in Paris. In the manuscript of the story, the author forgetfully refers to his subject as *Paul* and *not* as the Louis Séguin of the title, a young artist who speaks of his concern about a rival for the favors of an attractive countergirl. The young woman, Séguin says, is fond of the gentleman who writes letters to her, but shows distaste for the one in her presence, when in reality they are the same person. He speaks to the narrator:

I often ask myself what are my faults and how a person judges me, because I doubt that others see me as I see myself and know more of the things about me that I ignore. I often look at myself in the mirror...and I recall very well when I look because my true person is always very interesting and astonishing to me.... Is not the person whom you see in the mirror very distinct from you, a real being, living, capable of acting, of following you where ever you go, and yet, in the end, linked to you by the singular quality of reflection?[89]

If this anecdote refers to Paul Cézanne (and the phonetic similarity of the family name, the author's slip as to the Christian name, and the turbulent personality of the protagonist leave little doubt that this is the case),[90] it does so in a heightened expression of the artist's dual nature.

If we could presume, then, that the blonde man is Cézanne's alter ego, how can we account for the remaining persons in the picture? Aside from his stoic posture, the man in the distance has only one attribute which lends him distinction: a clay pipe. Cézanne and Zola often mentioned smoking in their early letters; the latter was particularly fond of a pipe. For both young men it was a custom associated with relaxation and reverie.[91] The image of a figure smoking and withdrawn from his companions appears several times in other paintings contemporary with *Le Déjeuner sur l'herbe.*[92] Twenty years later, about 1890–1892, the pipe-smoker

is found in the series of *Les Joueurs de cartes* . The more complex versions (and likely the earlier ones) show the smoker standing at the left rear with arms folded across his chest. A single white pipe lies at the table's center (as it does on the cloth in *Le Déjeuner*), its stem pointing to the standing man.[93] In the later works, when the game is confined to two players, the man seated at left always smokes a white clay pipe.[94]

From none of these figures, whose pose or activity is their only common bond, could we identify the smoker in our picture. Like his role in some scenes of cardplayers, the man stands in the distance, clearly not a participant in the conflict, but one watching how the game is played. Kurt Badt has suggested that the contemplator in *Les Joueurs de cartes* is Zola,[95] and since we know him as Cézanne's confidant, his presence in *Le Déjeuner sur l'herbe* would not be unlikely. If this were true, might he be a surrogate for Cézanne who had already represented himself in this posture in an earlier drawing?[96] Such a maneuver was intimated when Cézanne portrayed Zola in the contemporary *La Tentation de Saint Antoine*,[97] and likewise, years later, in Zola's *L'Oeuvre* where Sandoz/Zola was the model for Claude/Cézanne's painting.

In *Le Déjeuner*, the real, self-portrayed Cézanne gestures toward his alter ego, his ideal, from whom he receives only a patient smile and pity without consolation. He may have understood that from the shadowed and distant image of Zola, at this time well established and preoccupied in Paris, he would receive no more than that.[98]

Tell me why I find you ceaselessly
seated in the shadow where I pass.
Who are you, solitary visitor,
persistent guest to my sorrows.[99]

At the end of "La Nuit de décembre," the narrator's vision—the pale young man, the portrait clothed in black—identifies himself:

Friend, our father is the same;
I am neither guardian angel
nor the evil destiny of men.

I am neither God nor demon,
and you call me by name
when you call me your brother.
Where you go, I will go there always
until the end of your days
when I will sit on your tomb.

Heaven has given me your heart.
When you have grief,
come to me without worry,
I will follow on your path;
but I will not touch your hand,
friend; I am Solitude.[100]

Solitude, almost necessarily, became a way of life for Cézanne. If the smoking contemplator represents Zola, the concept of the artist's loneliness is reinforced by his friend's distance.

In his "picnic" Cézanne placed several objects close to where he is seated on the grass. At his right hand are a top hat and folded parasol; both appear again at the far left of the canvas, the hat on the man's head, the parasol now open, carried by the woman. Lying near the artist's left foot is a snake, and on it a bottle whose neck points toward the departing couple. Both seem bizarre companions at an every-day picnic. Again we must inquire as to a covert, personal meaning that these things could have had for Cézanne.[101]

The seated, fawn-colored dog is different from those in Cézanne's other pictures—from the comical *petit chien* in *Une Moderne Olympia* , the lunging black animal in *La Lutte d'amour,* and the one lying at the center of the Barnes and London *Baigneuses.*[102] Cézanne himself explained the presence of the barking black dog in *L'Apotheose de Delacroix* as a "symbole de l'envie,"[103] but such an association seems at odds with his pleasant recollections "d'être nous trois et le chien, la ou à peine quelques années auparavant nous étions."[104] The dog in *Le Déjeuner* has no visual connection with the friends' "Black," but it may stand for faithfulness, sitting obediently and observing cautiously. It bars the artist's path of exit, at the same time pointing its nose at the pale young man seated opposite. The two complement each other in their mutual coloring. A dog as pendant to a contemplative figure also occurs frequently in personifications of the Judgment of Paris, images surely known to Cézanne.[105]

Let us review our observations of this strange *mélange* of performers and attempt to propose the main scenario in which they act. The apples are both the subject, centrally placed, and the object awaiting action. Cézanne is the protagonist. The standing woman/temptress questions her own partaking of, or proffering, a piece of fruit. Cézanne's sister watches him, stifling a sound of warning or surprise. The artist, who gestures toward his alter ego as if seeking guidance, receives only a patient smile ("Tu me souris sans partager ma joie, tu me plain sans me consoler!"), no admonition or

help for his difficult decision. Another figure, calmly smoking, observes the scene from a distance.

But it is evident that the protagonist has made his own decision, as the secondary scene testifies. He has succumbed to the young woman's enticement; they have gathered their belongings and leave center stage. Like Adam, Cézanne yields to temptation, and with his Eve leaves the lighted garden for the darkness of the unknown wood. How much this departure, (and even the painted hemline of the woman's skirt), seems to echo Mathis' lovesick song in *Salammbô*:

> He pursued into the forest the female monster, whose tail undulated over the dead leaves like a silver brook.[106]

The canvas itself is neatly divided by the junction of dark forest at left and light sky at right, bringing to mind the traditional connection of left with evil, right with good, in a *paysage moralisé*. The duality in question, which appears frequently in Cézanne's work, seems characteristic even in his personal dilemma of choosing a career. In an argument based on Cézanne's numerous copies of *L'Hercule au repos*, Theodore Reff draws an analogy between the artist and the mythological hero, suggesting that Cézanne equated his choice between art/vice on the left and law/virtue on the right.[107] The tempting woman at the left, outlined by the black forest, and the head of his pious sister at right, contoured against the light blue sky, may allow us to see in *Le Déjeuner sur l'herbe* another temptation or choice for Cézanne. In "Rolla," the poem so beloved by the two friends, Musset perceives of Hercules' choice as steeped in the maladies of his own era. Nevertheless, the women between whom he must choose are familiar to us from this painting: "Il vit la Volupté qui lui tendait la main; Il suivit la Vertu, qui lui sembla plus belle."[108] But unlike the young Hercules, Cézanne has chosen the primrose path.

Because the organization of figures in Cézanne's picnic reflects so closely its prototypes—Giorgione's *Concert champêtre* and Manet's *Le Déjeuner sur l'herbe*—we might presume that its symbolic intention is the same. Recent interpretations of the Venetian work indicate its representation of an allegorical choice between vice and the natural life of passion (depicted by the woman at the musician's left), and virtue and the control of reason (depicted by Temperance at his right).[109] A similar analogy follows in George Mauner's study of Manet's painting. By tracing the source of both the seated nymph and the bathing figure to images by Raphael, we see that they represent respectively the profane and sacred attributes of water. When the gesturing man directs the observer's attention to

these two figures, he invites a moral choice between the flesh and the spirit, the passionate and the temperate.[110] In the progression of the three works, it becomes apparent that the human dilemma of choosing between evil and good exists on comparable levels of symbolic content.

In Cézanne's painting of St. Antony's predicament, the figurative similarity of the three nudes to older representations of the Judgment of Paris allowed Reff to suggest that the painting is a composite image of secular and Christian seduction. He cites Patinir's *Temptation of Saint Antony* as a similar conflation of the Judgment and Temptation themes where an apple is the object offered to the perplexed Saint.[111] This picture's connection with our *Déjeuner* is remarkable on two counts: the Saint's posture is identical, but in reverse, to Cézanne's; both are dressed as gentlemen. Secondly, the left half of the picture is dark, a wood with tortuous mountains shadowed by a stormy sky, while the right is bright, the sun breaking through to shed light on a serene landscape. Other symbols of despair and hope, or evil and good, in *Le Déjeuner sur l'herbe*, may be the two isolated trees, the left one fallen and leafless, the right erect and sprouting vibrant green growth. For Cézanne, the importance, as well as the arrangement of trees, is never forgotten. In later picnic scenes they flank or create a background for the figures, and from this point they develop into stylized motifs which persist into the last *Baigneurs* and *Baigneuses*.

Following the pattern of his own *Tentation de Saint Antoine*, many images converge in this "picnic" to represent for the artist an intimate, secularized, and veiled analogy to the Garden of Eden. When taking into account the concurrent date of the two pictures, about 1869–1870, the likelihood of their being a pendant for one another seems very strong. I must point out again their coincidence with the beginning of Cézanne's liaison with Hortense Fiquet. Although in the picnic the blonde woman bears no particular resemblance to Cézanne's mistress (and future wife), this is not the case in the scene of Saint Antony's temptation, as we have observed it.[112] Could the blonde woman in *Le Déjeuner* symbolize Cézanne's momentous decision to take Hortense into his life as a sexual partner? He reinforces the difficulty of his choice by including his "double" and his sister, a reminder of familial negative sentiment and judgment.[113] Where Cézanne first put his fantasies into poetry, they are now gathered and placed on canvas, becoming even more vivid reminders of guilt and indecision or acting as a catharsis for them.

When Duranty explains Paul Séguin's bizarre behaviour as he confronts himself in the mirror—"cet abominable individu ne peut avoir rien de commun avec

moi,"[114]—does he have only a single artist in mind, or was Séguin a symbol for the many painters and literati who met at the Café Barbois?

But was this original and subtle malady his own? For wanting the experience of knowing himself, Paul Séguin had an hallucination. He saw his double. Seeing his entirety, both physically and morally, this being which he had admired so much became odious. Was he right or wrong? I asked myself, when he left, if each of us, seeing himself repeated as another being, would have this same aversion.[115]

The philosophical examination of self, of the question "tort ou raison," seemed pervasive, even fashionable, in the mid-nineteenth century. Numerous novels told of the "good country girl" and the "bad city girl" who were conflicts in a young man's life. The Judgment of Paris was the theme of many operas. A similar theme is explicit in Wagner's *Tannhäuser*, so beloved by Cézanne.[116] It was in this work, according to Baudelaire, that the hero must choose between Satan and God, "cette dualité ... représentée toute de suite, par l' ouverture avec une incomparable habilité."[117]

Mauner believes that Manet's *Déjeuner sur l'herbe* was enigmatic for both his contemporaries and the public, and for this reason it is striking that Cézanne should emulate the older painter's subject as well as his composition. But for all their similarities, there is one distinct difference: the singular gesture, the pointing hand. If Manet's Parisian dandy distinguishes the upward/downward and sacred/profane dichotomy,[118] Cézanne's own hand points toward the other part of himself, thereby stressing the personal aspect of his choice. We might reason that if Manet's painting presents an abstract, philosophical choice, Cézanne's intent and his images may not have been cultivated in the same intellectual vein. They were expressed rather as a natural part of his innermost sensibilities, as the feeling between painter and subject. By arranging a "game of life" in *Le Déjeuner*, where the ubiquitous apple is a metaphor for choice or chance, by standing lover against sister and self against inner-self (vice against virtue, as it were, in each case), Cézanne actually sets forth his lifetime conflict in this picture of 1869–1870. More than twenty years later, the same opposition or duality may be evoked in the monumental *Les Joueurs de cartes* whose serious purpose likewise seems concealed by their apparently casual subject matter.[119]

* * * *

In tracing the chronology of Cézanne's early paintings, two narrative threads emerge: the repeated self-portrait of the artist (or a motif or literary allusion to him) and an evolution of relationships between the sexes, but more explicitly, as the works develop, between Cézanne and "woman." The scenes move from those of violence to the point of bodily injury (*La Femme etranglée, Le Meurtre*), to fear of eroticism (*La Tentation de Saint Antoine)*, to suppressed feeling in the guise of meditation, and eventually submission to woman (*Le Déjeuner sur l'herbe*). In the last group of figure paintings before he begins the series of bather pictures (ca. 1872 until his death in 1906), Cézanne removes himself from the primary narrative, maintaining his presence in the picture but acting as an observer rather than a participant. The visible dread of the temptation scene is overcome or suppressed, and the self-contemplation of the "picnic" is transferred to a nude woman on whom he looks with apparent detachment. She becomes an object seen intellectually and, seemingly, without lust. In her nudity, the woman might be a timeless or universal symbol. But at this point in his artistic development, Cézanne never fails to leave clues to the origins of her suggestive posture, allowing no doubt that an inner turmoil still haunts the outwardly detached artist.

Possibly the most familiar scene of "woman observed" is *Une Moderne Olympia* (Fig. 8–10) which was shown at the first Impressionist exhibition in 1874.[120] Much has been said about the picture's relationship to Manet's *Olympia*, a work which greatly affected Cézanne when it was hung in the Salon of 1865. Their differences, I believe, are more impressive than their affinities. Cézanne's heroine/courtesan appears drowsy, melancholy and introverted, a sharp contrast to the tense, impertinent Olympia. Her patron, in this case the artist himself, is introduced rather than intimated as he is in Manet's picture. This visitor serves a double function. Because of his position in the pictorial scheme, he detains us, as viewers, from establishing rapport with the woman, and yet because of his presence, affirms that we, with him a part of the outside world, can enter the habitat of the courtesan.

Manet's Olympia, the woman, astonished and shocked her audiences for many reasons, but most profoundly for the realism of her contemporaneity and nudity. If Cézanne had been creating a "modern" parody of this prototype, he has led us into a more "modern" painting by denying scale, perspective and objectivity. It is not his *thematic* interpretation that was new, but his artistic translation of it. In this environment, the painting moves away from the "real" toward the abstract. Several aspects of *Une Moderne Olympia* are remarkably similar to *Le Déjeuner sur l'herbe*: Cézanne's pos-

ture and his contemporary dress are the same; his black hat is in the same relative place behind him; he is confronting a tempting woman. The object/subject is centered and emphasized on white fabric. But the artist seems to take his Olympia beyond the every-day world into an imaginary, dream-like environment seen through his own eyes. The baroque furnishings—a three-legged table and a vase in contrasting colors of red and blue, a carpet of green, apples of polished gold, all actually mementos of an earlier era—frame the central cloud of whiteness. The laciness and fragility of the huge flowers are repeated across the top of the canvas in the filmy veil where the woman seems to float in an equivocal space. The nude's place in this incalculable distance relieves the artist of his role found in the intimate contest of *Le Déjeuner sur l'herbe*, establishing instead an emptiness between man and woman.[121] From this vantage point he gains the illusion of regarding her on a vast canvas.

This dreamy unreality reminds us of the artist Frenhofer in Balzac's *Chef-d'oeuvre inconnu* who, at sea in creative agitation, searches for the unearthly, spiritual model for his imaginary work of art.[122] Émile Bernard's well-known anecdote tells of Cézanne's identification with Balzac's legendary artist.

> One night, when I spoke to him about the *Chef-d'oeuvre inconnu* and of Frenhofer,... he rose from the table, stood in front of me, and, hitting his chest with his index finger, likened himself, without a word but with this repeated gesture, to the person in the story. He was so overwhelmed that tears filled his eyes.[123]

If Cézanne was so moved to enter the role of Frenhofer, it may not be mere coincidence that *Une Moderne Olympia* is replete with the details of Frenhofer's own painting.

> One sees a woman lying under curtains, on a couch of velvet. Near her a three-footed stool of gold exudes perfume. You are tempted to pull the tassels on the cords which draw back the draperies, and it seems that you can see the breast of Catherine Lescault, a beautiful courtesan called La Belle Noiseuse, move as she breathes.[124]

Whereas the only recognizable part of Frenhofer's beautiful Catherine that escaped his progressive destruction was a nude foot that emerged from a chaos of colors and obliterating brush strokes, Cézanne leaves us the allegorical figure of a woman revealed, with the artist still searching for her true identity. The perfect woman existed in Frenhofer's mind, but he never found his spiritual ideal in his painting. In the end, the mad artist proclaimed that his painting was life itself. Does Cézanne ponder here two such questions: the real, his ability to paint; and the ideal, his ability to fathom the "*éternel féminin*."?

Hardly revealing the ideal beauty of Frenhofer's Catherine or the svelte body of Manet's Olympia, Cézanne's woman is coiled like a languid, overfed cat (an amusing contrast to the tiny pert dog). She is soft, yet ready to spring, ever watchful through half-closed eyes. The artist seems to relate once more his ambivalent feelings toward woman. More secure in the third person, and at a safe distance, he can contemplate her sensuality and femininity, at once wily and feline, sad and repentant. It might be surmised that the emblematic spiritual void between them must be bridged in order to find truth in their relationship.

In *L'Éternel féminin*,[125] (Fig. 8–11), painted about two years after *Une Moderne Olympia*, the impression of alienation between Cézanne and "woman" broached in the earlier picture is carried even further. She remains the central focus, but her vertical posture, precariously suspended (or ascending) by unknown means in a white space, emphasizes her unworldliness in an otherwise mundane environment. Cézanne defers to her elevated position, moving back and to the side of his easel, allowing him to join the half-circle of admirers who pay homage to the courtesan. This maneuver reveals her as the subject of his painting-in-progress, a gesture which may be a further tribute to the sentiments of Frenhofer.

Schapiro calls *L'Éternel féminin* an embodiment of Cézanne's inner conflict "between the passions and his goal in art."[126] If that is the case, we might see here the presentation of a double allegory: a tribute to woman and to his artistic means of representing her. The result is a purely personal expression, glossed over by a heavy layer of irony. Yet its universality lies in the realistic, blatant exploitation of woman and her many attractions to all mankind. Here is the throng of admirers, including Cézanne, hailing an undeniably grotesque female. But close observation shows that Cézanne is painting not the woman, but the canopy and landscape that frame her. Curiously, the images take the same form, almost interchangeable and "redundantly feminine,"[127] a remarkable repetition of the Mt. Sainte Victoire. So Cézanne sets up his icon close to home, and in this arrangement of pulled-back drapery, of a strong horizontal emphasis near the top of the canvas, and the radiating organization of figures, the compositional solution reached in both the London and the Philadelphia *Grandes Baigneuses* finds its tentative beginnings.[128]

In coming to terms with painting a woman—in this picture unable (or unwilling) to do so, and in this respect much like Frenhofer—Cézanne's choice of a frontal recumbant, sexual position could not have been more unfortunate. The nude's anatomy is ill-defined and ambiguous, distortions surely dictated by the artist's temperament. That such a creature could be adored by even the most desperate of men may express the supreme irony in his artistic output. He simply *could not paint a nude woman* in an historically acceptable and acknowledged form.[129] The woman we see in our painting is grotesque in her sexually abandoned femininity, or is actually masculine. She is hostile, flaunting her ascendency over the male. She is clearly prefigured in Zola's character, Madeleine Férat:

> A little pale, she is healthy, vigorous, has strong shoulders, an ample bosom, a bright smile. Her damp red hair, heavy and warm, falls on her neck in a single wave. Her neck is thick and white, swollen and voluptuous. Her whole being takes on an attitude of superb vigor.[130]

The formidable, emasculating woman portrayed in the early works of both Cézanne and Zola (and undoubtedly expressing their similar feelings toward her), may have been the catalyst that destroyed the men's friendship. An artist's seemingly hopeless struggles with his career in painting, and his all-consuming attempts to represent his ideal woman on canvas, is the *dénoument* in Zola's novel, *L'Oeuvre*.[131] In this story, the artist's passionate bouts with both woman and art—actually represented as one and the same—were fatal. Of course, Cézanne never succumbed to the central character's ultimate solution to his dual frustration—suicide. Instead, as his works progress, he side-steps further confrontation with "woman," becoming more objective, apparently immersing his feelings in more subtle story-telling, fewer autobiographical references. When the bather compositions begin, some concurrent with *Une Moderne Olympia* and *L'Éternel féminin*, and work their way to the monumental conclusions thirty years later, his femme fatale becomes an artistic form, one used to build a composition. But the inheritance is from the early works, from the temptress and the *éternel féminin*. The essence of her ungainly, unattractive form is repeated continuously in groups of *baigneuses*.

When Cézanne chooses structural blocks for the ultimate figural work, *Les Grandes baigneuses*,[132] the forms come from pieces of sculpture or from other paintings, thereby acquiring proportions of grace and nobility that were never found in the imaginary women. We may sense that the subjective and personal content of the first works, found mirrored in the literature with which he was so familiar, become almost completely subsumed in the last paintings. With his revolutionary manipulation of color, volume and space, what Cézanne had experienced internally found its translation into painterly form.

Mary Louise Krumrine
The Pennsylvania State University

Notes

* Portions of this paper were published in the exhibition catalogues, *Cézanne: The Early Years 1859–1872*, Royal Academy of Arts, London, 1988; and *Cézanne: les années de jeunesse (1859–1872)*, Musée d'Orsay, Paris, 1988.

1 Edmund Duranty, "Le Peintre Louis Martin," in *Pays des Arts*, Paris, 1881, pp. 313–350 (published posthumously).

2 Excerpts from this story are found in Rewald, 1986, p. 140. Unless otherwise noted, the accounts of Cézanne's life are drawn from Professor Rewald's book as well as the original publication of his thesis; Rewald, 1936. See also Mack, p. 133.

3 Paul Gauguin, *Lettres de Gauguin, à sa femme et ses amis,* annot. by Maurice Malingue, Paris, 1946, pp. 45–46; letter to Émile Schuffenecker, 14 January 1885.

4 Mack, p. 240.

5 See particularly Cézanne, *Corres.*, p. 130; letter to Heinrich Morstatt, 24 May 1868.

6 V.126.

7 Rewald, 1986, pp. 56–57. All of Cézanne's works cited here are identified by numbers that refer to three publications: (for example, V.127, R.36, C.1156), Lionello Venturi; John Rewald, 1983; and Adrien Chappuis.

8 Quoted in Ambroise Vollard, *Paul Cézanne*, Paris, 1915, p. 35. The painting was probably V.224.

9 Zola's recollection of their friendship is in *L'Oeuvre*; 1927–29, XV, p. 34.

10 *Ibid.*, XLV, pp. 73–75.

Les jours de congé, les jours que nous pouvions voler à l'étude, nous nous échappions en des courses folles à travers la campagne. ...Et nos tendresses, en ce temps-la, étaient avant tout les pöetes. Pendant une anné, Victor Hugo régna sur nous en monarque absolu. Il nous avait conquis avec ses fortes allures de géant, il nous ravissait par sa rhétorique puissante. ...Puis, un matin, un de nous apporta un volume de Musset. La lecture de Musset fut pour nous l'éveil de notre propre coeur.

11 Rewald, 1986, pp. 21–28.

12 Zola, *Correspondance*, I, p. 141; letter of 25 March 1860.

J'ai fait un rêve, l'autre jour. J'avais écrit un beau livre, un livre sublime que tu avais illustré de belles, de sublimes gravures. Nos deux noms en lettres d'or brillaient, unis sur le premier feuillet, et, dans cette fraternité du génie, passaient inséperables à postérité.

13 Rewald, 1986, p. 34.

14 Zola to Cézanne, letter of 20 January 1862; *Correspondance*, I, p. 316.

15 It was not until 1880 that Zola again mentioned Cézanne in his critical writings; 1966, XII, p. 1018.

16 *Ibid.*, p. 785.

Heureux ceux qui ont des souvenirs! Je te vois dans ma vie comme ce pâle jeune homme dont parle Musset. Tu es toute ma jeunesse; je te retrouve mêle à chacune de mes joies, à chacune mes souffrances. Nos esprits, dans leur fraternité, se sont développés côte à côte. Aujourd'hui, au jour du début, nous avons foi en nous, parce que nous avons pénétré nos coeurs et nos chairs.

17 Rewald, 1986, pp. 74, 75, 78. Concerning Zola's appraisal of Cézanne's work, see his letter to Theodore Duret, 30 May 1870; *Correspondance*, II, p. 219..

18 The quotation is from Zola's manuscript for *La Fortune des Rougon*; cited by Rewald, 1936, p. 72, note 3.

19 The *ébauches* for *La Conquête de Plassans* seem to reveal very clearly that Cézanne's mother and father were the models for the Mouret parents; Zola, 1927–29, V, pp. 372 and 381.

20 A relationship like that of Cézanne and Zola is told in *Madeleine Férat* (1927–29, XXXIV, pp. 72–73) by Guillaume. "...de longues journées ensemble! Nous courions les champs, la main dans la main. Je me souviens d'un matin où nous pêchions des écrevisses sous les saules; il me disait: 'Guillaume, il n'y a qu'une bonne chose ici-bas, l'amitié. Aimons-nous bien, cela nous consolera plus tard.'" Compare, for example, with Cézanne, *Corres.*, pp. 19, 31.

21 Zola, 1927–29, XXXIV (*Thérèse Raquin*).

22 *Ibid.*, p. viii.

23 *Ibid.*, (*Madeleine Férat*).

24 Zola, 1927–29, XVIII.(*La Bête humaine*).

25 *L'Enlèvement*, V.101; ca. 1867; *La Pendule noire*, V.69, ca. 1870.

26 *Le Meurtre*, V.121, 1867–68; *La Femme étranglée*, V.123, 1870-72.

27 Venturi, p. 88, describes the scene of *L'Enlèvement*: "Le ciel qui sert de fond est d'un bleu precieux entre deux rideaux d'arbres verts..."

28 V.105, ca. 1868.

29 Zola, 1927–29, XXXIV, pp. 85–86.

Een face de lui, sur une dalle, Camille le regardait, étendu sur le dos, la tête levée, les yeux entr'ouverts.... Il resta immobile, pendant cinq grandes minutes, perdu dans une contemplation inconsciente, gravant malgré lui au fond de sa mémoire toutes les lignes horribles, toutes les couleurs sales du tableau qu'il avait sous les yeux.

30 Of chief concern here is the link between *Thérèse Raquin* and *L'Oeuvre*, as Laurent is the

prototype for the artist, Claude Lantier whom Zola considered "plus près de Cézanne;" Zola, 1927–29, XV, p. 410. See Lapp, p. 101, for further insight into this relationship, and particularly to the similarities of males and females in Cézanne's portraits, a "weakness" which also occurs in Laurent's paintings.

31 Rewald, 1936, pp. 1 and 69, associated their actual artistic output only when he stated, about *Thérèse Raquin*: "Cette lecture évoquera plutôt ces tableaux de Cézanne où des scènes étranges et érotiques sont rendues avec emphase."

32 V.103, ca. 1869. Consult Reff, 1962.

33 Charles Baudelaire, *Oeuvres complètes*, ed. Claude Pichois, rev. ed., Paris, 1960, p. 657.

34 Gustave Flaubert, "La Tentation de Saint Antoine," (1856), *L'Artiste*, 1856–57.

35 Flaubert, *La Tentation de Saint Antoine* (1874), Edition Garnier-Flammarion, Paris, 1967. See V. 240 and 241, ca. 1875.

36 Lapp; and Reff, 1962.

37 Reff, 1962, pp. 117–119; and Reff, 1966, pp. 40–41, discusses the relationship of all four nudes to earlier depictions of the Judgment of Paris.

38 "Antonio Abate," *Bibliotheca Sanctorum*, Rome, 1970, II, pp. 106–135.

39 I would cite only a few examples—ergotism, erysipelas, *Herpes genitalis*—the confusion of nomenclature, symptoms and diagnoses going back to Vergil, Lucretius and Seneca. I am grateful to Nancy McCall and Doris Thibodeau of the Institute of the History of Medicine, Johns Hopkins University, for their help in this research.

40 For this comparison, consult Veit Harold Bauer, *Das Antonius-Feuer in Kunst und Medizin,* Berlin, Heidelberg and New York, 1973, especially figs. 1 and 36. André Chastel, "La Tentation de Saint Antoine, ou le songe du mélancolique," *Gazette des Beaux-Arts*, XV, 1936, p. 227, and note 2 gives a different interpretation of the fire.

41 Chastel., pp. 224–229.

42 See R. Klibansky, E. Panofsky and F. Saxl, *Saturn and Melancholy*, London, 1964., figs. 77, 78, 81, 87, 90c.

43 Madeleine Bergman, *Hieronymous Bosch and Alchemy*, (Stockholm Studies in the History of Art, XXXI), Stockholm, 1979.

44 Cézanne may have adapted Delacroix' *Michelange dans son atelier* for the pose of the corner figure; Reff, 1966, p. 40. T. J. Clark, *The Absolute Bourgeois*, Princeton, 1982, p. 138, suggests that, in this painting, Delacroix acknowledged Michelangelo's sexual ambivalence.

45 Regarding the symbols of androgeny in philosophy and alchemy, consult Marie Delcourt, *Hermaphrodite, Myths and Rites of the Bisexual Figure*, trans. J. Nicholson, London, 1961, pp. 67–84.

46 Plato, *Symposium*, trans. W. Hamilton, New York, 1951, pp. 59–65.

47 *Ibid.*, pp. 63–64.

48 Michael Maier, *Atalanta Fugiens, hoc est, Emblemata Nova De Secretis Naturae Chymica*, Oppenheim, 1618, Facsimile ed., Kassel and Basel, 1964, p. 141. The Bibliothèque Méjanes in Aix-en-Provence, founded in the eighteenth century, has extensive holdings of seventeenth-century treatises dealing with magic and alchemy. Several are works by Michael Maier.

49 In the *Symposium*, pp. 60–61, Aristophanes tells that each original human being had "two identically similar faces upon a circular neck with one head common to both faces, which were turned in opposite directions." Zeus, as he bisected each,..."bade Apollo turn round the face and the half-neck attached to it towards the cut side, so that the victim, having evidence of bisection before his eyes, might behave better in the future."

50 The painting is V.19. Noted by Reff, 1962, p. 117, note 40; and Reff, 1966, p. 40.

51 F.W.J. Hemmings, *The Life and Times of Émile Zola*, London, 1977, p. 108, and fig. 42.

52 Zola was thus portrayed in the Goncourts' notations of 14 December 1868; Edmond and Jules

de Goncourt, *Journal*, Vol. VIII, Paris, 1956, pp. 154–156. See also Lapp's discussion, especially pp. 138–146, of Zola's "autobiographical" characters in his early novels—their ambivalent sexuality and their relationship to women.

53 Meyer Schapiro, 1968, p. 36, and note 10. Lapp, pp. 139–141, refers to Zola's projection, into his novel *La Curée,* of his own early familiarity with sexual inversion. As an addendum to Schapiro's notion that Zola joined his name with his friend's in *L'Oeuvre,* i.e. Sandoz, I would point out what may be a similar "merger" on Cézanne's part. This occurs in *La Lecture chez Zola* (V.118, 1869–70; see Fig. 8–12) which supposedly portrays the writer Paul Alexis and Zola. It seems very clear to me that the man who faces us, although called Zola, may also be Cézanne. Although the figure obviously has Zola's nose, he is bearded with long hair and has a high forehead which suggests the artist's premature balding. Fascinating to note as well is that the position of Zola's hands, holding a book, so closely resembles the preparatory sketch of a single figure (V.568) for *Les Joueurs de cartes.* Compare the similar and contemporary composition, V.117, where the rendering of Zola's head is completely different.

54 Lapp, p. 141, when speaking of letters which Zola had received pertaining to the ambivalence of his characters, assesses the novelist's reaction. "One reason why Zola may have been disturbed by the revelations in these letters is that they brought home to him the personal factor in his literary creations, revealing the close connection between the traditional 'Byzantium' and the actual homosexual in a hostile world, a connection of which he may have been only subconsciously aware."

55 Lapp, "Zola et la tentation de Saint Antoine," *Revue des sciences humaines*, XCII, 1958, p. 516. How vividly this description recalls Émile Bernard's account (*Souvenirs sur Paul Cézanne,* 5th ed., Paris, 1921, pp. 56–57) of his attempt to assist the aging Cézanne. The artist screamed at him: "Personne ne me touchera...ne me mettra le grappins dessus. Jamais! Jamais!"

56 See note 16 above. In *Madeleine Férat,* 1927–29, XXXIV, pp. 113–114, Zola repeats an exactly similar phrase in an overtly sexual connotation.

La jeune femme l'avait absorbé; elle le portait en elle maintenant. Ainsi qu'il arrive dans toute union, l'être fort avait pris fatalement possession de l'être faible, et desormais Guillaume appartenait a celle qui le dominait. Il lui appartenait d'une facon etrange et profonde. Il en recevait une influence continuelle, ayant ses tristesses et ses joies, la suivant dans chaque changement de sa nature. Lui, il disparaissait, il ne s'imposait jamais. Il aurait voulu se révolter qu'il se serait trouvé comme emporte dans la volonté de Madeleine. A l'avenir, sa tranquillité dépendait de cette femme, dont l'existence devait forcement devenir la sienne. Si elle gardait sa paix, il vivrait paisiblement de son côté; si elle s'affolait, il se sentirait fou comme elle. C'était une pénétration complète de chair et de coeur.

Consult also note 53 above and Rewald, 1936, p. 163. Badt, pp. 108–109, proposes that Cézanne's compositions in *Mardi Gras* (V.552) and *Les Joueurs de cartes* (V.559 and 560) metaphorically fuse two figures into one person.

57 Compare Lapp's interpretation; p. 130–131.

58 See the discussion below of *Le Déjeuner sur l'herbe*, and observations on *Pastorale* (V.103, ca. 1870) in my unpublished dissertation, "Cézanne's Bathers: Autobiographical Origins of Form and Content," The Pennsylvania State University, 1984, Chapter II.

59 Lapp, p. 132. Reff, 1962, p. 118, as we have noted above in note 37, likens the nudes to the three goddesses in the Judgment of Paris. In the conglomerate of legends about Saint Antony, artists probably found their inspiration in the *Vitae Patrum*, the *Legenda Aurea*, coupled with the account of Alphonsus Bonihominus. We find Antony tempted four times throughout his life by the devil who appeared in different guises: in the shape of a woman who was unsuccessful in seduction; by a youth with dark complexion who tempts carnal sin; by a woman bathing naked in a river; by a beautiful queen also bathing with her maidens. See Bergman, cited in note 43, pp. 16–17. The first two, the seducer and the dark young man, seem to be described in our picture. Coincidentally, the last two, the bathing women and companions, may turn up in later "bathers."

60 Zola, 1927–29, XXXIV, pp. 160–161.

Le peignoir [bleu] s'écartait encore, montrant la gorge que la chemise ouvert cachait a peine.... On eut dit qu'elle ignorait sa nudité et qu'elle ne sentait pas sur sa peau les caresses cuisantes du feu.

Guillaume la contemplait. ...Il s'aborsba dans le spectacle de cette créature demi-nue, dont les formes grasses et fermes n'éveillaient en lui qu'une inquiétude douloureuse; il n'éprouvait aucun désir, il lui trouvait une attitude de courtisane, une face dure et épaisse de femme rassasiée. ...toute la physiognomie, muette et comme figée, prenait un air de cruauté. Et, le long des joues jusqu'au menton, la chevelure rousse, encore roide d'eau de pluie, tombait par masses lourdes, encadrant la figure de lignes rigides.... Lorsque ses regards s'égaraient plus bas, sur la poitrine et sur les jambes nues, il y regardait danser la lueur jaune du foyer avec une sorte d'effroi. La peau blondissait; par moments, on êut dit qu'elle se couvrait de taches de sang qui coulaient rapidement sur les rondeurs des seins et des genoux, disparaissant, puis revenant encore marbrer l'épiderme tendre et délicat.

61 "La Curée," in *La Cloche et La Republique des lettres*, Paris, 1871; noted in Rewald, 1936, p. 186. The novel in its entirety was published in 1872; but according to Henri Guilleman, *Présentation des Rougon-Macquart*, Paris, 1964, p. 25, much of *La Curée* was written in the first months of 1870.

62 Lapp, p. 139, mentions this woman, but does not relate her to Cézanne's *La Tentation de Saint Antoine*. Observe that, near her right hand, curved strokes of red paint suggest an apple.

63 Zola, 1927–29, III, pp. 186–187.

Il vit Renée agenouillée, penchée, avec des yeux fixes, une attitude brutale qui lui fit peur. Les cheveux tombés, les épaules nues, elle s'appuyait sur ses poings, l'échine allongée, pareille à une grande chatte aux yeux phosphorescents.... Ils eurent une nuit d'amour fou. Renée était l'homme, la volonté passionnée et agissante. Maxime subissait. Cet être neutre, blonde et joli, frappé dès l'enfance dans sa virilité, devenait, aux bras curieux de la femme, une grande fille, avec ses membres épilés, ses maigreurs gracieuses d'ephèbe romain.

64 Rewald, 1986, p. 78; see also p. 164.

65 Cézanne, *Corres.*, pp. 31–32, letter of 9 July 1858; translation in Cézanne *Letters*, ed. John Rewald, trans. Seymour Hacker, N.Y., 1984, p. 22:

(Infandum n'abordons pas ce sujet corrupture):

Notre âme encore candide,
Marchant d'un pas timide,
N'a pas encore heurté
Au bord du precipice
Ou si souvent l'on glisse,
En cette époque corruptrice,
Je n'ai pas encore porté
A mes lèvres innocentes,
Le bol de la volupté
Ou les âmes aimantes
Boivent à satiété.

In a letter to Cézanne, dated 30 December 1859, Zola (*Correspondance*, I, p. 119) wrote of his own "innocence" in love: "...comme je te le dis, je n'ai jamais aimé qu'en rêve, et l'on ne m'a jamais aime, meme en rêve!"

66 Zola, 1927–29, XV, p. 50.

C'était sa passion de chaste pour la chair de la femme, un amour fou des nudités desirées et jamais possédées, une impuissance à se satisfaire, à créer de cette chair autant qu'il rêvait d'en éteindre, de ses deux bras éperdus. Ces filles qu'il chassait de son atelier, il les adorait dans ses tableaux, il les caressait et les violentait, désespéré jusqu'aux larmes de ne pouvoir les faire assez belles, assez vivantes.

Concerning the identity of Zola's Claude Lantier, see Robert J. Niess, *Zola, Cézanne and Manet*, Ann Arbor, 1968, especially Chapters IV and V.

67 I think particularly of V.527, and also V.569. See Rewald, 1986, p. 136, concerning the painting of a young woman (Hortense?) whose figure becomes part of the compositions of *Baigneuses*.

68 Zola, 1927–29, XXXIV, p. 153.

Cette créature venait de Satan, le ciel l'avait mise sur la terre pour la damnation des hommes. Elle la regardait se tordre et s'écheveler, comme elle eût regardé les tronçons d'un serpent remuer dans la poussière....

Lapp, p. 128 and note 6, mentions the woman-serpent analogies in works by Flaubert and in Baudelaire's *Les Fleurs du mal*.

69 V.542, 1885–88; C.514. In these paintings and drawings the left arm crosses in front of the body, a change in direction or position that occurs frequently in the bather pictures. In three early works, the figure is in the same position: V.266, 267, 898, and C.368. Figure with arm reversed: V.382–386, 547; C.514, 518–522, 373. In V.542 and C.517, the figure is moved to the right side.

70 C.520.

71 Zola, 1927–29, XXXIV, p. 160.

Ce masque froid, ce front de morte, ces yeux gris et ces lèvres rouges que le sourire n'éclairait pas, causaient au jeune homme un étonnement plein de malaise.

72 V.107, 1869–70.

73 R.65, ca. 1878.

74 Hélène Adhémar, *Embarkation for Cythera*, London, 1947.

75 Joel Isaacson, *Monet: Le Déjeuner sur l'herbe*, New York, 1972, pls. 2-5, 33. John Rewald, *History of Impressionism*, 4th ed. rev., New York, 1973, p. 177; and *ibid.*, p. 595, documents Cézanne's visit in 1865 to the studio Bazille shared with Monet.

76 Expressed by Badt, p. 256.

77 Cézanne, *Corres.*, pp. 27, 29. Letters are of 29 ...1858 and 9 July 1858. The charade was in a letter of 29 December 1859. *Ibid.*, p. 61.

78 *Ibid.*, pp. 21–22, Fig. 3; letter of 3 May 1858.

79 Suggested by Schapiro, 1952, p. 34.

80 Consider particularly V.559 and V.560

81 Zola, 1927–29, XXXIV, pp. 217–218.

Elle s'habillait comme une fille, avec sa robe a longue trâine: elle se dandinait sur le trottoir d'une façon provocante, regardant les hommes, ... la jeune femme marchait lentement, la tête un peu renversée, les cheveux dans le dos.

82 V.90, 1866–67; the likeness of the woman to Marie is also observed by Rewald, 1986, p. 63. About the identity of the figures and the date of this version of *Ouverture de Tannhäuser*, see Mack, p. 22, and Alfred Barr, Jr., and M. Scolari, "Cézanne in the Letters of Marion to Morstatt, 1865–68," *Magazine of Art*, May 1938, pp. 289–291. It is thought that Marie had considerable dominance over the artist. She was a spinster and, like her mother, was known for her nearly fanatical piety. Her nature seems well described in Cézanne's painting, *Marie en prière*, ca. 1860, published in *Cézanne ou la peinture en jeu*, Limoges, 1982, p. 56. See also the figure at the lower left in *Le Christ aux Limbes*, V.84.

83 Zola, 1927–29, XV, pp. 32 and 47.

Comme au premier plan, le peintre avait eu besoin d'une opposition noire, il s'était bonnement satisfait, en y asseyant un monsieur, vêtu d'un simple veston de velours. Ce monsieur tournait le dos, on ne voyait de lui que sa main gauche, sur laquelle il s'appuyait, dans l'herbe.

Le monsieur en veston de velours était ébauché entièrement; la main, plus poussée que le reste, faisait dans l'herbe une note très intéressante, d'une jolie fraîcheur de ton; et la tache sombre du dos s'enlevait avec tant de vigueur.

84 Cézanne worked often with this motif; one drawing (C.212) exists of a pointing hand done during the same period as the painting. His concern with the attitude and concept of the gesture shows in later preparatory sketches for individual and composite bather pictures. The pointing finger makes its definitive appearance in the Basel *Baigneuses* (V.542).

85 Zola, 1966, XII, p. 785. In Zola's youth, his admiration for Musset was exceded only by the influence the poet had on him. Observe his frequent references to, and adaptations of, Musset's work in his *Correspondance, passim*. The feeling of "les plus chers souvenirs de ma jeunesse" permeates Zola's commemorative essay on the poet (Zola, 1966, XII, pp. 327–351). In "Les cimetières—La tombe de Musset," one of *Les Nouveaux Contes à Ninon*, Zola weighed the strange power on his generation that came from Musset. According to Reff, ("Cézanne's 'Dream of Hannibal'," *Art Bulletin*, XLV, 1963, pp. 148–152), some of Cézanne's own verses reveal the moods of Musset's "Rolla" and "Les

Contes d´Espagne et d´Italie." He finds thematic, even personal, links with "Le Songe d'Annibal," written in 1858. The progression of Cézanne's images—from fantasy, to verse, to painting—when in a period of ten years "Le Songe" moved toward *L´Orgie*, have been noted. There are good reasons to believe, then, that *Le Déjeuner*, nearly contemporary with both *L´Orgie* and Zola's "Les Cimetières" (published in 1868), also bears the mark of the romantic poet.

86 Musset, pp. 317–323.

Qui donc es-tu, toi que dans cette vie
Je vois toujours sur mon chemin?
Je ne puis croire, à ta mélancholie,
Que tu sois mon mauvais destin.
Ton doux sourire a trop de patience,
Tes larmes ont trop de pitié.
En te voyant, j´aime la Providence.
Ta douleur même est soeur de ma souffrance;
Elle ressemble a l´Amitié.

Qui donc es-tu? —Tu n´es pas mon bon ange;
Jamais tu ne viens m´avertir.
Tu vois mes maux (c´est une chose étrange!)
Et tu me regardes souffrir.
Depuis vingt ans tu marches dans ma voie,
Et je ne saurais t´appeler.
Qui donc es-tu, si c´est Dieu qui t´envoie?
Tu me souris sans partager ma joie,
Tu me plains sans me consoler!

Qui donc es-tu, morne et pâle visage,
Sombre portrait vêtu de noir?
Que me veux-tu, triste oiseau de passage?
Est-ce un vain rêve, est-ce ma propre image?
Que j´aperçois dans ce miroir?

To Lois Boe Hyslop I owe thanks for many conversations about Zola and Baudelaire. It was she who knew also of the *Doppelgänger* in Musset's poetry.

87 William Rubin, "From Narrative to 'Iconic' in Picasso: The Buried Allegory in *Bread and Fruitdish on a Table* and the Role of *Les Demoiselles d´Avignon*," *Art Bulletin*, LXV, 1983, pp. 637–638, suggests that the contemplative figure in our *Le Déjeuner* was transposed, as an image of Cézanne, into Picasso's *Bread and Fruitdish*. But could Picasso have assumed that this was Cézanne's alter ego? Reff speaks of the "first fully realized alter ego" in Picasso's art during the Rose Period when the artist portrayed himself as an idealized Harlequin ("Harlequins, Saltimbanques, Clowns and Fools," *Artforum*, 1971, pp. 32 and 42). *Ibid*, p. 38, notes that Cézanne's *Mardi Gras* (V.552) was well known to Picasso and probably served as a model. How coincidental could it be that Badt, pp. 107–109, sees Cézanne himself as Harlequin in *Mardi Gras*?

88 Petrone, pp. 235–239. The author believes that the character may be Manet or Degas; but the personality of Séguin, as Duranty describes it, would seem to rule this out. On the other hand, since Manet was a member of the Guerbois circle, it seems likely that he, like Duranty, was fascinated by the notion of the homo-duplex, a concept that he dealt with in his own art. See Mauner, particularly pp. 15–18.

89 Petrone, pp. 237–238.

Je me suis souvent demandé quels peuvent être mes défauts et comment on me juge, car je me doute bien qu´autri ne me voit pas comme je me vois, et connait de moi bien des choses que j´ignore.... Il m´arrivait souvent jadis de me regarder dans la glace. Et je me rapelle très bien ce qui m´arrivait... car ma propre personne m´a toujours prodigieusement interesse et étonné.... Eh, bien, je me sentais pris d´un sentiment de critique, de jugement sévère envers cet être qui se dressait devant moi.... N´est-ce pas que le personnage qu´on voit dans une glace lorsqu´on veut s´y regarder est un être bien distinct de vous, un être réel, vivant, capable d´agir, par exemple de vous suivre partout où vous allez, et étant lié en somme à vous par les singulières vertus de l´émanation lumineuse....

90 Rewald, 1986, p. 142 and note 12, refers to Duranty's frequent play on names.

91 See the friends' letters: Zola, *Correspondance*, I, p. 126, letter of 5 January 1860; *ibid*., p. 142, letter of 25 March 1860. Cézanne would compliment his friend on his gift of cigars: "Par ma foi, mon vieux, tes cigares sont excellents, j´en fume un en t´écrivant; ...grâce à ton cigare voilà mon esprit qui se raffermit,...". *Corres.*, p. 49.

92 *Pastorale*, V.104 and *Les Voleurs et l'âne*, V.108.

93 V.559, 560. Compare also with V.561 and 563.

94 V.556–558; this is also true in the individual portrait for the figure on the left, V.563.

95 Badt, p. 113.

96 C.162, 1864–67.

97 Cézanne's interchanging of roles, moods, and characters, which becomes more evident in the bather pictures, seems well chronicled in *Les Joueurs de cartes*. If the standing contemplator in *Le Déjeuner sur l'herbe* represents a conflated Cézanne/Zola, when the figure enters the *Cardplayers* as a seated opponent, he wears a Kronstadt hat, one that Cézanne often wore himself (note, for example, V.514 and 515). See Rubin, as in note 87 above, pp. 637–638, and figs. 26 and 31.

98 At this time, Cézanne may have sensed his friend's increasing desire, while still avowing lasting devotion, to disengage himself from the artist's temperamental explosions and personal difficulties. Such hints of a cooling relationship are first expressed in Zola's letter to Baille written soon after Cézanne's arrival in Paris. See particularly the letters of 10 June 1861 and [end of June—beginning of July 1861]. Zola, *Correspondance*, I, pp. 292 f. and 298 f.

99 Musset, p. 322.

Dis-moi pourquoi je te trouve sans cesse
Assis dans l'ombre où j'ai passé.
Qui donc es-tu, visiteur solitaire,
Hôte assidu de mes douleurs?

100 *Ibid.*, pp. 322–323.

—Ami, notre père est le tien.
Je ne suis ni l'ange gardien
Ni le mauvais destin des hommes.
Ceux que j'aime, je ne sais pas
De quel côte s'en vont leurs pas
Sur ce peu de fange où nous sommes.

Je ne suis ni dieu ni démon,
Et tu m'as nommé par mon nom
Quand tu m'as appelé ton frère;
Où tu vas, j'y serai toujours,
Jusques au dernier de tes jours,
Où j'irai m'asseoir sur ta pierre.

Le ciel m'a confié ton coeur.
Quand tu seras dans la douleur,
Viens à moi sans inquiétude,
Je te suivrai sur le chemin;
Mais je ne puis toucher ta main
Ami, je suis Solitude.

101 The snake makes a more colorful appearance in the lower right corner of *L'Orgie*; V.92. Cézanne, in his early letters and notably in his poem "Le Songe d'Annibal", alludes to drinking, often in excess; *Corres.*, pp. 25; 37–38.

102 V.380, 1875–77; V.720, 721, 1895–1906.

103 V.245. The quotation is from Émile Bernard, p. 55, as in note 55 above.

104 Cézanne, *Corres.*, p. 131. Letter to Numa Coste, ca. beginning of July 1868. The three were Cézanne, Baille and Zola. Cézanne does call the dog "Black"; *ibid.*, p. 109; letter to Coste, 5 January 1863.

105 See note 37 above.

106 G. Flaubert, *Salammbô*, ed. Garnier Frères, Paris, 1961, p. 35.

Il poursuivait dans la forêt le monstre femelle dont la queue ondulait sur les feuilles mortes, comme un ruisseau d'argent.

In Zola's *La Faute de l'abbé Mouret*, 1927–29, VI, p. 216, the description of Serge following Albine in the garden, Paradou, is remarkably similar. "Jamais il n'avait fait attention au balancement de sa taille, à traînée vivante de sa jupe, qui la suivant d'un frôlement de couleuvre." To Michael Losch, my thanks for leading me to Abbé Mouret. Further associations with this novel and Cézanne's paintings will be explored in my forthcoming publication on the Bathers.

107 Reff, 1966, particularly pp. 35–38. See again Zola, *La Faute de l'abbé Mouret*, pp. 246–247, where the lovers turn left, to find the Tree of Life, the choice between Good and Evil: Albine murmurs to Serge, "C'est comme cela qu'on serait bien, dans un coin que je connais.. Là, rien ne nous troublerait. ...C'est là-bas. Je ne puis pas t'indiquer. Il faut suivre la longue allé, puis on tourne à gauche, et encore à gauche."

108 Musset, "Rolla," p. 284.

109 Schapiro, 1968, p. 38. See also Eugenio Battisti, article in press.

110 Mauner, pp. 7–45, develops this argument.

111 Reff, 1966, p. 40. See Robert A. Koch, *Joachim Patinir*, Princeton, 1968, fig. 44. The painting, in the Prado, is now attributed to Patinir and Quentin Massys. In Cézanne's *Tentation*, there are curved red brush strokes nearly hidden in the white drapery which belongs to the squatting figure. Surely we must think of another apple! See note 62 above.

112 See note 67 above.

113 Theodore Reff, "Cézanne: the severed head and the skull," *Arts Magazine,* LVII, 1983, pp. 84–100, elaborates on Cézanne's guilts and fears that are so closely associated with his family. A little known picture, V.87, painted about 1864–66 and remaining in the Jas da Bouffan until 1936, shows a double image of a man and woman. He closely resembles Cézanne with dark hair and bushy beard; she has light skin and is shown in profile. Entitled *Contrastes*, we would wonder if they could be Paul and Marie Cézanne.

114 Petrone, p. 239.

115 *Ibid.*

Mais n´était-ce pas une originale et subtile maladie que la sienne? Pour avoir trop voulu pratiquer le connais-toi toi-même, Paul Séguin en etait venu à l´hallucination. Il se dedoublait, se voyait tout entier physiquement et moralement et cet être que chacun admire tant, soimême, lui était devenu odieux. Avait-il tort ou raison? Je me demandai en le quittant si chacun de nous, se voyant comme lui répété et un autre être, prendrait aussi celui-ci en aversion?

116 Barr, (cited in note 82 above) pp. 288–291. This popular theme was discussed by George Mauner in his lecture, "Manet and the Playing Card Principle," given at The National Gallery of Art, 4 March 1983.

117 Baudelaire, *Oeuvres complètes* (as in note 33) p. 1223.

118 See Mauner, fig. 7.

119 Schapiro, 1952, p. 88, notes that the two players in the later versions are opposite types—left dark; right light; hat down, hat up; face in shadow, face in light. Could both of these represent Cézanne, alluding again to the homo duplex?

120 V.225, 1872–73; V.106 is a similar composition, usually dated ca. 1870.

121 Such spatial ambiguity is not felt in the earlier version, V.106. It does, however, seem reminiscent of the indistinct location of the bathing figure in Manet's *Le Déjeuner sur l'herbe.*

122 See Dore Ashton, *A Fable of Modern Art*, London, 1980, pp. 30–47, concerning Cézanne's association with Frenhofer.

123 Bernard, (as in note 55 above), p. 44.

Un soir que je lui parlais du *Chef-d'oeuvre inconnu* et de Frenhofer,...il se leva de table, se dressa devant moi, et, frappant sa poitrine avec son index, il s'accusa sans un mot, mais par ce geste multiplié, le personnage même du roman. Il en était si ému que des larmes emplissaient ses yeux.

124 Honoré de Balzac, *Oeuvres complètes*, XIV, Paris, 1845 (Facsimile Ed. 1967), pp. 301–302.

Qui le verrait, croirait apercevoir une femme couchée sur un lit de velours, sous des courtines. Près d'elle un trépied d'or exhale des parfums. Tu serais tenté de prendre le gland des cordons qui retiennent les rideaux, et il te semblerait voir le sein de Catherine Lescault, une belle courtisane appelée la Belle-Noiseuse, rendre le mouvement de sa respiration.

125 V.247, 1875–77.

126 Schapiro, 1968, p. 49.

127 *Ibid.* The similarity of forms, of woman and mountain, is especially evident in a watercolor prepared for the larger picture; R.57, ca. 1877. This relationship can also be seen in the little painting that hangs over the mantle-piece in *La Lecture chez Zola*, V.118, ca. 1869 (Fig. 8-12).

128 V.721 and V.719 respectively.

129 Note particularly the watercolor study, R.57, ca. 1877, and the drawings C.257 and C.258.

130 Zola, 1927–29, XXXIV, pp. 99–100, 244.

"Un peu pale, fortes epaules, [elle est] saine, vigoreuse, les membres solides, elle était devenue une puissante fille, a la poitrine large, au rire clair. ...Ses cheveux roux, a peine noues, tombaient sur sa nuque en un seul flot épais et ardent. Tout son être prenait des attitudes d'une vigueur superbe." "...son cou, gras et blanc, [était] gonflé de volupté."

131 Zola, 1927–29, XV, pp. 380 and 391. Concerning Zola's projecting himself into this conflict of passion and art, see Niess, as in note 66, Chapter VII, especially pp. 159–169. Rewald, 1986, pp. 171–184, discusses the break with Zola.

132 V.719, 1900–06.

Bibliography

Badt, Kurt. *The Art of Cézanne.* Translated by Sheila Ann Ogilvie. Berkeley and Los Angeles, 1965.

Cézanne, Paul. *Correspondance.* Revised edition. Annotated by John Rewald. Paris, 1978.

Chappuis, Adrien. *The Drawings of Paul Cézanne.* 2 Volumes. Greenwich, Connecticut, 1973.

Lapp, John C. *Zola before the "Rougon-Macquart."* Toronto, 1964.

Mack, Gerstel. *Paul Cézanne.* New York, 1935.

Mauner, George. *Manet. Peintre-Philosophe.* University Park, Pennsylvania, and London, 1975.

Musset, Alfred de. *Poésies complètes.* Edition Pléiades. Paris, 1923.

Petrone, Mario. "'La Double vue de Louis Séguin,' de Duranty," *Gazette des Beaux-Arts* LXXXVIII, 1976, pp. 235–239.

Reff, Theodore. "Cézanne, Flaubert, St. Anthony, and the Queen of Sheba," *Art Bulletin* XLIV, 1962, pp. 113–125.

Reff, Theodore. "Cézanne and Hercules." *Art Bulletin* XLVIII, 1966, pp. 35–44.

Rewald, John. *Cézanne et Zola.* Paris, 1936.

Rewald, John. *Paul Cézanne: The Watercolors.* Boston, 1983.

Rewald, John. *Cézanne: A Biography.* New York, 1986.

Schapiro, Meyer. *Paul Cézanne.* New York, 1952.

Schapiro, Meyer. "The Apples of Cézanne: An Essay on the Meaning of Still-life," *The Avant-Garde. Art News Annual* XXXIV, 1968, pp. 35–53. Reprinted in Schapiro, Meyer. *Modern Art.* New York, 1978, pp. 1–38.

Venturi, Lionello. *Cézanne, son art, son oeuvre.* 2 Volumes. Paris, 1936.

Zola, Émile. *Correspondance.* Edited by B. H. Bakker. 5 Volumes. Montreal, 1978.

Zola, Émile. *Oeuvres complètes.* Notes and commentaries by Maurice Le Blond. Paris, 1927–29.
Vol. III, *La Curée.*
Vol. V, *La Conquête de Plassans.*
Vol. VI, *La Faute de l'abbé Mouret.*
Vol. XV, *L'Oeuvre.*
Vol. XVIII, *La Bête humaine.*
Vol. XXXIV, *Thérèse Raquin; Madeleine Férat..*
Vol. XLV, *Documents littéraires.*

Zola, Émile. *Oeuvres complètes.* Edited by Henri Mitterand. Paris, 1966.
Vol. XII *Oeuvres critiques.*

Figures begin on the following page.
Unless otherwise noted, all works illustrated are by Paul Cézanne.

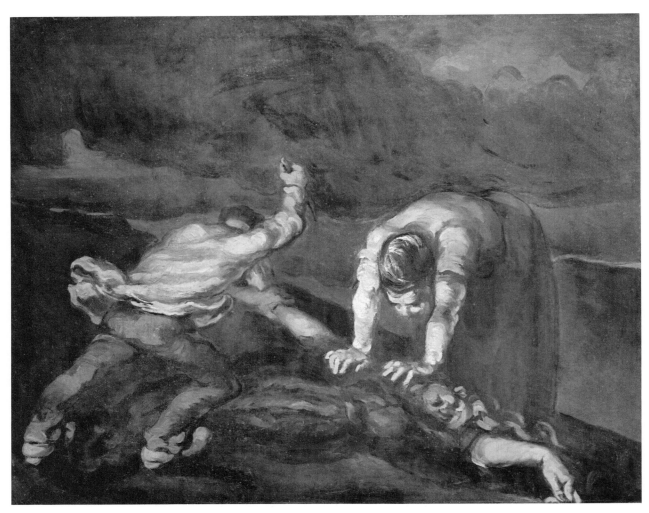

Fig. 8–1 *Le Meurtre* (V.121), 1867–1868. Walker Art Gallery, Liverpool.

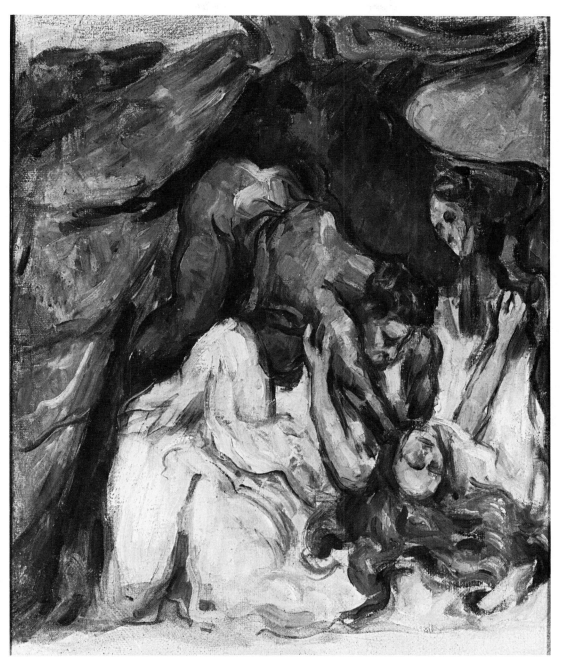

Fig. 8–2 *La Femme Étranglée* (V.123), 1870–1872. Musée d'Orsay, Paris.

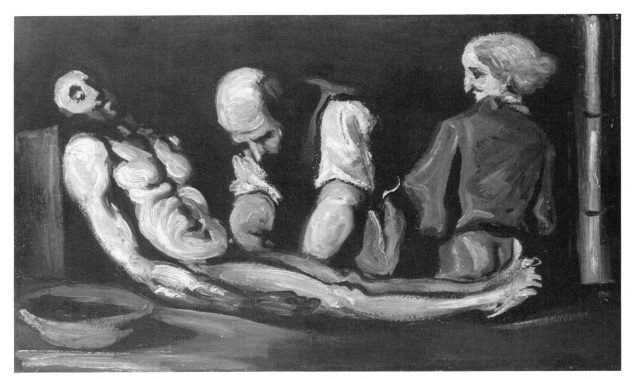

Fig. 8–3 *L'Autopsie* (V.105), ca. 1868. Private Collection. Photo courtesy Ernst Beyeler Galerie, Basel.

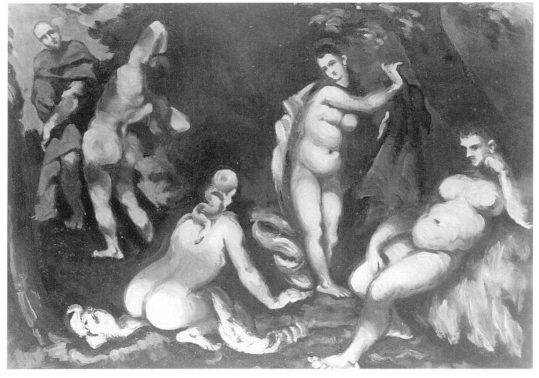

Fig. 8–4 *La Tentation de Saint Antoine* (V.103), ca. 1870. Collection E. G. Bührle, Zürich.

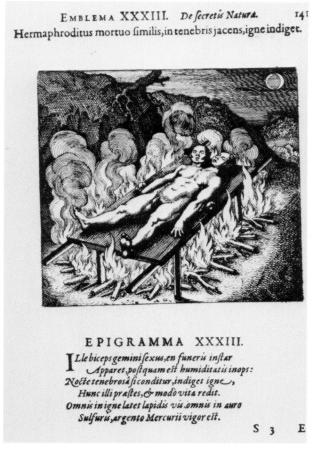

Fig. 8–5 *Hermaphroditus mortuo...*, illustration from Michael Maier, *Atalanta Fugiens, hoc est, Emblemata Nova De Secretis Naturae Chymica*, Oppenheim, 1618.

Fig. 8–6 *Portrait of Émile Zola* (V.19), 1862–1864. Photo, John Rewald, *Cézanne: A Biography*, 1986.

Fig. 8–7 *Esquisses des baigneuses* (C.520), 1883–1885. A. Chappuis, Tresserve.

Fig. 8–8 *Le Déjeuner sur l'herbe* (V.107), ca. 1870. Private Collection, Paris.

Fig. 8–9 *Ouverture du Tannhäuser* (V.90), 1869–1870. Hermitage, Leningrad.

Fig. 8–10 *Une Moderne Olympia* (V.225), 1873–1875. Musée d'Orsay, Paris.

Fig. 8–11 *L'Éternel féminin* (V.247), 1875–1877. J. Paul Getty Museum, Malibu.

Fig. 9–12 Juan Gris. *Portrait of Picasso.* "L'Age Canonique," *L'Assiette au Beurre* (July 9, 1910).

Picasso and the Catalan Colony in Paris Before the Great War

9

Painting in the nineteenth century was only done in France and by Frenchmen, apart from that, painting did not exist, in the twentieth century it was done in France but by Spaniards.[1]

As is so often the case, one of Gertrude Stein's provocative statements, absurd if taken at its face value, nevertheless gets close to the heart of the matter. The Spanish painters she was referring to were Picasso and Gris—and one might add Miró—and although only the last of these was actually Catalan, they were leading members of a Catalan circle in Paris that had a continuous existence from the late 1880s to the outbreak of World War II. Close examination of this group during the first fifteen years of the century shows a remarkable interaction between the expatriate community and the artworlds both of their homeland and their host city, for not only did art as experienced in Paris affect the course of Catalan and Spanish art as a whole, but, as Gertrude Stein pointed out, Spanish artists working in Paris profoundly affected the course of mainstream art. The complex patterns of this interaction offer a paradigm for the examination of the impact of a foreign community on the cultural life of other cities at other times, and similar questions could be asked, for example, about the Americans in Paris in the twenties and thirties.

By 1900, when Pablo Picasso (1881–1973) and many others came to Paris to visit the Exposition Universelle, a Catalan community which counted among its members painters, sculptors, writers, musicians, political exiles, businessmen and others, was well established.[2] For artists the way had been paved by the first generation of *Modernistes*, namely Santiago Rusiñol (1861–1931) and Ramon Casas (1866–1932), whose Parisian canvases had already initiated something of an artistic revolution in Barcelona as early as 1891. Their work and their experiences had changed all

hopes and expectations for younger artists, who, bored with the local academy as well as with the occasional prospect of studying in Madrid or Rome (as their teachers had traditionally done) and having little if any opportunity to see foreign art, now regarded Paris as their mecca.

Rusiñol and Casas, along with the bohemian critic and shadow-puppet producer Miquel Utrillo (1862–1934), had actually shared an apartment above the famed dance hall and icon of modern French painting, the Moulin de la Galette, beginning in 1890. Rusiñol's and Casas's depictions of life in artists' studios, the outskirts of Paris, and in the dance hall itself, such as Casas's bleak *Dance in the Moulin de la Galette* (Fig. 9–1), a Sunday afternoon scene of bored dancers in the darkened interior of the dance hall, not only benefited from the painters' exposure to similar scenes in the works of French artists (Degas and Toulouse Lautrec, for example) but also was tied to their commitment to a kind of realism, especially in the case of Rusiñol, that had its origins in Catalan landscape painting.[3] Comparisons with Zola-like naturalism were made by Barcelona critics, who found the sordid views of urban life unsettling. Rusiñol's depiction of the emptiness of the *Kitchen in the Moulin de la Galette* (Fig. 9–2), for example, communicated not only the absence of dance hall gaiety but also the suggestion of dreary labor by contrasting the worn, grey surfaces with the sparkling light of the "Renoir garden" beyond.

Although the subjects of the Impressionists had a great appeal to the Catalans, any attempt to imitate Impressionist facture—especially the abbreviated brushstroke that functioned as a unit of color sensation—was absent in their paintings. Casas did have a taste for atmospheric effects, but these he learned from his experiences as a student in the atelier of Carolus Duran and at

the Académie Carrière. In addition, Casas admired canvases by Sargent (also a student of Duran) and other foreigners working in Paris. For instance, his use of a thin unifying application of color—often a hazy blue, such as in Fig. 9–1—derives in part from the study of atmospheric paintings of this period by Whistler. In this connection, it is worth mentioning that another aspect of the artistic influences affecting the foreign colony in Paris was the cross-contact with other non-French artists. Because they often met at the same academies, one could argue that a kind of international style developed among them. Indeed, in the 1880s and 1890s, striking similarities—notably in portrait or society painting—occur in the canvases of Casas and in those of the Italians Boldini and Raffaelli, the Swede Zorn and the Americans Sargent and Whistler, to name only a few.

Both Rusiñol and Casas usually spent about half the year in France, the other half in Catalonia, and while they contributed to the Paris salons, their annual output was shown on a fairly regular basis in Barcelona throughout the nineties at its one major commercial gallery, the Sala Parés. These large exhibitions were unlike anything the local artists or public had ever seen before. Critics described their Parisian canvases as "*Modernistd*" principally because of the new subject-matter—modern life. Raimon Casellas, for example, in the radical journal *L'Avenç*, likened the 68 works by the two artists in the 1891 show to pages "from an album that make us experience through analytic painting the varied aspects of a strange and sick slice of life..."[4] But "*Modernista*'" also signified what were perceived as similarities and affinities with the literary and intellectual *Modernista* movement in Catalonia, which had developed since the 1880s and reflected European trends, such as naturalism and, later, symbolism, within an overall Catalan context. Its proponents aimed to take Barcelona away from the orbit of Madrid and Spanish culture and open it to the world. Thus, the painters' alliance with Paris and French culture fitted the general aims of the movement.

Young Catalan artists had the opportunity of regular first-hand contact with Rusiñol and Casas and others of their generation at the café Els Quatre Gats, which opened in 1897 and was modeled after Rodolphe Salis's Le Chat Noir. Its four founders were Casas, Rusiñol, Utrillo and Pere Romeu (c. 1862–1908), a Catalan who had worked in Paris for Aristide Bruant and who managed the café. In a sense Els Quatre Gats was headquarters for the Barcelona-Paris connection: conversations continued from Montmartre at the Quatre Gats tables; French and other foreign guests were entertained there; and examples of foreign art were on hand, especially graphic work, which was easily transported. In addition, works by the *Modernistes* could be seen in small exhibitions, and opportunities for artistic collaborations were available to all the artists and writers of the group. For instance, in 1899 the café issued a small, illustrated journal called *Quatre Gats*, just as Salis had published *Chat Noir,* and drawings and poems by members of the Quatre Gats circle were included. This publication was succeeded by the illustrated art journal *Pèl & Ploma* (modeled after the French magazine *La Plume* and run by Casas and Utrillo), which included articles on local and foreign artists alike with drawings principally by Casas. Picasso was featured in June 1901.

One activity that involved most of the artists at Els Quatre Gats and was central for the younger generation was poster design. The flowering of commercial art in Paris perfectly matched the growing prosperity of Barcelona. Casas, who not only designed advertisements for the café but also for numerous Catalan commercial establishments throughout the nineties and the first decade of this century, succeeded in drawing international attention to the 'Spanish School' of poster artists, and both French and English journals devoted space to them.[5] Utrillo also worked successfully as a poster designer, and in fact many of his and Casas's posters were printed by his uncle's lithographic firm, Utrillo i Rialp. Poster exhibitions, featuring both local and foreign artists were held at the café as well as the Sala Parés, and poster competitions were sponsored to encourage the development of this aspect of *Modernista* art. In 1900, for example, Picasso and his studio-mate, Carles Casagemas, were named runners-up in the Carnival poster competition held at Els Quatre Gats early in the year.

In many ways the paintings of Rusiñol and Casas and their literary and artistic connections outside Spain gave Picasso and his generation first contact with recent French trends. The impact of this indirect acquaintance with Parisian art can be traced directly in their own work as well as in what they first chose to look at—in a sense what they were prepared to see—when they first went to Paris. The painter Isidre Nonell (1873–1911), for instance, who made his first trip to Paris in 1897, wrote to Casellas reporting his initial responses to recent French painting:

"Works by C. Monet, Degas, Pissarro, Manet, Renoir, etc., in the beginning I found weak. Now that I've studied them more attentively I like them better; even so, for me they are not as great as I had thought. Monet especially is quite different from what I expected. Perhaps when I've seen more of his work (I've seen only a few examples and they say they are not

the best), I'll become more enthusiastic. The artists that I have liked best from the start are Puvis de Chavannes, Wisler [*sic*] Sargent and Carrière. The first is without a doubt the greatest living painter." [6]

Here it is worth noting that both Rusiñol and Casas had as students known Puvis and Carrière and that Sargent and Whistler were in a real sense Casas's artistic heroes.

When Picasso made his first trip to Paris in 1900, the one major canvas he made was a depiction of the *Moulin de la Galette* (Guggenheim Museum, New York), a tribute not only to the *Modernista* work (and former residence) of his predecessor Casas but also to recent French tradition in the work of Renoir and Toulouse Lautrec. More alert than his fellows, Picasso was clearly also affected by Van Gogh, but his future hero, Cézanne, on the other hand, seems not yet to have had any traceable impact on him.

* * * *

While opportunities for trade attracted the already prosperous Catalan business community, political instability in Barcelona on occasion resulted in short-time exile in France for anarchist-sympathizers and Catalan separatists. Especially during the late nineties Paris saw an influx of Barcelona intellectuals whose political views had put them into danger on home ground. Increased anarchist terrorism during the period, notably the attempted assassination of the Spanish prime minister Canovas and the subsequent bombing of the Liceu opera house in Barcelona by Santiago Salvador in 1893, and the bombing of the Corpus Christi procession also in Barcelona in 1896 (widely believed to have been carried out by a government agent), had led to a repressive climate in which all persons of liberal or anti-government persuasion, particularly those with anarchist sympathies, were suspected of collaboration. The infamous Montjuich trials beginning in 1896 had started with the rounding up of some 400 sympathizers, many of whom were later deported and some of whom died from torture. To avoid arrest, others, such as opera critic Alexandre Cortada and the writer Jaume Brossa (who went on to London) fled to Paris;[7] and there they not only found a sympathetic colony of Catalans but also a situation in which they were able to continue to voice their opinions in Barcelona through journalistic activity.

The political climate both in Barcelona and in the Catalan colony in Paris of the years around the turn of the century is of particular interest to the artistic situation, although its complexities have baffled recent attempts to pin an anarchist label on the young Picasso.[8] Because of the small number of individuals involved both in the arts and in politics—often they were one and the same—and especially because of the close contact of exiles in Paris, Catalan politics of this period deserve further consideration. The Montjuich trials, for instance, had produced a brief alliance of sympathy between the movement for Catalan autonomy and the anarchists, but calls by the Catalan bourgeoisie for political and social reform were part of a general dissatisfaction with the unholy alliance of the military and the corrupt Madrid government rather than a specific reflection of support for the anarchist cause. As far as the painters were concerned, almost all reflected one shade or another of the Catalan regionalist movement.

The first generation of *Modernistes* (that is, those born in the 1860s) were in practically all cases themselves products of the prosperous Catalan bourgeoisie that by the 1890s was one of the principal forces for regionalism. Primarily, though not exclusively, an urban movement, political Catalanism aimed in varying degrees (depending on the faction) at regional autonomy. From its infancy in the 1860s the cultural expression of Catalanism emerged in three specific areas: one was a conscious revival of the language, literature, music and art of the great days of the Catalan Kings in the late Middle Ages; the second was the choral movement founded by Anselm Clavé, which drew on folk traditions and took regionalism into the rural areas and which well into the twentieth century was the popular expression of Catalan aspirations; the third was landscape painting—the expression of *la terra catalana*. The Olot school (beginning in the 1880s) led by Joaquim Vayreda, the Luminists of Sitges (in the 1890s) and even the Colla de Sant Martí, formed in the mid-1890s by students who later became Picasso's friends, are all manifestations of this aspect of regionalism.

The working-class movements were republican and, in general, opposed the regional movement—partly because Catalonia had already attracted labor from other parts of Spain, particularly the south. Anarchism was also a very strong force, although the number of strict anarchists, who believed in terror and the "propaganda of the deed" seems to have been small. The anarchosyndicalists, who aimed at power through organized labor, were the single most important group—at the expense of Marxist socialists. Anarchist thinking, however, influenced many (including artists and intellectuals) who were not anarchists at all. Proudhon and Bakunin, Stirner and Kropotkin were all widely discussed, while the ideas of Nietzsche, variously interpreted, found resonance in almost every shade of opinion.

Some obvious expressions of artistic sympathy with the anarchists were the drawings made by both Rusiñol and Casas—the two leaders of bourgeois Catalan *Modernisme* —in connection with the Liceu bomb (Fig. 9–5) and the Cuban war (1897–1898). Moreover, Casas did three large paintings at this period reflecting contemporary events: *The Garroting* (Fig. 9–4), painted in the wake of the execution of the opera-house bomber; *Corpus Christi procession leaving the church of Santa Maria del Mar* (Museu d'Art Modern, Barcelona), painted two years after the bomb outrage of 1896; and *The Charge* (Fig. 9–3), a huge painting which shows a workers' protest with a fallen protestor being ridden down by a civil guard. It is difficult to know just how these works were intended.

In one sense they are clearly intended as modern history paintings in emulation of Goya and Manet, but Casas seems to take an almost neutral moral stance, using the subjects as opportunitites to display his painterly technique—creating a grim atmosphere for the execution scene and an air of festive bourgeois celebration for the procession (only the title suggests its political reference), while the brutal guard in *The Charge*, painted life-size, becomes a splendid figure. *The Garroting* created a sensation when it was exhibited, and *The Charge* was clearly considered too controversial to be accepted for the official Spanish section of the 1900 Paris exhibition (while Picasso's morbid, *Modernista* canvas entitled *Last Moments* was chosen), but Casas retitled the painting *Barcelona 1902*, with reference to the violent clashes between workers and the Civil Guard during the general stike that February, redated it 1903 and exhibited it in Paris at the Champ de Mars Salon. Not only did the work earn Casas the title of Sociétaire, but in 1904 it won him a first-class medal in Madrid and an invitation to do a state portrait of the young king of Spain, who had assumed the throne in 1902. Casas's artistic opportunism had paid off. But by this time the political balance was also changing: the Madrid government was being forced into reform and Catalonia was well on its way towards achieving real regional autonomy. There was a rapid polarization between the conservative Catalanists with their growing political power and the workers' parties—now increasingly radical republicans rather than anarchists.

These "modern history paintings" of Casas produced no obvious response in the younger generation, but the whole subject of "modern life" was taken up by both Picasso and Nonell. Nonell had done journalistic illustrations for the liberal daily *La Vanguardia* since 1894, and he had made a moving series of drawings based upon a community of cretins in the remote Catalan village of Bohí in 1896, which brought him local

recognition. However, in his paintings (beginning in 1900) his interest in gypsies (Fig. 9–6) became an obsession, an identification with his subjects that was far too personal to include any political dimension. Picasso's paintings of social outcasts (Fig. 9–7) during his 'Blue Period' (1901–4) also fall out of the range of politically motivated art, that is, art which through narrative means aims for real social change. The distance both artists keep from their subjects, principally through lack of journalistic detail and because of the primacy of artistic considerations, suggests that their paintings in the early years of this century have as much to do with their own origins in Spanish tradition, including El Greco, seventeenth-century Spanish painting (in which beggars often appear) and Goya, as they do with modern life in a *Modernista* sense. Undoubtedly Picasso and his friends felt affinities with the downtrodden, especially during this period of political unrest, but their artistic ambitions overshadowed any tendency towards political activism.

Because of Picasso's dominant position in twentieth-century painting, his work has become the subject of analyses from every possible point of view. Jung himself gave an interpretation of one of the principal Blue Period works,[9] others have projected Freudian fantasies onto Picasso, and he has constantly been claimed by writers with a political axe to grind. It is not at all easy to establish what Picasso's own political views were at any point in his life, with perhaps the exception of the period of the Spanish Civil War. What is clear is that throughout his career he used his art to reflect the circumstances of his personal life and that he saw his work, however radical it might be, as part of the traditional practice of painting. This is not to argue for a purely formalist approach but to emphasize the importance of arguing from real evidence. For example, Picasso's subject-matter throughout his career remains very close to traditional sources and, even when his work was at its most revolutionary stage, its development must be seen within the context of tradition.[10] Certainly the subjects of the works in the Blue Period can be traced to such sources on the basis of firm evidence, while his social or political attitudes towards the people he was painting remain enigmatic.

* * * *

By the time of his Blue Period Picasso had experienced Paris at first hand, and his choice of Paris in which to continue his career follows the accepted pattern for Barcelona artists. Choosing Paris rather than Madrid as the center of their cultural orbit was one way in which the Catalanists expressed their cultural inde-

pendence—and it was a choice that conformed conveniently with the widening business interests of Catalan industrialists. The Catalan language (which Picasso had mastered by 1899) also provided another general reason for living in France; for it has as many affinities with French as with Castilian. Moreover, Paris was geographically the closest of important fin-de-siècle art centers, although Munich and Vienna held great attraction for Spanish artists, including Picasso and Gris, who both had expressed interest in Munich early in their careers.[11] But not only was Germany at a much greater distance from Barcelona (Paris was only an overnight train ride away), the German language itself presented an even greater obstacle.

Picasso, as a non-Catalan, had first tried out Madrid at his family's instigation in 1897–1898—the obvious choice for a Spanish artist, since it offered the Prado and the San Fernando art academy—but he abandoned his classes out of boredom and produced very little work. Much later, he claimed that he had really wanted to go to London in 1900 when he first left Spain, having read a biography of Lady Hester Stanhope as a child, which had left him with the hopes of finding free-spirited English women.[12] Perhaps he also fancied his father's reputed resemblance to an Englishman as an ancestral tie; but more likely he made the comment to please his English friend Roland Penrose. Indeed, London offered a strong nineteenth-century painting tradition, including the Pre-Raphaelites. But the circle around William Morris was perhaps more of interest to politically commited Catalans, such as Brossa, or to those artists, such as Alexandre de Riquer (1856–1920), who contributed to a revival in arts and crafts as a part of the Catalan cultural movement. It was Riquer, in fact, who almost single-handedly introduced techniques of printing and English design to Barcelona during this period. But to a painter, London offered little more than Barcelona at the turn of the century when it came to new artistic developments.

Another alternative might have been Brussels, for great enthusiasm among the Catalans was felt during this period for writers such as Verhaeren and Maeterlinck (*L'Intruse,* for instance, was performed in Catalan translation in 1893); moreover, many Barcelona musicians were drawn to the Brussels Conservatoire. But the case was different with most Catalan artists and writers, for in spite of the activities of *Les Vingt,* Brussels must have seemed too similar to Barcelona. Like the Catalans, the Belgians were also experiencing a nationalist movement which included the revival of a regional (unfamiliar) language. Both cities were also still quite small in contrast to Paris (Barcelona numbered around 350,000 in 1893, Brussels around 500,000, while Paris

was at the two and a half million mark), and both were in the process of physical change and expansion. In terms of architecture, compelling comparisons may be made between on-going building and design activity, especially in the Art Nouveau buildings and furniture of Victor Horta and Henry Van de Velde, and in the work of *Modernista* architects and designers, such as Antoni Gaudí, Lluís Domènech i Montaner and Gaspar Homar.[13]

But Casas and Rusiñol had set the pattern for going to Paris. Moreover they were the giants on the Barcelona artistic scene in the closing years of the century, and, as has been pointed out, it was largely through their eyes that Picasso and the younger generation that frequented Els Quatre Gats first saw French art. When the latter reached Paris, their knowledge of French art was highly eclectic, and it was made up of two components: work that they knew at first hand, which was primarily the work of graphic artists, such as Steinlen and Forain; and the French currents that were implicit in the paintings and posters of Casas and Rusiñol. This, naturally, influenced their receptivity to contemporary art when they actually got to Paris: Toulouse-Lautrec, Steinlen, Puvis and Carrière made a far greater impact than the Impressionists. This interrupted chain of influence is surely characteristic of the art of a foreign community in a mainstream center.

In 1900 the specific attraction to Paris for Picasso and many of his friends was the Exposition Universelle, but in a sense the decision to live and work in the French capital—and that usually meant Montmartre—had already been made for them by the previous generation of Barcelona artists, who had created the Catalan colony there. To follow in their footsteps was the most natural course to take, whether they went in search of a bohemian lifestyle, good times and particularly foreign women—there were practically no Catalan women who went on their own—or whether their goal was the serious attraction of an artistic future there.

On that first trip to Paris, apart from women, Picasso's Catalan friends were his companions for almost all of his time there. He shared a studio with Carles Casagemas (1880–1901), the elegant, well-to-do and rather unsuccessful painter and writer who was also Picasso's moody studio-mate in Barcelona, and Manuel Pallarés (1876–1974), Picasso's oldest Barcelona chum from his art school days. (Picasso, originally from Málaga, had first arrived in Barcelona in 1895 and had attended classes at the local academy where his father had recently been appointed professor. There he met Pallarés, and in 1896 they also had shared a small studio.) The three friends were immediately taken care of

by the Catalan community and soon after their arrival they moved into a studio in Montmartre (at 49 rue Gabrielle) that had recently been vacated (and was presumably still rented) by two other Barcelona artists from the Quatre Gats circle, Nonell and Ricard Canals (1876–1931). Conveniently they seem to have left behind their French girlfriends, two sisters called Antoinette Fornerod (who became Pallarés's lover) and Germaine Gargallo (with whom Casagemas became infatuated), and Odette (Louise) Lenoir (with whom Picasso became involved).

Not only had Nonell and Canals left Picasso and his friends with a comfortable living situation (Casagemas called it "a kind of dirty arcadia")[14] but also they had established themselves professionally in Paris in a way that was to affect the aspirations of the younger artists, especially of Picasso. Like Rusiñol and Casas, who had exhibited in Paris for a number of years at the annual official salons, Nonell and Canals showed their work at the salons, but also chose to align themselves with the new dealers on the rue Lafitte. In 1897, for instance, their works had hung alongside those of Gauguin and other French artists in the *Quinzième Exposition des Peintres Impressionistes* at Le Barc de Boutteville. The moderate success in sales they enjoyed, especially Canals, during those years was almost certainly due to the French taste for anything Spanish—in fact, the dealer Durand-Ruel himself sent Canals off in 1900 and again in 1902 to Madrid and Seville to get new "authentic" material for his work. When Picasso made his first sales in Paris in 1900 to Berthe Weill, through his Catalan dealer Pere Manyac, he was to follow suit with his depictions of bullfights.

After his first two-month visit to Paris, Picasso traveled back and forth several times between Paris and Spain (not an unusual pattern for a Barcelona artist) finally making what turned out to be a permanent move to France in the spring of 1904. It was not an easy decision, for Picasso was strongly attached to Spain, but this was a period in which he experienced personal difficulties there—he was out of money most of the time, he was saddened by the suicide of his friend Casagemas in 1901, and he increasingly found his friends in Barcelona to be less ambitious than he, lazy and really not that good. (Later he said that Nonell, who had settled in Barcelona rather than Paris, was the only exception.) Thus, the decision to move seemed inevitable, and it was probably because his friend, the artist-journalist Sebastià Junyer-Vidal (1878–1966), who had plenty of money, was planning a trip that Picasso left for Paris when he did.

When they arrived in April 1904, they learned that the Basque sculptor Paco Durio (1875–1940) was giving up his studio at no. 13 rue Ravignan, and Junyer-Vidal immediately took it over. He and Picasso shared the space until Sebastià departed for Mallorca, probably in the summer, and Picasso stayed on—actually until 1909. There in August of 1904 he met Fernande Olivier, just outside on the Plaçe Ravignan, and she moved in with him in September of the following year. Many of the artists who already occupied the studios in the so-called Bateau Lavoir, a dilapidated, rambling building Max Jacob said looked like a Parisian washboat, were in fact Spaniards. Before Junyer-Vidal and Picasso moved in, Durio himself had been in the studio for some time, and it was here that he had introduced Picasso to the work of his friend Gauguin.[15]

Another member of the Catalan community (and an old friend of Durio's) who had also been in residence in the Bateau Lavoir was the painter Joaquim Sunyer (1874–1956). His relationship with Picasso was at first rather cool, since Sunyer had been having an affair with Fernande before Picasso had met her;[16] but this appears soon to have been forgotten—the women in these circles seem to have changed hands among them often. Sunyer moved out of the Bateau Lavoir at almost the same time Picasso arrived, and his studio was taken over by Canals, who had just returned from Madrid. Canals lived there until 1906 with his wife Benedetta Bianca, an Italian model (reportedly for Renoir, Degas and the sculptor Bartolomé) and a personal friend of Fernande's. In fact the two women modeled together in 1902 for Canals as Spanish majas in the *Box at the Bullring*,[17] and again for Sunyer in 1905 in his pastel *At the Circus* (Fig. 9–8). Soon after Canals arrived he reestablished contact with Picasso, whom he had known since the Quatre Gats days, and involved him once again as he had in Barcelona in techniques of printmaking. When Fernande described her first visit to Picasso's studio in the autumn of 1904, she singled out his etching *The Frugal Repast*, the print he had made as a result of Canals's advice.[18]

Picasso's portrait of *Benedetta as a Maja* (Fig. 9–9) also dates from this period (1905). Picasso's transformation of the women he loved or admired into Spanish types would later be repeated on several occasions—he painted his Russian wife Olga in 1917 in a mantilla in Barcelona, and his widow Jacqueline often appeared in Spanish regalia in Picasso's work of the sixties.

Another of Picasso's immediate circle who turned up frequently looking for meals and a place to sleep was the sculptor and petty thief Manuel Martínez Hugué (1872–1945), known as Manolo. Picasso's and Manolo's lives had already crossed several times, for although the sculptor had been to Paris as early as the mid-1890s, he had lived mostly in Barcelona, where he

had been a regular at Els Quatre Gats. There he worked for a time as an assistant to Juli Pi on the children's puppet theater. Unlike his bourgeois Catalan friends—most of whom had plenty of money—since childhood Manolo had been poor (his father had abandoned the family and gone to Cuba) and he had learned to live on the margins of society in any way he could. By the time Picasso met him at Els Quatre Gats, his reputation as a bohemian scavenger and jokester preceded him, but Picasso loved him, probably because of his humor, tricks, and ability to live as a modern-day Lazarillo de Tormes.

One day at Els Quatre Gats early in 1901, according to Manolo, the Catalan businessman and collector Alexandre Riera proposed that Manolo accompany him to Paris.[19] The sculptor accepted, scrounged money from Rusiñol's wife for the train journey, and once there lived off Riera until the latter had to leave Paris on business. Coincidentally, Carles Casagemas had just returned from Spain (where he had been with Picasso), and Manolo approached him at his apartment asking for money. The well-off Casagemas assured him of his willingness to assist him, and then they joined a group of friends at the Café Rotonde for a farewell lunch for Riera. Among the guests was Germaine, Casagemas's girlfriend of the previous autumn, and it was on this unfortunate occasion that Casagemas, despondent over their failed love affair, attempted to shoot her. Thinking he had killed her, Casagemas shot himself, falling into Manolo's arms, and died soon afterwards.

Manolo stayed on in Casagemas's studio until Picasso arrived in May and took it over, but it is unlikely that the sculptor ever paid rent. In fact, Picasso later wrote in a letter that summer that Manolo had been forceably taken out of the studio by the police.[20] But while he was there Manolo recounted the full story of Casagemas's suicide to Picasso, which accounts for the delay in Picasso's death portraits of Casagemas (Casagemas died in February 1901 and the paintings were made the following autumn) and the *Evocation* or *Burial of Casagemas* (Musée Picasso, Paris), a key work which stands at the beginning of the Blue Period.

The Manolo Picasso knew as part of the Catalan circle a few years later was still decidedly poor, but his efforts at sculpture and, with the help of Paco Durio, at jewelry-making (he produced a series for the Barcelona firm Arnould y Vin from 1903 to 1907) began to pay off.[21] By 1910 Picasso's dealer Kahnweiler began giving him money, and the sculptor, now with a wife by the name of Totote (a woman who would figure in Picasso's personal life in the 1950s when she tried to marry him off to her adopted daughter Rosita), moved to Ceret in the south of France, where a number of the Cubists

would visit him, including Picasso, Braque and Gris, as well as others from the Catalan community in Paris, notably Sunyer, the poet Josep Junoy and the painter Ramon Pichot.

By the end of the nineties Pichot (1870–1925) was already recognized as an established *Modernista* in Barcelona—some years earlier he had collaborated with Rusiñol on illustrated books and in the *Modernista* festivals in Sitges. He had also been his companion on a journey through Spain—and he had held a one-man show at Els Quatre Gats in February 1899, just about the time Picasso was beginning to frequent the café. In spite of an eleven-year difference in age, he and Picasso became close friends early on, and Pichot introduced the young Andalusian to many Catalan artists and intellectuals who gathered regularly at his family's home. In 1900 Pichot was also in Paris when Picasso was there, and his Don Quixote-like physique (Fernande's description)[22] stands out in Picasso's drawing (Fig. 9–10) of a group of drunken friends leaving the Exposition Universelle: Pichot appears alongside Picasso, whose girlfriend Odette is on the other arm; in the middle is Miquel Utrillo; and at the right is Casagemas in the company of Germaine, the same woman who would later become Pichot's wife.

Pichot was one of the few Spanish artists who, like Picasso, remained in Paris in the early years of the war, and it is likely that they continued to see each other even though Picasso had long since left Fernande, who had become Germaine's great friend. Around 1920 the Pichots left Paris to return to Spain, first to Barcelona and then to Madrid; but on a visit to Paris in 1925 Pichot suddenly died. Picasso responded to his own sense of loss, as he had done in his evocations of Casagemas's death, in his work, and he included the profile of his friend as a kind of half-voyeur, half-participant in his major composition of that year, *The Dance* (fig. 9–11). Although John Golding has convincingly argued the primitive sources for the atavistic intensity of the dancing figures as well as the central figure's similarity to scenes of the Crucifixion,[23] the actual dance represented suggests a specific Catalan source: the *sardana,* which is danced—as a symbol of national unity (and friendship)—in a circle, arms held high, hands together, and with a stepping motion—thus, in this way, Picasso has bid one of the most important friends of the Catalan circle farewell.

* * * *

The Catalan community in Paris, which had its own character apart from the *bande à Picasso,* was essen-

tially a Barcelona colony which both drew in people who were not Catalan and also attracted transient members. In their work they obviously responded to Paris, but (unlike Picasso) what they gained was from the general artistic ambience they encountered there, for as a colony they remained somewhat aloof from the latest French artistic trends. What is even more remarkable is that beginning around 1906 the principal Barcelona art movement of the following decade essentially took shape and developed on French soil. The major spokesman of the new movement, which he named *"Noucentisme'"* (that is, art created in the spirit of the twentieth century) in 1906, was Eugeni d'Ors (1881–1954), an essayist and critic who like so many of the Catalan group had begun his literary activities at the Quatre Gats café.[24]

D'Ors arrived in Paris in late May 1906 to assume the post that had recently become vacant because of the death of Pere Coll i Rataflutis (who had been an early supporter of Picasso)[25] as Paris correspondent for the Catalan daily *La Veu de Catalunya.* Through his columns, collectively known as the *Glosari,* d'Ors described symptoms of what he perceived to be the emergence of a new cultural and intellectual current, which because of its "classical" nature had special resonance in Barcelona, where conditions were ripe for a new art movement.

By this time the position of the Catalanist movement had changed considerably. In 1901 four Catalanists had been elected to the parliament in Madrid, which in effect broke the stranglehold of centralist parties; and from then on the advance of Catalanism was relentless, despite attempts by Madrid to check its progress. So, although in 1902 the use of the Catalan language in schools was prohibited, the following year saw the start of university courses in Catalan. In 1905 Catalanists took control of the Barcelona city council, and in spite of the passing that year of the infamous "law of jurisdictions," which gave military courts the right to try any offences against the unity of the nation and the honor of its armed forces—under which any manifestation of Catalanism could be considered an offence—the Catalanist party continued solidifying its base. In 1907 the Institut d'Estudis Catalans was founded, and in 1911 an autonomous administration for the whole of Catalonia, the Mancomunitat, was established.

These same years saw the dispersal of the *Modernista* group; the Quatre Gats café had closed in 1903, while the decorative strain of the *Modernista* style had reached a point of extreme decadence in the eyes of its critics. No longer did the individualism of Art Nouveau-influenced design or the symbolist nuances of

theater or poetry complement the optimistic and increasingly independent political situation. Although internal strife continued among the various factions of the Catalanist movement, in general, from right to far right, the prosperous bourgeoisie was in better shape than ever before.

In the arts the response to these political changes was reflected in a return to classical values, which were seen as fundamental to the creation of a new twentieth-century expression. The excesses of Art-Nouveau organicism, for example, were replaced (as happened elsewhere in European decorative art and architecture) by a tendency towards geometric design, and the psychological moods of Ibsen and Maeterlinck were rejected in favor of subjects that underlined the solidity and pride of Mediterranean peoples. To this aim, d'Ors began to define this new artistic and literary movement, *Noucentisme,* by pointing to a new order of things in the arts that stressed, above all, structure. Classicism in this sense was thus interpreted as a hierarchical ordering.

Very quickly d'Ors began to see evidence of a new classical direction all around him, and in his columns he reported its various manifestations in art, science and politics back to a curious and attentive audience in Barcelona. For example, soon after he arrived in 1906, he wrote of Cézanne, who had recently died and whose work was featured at the Salon d'Automne that year, in this context.[26] By contrast, in a series he devoted to Impressionism in the following year, he criticized Impressionist painters for their lack of structure and for being too vague and too personal.[27] D'Ors also believed that as part of his role as correspondent but more importantly as spokesman for the new *Noucentista* movement, he must offer the Catalan reader a picture of scientific life in Paris. With this in mind, he attended science and philosophy classes at the Collège de France.

When d'Ors returned to Barcelona to live in 1911, he continued his *Glosari,* in which he "nominated" an ever-increasing number of *Noucentistes,* whose activities ranged from music to painting and sculpture, literature and science. In 1911 he grouped together a rather curious cross-section of *Noucentistes* (who included Homer and Goethe as honorary figures and among contemporaries ranged from a Japanese jujitsu teacher cum poet, Ra-ku, to Gargallo and Picasso), whom he deemed to be representative of the principal currents of *Noucentisme,* in a special publication which he edited, the *Almanach dels Noucentistes.* In a sense this literary calendar was regarded as a kind of manifesto of the Barcelona movement; and the fact that so many of the artists (including Picasso) and writers were resident in Paris was really beside the point. The activities of the Cata-

lan colony there were so integral to the development of *Noucentisme* that their validity was never questioned, nor was the movement ever regarded in Barcelona as just an extension of French mainstream art.

One of the linguistic extensions d'Ors made to the notion of a new classicism was to call it a "Mediterranean" movement. Since the Catalans felt a sense of identity with the cultural heritage of the Mediterranean basin (there had been important Iberian and Roman settlements along its coastline), this seemed a logical expression of the contemporary Catalan movement, although there was no doubt a racial element, which is evident in the writings of d'Ors and a number of his contemporaries.[28]

While d'Ors was the dominant voice on the cultural scene, there were other younger journalists who were making a mark, among them a lively exponent of the avant-garde, the poet, cartoonist and critic Josep Junoy (1877–1955). Junoy had arrived in Paris in 1907 and had begun working for Paul Guillaume, from whom he acquired a fairly wide knowledge both of modern and ethnic art. He also moved in literary circles that included Apollinaire, whose work would profoundly influence Junoy's own poetry some years later. In 1911 he began to write a column for the Barcelona daily *La Publicidad*, in which he concentrated mainly on the activities of Barcelona artists resident in Paris. Among the principal qualities he sought, like d'Ors, were the idea of a new order, an emphasis on structure and a reflection of Mediterranean culture in the work of the artists he considered, and he especially commended the painting of Sunyer and the sculpture of Enric Casanovas (Picasso's friend who had suggested in 1906 that he spend the summer in the Catalan village of Gosol).[29]

The concepts of Mediterraneanism and classical structure were applied by Junoy to art with a far greater perception than by the columnist-philosopher d'Ors. When Junoy published his book *Arte y Artistas* in 1912, his defense of Cubism was shaped by the *Noucentista* emphasis on structure and rational order. While his willingness to reproduce contemporary Cubist works by Picasso was exceptional in Barcelona (where Picasso's reputation still rested on the Blue Period, which was associated with Barcelona, and on the "classicizing" spirit of his Harlequins of 1905, by which he was represented in the *Almanach dels Noucentistes),* it is also further evidence of how the Catalan community still considered Picasso as one of them rather than as the chef d'école of Parisian art.

* * * *

Picasso was really the first of the Barcelona colony to break the mold of the artist who never became fully absorbed in Parisian life, and in some ways he served as a bridge between the colony and Paris. Certainly his commitment to what he discovered there was much greater, and the response in his art and life was far more acute. His own rootlessness probably aided him—beginning as a child he had moved with his family from Málaga to La Coruña to Barcelona, briefly once more to Madrid, and then back and forth between Barcelona and Paris. Furthermore, he was not Catalan, and thus the strong pull of regionalism and cultural identification was never an issue for him as it was for many of his friends.

Unlike the others, Picasso turned himself into a Parisian, and although his *"bande"* included, almost by definition, any Catalan who arrived in Paris during those years, his closest friends were Guillaume Apollinaire, André Salmon and Max Jacob. As Jacob later recalled his first meeting with Picasso, they did not share a common language, but stayed up all of the night discussing art and poetry using sign language.[30] This encounter is a good example of the way in which Picasso still without French not only responded to the sympathetic personality of the poet but also instinctively recognized an entrée into Parisian intellectual life. In fact, after that meeting, when Picasso was in Barcelona it was in his letters to Jacob (in a very rudimentary French) that he begins to complain about working in Barcelona and to make derogatory remarks about his Catalan artist friends.[31]

Picasso needed his French friends just as he needed Paris, and his extraordinary ability to absorb the latest artistic and intellectual currents led to a rapid personal development in his art. By 1906 Picasso had passed through phases responding to post-impressionist facture, especially to Van Gogh, and to Gauguin's flattened forms of color enclosed by strong contour lines. His Blue Period (from late 1901 to 1904) was in part a response to symbolist currents in France (in the work of Puvis de Chavannes and Gauguin for example) as well as to the *Modernista* ambience of Barcelona and its special regard for the work of El Greco. His change in palette and subject-matter in 1905 reflects not only brighter personal circumstances but also an admiration for the poetry of his friend Apollinaire. Later that year he met Gertrude Stein and through her (another foreigner in Paris) he met Matisse and many others. The radical changes that began to occur in his work in 1906 reflect an awareness not only of his personal connections to Iberian and Mediterranean tradition, but also to the spirit of the savage art of the *"Fauves"*. Then his friendship with Braque and their shared admiration for the

work of Cézanne set them on their course towards the development of Cubism.

Although Picasso was the star of the Catalan community in Paris and although some of its members, such as Pichot, became very important to him personally, there is practically no evidence at all of the impact of Picasso's art after 1905 on their work. Interestingly, if the work of Picasso, Canals, Sunyer, or the work of another member of the Catalan community, Anglada Camarasa (who even adopted French citizenship) is compared around 1901 there are many similarities. Yet by 1910, their artistic paths had diverged markedly: Canals had settled on a kind of bravura-style which had not changed much at all since 1900; and similarly Anglada had developed a slick formula combining Spanish types, a bright palette and a format influenced by contact with Klimt at the Secession in 1904. But by 1910, when Picasso, Fernande, Derain and his wife vacationed with the Pichots at their summer home in Cadaqués, Picasso was well into the analytic phase of Cubism. Pichot, by contrast, was described by Apollinaire just a few months later as a representative (like Picasso) of "that brilliant group of Spanish painters in Paris who are continuing the tradition of Goya or, better still, of Velázquez."[32] But he says of Pichot's still lifes that they were "so beautifully arranged that one would think they were painted by a woman" —certainly a far cry from Picasso's radical analysis of form and of the whole question of representation itself.

There were two other artists who were also able to break out of the mold of the foreign colony. One was Sunyer (to whom we shall return) and the other Juan Gris (1887–1947), the one artist who felt the impact of Picasso's art directly. In her memoirs Fernande Olivier recalled that Picasso had welcomed and supported a young Spanish cartoonist when he arrived late in 1906.[33] José Victoriano González, who had used the name Gris as an illustrator's pseudonym before leaving Madrid, upon his arrival in Paris had been taken by a mutual Spanish friend (the painter Daniel Vázquez Diaz) to meet Picasso in the Bateau Lavoir, and Gris moved into a small studio there. Although he did not begin exhibiting paintings until 1912—that is, over five years after his arrival (even then his earliest known dated painting is only from 1910), he soon established a reputation both in Paris and, in fact, in Barcelona as a professional cartoonist for journals such as L'Assiette au beurre and the most important Catalan satirical journal of the period, Papitu.

Although Gris had never been to Barcelona, he was drawn into the Catalan circle in Paris, and it was through them that he met Feliu Elias (1878–1948), the critic (under the name Joan Sacs), cartoonist (as Apa), and painter. Elias, who founded the journal Papitu in 1908, invited Gris to become one of its principal illustrators in that year. Not only did Gris's real survival depend upon his graphic work—he was almost destitute for much of this period—but his fascination and understanding of the possibilities of mechanical printing techniques and the preparation of transfer drawings would provide the basis for much of his early cubist experimentation—a little studied aspect of his work that almost certainly did not escape Picasso's eye. Gris, however, in those days regarded Picasso as his master and acknowledged him in his work first in a cartoon (Fig. 9–12) he published in L'Assiette au beurre on July 9th, 1910, and again two years later in his portrait of him (Art Institute of Chicago), when Gris made his début at the Salon des Indépendants now as a Cubist. Although Gris continued to develop and establish a strong professional reputation, the shadow of Picasso was always over him; and his letters of later years reveal a sense of grudging envy of his idol's continued social and financial success.[34] It must have been difficult for all of the Spaniards in Picasso's circle to come to terms with his work, for with the exception of Gris and Sunyer, none of them was prepared to lose his identity as a Barcelona artist working in Paris and become Parisian.

Sunyer, who moved to Paris in 1896, had decided to settle in France, and it was only because of the war that he reluctantly returned to Catalonia, where he remained for the rest of his life. His early experiences in the French capital had followed the pattern of Rusiñol and Casas: as they had done he attended the Académie Carrière, while many of his close friends in Paris were from the Catalan colony. Among them, for instance, were political exiles and writers including Brossa and Cortada, as well as the sculptor Manolo. But Sunyer (like Manolo, Picasso and later Gris) did not have the luxury of family money back home to support his bohemian adventure, and in his real struggle to survive he entered into Parisian life more fully than most of the circle.

As early as 1897 Sunyer's drawings began to appear in journals (such as Cri de Paris) as well as in illustrated books, including Rictus's Les soliloques du pauvre (1897), 5 Heures Rue du Croissant by Henry Fèvre (1901), and Gustave Geffroy's 7 Heures Belleville (1902). It was through his friendship with Geffroy, in fact, that he developed his admiration for Cézanne, and his contacts with French artistic circles widened. He met the dealer Vollard, who reportedly bought some of Sunyer's works during those years, and around 1903 Sunyer claimed to have met and worked alongside Renoir.[35] He also met other artists at the academy on Boulevard Clichy, and in 1904 two of his

fellow-students there, Marquet and Modigliani, were numbered among his closest friends. In that year Sunyer's work was shown alongside that of Matisse, Vuillard, Manguin and Marquet—some of whom would make their names as Fauves the following year.[36]

In 1905 the dealer Barbazanges (who handled some of Renoir's work) also became interested in Sunyer and essentially took him on as one of his artists until Sunyer left France in 1914. Just as Durand-Ruel had advised Canals to go to Andalusia for subjects a few years earlier, Barbazanges reportedly paid for Sunyer to go to Madrid to work (which he did in 1905–1906). But Sunyer's "Spanishness" never turned into the trivial portrayal of gypsies or Spanish girls in festive dress as it had for so many of the others. Rather, Sunyer's sense of identity with his Mediterranean origins led to the development of a personal style based in landscape painting. His arcadian compositions beginning in about 1910 also reflected a naive response to Cézanne, Renoir and Matisse, as well as an awareness of the work of Le Douanier Rousseau. In 1910 Barbazanges showed fifty works by Sunyer at his gallery (at 109 Faubourg Saint-Honoré), and French critics such as Picasso's friends Salmon and Apollinaire responded favorably, as did the inventor of the terms "fauvism" and (along with Matisse) "cubism," Louis Vauxcelles.[37]

Around the time of the Barbazanges show Sunyer also became especially friendly with the critic Gustave Coquiot, who had been an early admirer of Picasso (in 1901). In fact, Coquiot, who wrote about Sunyer in his *Cubistes, Futuristes, Passéistes* in 1914, considered him, along with Picasso, to be one of the two most important resident Spanish artists in Paris. But Sunyer's wide circle of both French and Spanish friends and the beginnings of a successful career in France ended in that same year; just before he left Paris because of the war he wrote a friend: "It is difficult for me to leave the Paris I am so close to ... it almost means giving up living and seeing life lived so fully."[38]

Sunyer's importance in Barcelona, however, far exceeded that of the others of his generation who had returned. For one thing his work was much more in tune with current developments in the Catalan artistic and intellectual movement as articulated by both d'Ors (even though he failed to include Sunyer in the *Almanach dels Noucentistes*) and Junoy, while the concerns of most of the others were in a sense still those of the second generation of *Modernistes*. The one exception was Nonell, whose work had developed and who had enjoyed an almost unrivaled reputation as Barcelona's leading artist during the first decade; but he suddenly died early in 1911. Thus when Sunyer's work

was featured in an exhibition at the new Faianç Català gallery in the spring of that year, he was essentially anointed as the leading painter of Barcelona's *Noucentista* movement. Consequently, his painting *Pastoral* (Fig. 9–13) was regarded as the quintessential image of *Noucentisme*, for it combined what were perceived as advanced compositional ideas deriving from recent French painting with the idea of arcadia, Mediterranean light and above all, the colors of *la terra catalana*. The way had already been paved by d'Ors to receive Sunyer's work in this sense, and the celebration of the Mediterranean as a characteristic of Sunyer's work both influenced this direction and also came to exemplify it in Catalan painting.

Just as Rusiñol and Casas had brought back aspects of Parisian art in the nineties but also initiated a new movement in Catalan art—*Modernisme*—Sunyer's work had a parallel role for the next generation of local artists in that it brought back something new, though not the incomprehensibility of Picasso's Cubism. Even though the dealer Dalmau had put on an important Cubist show in Barcelona as early as 1912 (featuring Gleizes, Metzinger and Duchamp but not Picasso and Braque), no appreciable response to Cubism was felt there until a few years later. Part of the reason for the seemingly indifferent reaction to such a controversial work as Duchamp's *Nude Descending a Staircase* (which was shown for the first time at Dalmau's) can be accounted for in the example of the preceding generation. Artists like Picasso had their first education through the work of Rusiñol and Casas—through them they learned Degas and Manet, for example—and this stage was necessary before they could tackle artists such as Van Gogh or Gauguin, because they lacked a comparable artistic tradition in Spain which would have prepared the older artists themselves to respond to such work when they arrived in Paris. Similarly, young artists in Barcelona in the teens had to understand Cézanne before they could understand Cubism, and this they did through Sunyer. The work he produced once back on Catalan soil seemed to bring together most coherently, in works such as *Cala Forn* (Fig. 9–14) of 1917, the lessons of Paris in the context of local *Noucentisme*.

Sunyer's return in 1914 coincided with the dispersal of the Cubist circle in Paris because of the war. Some of them like Braque and Apollinaire went to the front, while others like Picasso (at least until 1917) and Gertrude Stein chose to stay in France. Most of the Catalan colony, however, returned home, and since Spain was a neutral country many others, including French artists, sought exile there. In this particular case, in fact, Paris came to Barcelona, and the impact of Paris artists on the local scene produced a small but significant avant-garde

movement. By 1917 the effects of this can be seen in the work of Sunyer's immediate heirs, notably two young art students and studio-mates, Enric Ricart (1893–1960) and Joan Miró (1893–1983). Works such as *The Porch* (Fig. 9–15) and *Garden with a Donkey* (Fig. 9–16) (both done in 1918), draw both on Sunyer's work (which perhaps had reached its apogee in 1917) and also on the Cubist work of Gleizes and Delaunay, who had turned up in Barcelona and whose painting (which could be seen at Dalmau's gallery) represented a less hermetic kind of Cubism than that of Picasso. Moreover, Gleizes and Delaunay, as well as the anarchic Picabia, who was also there, shared many of the same sources as Sunyer—the work of Matisse and Cézanne, for example—and for this reason their work was not totally incompatible in the eyes of young Catalan artists. The Cubist work that Picasso produced in Barcelona in the summer of 1917 was not shown there until 1919, while there is no doubt that the influence of *Noucentisme* combined with other classical trends that affected Picasso's work at this time.[39]

As soon as the war was over, Ricart and Miró went off to Paris and there, as would be expected, they sought out Picasso, who had returned to France from Barcelona in the autumn of 1917. While the Catalan community (and obviously Picasso still at its center) had survived, it resumed now with a new cast of characters, among whom Miró would assume a principal role. On this particular occasion he and Ricart stayed only a short while and then returned to Barcelona, but there they parted ways: Ricart retired to a village on the coast and thereafter worked as a *Noucentista* graphic designer; while Miró returned to Paris, where his work, which had been inspired first in Barcelona, developed in France and itself influenced the Parisian artworld in the twenties. Miró, like Picasso, was able to break out of the mold of the artists in the Catalan community and, in a sense, the pattern had repeated itself.

This paradigm demonstrates that the stream of art-historical influence is not necessarily a direct one. The study of things which appear to be outside the mainstream—such as the work of Rusiñol, Casas or Sunyer—not only results in a greater understanding of the context from which major artists—such as Picasso, Gris or Miró—emerged but also shows how this influence through the younger artists is returned to the source, in this case, Paris, and how it can affect the course of the mainstream itself. As Gertrude Stein observed, "painting in the twentieth century was done in France but by Spaniards."

<div style="text-align:right">

Marilyn McCully
London, England

</div>

Notes

1 Gertrude Stein, *Picasso,* London (1938), p. 1.

2 Another section of the Spanish community is discussed in the chapter on the pianist Ricardo Viñes in Elaine Brody's *Paris: The Musical Kaleidoscope 1870–1925*, New York (1987), pp. 168–315. The information she gives in passing on painters tends to be unreliable.

3 Rusiñol had first studied with the genre painter Tomás Moragas, whose own typically narrative canvases stressed a technique based upon an accurate recording of detail. Of greater significance was Rusiñol's contact in the 1880s with the "School of Olot," under the leadership of Joaquim Vayreda, who stressed the value of "truth to nature" in painting—above all, the Catalan landscape. Rusiñol's inclusion of signs of modern landscape—railway stations and the like—was perceived as an early revolutionary advance in the subject-matter of the Catalan school.

4 Raimon Casellas, "Exposició de pinturas," *L'Avenç* (Nov. 30, 1891).

5 See, for example, Léon Deschamps, "L'Affiche espagnole," *La Plume* (1 July 1899), pp. 417–423; Pylax, "New Posters," *The Poster Collector's Circular*, no., 2 (Feb. 1899), pp. 23–27; and C. Street, "Spanish Posters. Part I," *The Poster* (Nov. 1899), pp. 118–124 and "Part II," (Dec. 1899), pp. 159–164.

6 Isidre Nonell, Letter to Raimon Casellas (March 3, 1897); reproduced in *D'Art* (May 1973), p. 10.

7 By 1900 Alexandre Cortada (1865–1935), whom Picasso caricatured as "chief of the separatist committee" (in Paris) in a letter (Nov. 11, 1900) he and Casagemas sent to their friend the writer Reventós in Barcelona, had already turned into a Catalan businessman. In the same letter Casagemas described him as a "miserly bastard," "loaded with millions," who "considers himself an intellectual but he's an arse." Quoted in Marilyn McCully, *A Picasso Anthology*, London (1981), p. 27.

Jaume Brossa (c. 1869–1919), had earlier worked along with Cortada on the journal

L'Avenç in Barcelona, where he had voiced his pro-workers' ideas and his interest in Nietzsche. Picasso seems to have drawn him only once (Barnes Foundation, Philadelphia), also on his first visit to Paris in 1900, along with Catalans Pichot, Manyac, Casagemas and Gener; see *Der Junge Picasso,* Kunstmuseum Bern (1984), p. 174.

8 The influence of anarchist thought on *Modernisme* and the way disillusion with both movements turned so many Barcelona artists and intellectuals to *Noucentisme* (see p. 230) is a subject that would repay careful study and analysis. Patricia Leighten's imaginative article, "Picasso's Collages and the Threat of War, 1912–13," *Art Bulletin* (March 1987), pp. 134–136; and her unpublished dissertation, "Picasso: Anarchism and Art, 1897–1914" (Rutgers, 1983), unfortunately make no contribution of any value to the question of art and politics in Barcelona, since her arguments are based upon so many misunderstandings and fundamental errors of fact, while her enthusiasm for her thesis that a politically committed Picasso acted out the part of the "anarchist artist-hero" leads her to see all evidence in this light.

9 Jung discusses the Blue Period and *Evocation* in particular in "Picasso," *Neue Zürcher Zeitung,* CLIII:2, Zurich, 12 November 1932; quoted in McCully, *A Picasso Anthology,* pp. 182–186.

10 John Richardson in "Picasso's Apocalyptic Whorehouse," *The New York Review of Books* (23 April 1987), pp. 40–47, has persuasively argued this point with particular reference to Picasso, El Greco and the evolution of the *Demoiselles d'Avignon.*

11 In a letter (November 3, 1897) from Madrid to a Barcelona art-school chum, Joaquim Bas i Gich, Picasso declared that "if he had a son who wanted to be a painter, he wouldn't send him to Madrid but to Munik [*sic*]"; reproduced in Dore Ashton, *Picasso on Art,* New York (1972), p. 105. Concerning Gris's contact with the German cartoonist Willy Geiger in Madrid, see: Marilyn McCully. "Los comienzos de Juan Gris como dibujante," *Juan Gris,* Madrid (1985), pp. 17–18.

12 Roland Penrose, *Picasso: His Life and Work,* London (1981), p. 56.

13 See, for example, Ignasi de Solà-Morales, "Modernista architecture," and Daniel Giralt-Miracle, "The Decorative Arts in everyday life," in *Homage to Barcelona,* London (1985).

14 See Casagemas's letter to Reventós (Nov. 11, 1900) quoted in McCully, *A Picasso Anthology,* pp. 27–30.

15 Jaime Sabartés, *Picasso: An Intimate Portrait,* London (1949), p. 80.

16 Fernande Olivier, *Souvenirs Intimes,* Paris (1988), p. 178. Jaume Sunyer also recalled his father's affectionate memories of Fernande in "Joaquim Sunyer," *Picasso, Barcelona, Catalunya,* Barcelona (1981), pp. 61–64.

17 Canals's painting of Fernande and Benedetta at a bullfight (Priv. Coll., Barcelona; reproduced as Cat. no. 7, *Canals en el Museo de Arte Moderno,* Barcelona (Oct.–Dec., 1976), p. 109), was commissioned in 1902 by a Catalan banker, Ivo Bosch, who lived in Paris. Fernande also recalled that it was shown at the Salon d'Automne of that year; Fernande Olivier, *Picasso et ses amis,* Paris (1933), p. 31. In *Souvenire Intimes* (pp. 129–147 ff.), Fernande recounts that she worked as an artist's model, notably for Fernand Cormon, in the years before she met Picasso.

18 Olivier, *Picasso et ses amis,* p. 26.

19 Josep Pla, *Vida de Manolo,* Barcelona (1930), pp. 103–106.

20 See Picasso's letter to Utrillo (June 1901) quoted in Josep Palau i Fabre, *Picasso Vivo,* Barcelona (1981), p. 259.

21 Manolo later claimed (see Pla, pp. 107–108) that he could have made some money by making sculpture for Ivo Bosch (see note 17 above), but that the banker, who fancied himself a patron of Catalan artists in Paris, also liked to dictate the kind of work that they produced.

22 Olivier, *Picasso et ses amis,* p. 29.

23 John Golding, "Picasso and Surrealism," *Picasso in Retrospect,* New York (1973), pp. 54–55.

24 Enric Jardí, *Eugenio d'Ors,* Barcelona (1967), pp. 37–40.

25 Coll, who was secretary to the banker Ivo Bosch, reviewed Picasso's 1901 exhibition at Vollard's; quoted in McCully, *A Picasso Anthology*, pp. 34–35.

26 Three short reviews of the salon appeared in *La Veu de Catalunya* on 30 October, 10 and 15 November 1906.

27 Short articles on Manet, Monet, Renoir, Sisley, Pissarro, Morisot and Cassatt among others appeared in *Le Veu de Catalunya* on the following days in April: 16, 18, 24, 25, 26, 27, 29, 30.

28 The influence of Nietzsche, for example, on a writer like Pompeu Gener no longer had anything to do with anarchism but with Catalan nationalism; for further discussion, see M. J. McCarthy, "Catalan Modernisme, Messianism and Nationalist myths," *Bulletin of Hispanic Studies* LII (1975), pp. 379–395.

29 For discussion of Casanovas and *Noucentisme*, see Francesc Fontbona, "The Art of Noucentisme," *Homage to Barcelona*, London (1985), pp. 173–174, and the Palau de la Virreina exhibition catalog, *Enric Casanovas*, Barcelona (1985).

30 Max Jacob, "Meeting Picasso in Paris," quoted in McCully, *A Picasso Anthology*, pp. 37–38.

31 See Picasso's letter to Jacob (July 1902) quoted in McCully, *A Picasso Anthology*, p. 38.

32 Guillaume Apollinaire. "The Ramon Pichot Exhibition" (Nov. 1911); quoted in *Apollinaire on Art*, New York (1972), pp. 117–118.

33 Olivier, *Picasso et ses amis*, p. 158.

34 See: Douglas Cooper, *Letters of Juan Gris: 1913–1927*, London (1956).

35 Rafael Benet, *Sunyer*, Barcelona (1975), p. 154.

36 According to Benet (p. 112), the collective exhibition was held at "a gallery on the Rive Gauche."

37 These reviews are reproduced in the Caixa exhibition catalog *Joaquim Sunyer*, Barcelona (1983), p. 211.

38 Benet, p. 173.

39 See Marilyn McCully, "Noucentisme: Picasso, Junoy und der Klassizismus von Barcelona," *Picassos Klassizismus*, Bielefeld (1988), pp. 43–50.

Fig. 9–1 Ramon Casas. *Dance in the Moulin de la Galette*,
1890. Museu Cau Ferrat, Sitges.

Fig. 9–2 Santiago Rusiñol. *Kitchen in the Moulin de la Galette*, 1890.
Museu Cau Ferrat, Sitges. Photo: Arxiu Mas.

Fig. 9–3 Ramon Casas. *The Charge (Barcelona 1902)*, 1899 (redated 1903). Museu d'Art Modern, Olot. Photo: Arxiu Mas.

Fig. 9–4 Ramon Casas. *The Garroting*, 1894. Museo de Arte Contemporáneo, Madrid. Photo: Arxiu Mas.

Fig. 9–5 Santiago Rusiñol. *Anarchists*, 1893–94. Museu Cau Ferrat, Sitges.

Fig. 9–6 Isidre Nonell. *Repose*, 1904. Museu d'Art Modern,
Barcelona. Photo: Arxiu Mas.

Fig. 9–7 Pablo Picasso. *Crouching Woman, Meditating,* 1902. Private collection, Philadelphia. (Copyright ARS N. Y. / SPADEM, 1988.)

Fig. 9–8 Joaquim Sunyer. *At the Circus*, 1905. Private Collection, Barcelona. Photo: Arxiu Mas.

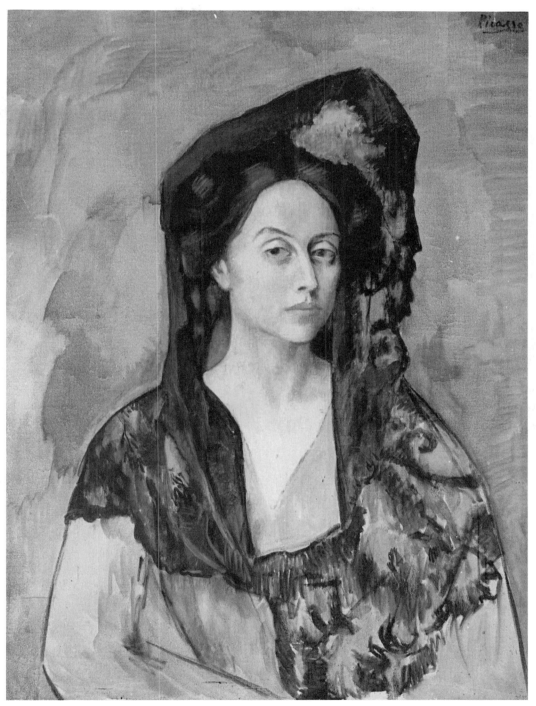

Fig. 9–9 Pablo Picasso. *Benedetta as a Maja*, 1905. Museu Picasso, Barcelona. Photo: Arxiu Mas. (Copyright ARS N. Y. / SPADEM, 1988.)

Fig. 9–10 Pablo Picasso. *Leaving the Exposition Universelle*, 1900. Formerly Acquavella Galleries, New York. (Copyright ARS N.Y. / SPADEM, 1988.)

Fig. 9–11 Pablo Picasso. *The Dance*, 1925. Tate Gallery, London. (Copyright ARS
N.Y. / SPADEM, 1988.)

Fig. 9–13 Joaquim Sunyer. *Pastoral*, 1910–1911. Private Collection, Barcelona. Photo: Arxiu Mas.

Fig. 9–14 Joaquim Sunyer. *Cala Forn*, 1917. Museu d'Art Modern, Barcelona.

Fig. 9–15 Enric Ricart. *The Porch*, 1918. Museu Victor Balaguer, Vilanova i Geltrú.

Fig. 9–16 Joan Miró. *Garden with a Donkey*, 1918. Moderna Museet, Stockholm. Photo: Statens Konstmuseer.

Support for this volume of the *Papers in Art History from The Pennsylvania State University*
was provided by the George Dewey and Mary J. Krumrine Endowment,
and the College of Arts and Architecture.

The project was also generously assisted by
the Institute for the Arts and Humanistic Studies
of The Pennsylvania State University.

Cover illustration: Elizabeth Vigée Le Brun, *Marie Antoinette and Her Children*, 1787,
Musé National du Château de Versailles.

Half-title illustration: Charles Nègre, *Le Secq on Notre-Dame*, ca. 1853, detail of Fig. 1–1.

Frontispiece: The Moses Window, Abbey Church of Saint-Denis. Photo: Michael Cothren.

First preface frontispiece: Paris, *La Place de l'Opera*, 19th century engraving.

Second preface frontispiece: *Performance by the Théâtre Italien in the Salle Ventadour*,
Paris, engraving of ca. 1843.

Detail on page 4 : Fontaine Durenne by M. Ch. Courtry, *L'Exposition Universelle de 1867*.
Detail on page 6: Gargoyle from Notre-Dame, Paris (19th century photograph).

This publication was formatted in its entirety with an Apple ® Macintosh™
and Pagemaker® 3.0 by Aldus Corporation.

Printed by Thomson-Shore, Inc., Dexter, Michigan.